Aberdeen College Library

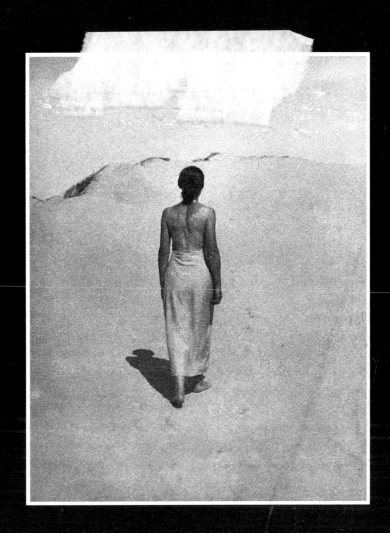

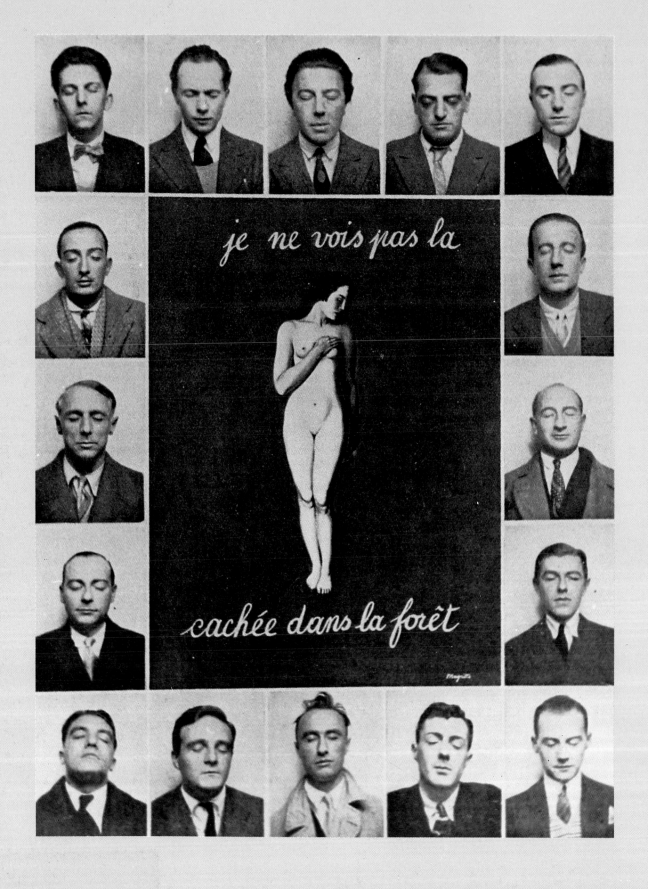

WHITNEY CHADWICK

Women Artists and the Surrealist Movement

220 illustrations, 20 in colour

WITHDRAWN

THAMES AND HUDSON

The cover illustration is a detail from Frida Kahlo's painting, *Self-Portrait with Thorn Necklace and Hummingbird*, 1940. The painting is reproduced in full on page 24.

1 (*half-title page*) Valentine Penrose, 1934

2 (*opposite title page*) René Magritte, *I Do Not See the* (Woman) *Hidden in the Forest*, 1929, surrounded by photographs of Surrealists: (*clockwise from top left*) Maxime Alexandre, Louis Aragon, André Breton, Luis Buñuel, Jean Caupenne, Paul Eluard, Marcel Fourrier, René Magritte, Albert Valentin, André Thirion, Yves Tanguy, Georges Sadoul, Paul Nougé, Camille Goemans, Max Ernst, Salvador Dali

3 (*opposite*) Toyen, *Seules les crécerelles . . .*, 1939

Any copy of this book issued by the publisher as a paperback is sold subject to the condition that it shall not, by way of trade or otherwise, be lent, resold, hired out or otherwise circulated, without the publisher's prior consent, in any form of binding or cover other than that in which it is published and without a similar condition including these words being imposed on a subsequent purchaser.

© 1985 Whitney Chadwick
First paperback edition 1991
Reprinted 1997

All Rights Reserved. No part of this publication may be reproduced or transmitted in any form or by any means, electronic or mechanical, including photocopy, recording or any information storage and retrieval system, without prior permission in writing from the publisher.

ISBN 0-500-27622-6

Printed and bound in Great Britain by
BAS Printers Limited, Over Wallop, Hampshire

Contents

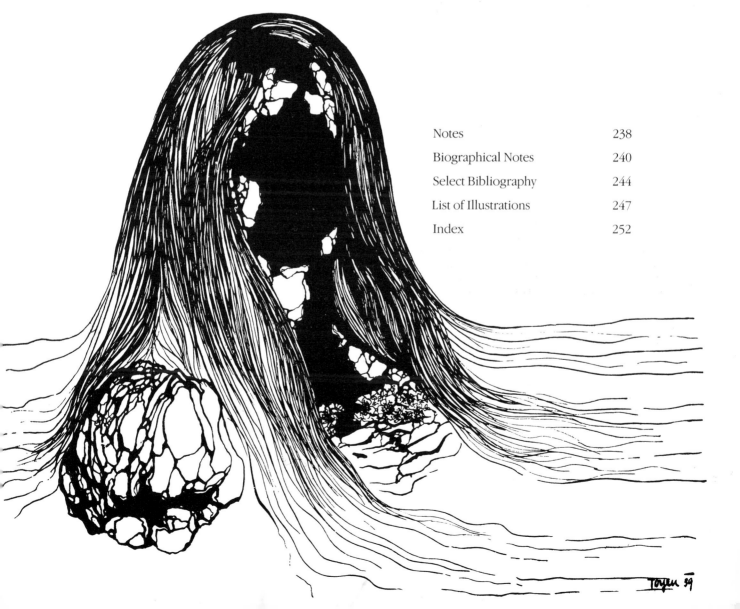

Acknowledgments

The good will and generous cooperation of many people contributed to making this book possible. I am deeply indebted to Eileen Agar, Emmy Bridgwater, Leonora Carrington, Ann Alpert, Ithell Colquhoun, Léonor Fini, Rita Kernn-Larsen Grünberg, Jacqueline Lamba, and Edith Rimmington for their willingness to make their work and their histories available to me.

Research was begun under a Fellowship for College Teachers from the National Endowment for the Humanities; a grant from the American Council of Learned Societies enabled me to complete the research in London, Paris, and Mexico City. I am grateful to Clive Philpott and the staff of the Museum of Modern Art library in New York, François Chapon of the Bibliothèque Jacques Doucet and the staff at the Centre de Documentation of the Centre National d'Art et de Culture Georges Pompidou in Paris, and the Smithsonian Institute's Archive of American Art.

I am deeply indebted to others who have written or are currently preparing biographies or monographs on several of the artists in the book and who freely shared their knowledge, their insights, and their information with me. My thanks to Hayden Herrera, Janet Kaplan, Stephen Miller, and Anthony Penrose. Eileen Agar has kindly allowed me to quote from her unpublished autobiography; Janet Kaplan and Walter Gruen allowed me to consult Varo's notebooks and diaries.

Many people have given freely of their time in interviews and conversations and have patiently responded to my numerous requests for information. I have been helped by more individuals than it is possible to name. I am most grateful to Lionel Abel, Dawn Ades, John Cage, Nicolas Calas, Noma Copley, Georgette Dupin, Aube Breton Elléouët, Peter Engel, Gunther Gerszo, Ursula and Ernö Goldfinger, Walter and Alexandra Gruen, Nancy Hall-Duncan, Sir David and Lady Millicent Hildyard, Mira Jacob, E. F. W. James, Esq., Alain Jouffroy, Robert Lebel, Jean Levy, Valerie Lloyd, Ninette Lyon, Conroy Maddox, Georges Marci, Mary-Anne Martin, Pierre Matisse, Malitte Matta, Gordon Onslow-Ford, Richard Overstreet, Sir Roland Penrose, Sir Philip and Lady Philippa Powell, Michel Remy, Gert Schiff, Joel Tanguy, and Patrick Waldberg.

To the owners of works of art who allowed them to be photographed and reproduced and to the many people who searched out photographs and other documentary material, I owe a debt of gratitude. A special note of appreciation is due to Ann Alpert, Timothy Baum, the Jerry Brewster Gallery, Emmy Bridgwater, Charles Byron, Roger Cardinal, Leonora Carrington, Ithell Colquhoun, Helen Escobedo, Daniel Filipacchi, Léonor Fini, John Halkes, Anthony Grant and the Department of Latin American Painting at Sotheby Parke Bernet, Walter Gruen, Rita Kernn-Larsen Grünberg, Jeffrey Loria, the Lee Miller Archive, Dolores Olmedo, Richard Overstreet, Elisabeth Partridge, Edith Rimmington, Arturo Schwarz, Robert Short, Daniel Varenne, José Vovelle, and Alejandra Yturbe. My thanks go also to Cristelle Baskins and Paul Freedman who labored with good humor and tenacity over the typing; to Lawrence Alloway, Phillis Ideal, Janet Kaplan, Joyce Kozloff, and Josephine Withers for their judicious reading of the manuscript in its various drafts; to my husband, Robert Bechtle, who did much photographic work for the book and whose patient reading of the text proved invaluable; and to my editor, Nikos Stangos, for his commitment, enthusiasm, and sound advice.

"The problem of woman," André Breton wrote in 1929, "is the most marvelous and disturbing problem in all the world." No artistic movement since Romanticism has elevated the image of woman to as significant a role in the creative life of man as Surrealism did; no group or movement has ever defined such a revolutionary role for her. And no other movement has had such a large number of active women participants, their presence recorded both in the poetry and art of male Surrealists, and in the catalogues of the international Surrealist exhibitions of 1935 (Copenhagen and Prague), 1936 (London and New York), 1938 (Paris), 1940 (Mexico City), and 1947 (Paris). Yet the actual role, or roles, played by women artists in the Surrealist movement has been more difficult to evaluate, for their own histories have often remained buried under those of male Surrealists who have gained wider public recognition.

When one is reading Surrealist texts, reviews, and memoirs, it is sometimes difficult to reconcile the scarcity of information about actual women with the central position given to discussions of love in Surrealist literature. Although some have argued that woman's role as muse in Surrealism outweighs her role as artist, the fact that so many women continued active exhibition careers after leaving the Surrealist circle belies this denial of their creative lives. Women were active participants in Surrealist exhibitions after 1929, and the catalogues of their individual exhibitions are filled with introductions by their Surrealist colleagues and friends. While the Surrealist movement did show interest in the question of woman's liberty, it is nevertheless necessary to keep in mind that the history of her place in Surrealism has not been written by, or about, real women. That we know more about Kiki of Montparnasse and Nadja than Lee Miller and Valentine Hugo, who succeeded them in Man Ray's and Breton's affections, suggests a greater freedom among the Surrealists in discussing women of social classes and milieus other than their own. Fifty years later, while doing the research for this book, I was informed more than once by former Surrealists that while the lives of male Surrealists may be considered "history," attempts to piece together the lives of the women involved constituted a search for mere "gossip." That Breton's faith in a concept of "unique love" resulted in three wives and several other romantic liaisons, a contradiction he attempted to explain in *Les Vases Communicants*, only confirms that poetic beliefs and emotional needs are often incompatible. Robert Benayoun has suggested that while Surrealism exalted *la femme*, the Surrealists did not equally revere *les femmes*.[1] "Women should be free and adored," Breton was fond of remarking, but Nicolas Calas remembers that on the whole Breton disliked the wives of the artists he liked.[2]

Introduction

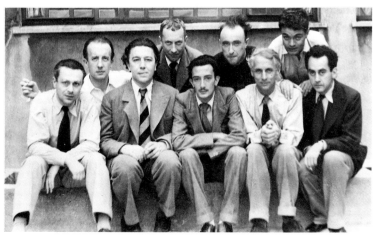

4 The Surrealist group in 1930: (*left to right, back row*) Paul Eluard, Jean Arp, Yves Tanguy, René Crevel, (*front row*) Tristan Tzara, André Breton, Salvador Dali, Max Ernst, Man Ray

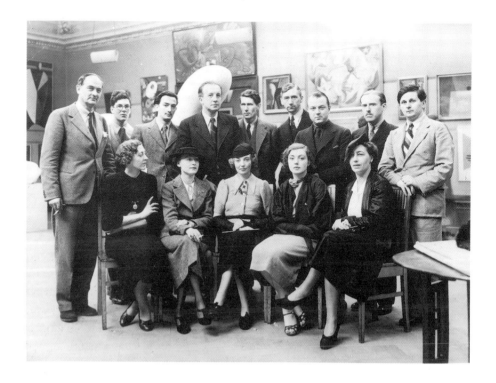

5 Members of the International Surrealist Exhibition in London, 1936, including: (*left to right, standing*) Rupert Lee, Ruthven Todd, Salvador Dali, Paul Eluard, Roland Penrose, Herbert Read, E. L. T. Mesens, George Reavey, Hugh Sykes-Davies; (*seated*) Diana Brinton Lee, Nusch Eluard, Eileen Agar, Sheila Legge, and an unidentified friend of Dali's

There are as many versions of woman's true place in the Surrealist movement as there are respondents, for between the "problem of woman" as Breton defined it in the second Surrealist Manifesto and the theoretical, artistic, and practical problems confronting women artists active in the movement lay an abyss presided over by the often unreconcilable demands of poetic expression and everyday life, intellectual conviction and emotional need. Breton's own attitudes toward women often appear ambivalent and contradictory to the contemporary reader. He was committed to an ideal of sexual and spiritual liberation, yet his poetry and his lifelong search for unique love remained dominated by a Romantic vision of perfect union with the loved one. Unable to liberate himself from the beliefs and conventions of his own age, he, like many others of us, retreated from the real and sought refuge in the theoretical. While it is important to understand the sources of his attitudes and his beliefs, he cannot be condemned for holding positions common to his age, and not yet resolved by ours.

Many women did indeed move through the Surrealist orbit after 1924. Some came as friends and fellow travelers, others came seeking an artistic identity. The length of their stays varied widely, as did their commitment to their own art. The fact that history has recorded none of them as essential to the development of Surrealist theory and practice except as they affected male creativity raises many questions about their roles in the movement. But these questions do not constitute reason enough to omit their story from a movement that argued that the value of a work of art lay not in stylistic, aesthetic, or formal concerns but in the extent to which it encompassed the whole psychophysical field, of which the conscious represents only a small part.

Personal and social contacts with male Surrealists drew Leonora Carrington, Léonor Fini, Valentine Hugo, Jacqueline Lamba, Dora Maar, Lee Miller, Valentine

Penrose, Alice Rahon, and Remedios Varo to Surrealism. Eileen Agar, Frida Kahlo, Meret Oppenheim, and Kay Sage were Surrealist "discoveries," living proof of the efficacy of the chance encounter and the eruption of the "marvelous" into the world of everyday reality. The international exhibitions widened the Surrealist network, attracting new members in large numbers. Among them were the English painters Ithell Colquhoun, Emmy Bridgwater, Edith Rimmington, and Grace Pailthorpe, the Danish artist Rita Kernn-Larsen, and the American Dorothea Tanning. None of these women were present when Surrealism was officially launched in 1924. Their photographs are missing from formal Surrealist group portraits taken as late as 1934, but they appear frequently in informal snapshots of group activities.

The history of the women artists associated with Surrealism is more complex and more poignant than the listing of their names might suggest. It is the story of a group of women who dared to renounce the conventions of their upbringing, who attempted to find some consonance between their ideas and their lives, and who embarked on the difficult path to artistic maturity at a time when few role models existed for women in the visual arts and there was little encouragement for women to establish professional identities for themselves. Young, beautiful, and rebellious, they became an embodiment of their age and a herald of the future as they explored more fully than any group of women before them the interior sources of woman's creative imagination.

The diversity of experience and attitude on the part of women artists active in Surrealism has proved both an obstacle and a challenge in the writing of this book. Almost fifty years have passed and some history that went unrecorded then is lost to us now. The works of many of these artists, particularly those executed during the 1930s, have remained in private rather than public collections and are often inaccessible. Kahlo's work was little known in England and America until traveling exhibitions were organized in 1978 and 1982. All the work that Jaqueline Lamba stored in the apartment on the rue Fontaine when she fled Paris with Breton in 1940 had mysteriously disappeared by the time she returned, divorced from Breton, in 1954. She herself destroyed many of her Surrealist works in New York when Surrealism no longer seemed relevant to her artistic goals.

People remember the past very differently, and Surrealism's primary concern has not been with historical "reality." In many cases, I have been unable to find two people whose versions of the same event corroborated each other. At times an invented history has obscured or obliterated the realities of these women, and they appear as if seen through a distorting mirror, slightly out of focus, a little insubstantial. At times I felt that if they weren't known then, it would be impossible to recreate them now. In some cases, that realization proved true. Their own stories are often contradictory; the independence of these women serves as a constant warning to the art historian whose language is more often the generalized language of movements and groups than that of individuals.

Between 1980, when this project began, and the present, my understanding of what it meant to be a woman artist in a Surrealist context changed many times. The more I learned from those women who were still living, the less I seemed to know.

As I went through the unpublished autobiographies and other documents that were made available to me, and as I traveled from California to Western Europe and Mexico, the particularity of individual experience often seemed to dominate Surrealism's collective goals. In the end, I came to view such diversity as a tribute to these women, an affirmation of their strength as individuals and a mark of their commitment to a form of creative expression in which personal reality dominates. Most of the artists in this book deserve a monograph or a biography, and the present study makes no claim to being definitive.

Unconvinced about the usefulness of attempting to define what makes an artist "a Surrealist," I have chosen instead to write about a group of artists who were *associated with* Surrealism. In some cases they have accepted the designation "Surrealist"; in others, they have rejected it entirely. But most of these artists have participated in at least one, and usually more, of the international Surrealist exhibitions, they have all contributed work to major Surrealist periodicals, and in each case their work shows the clear influence of Surrealist ideas about art and the creative process. Several factors prompted my decision to concentrate this study on the work of women artists. Earlier articles I had written on images of women in Surrealist painting had revealed contradictions between images *of* women and those *by* women. A growing interest in the work of women artists generally, prompted by Feminist reappraisals of the early 1970s, led to the realization that while the names of women artists appear frequently in the literature of Surrealism, discussions of the content and meaning of their images has been too often unavailable in English. And I had seen the names of women who had exhibited in the major international exhibitions of the 1930s and 1940s dropped from the catalogues of the 1950s and 1960s; the exhibitions were organized by a new generation of museum curators rather than by the Surrealists themselves. It seemed important to make the histories of these artists available as part of a larger thematic study of Surrealism. My intention was not to isolate the women, but to make their stories more accessible in the hope that they will be more fully represented in future histories of the Surrealist movement and its artists. Two other factors played a role in determining the group's parameters for the purpose of this study. One was a decision to concentrate on women whose artistic lives were not solely defined by their proximity to Surrealism, but who also exhibited independently of the group and whose self-identity was linked to their lives as artists. The other, the consideration of space, time, and personal energy, led to the decision to have the book concentrate on the years between 1924, the date of the first Surrealist Manifesto, and 1947, when a major exhibition at the Galerie Maeght celebrated Surrealism's postwar return to Paris. After that date, an important nucleus of younger women artists emerged at the center of the group now re-formed around Breton. They have done much to keep the Surrealist banner flying, and their story, unfortunately omitted here, forms yet another chapter in the history of a spirit that, by definition, has neither beginning nor end. Although I have at times gone outside those dates in order to make specific points or, in one case, to bring the mature work of Remedios Varo into the text, I have tried to concentrate the discussion on the years between 1924 and 1947, and on a group of artists who

make up Surrealism's "first generation." More difficult by far than deciding which artists to include was reconciling the conflicting attitudes expressed by those artists who are still living both toward what constitutes Surrealism and toward the Feminist implications of a book that largely excludes the work of male artists.

Almost without exception, women artists interviewed in the course of the research for this book spoke positively of the support and encouragement they received from Breton and other Surrealists. Many of them were learning to be artists in the face of strenuous family disapproval, others had found their training in art school rigid and mechanical, almost all of them were in revolt against the conventional female roles assigned to them by family, class, and society. Surrealism provided a sympathetic milieu and served as an important milestone on their journeys toward artistic and personal maturity. Beyond this there was little consensus. Asked why Breton had never written about her work, Tanning remarked that he was interested only in that of Ernst, and continued that her lack of fluency in French and her shyness prevented her from really talking to him when they met in New York during the early 1940s. "I noticed with a certain consternation," she added in an interview with Alain Jouffroy, "that the place of woman in Surrealism was no different than her place in bourgeois society in general." Jacqueline Lamba, commenting on Frida Kahlo's first Paris exhibition, noted that "Women were still undervalued. It was very hard to be a woman painter."[3] Over and over I heard the refrain, "But I wasn't really a Surrealist," or "X was a very good painter, but of course she wasn't really a Surrealist." At first I heard the words as an echo of every artist's dislike of being categorized. Later I came to recognize in them the kernel of an important truth about the role of women artists in the Surrealist movement of the 1930s and 1940s.

Almost without exception, women artists viewed themselves as having functioned independently of Breton's inner circle and the shaping of Surrealist doctrine. Many of them were younger than their male colleagues; most of them were just embarking on their lives as artists when they first encountered Surrealism and would do their mature work after leaving the group. Their involvement was defined by personal relationships, networks of friends and lovers, not by active participation in an inner circle dominated by Breton's presence. In an interview in 1957, Remedios Varo summed up what that meant for herself, as well as other women: "Yes, I attended those meetings where they talked a lot and one learned various things; sometimes I participated with works in their exhibitions; my position was one of a timid and humble listener; I was not old enough nor did I have the aplomb to face up to them, to a Paul Eluard, a Benjamin Peret, or an André Breton. I was with an open mouth within this group of brilliant and gifted people. I was together with them because I felt a certain affinity...."[4]

Other women came late to the movement, during periods of expansion or consolidation, rather than instigation. They were, in fact, not present at those decisive experiments in automatic writing and the narrating of dreams that Breton conducted in his apartment on the rue Fontaine, though his wife Simone, Gala Eluard, and other women sometimes attended the sessions as observers. And when, in 1928, a group discussion on the subject of sexuality took place, only Louis

Aragon suggested that in discussing woman's sexuality it would have been preferable to have had a woman present.

After 1929 women artists became active in Surrealism, but their involvement continued to be shaped, and sometimes plagued, by attitudes toward women and toward love formulated in their absence. And, although Breton and Surrealism are often taken as synonymous, and Surrealism bears the clear stamp of his personality and his will, many women artists perceive themselves as having operated very much outside his center of personal power and influence. Carrington remembers finding the theoretical and judgmental side of Surrealism extremely distasteful; in a recent biography of Frida Kahlo, Hayden Herrera makes clear the Mexican artist's scorn for Breton's position.[5] But despite, or perhaps because of, statements such as these, I came to feel the need to complete this book even more strongly. It seems to me as important to assess the ways that Surrealism failed to meet the needs of women artists who turned to it for support as it is to celebrate its, and their, considerable achievements.

That the very existence of such a book creates philosophical problems for some of the women involved seems to me regrettable, if unavoidable. Tanning and Fini both feel that books devoted to women unnecessarily isolate and perpetuate their "exile." Both would prefer to be omitted from a book that largely excludes their male colleagues; unfortunately, to do so would be to falsify the history of Surrealism as I understand it. Although I agree that in the long run their argument is true, the fact remains that histories of Surrealism have not been without gender bias. Rather than retell histories of male Surrealists that are already widely available, I have chosen in this instance to concentrate on aspects of Surrealism that are perhaps less widely known.

Meret Oppenheim has specifically requested that no work of hers be reproduced in this book. Arguing that the "male centeredness" of the Surrealist group merely reflected the inheritance of late-nineteenth-century attitudes toward women, and that the Surrealists accepted female artists and writers without prejudice, she goes on to say:

> When I met the group, end of 1933, I was twenty years old and I was not at all sure about political opinions. I made my work and did not worry about these discussions. (After the war I met Man Ray again. He said to me: "But you are speaking!" I asked him: "Why do you say that?" He answered: "You never said a word formerly.")
>
> Concerning the theme of the "Muse" I want to say: the "Muse" is an allegorical representation of the *spiritual* female part in the creative male, the "genius." And the "genius" represents the *spiritual* male part in the creative female, the "Muse."... Personally I consider the problem of female versus male as solved, although I know that many have not arrived at this point.[6]

But if, as Oppenheim asserts, the creative spirit is androgynous, it is an unfortunate fact of contemporary life that access to information has not always been blind to sexual differentiation. It is in the hope of bringing a little more of that information to light that I have embarked on this project.

One day the fact that I am about to tell you will be venerated as a
wonderful myth. The genius of the great Surrealists will owe its
Renaissance to the young women who dared to and were capable
of loving them.

JOË BOUSQUET, "Letter to the Nymph Echo," 1949

Surrealism, a collective adventure committed to nothing less than the complete transformation of human values, remained strident in its demand for the liberation of consciousness from the bondage of Western civilization. Yet the Surrealist revolution failed in its bid to resolve the conflict between a nineteenth-century image of woman as passive, dependent, and defined through her relationship to an active male presence, and a more contemporary demand for female autonomy and independence. At the end of the nineteenth century Freud had asked what it was that women really wanted; at the end of the twentieth, the American public lined up on opposite sides of a constitutional amendment legislating equal rights for women. Between the two, Surrealism struggled with the inconsistencies of its own polarized visions of woman: one Romantic, the other revolutionary.

A vision of woman as muse, the image of man's inspiration and his salvation, is inseparable from the pain and anger that gave birth to Surrealism. As the stimulus for the convulsive, sensuous disorientation that was to resolve polarized states of experience and awareness into a new, revolutionary surreality, she existed in many guises: as virgin, child, celestial creature, on the one hand; as sorceress, erotic object, and *femme fatale*, on the other. In each of these roles she exists to complement and complete the male creative cycle. But it was as autonomous individuals that the young women who inspired so much Surrealist painting and poetry would struggle to define their own creative identities in a Surrealist context. Their search cannot be understood without considering both the social roles ascribed to women during the 1920s and 1930s and the personality and beliefs of Surrealism's leader, the poet and charismatic personality, André Breton.

Demobilized, unemployed, and disillusioned, Breton returned to Paris at the end of World War I to confront a society he had come to despise. He held his culture and its values personally responsible for the recent and senseless slaughter of tens of thousands of young men. Wandering aimlessly through the streets of Paris and spending hours in cafés with fellow poets and old friends like Benjamin Peret, Louis Aragon, and Philippe Souphault, he vented his anger at an educational system that had glorified the history of war and conquest, and a literary establishment that he saw as effete, complicitous, and isolated from political and social realities. It was the ghost of Guillaume Apollinaire, the poet of conflict who had succumbed to a flu epidemic raging through Paris late in the fall of 1918 and died just two days before the Armistice, that began to lead Breton toward a new poetic vision.

Aroused by Apollinaire's call for an art of revolt, Breton began to put his faith in poetry as a means of confronting complex social issues and problems. As he explored the sources of the creative impulse more deeply, he began to understand

the opposition between the forces of love and those of destruction. He adopted Engel's belief that only after the revolutionary transformation of society will man be liberated from the need to purchase the surrender of a woman through money or social pressure, and woman free to surrender to man for no reason other than love (even as he failed to understand the fundamental incompatibility between the ends of surrender and liberation). He turned to Freud's thesis concerning the dynamics of erotic desire and the "pleasure principle," revived Sade as a spokesman for revolutionary eroticism, and committed himself to the reintegration of male and female principles (with woman as a necessary part of the male dynamic rather than as a separate entity).

He himself was a figure of endless complexity and endless fascination, a brilliant and charismatic personality whose arrogance and petulance sometimes appalled even his closest friends. Adored and despised, he left few who knew him unmoved; some years after his death the painter André Masson, himself the subject of one of Breton's frequent "excommunications," remarked that the memory of this larger than life-size presence was enough to move one to tears. He excoriated his enemies, and sometimes his friends, for their deviations from the path of his Surrealism, but his courtesy and gallant behavior toward women were legendary, and he elevated the hand kiss to a Surrealist rite. The Danish painter Rita Kernn-Larsen remembers that he was "very French and chivalrous"; others recall his compelling speaking voice and perfect diction. Valentine Hugo, who began to collect Dada and Surrealist books and periodicals in the late 1920s and who later became an intimate companion of Breton's, received a copy of his recently published novel *Nadja* in 1928 with a rather mysterious dedication that she says "resembled him very much in going from humility to arrogance, terseness to flowing language."[1] She saw him as simultaneously young, enthusiastic and seductive, and severe and judgmental, given to abrupt shifts in mood and sudden outbursts. His complex character, his indifference to material comforts and security, and the financial and emotional crises he periodically faced introduced into the history of Surrealism an element of sordid behavior which sometimes triumphed over romantic love; Surrealism's relations with women were to be neither consistent nor easily understood.

From the beginning, male Surrealists encouraged creative activity among women associated with the group and demanded the liberation of all women from the bondage of home and hearth. But throughout the 1920s and 1930s they would play out their theoretical and poetic exaltation of woman against the backdrop of a group of very real women whose needs and desires could not be mythologized away, whose emotional liaisons at times shook the group to its core, and whose rapidly changing status in Western Europe and America after the First World War altered social attitudes more dramatically than the Surrealist revolution itself.

The same war that filled Breton with contempt for a society unwilling to give up its faith in reason and logic had liberated many women from domestic captivity. Sent into hospitals and factories to aid the war effort, they reemerged in 1918 ready to fight for women's rights in the work place and the polling place. During the 1920s women became aviators and art patrons. Sylvia Beach opened her bookshop

6 Valentine Hugo in front of her painting *The Constellations*, 1935, ▷
in a photograph by Man Ray

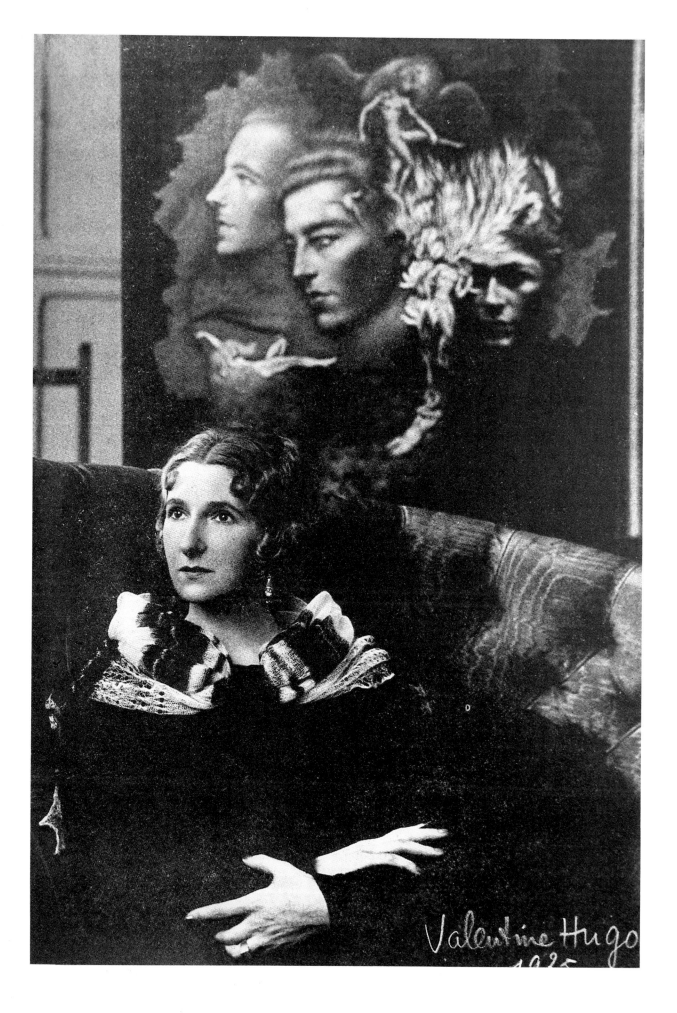

on the rue de l'Odéon, the tennis player Suzanne Lenglen became the most famous woman in France, and the Midinettes marched in the streets demanding better working conditions and higher wages. Women bobbed their hair, shaped their mouths into red bows, and wore pants. The war, which had impoverished a large part of the middle class, gave young women an unprecedented opportunity to enter business as clerical workers in banks and government offices. Literary and artistic circles were dominated by talk of the "new woman," an independent, often androgynous, being who had fled the stifling domesticity of late Victorian culture.

In Paris, André Gide, Jean Cocteau, and their friends were demanding the liberation of women and homosexuals while women's magazines struggled to capture *le style nouveau*: high-collared blouses, cloche hats, and sack dresses. Breton and his circle found themselves in conflict. They believed in the liberation of women but were unwilling to join the clamor and support a movement promoted by the very individuals whom they held personally responsible for the current state of literary and moral bankruptcy. Moreover, their adolescent images of women had derived from literature, and from nineteenth-century literature at that. Surrealism's poetic sources lie in Romanticism and Symbolism; male Surrealists inherited from the late-nineteenth-century Symbolists a polarized view of woman that embraced both the creative and the subversive powers of the love instinct. Turning to Freud for a psychological model, they found the same nineteenth-century ambivalence. "What sorceresses you women are," he wrote to his fiancée, Martha Bernays, in 1882; and in "The Theme of the Three Caskets" of 1913 he further developed what he saw as the source of woman's dual nature—her incompatible roles as mother and the bearer of life, and as harbinger of death and destruction. Surrealist poets would remain haunted by an image of woman at once ethereal and inner directed, and also capable of revolutionary action in the world.

In Yvonne de Bray's performance in *La Femme Nue* at the Théâtre du Vaudeville, they found an image of a spontaneous, instinctive woman who rebels against the social order, an image they could oppose both to the bourgeois ideal of woman at work and to a contemporary literary stereotype of the female heroine as either passive, wanton, or cruel. The woman who entered Breton's poetry of the 1920s did so as an image of beauty flickering in the shadows of dream and imagination: *Si dans le fond de l'opéra deux seins miroitants et clairs/ composaient pour le mot amour la plus merveilleuse lettrine vivante* ("If only in the depths of the Opera two breasts dazzlingly clear/ would ornament the word love with the most marvelously living letter"), he wrote in *Clair de Terre*, published in 1923. In turning to this ethereal and magical being, he rejected the image of woman that dominated both the literary and popular imagination of the 1920s.

The writings of Apollinaire, the twentieth century's first effective champion of an art of revolt, helped shape the Surrealist revolution, but offered little in the way of a new image of woman. The first French poet of this century to integrate erotic and poetic expression, Apollinaire nevertheless confused love and war, invoked Symbolist polarities to express the duality of feminine nature (purity/impurity, for example), and constructed an image of his longtime companion, the painter Marie Laurencin, as an eternal child.

COLOR PLATES

16

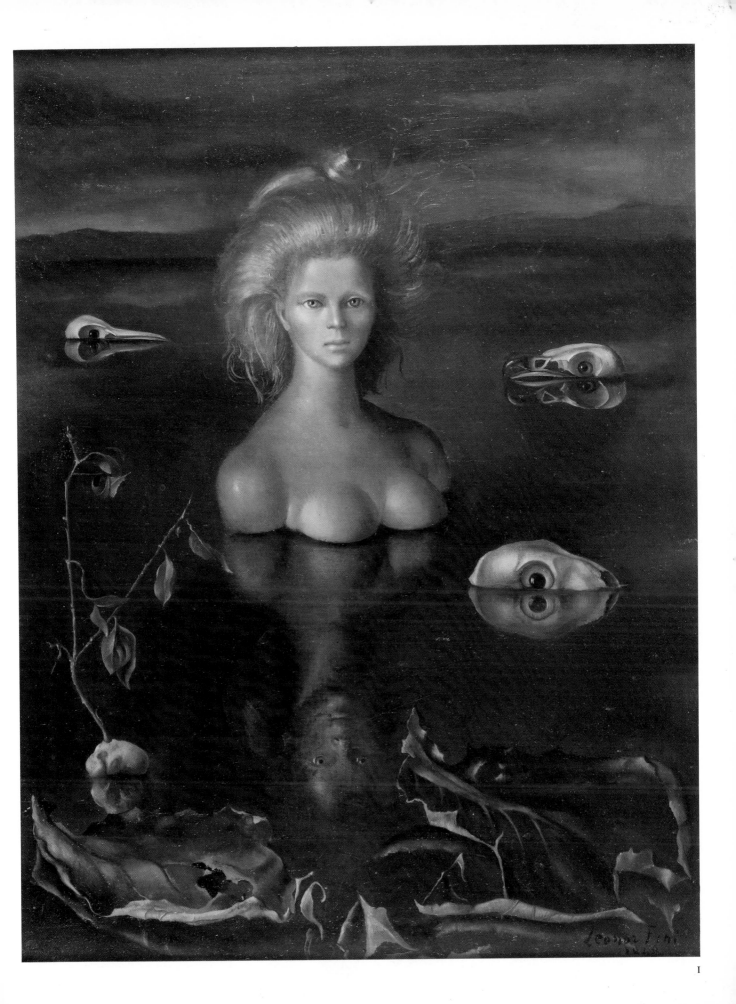

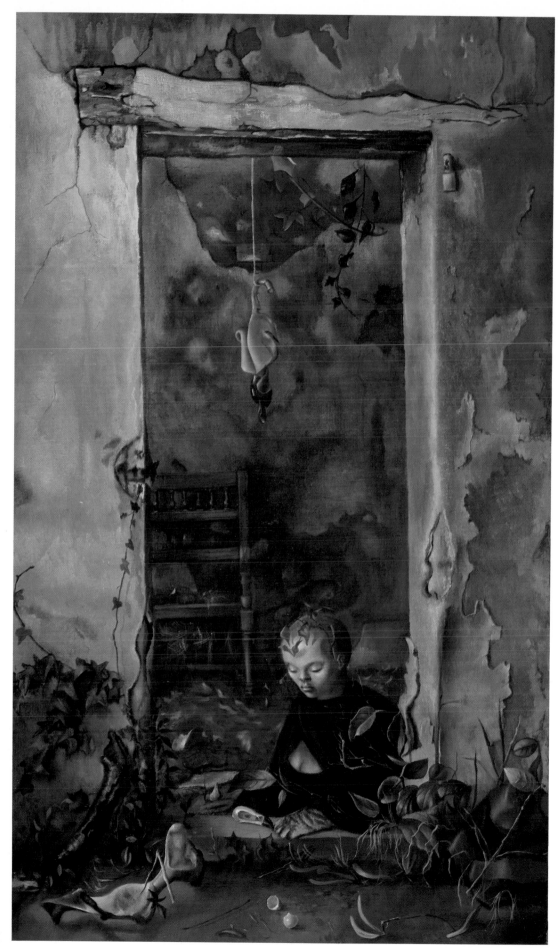

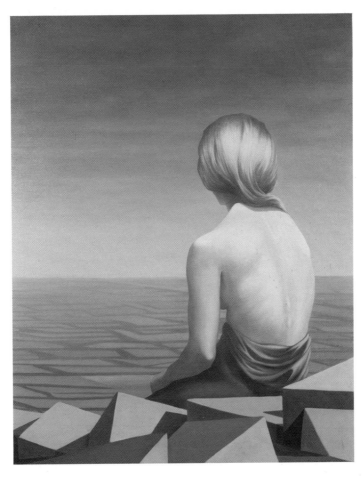

III

IV

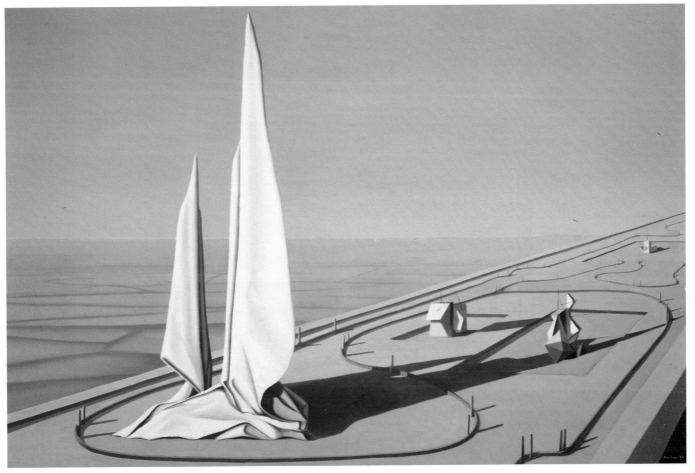

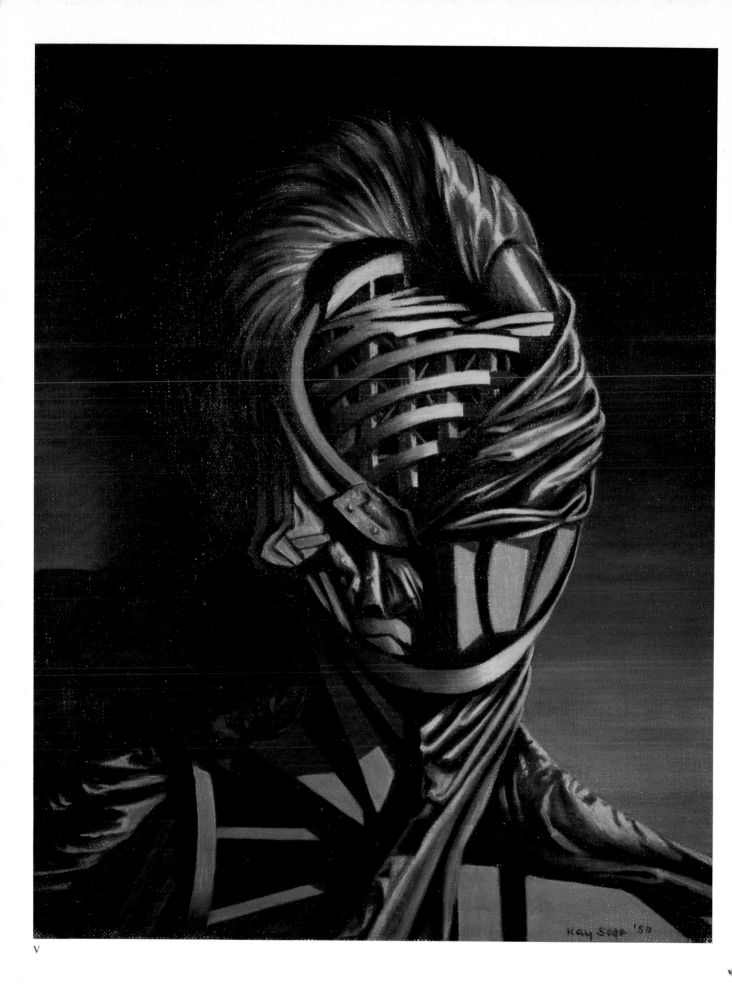

V

VII

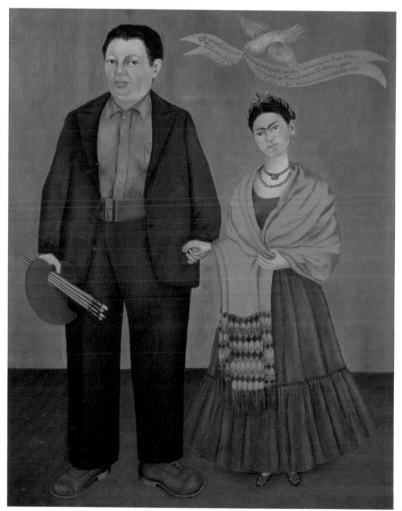

VIII

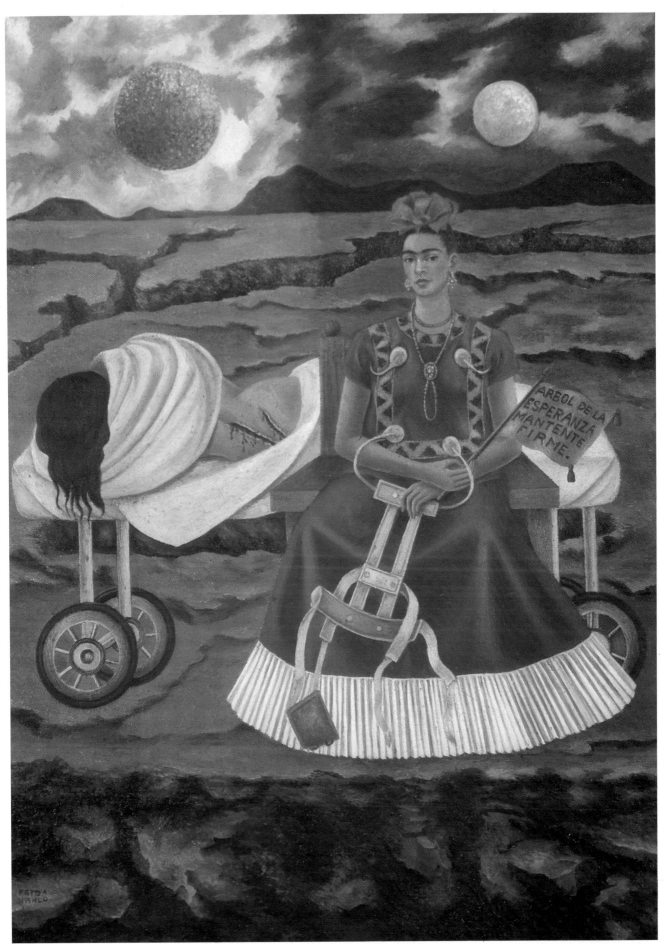

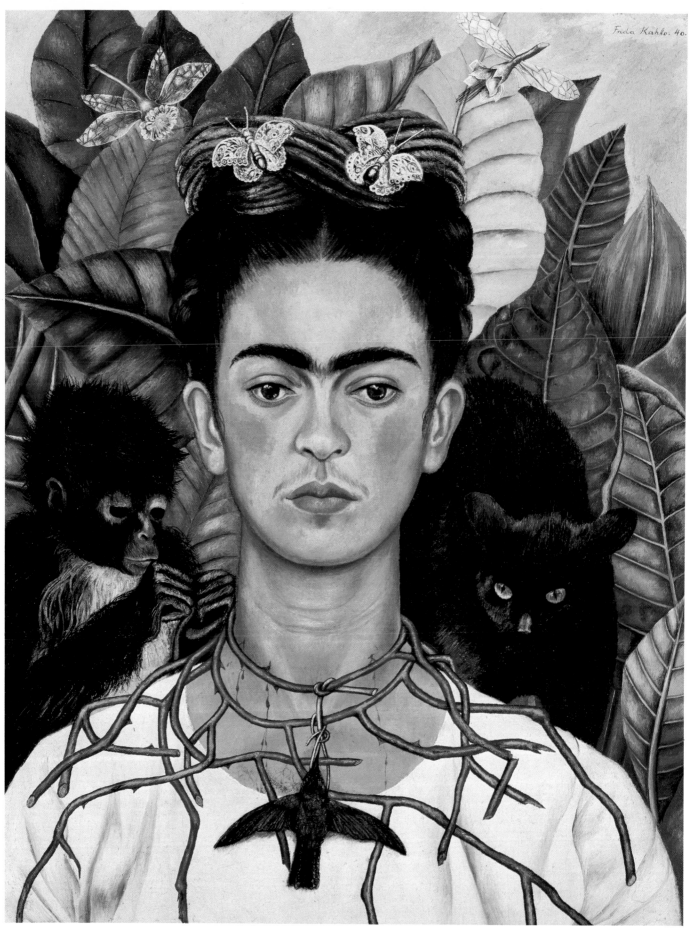

Apollinaire's inclusion of Laurencin in *Les Peintres Cubistes* surely served as a model for Breton's inclusion of women in later editions of *Le Surréalisme et la Peinture*, and his pre-Surrealist play, *Les Mamelles de Tirésias*, first performed in 1917 before an excited audience that included Breton, introduced the term *surrealism*.

Intended as a satire on Feminism, *Les Mamelles de Tirésias* developed themes on which Apollinaire had begun to expound when, in 1909, he took over a column on women authors in the review *Les Marges* and began to contribute coy articles on women poets. The heroine, Thérèse, renounces the roles of mother and housewife and is magically transformed into Tirésias, the Seer. "No mister husband, you won't give me orders; because you made love to me in Connecticut doesn't mean I have to cook for you in Zanzibar," she loudly protests. Feminist author Gloria Orenstein has pointed out that it is in this play that Surrealist ambivalence about the role of woman first surfaces; its irony lies in the fact that even as it claims to expose the concept of women's liberation as preposterous, it reveals that only by giving up the conventional woman's role and by demanding power and autonomy is Thérèse metamorphosed into an androgynous being and a clairvoyant.[2]

If the experiments in automatic writing (defined by Breton as "psychic automatism" in the first Manifesto; texts which resulted from free association that liberated the flow of thought and revealed unconscious imagery) and the narrating of dreams that first unified the Surrealist group between 1922 and 1924 had female practitioners, they have gone unrecorded, overpowered perhaps by the hypnotic facility of Robert Desnos's trance narrations and the subversive power of the first automatic texts. The group that gathered around Breton in his apartment on the rue Fontaine was male at the core, poets and writers united by the need to define a new poetic and social reality. Accompanying them on this journey were women like Simone Kahn, whom Breton had married in 1921 after meeting her through a mysterious chance encounter, and Gala Eluard.

Neither Simone Kahn nor Gala Eluard was an artist, but Gala soon became the first incarnation of the Surrealist muse. The daughter of a Moscow lawyer, she had met the poet Paul Eluard while both were adolescent patients at the tuberculosis sanatorium at Clavedel. A young woman with brown hair, high cheekbones in a face that quivered with feeling, and glowing dark eyes, Gala was intelligent but secretive, seductive but willful. "I am your disciple," the seventeen-year-old poet had written to her in a notebook a few years before convincing her to become his wife. Gala differed from historical prototypes of the Muse of Poetry in the degree of free sexual expression that she demanded and was granted; in all other respects she easily fitted the model of woman in which the female presence augmented the male creative cycle.

For Eluard, all poetic expression rested on *eros*, and it was woman who gave form and definition to an erotically charged universe. Gala was the first of his muses and he kept a photograph of her nude body in his briefcase, taking it out at Surrealist gatherings and passing it among his friends. "She has the shape of my hands, she has the color of my eyes, she is engulfed in my shadow...," he wrote in *L'Amoureuse*, refusing her a reality separate from objects of the world and from him.

7

13,14

COLOR PLATES

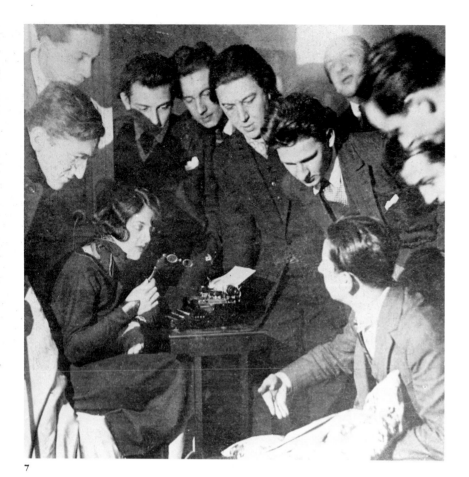

7

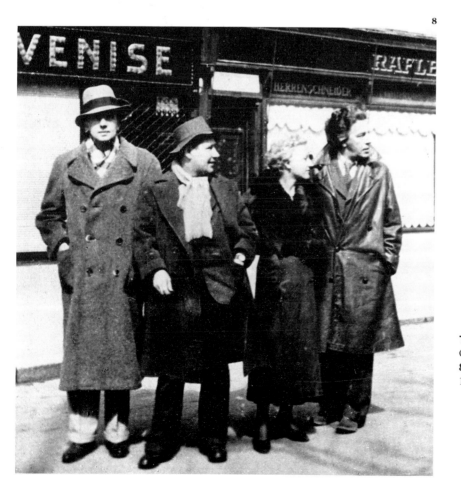

BRETON AND HIS PARTNERS

Although André Breton's chivalry toward women was legendary, and his belief in the power of love unbounded, his relations with them were complicated *his poetic idealism. His first wife, Simone Kahn, was no* *an artist, but her shrewd business sense enabled the couple to survive financially. Valentine Hugo, with whom he became involved around 1930, had an established professional reputation before she met the Surrealists. His second wife, Jacqueline Lamba, "the Ele* *Woman," had studied decorative arts in Paris but did* *have her first solo exhibition until after she had left Breton in New York. She traveled to Prague and Mexic* *with Breton during the 1930s.*

7 Simone Breton and other Surrealists at the Surrealist Centrale in 1927

8 Paul Eluard, Karel Teige, Jacqueline and André Breto* 1933

CADAVRES EXQUIS

Women were active participants in group pursuits. Their objects and drawings, like these "Exquisite Corpses" (each participant drew a section of the "figure" on a folded sheet of paper without seeing the section that preceded or knowing how it would be continued) which Breton believed revealed the unconscious correspondences of a "collective imagination," appeared frequently in exhibitions held after 1929.

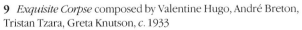

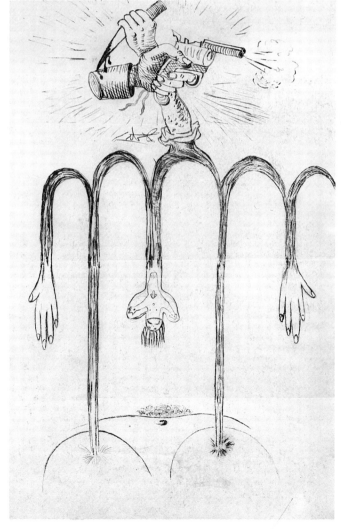

9 *Exquisite Corpse* composed by Valentine Hugo, André Breton, Tristan Tzara, Greta Knutson, *c.* 1933
10 *Exquisite Corpse* composed by Nusch Eluard, Valentine Hugo, André Breton, and Yves Tanguy, 1935
11 *Exquisite Corpse* composed by Salvador Dali, Gala, André Breton, and Valentine Hugo, *c.* 1930

12

GALA AS MUSE

Though not an artist, Gala became the first incarnation of the Surrealist muse. While she was married to Eluard, Max Ernst fell in love with her and, in 1922, left his wife to follow Gala to Paris where he included her image in a painting commemorating his reunion with the Surrealist poets. Dali met her in 1929; soon he incorporated her image and her reality into a mythologized vision of the salvationary heroine, and she appears in this guise in many of his paintings of the 1930s.

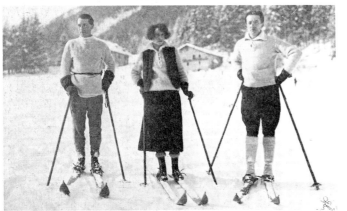

13

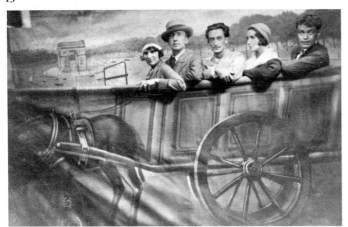

14

12 Max Ernst, *Au Rendez-Vous des Amis*, 1922
13 Max Ernst, Gala, and Paul Eluard in Austria in 1922
14 Gala, Paul Eluard, Salvador Dali, Valentine Hugo, and René Crevel at the Montmartre Fair in 1931
15 Salvador Dali, *Portrait of Gala*, 1935

Gala continued to exist as an object of devotion and a source of inspiration for Eluard and others throughout the decade. Her clarity and strength of purpose, her mysterious moods and dramatic dark eyes captivated many and angered a few. She always knew what she wanted: love and pleasure, financial security, and the company of genius. She had no interest in political or philosophical discussions, but Matthew Josephson recalls that the Surrealists often greeted the appearance of a particularly successful painting or poem with the words, "Ah well, he was in love with Gala then."

Among those captivated was Max Ernst, who met her during the summer of 1922 when he and his family joined the Eluards in the Tyrol. Soon infatuated, he separated from his wife and child and moved into the Eluard quarters in the inn where the group was lodged. "Well, I love Max much more than I do Gala," Eluard is reported to have responded bravely. But the debonair assertion rang false, and other members of the party have since remarked on his despondent air.

Entering the Surrealist circle as a focus of erotic and poetic energy and as a source of masculine inspiration, Gala nevertheless emerges in Surrealist art as a spectator at the birth of the movement. At the end of the summer of 1922, Ernst left his wife and child in Cologne and followed her to Paris. Once there, he painted *Au Rendez-vous des Amis* (1922) in celebration of his reunion with the poets who formed the nucleus of the first Surrealist group: René Crevel, Philippe Souphault, Robert Desnos, Paul Eluard, Benjamin Peret, and Louis Aragon. Breton is present in the painting, his position as leader underscored by scale, dramatic gesture, and the restless energy that animates his figure, tossing up the corners of the short cape he wears as a mantle. Ernst inserted the historical figures of Dostoevski and Raphael Sanzio into the Alpine landscape that he had recently left, and then added Gala, still married to Eluard, but in love with the German painter. The figures on the left press closely together, linked into groups and subgroups by the repetition of their gestures and the rhythmic interplay of their gazes. Ernst himself sits on Dostoevski's lap and playfully pulls the Russian's beard while Gala, separated from the group by the columnar figure of the Italian metaphysical painter Giorgio de Chirico, turns her back. The figures of Breton, Desnos, and Ernst Baargeld rush past her toward the center of the painting further emphasizing her marginal position, and, inspiration though she may have been, she functions here as a kind of compositional foil for the more animated and active male figures.

The appearance of Breton's *Manifeste du Surréalisme* in 1924 marked the official founding of the movement. The following year the first group exhibition of Surrealist painting at the Galerie Pierre brought together works by Hans Arp, Paul Klee, Joan Miró, André Masson, Pierre Roy, Ernst, Picasso, Chirico, and others. There was no work by women artists, and only the names of Ernst, Arp, and Masson would remain an integral part of the Surrealist pantheon.

Photographs from 1924, published in *La Révolution Surréaliste*, reveal a growing discrepancy between the poetic and political roles ascribed to woman, and the practical roles often assumed by women associated with the Surrealist group. In one composition, photographs of the Surrealists are arranged around an image of Germaine Berton, a young anarchist who, on January 22, 1923, had walked into the

office of the right-wing newspaper, *Action Française*, and shot Marius Plateau, head of the Camelots du Roi. The Surrealists rallied to her defense with brochures and demonstrations, Aragon called the assassination "The most beautiful protest raised to the world against the hideous lie of *bonheur*," and the image of woman as a political subversive entered the Surrealist lexicon. She appears here as a revolutionary antithesis of traditional female personifications of liberty and patriotism. Presented in a straightforward and unidealized manner, her political commitment demands direct action without regard for personal consequences. "Woman is the being who projects the greatest shadow or the greatest light into our dreams," proclaims the quote from Baudelaire that accompanies the photograph. Nevertheless, although the Surrealists continued to extoll the radical acts of specific women outside the group, they increasingly narrowed their definition of the role of the Surrealist woman to direct attention away from political activism and elicit little more from women active in the group than their signatures on Surrealist tracts and manifestos.

In the second photograph, taken at the office of Surrealist Research, a group of 7
Surrealists surround the figure of a young man who has come in response to a Surrealist invitation to the public to "bring their dreams," and who unburdens himself under their avid gazes. There is one woman present, Simone Breton. She sits at a typewriter prepared to record the visitor's utterances, a passive transcriber of messages over which she asserts little direct control, and a herald of the gradual shaping of woman's image into "a creature of grace and promise close in her sensibility and behavior to the two sacred worlds of childhood and madness."[3]

By 1924, Breton had defined love as a means of creation and a source of revelation, and added a commitment to exploring the dynamics of erotic and spiritual desire to the goals of political revolution and the search for the sources of poetic imagery in the dream and the unconscious. The thirty-two chapters of *Poisson Soluble*, published that year, evoke an enchanted land ruled by memory and desire. Memories of the poet's youth are related like dreams and filled with hermetic references and mysterious and elusive female images. Behind his claim that "We will reduce art to its simplest expression which is love" lies a recognition of the intimate relationship between automatism and sexual desire. The release of desire into the world would find its most potent metaphor in an image of female beauty both ethereal and fragmentary. By 1924, faced with a social demand for the emancipation of women that he found bourgeois rather than revolutionary in origin, Breton had defined a poetic role for woman that represented a major step away from an acceptance of the complex realities of contemporary life as they affected relations between men and women. Retreating not into the shadowy world of romantic withdrawal, but instead actively defining a role for woman in which her image is more often projected onto the world than elicited from it, he established the male ego as superior, poetic expression as dominant. From this moment Breton's commitment to a spiritual and poetic ideal of woman would effectively inhibit him from initiating a radical revision of contemporary gender values.

In the ninth issue of *La Révolution Surréaliste*, which appeared on October 1, 1927, it was again a moral problem that was raised in the name of love. "Hands Off

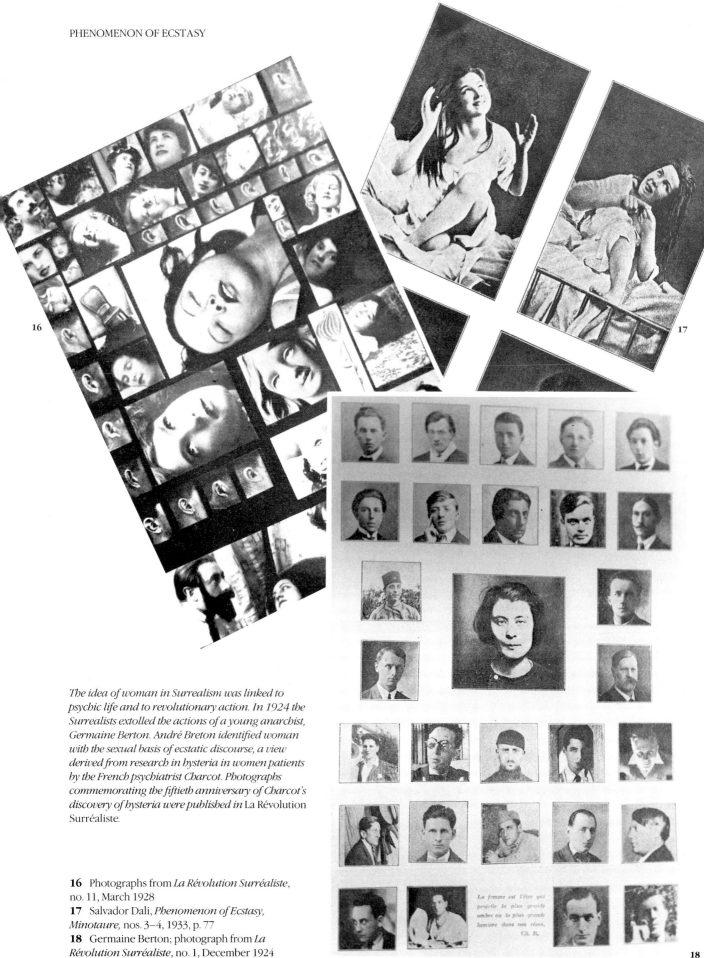

16

17

The idea of woman in Surrealism was linked to psychic life and to revolutionary action. In 1924 the Surrealists extolled the actions of a young anarchist, Germaine Berton. André Breton identified woman with the sexual basis of ecstatic discourse, a view derived from research in hysteria in women patients by the French psychiatrist Charcot. Photographs commemorating the fiftieth anniversary of Charcot's discovery of hysteria were published in La Révolution Surréaliste.

16 Photographs from *La Révolution Surréaliste*, no. 11, March 1928
17 Salvador Dali, *Phenomenon of Ecstasy, Minotaure,* nos. 3–4, 1933, p. 77
18 Germaine Berton; photograph from *La Révolution Surréaliste,* no. 1, December 1924

18

Love" was a Surrealist attack on a divorce suit brought against Charlie Chaplin by his wife. Did Chaplin have the right to regard love and practice it in his own way— or was he to be dominated by a wife who was suing him for divorce because he was unfaithful and had rejected the fatherhood imposed on him by her two pregnancies? The Surrealists, in an editorial not signed by any women, passionately defended their hero, vilified his wife, and denounced the restraints of bourgeois love. Chaplin's freedom of behavior and independent spirit enchanted the Surrealists; his case became a rallying point for their demand that love remain free of the restraints of conventional marriage. Within the Surrealist circle, similar conflicts were less easily resolved; only a few years earlier Lou Straus-Ernst had reacted with anger and bitterness to Ernst's announcement that he would follow Gala Eluard to Paris. "You don't have any need for a husband anymore," he had argued. "You are twenty-eight years old. You know all about love; you have a son.... What more do you want?"[4] To a young woman left with the primary responsibility for providing for a child the words were of little consolation.

The same issue of *La Révolution Surréaliste* that carried the Surrealist defense of Charlie Chaplin's right to an unencumbered sexual freedom also introduced the Surrealist woman in a new guise, one that would come to dominate Breton's vision throughout the 1930s. A prototype of the *femme-enfant*, or woman-child, that enchanting creature who through her youth, naiveté, and purity possesses the more direct and pure connection with her own unconscious that allows her to serve as a guide for man, appeared under the title *L'Ecriture Automatique*. The illustration depicts a young woman dressed in the costume of a schoolgirl and seated awkwardly at a child's desk. Her eyes, though wide open, have a hypnotic glaze as, pen posed, she waits for the stream of automatic images to begin flowing. Midway between child and vamp with her rosebud mouth and the revealing patch of white flesh above her dark stockings, this muse of automatic writing, this "false schoolgirl," is an image of inspiration caught in a moment of sexual ambiguity. In Julien Levy's prose poem "The Queen of Diamonds," a similar schoolchild "turns round to ask me for the solution of a problem, the innocence of her eyes confounds me to such a degree that she, taking pity on my agitation, passes her arms around my neck." These images of the *femme-enfant* augur the Surrealist search for the woman-child whose presence would inevitably, and perhaps more than any other single factor, work to exclude women artists from the possibility of a profound personal identification with the theoretical side of Surrealism during the next decade.

The first of these *femmes-enfants* was surely Marie-Berthe Aurenche whom Max Ernst met and married in 1927 and who inspired his collage novel, *Dream of a Little Girl Who Wanted to Enter a Convent*. Marie-Berthe Aurenche was twenty-two years old when he saw her for the first time in an art gallery on the Left Bank where she was working as a secretary. She had a ravishing face with large blue eyes and blonde curls, and parents who immediately demanded her return to the convent when they learned of her interest in the penniless German painter sixteen years her senior. She was a minor when she ran off with Ernst, championed by the Surrealists who hid the couple while loudly proclaiming the triumph of *l'amour*

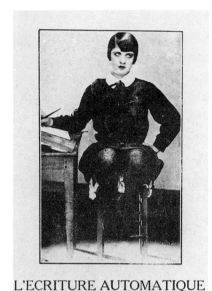

L'ECRITURE AUTOMATIQUE

19 *L'Ecriture Automatique*, 1927

20

20 Marie-Berthe Aurenche, Max Ernst, Lee Miller, and Man Ray in the early 1930s, in a photograph by Man Ray

passionnelle, and pursued by her parents with a warrant for Ernst's arrest.

Surrealism came naturally to the whimsical and pensive young woman. Childlike and emotionally dependent, she greatly admired Ernst's paintings and soon began to experiment herself. Among her early efforts there was reputed to be a portrait landscape of Breton that the latter persisted, wrongly, in attributing to Ernst.

The tension between mental and physical love, freedom and dependency, emotional liberation and bondage is nowhere so dramatically illustrated in Surrealism as in Breton's *Nadja*, published the following year. Overtly the story of his attraction to a disturbed young woman with clairvoyant powers, the book quickly becomes a vehicle for exploring the quest for love and self-knowledge, and for musing on the relationship between art and life. He launches his inquiry with a long discussion of the need to know the artist through the events of his life as well as the creations of his art, but there is much that is obscure in the book. At no future time would Breton be as explicit about his relationship with a woman, yet questions linger as to whether his willingness to divulge the facts of his experience with Nadja arises, at least in part, from the lack of equality that exists between them and from the fact that he is in no way dependent on her.

The short-lived relationship with Nadja is filled with conflict for the poet. He is initially drawn to her in the hope that she will provide an answer to his question "Who am I?" and will help him better understand the sources of woman's visionary powers. But as he realizes that she views him as the all-powerful one, her attraction for him begins to pose a series of moral dilemmas. Torn by the question of his responsibility for her well-being, he is alternately fascinated by her visionary power and bored by the realities of her life and experience. Her reality as a victim of male desire alienates him and, even as he believes that only the power of love might cure her mental distress, he is forced to admit that he does not love her and, therefore, must ultimately fail her.

Nadja's own reality is impossible to assess, for we see her only through Breton's eyes. Her life gains credibility for him because she belongs to the world of the street rather than to that of domestic life, and it is this world that has fascinated Breton since his return to Paris at the end of the war. In his poetry, he often links his own search for self-knowledge to the sites of Paris, plotting the course of psychic reality through the physical world. Nadja is an embodiment of the ephemeral female figures who beckoned to the poet in *Poisson Soluble*, a being capable of revealing man's destiny to him.

Telling him that she is Melusine, she depicts herself in drawings as the legendary winged siren with the lower body of a snake (see Chapter 4). But Breton's fascination with the image of Melusine predates his encounter with Nadja, and it is difficult not to suspect that he may have suggested the image to her. Her fascination for him stems from the fact that she incarnates the characteristics on which he bases his poetry: enigma, a discourse free from the restraints of logic and closely akin to that of Surrealist poetry, and the gift of second sight. The ambivalence and confusion he feels toward the young woman's unpredictable behavior, his periodic emotional withdrawals from her complex reality, and his frequent retreats to the mythological ideal of the Eternal Feminine infuse the book with a haunting elusiveness.

Nadja's own mythology, revealed in her drawings and in the stories she tells Breton, centers around her search for a self-image that can triumph over her fear of death and psychological disintegration. He asks, "Who are you?" and she responds with the words, "I am the soul in limbo." Obsessed with death, she recoils from "the dead who lie under the Place Dauphine" and from the "blue wind of death." Her drawings evoke the eternal and cyclical patterns of death and regeneration, and draw their images from Christian and Celtic symbols of death and judgment. "You are my master," she tells Breton, "I am only an atom respiring at the corner of your lip." He desperately wants to view this woman, so intuitively close to her own unconscious, so possessed of powers he reveres, as a free spirit (she sees him as a god), but her helplessness and victimization at the hands of other men repel him at the same time that they force him to recognize the illusory nature of her "freedom." He speaks of Nadja's "intellectual seduction" but, in the end, she fails to inspire in him the amorous rapture through which he seeks creative transformation. Her institutionalization at the book's end provides the springboard for his attack on the shackling of a free spirit, but as he is himself unwilling or unable to assume the responsibility for her care, he is unable to resolve the complex issues that arise from his relationship with her.

Breton's association with Nadja stopped at the asylum doors. Once institutionalized, she ceased to exist for him except as a poetic principle, and when, in 1928, he and Aragon proposed to celebrate the fiftieth anniversary of Hysteria, they turned to the resources of the Salpêtrié hospital archives, publishing a series of photographs showing women patients in ecstatic states or *attitudes passion-nelles*. They provided a new definition, one that raised the status of Hysteria from a mental disorder to a poetic precept. "Hysteria *is not a pathological phenomenon* and can in every way be considered as *a supreme means of expression*," they wrote in the last issue of *La Révolution Surréaliste*. The disorder, which manifested itself in physical symptoms for which no physiological source could be found, was first clearly defined by Freud's teacher, Charcot, in 1875. It had been recognized and identified with women long before Freud and Charcot and, at the beginning of the twentieth century, was still believed to be an almost exclusively female affliction. Freud himself believed that Hysteria resulted from an inability to release sexual excitement through normal channels and from the subsequent transformation of the repressed energy into physical symptoms. His analyses of *Dora* and *Anna O.* pointed the way to his understanding of the phenomenon of "transference love" and the seduction theory, but it was the research of the French psychiatrist Pierre Janet, with whom Breton had studied while a medical student, which provided Surrealism with a model for the sexual basis of ecstatic discourse. In his study of Hysteria, Janet called the ecstatic states of his female patients *l'amour fou*, or mad love; his vision became the basis for Breton's belief in the transformative power of the ecstatic state, at once erotic and irrational. Breton was content to maintain the identification of woman with this image of convulsive reality; once again, she completes the male vision by absorbing into herself those qualities that man recognizes as important but does not wish to possess himself. Breton claimed the right of each individual to be mad, Dali published a "Declaration of the

16

35

Independence of the Imagination and the Rights of Man to His Own Madness," but as we shall see, true madness was not an enviable state and it was often the image of woman that mediated man's encounters with the irrational.

The demands that Nadja had placed on Breton carried over into his domestic life, deepening the rift with Simone and contributing to their separation in 1929. Separation and divorce plunged him into a period of self-doubt and confusion. A liaison with Suzanne Musard, a passionate involvement with the mysterious X whom he so rapturously describes in *Les Vases Communicants*, close friendships with other Surrealists, and an active life as the movement's leader and most prominent voice sustained Breton during the difficult years of the late 1920s and early 1930s when personal and political conflicts came close to tearing apart the movement.

There was no overt sign of Breton's unhappy domestic situation when, in December 1929, he once again took up the subject of woman in the second Surrealist Manifesto. Bruised by love and frustrated by the political conflicts that had arisen in response to Surrealism's attempt to accommodate itself successfully to the Communist struggle, Breton turned to the hermetic tradition, invoking the figure of the fourteenth-century Gnostic Nicolas Flamel, welcoming the occult in Surrealism and calling for the exaltation of love. "The problem of woman is all that is marvelous and troubling in the world," he writes:

> And it is to the very degree to which a non-corrupted man must be able to put his faith not only in Revolution, but *even more so in love* [Breton's italics].... Yes I believe, I have always believed, that to give up love, whether or not it be done under some ideological pretext, is one of the few unatonable crimes that a man possessed of some degree of intelligence can commit in the course of his life.

The Surrealist defense of Charlie Chaplin, Breton and Aragon's celebration of the fiftieth anniversary of Hysteria, and the publication of the results of a Surrealist inquiry into sexual love in the last issue of *La Révolution Surréaliste* were all evidence of a growing preoccupation with the use of the powerful forces of erotic desire as a means of transforming human consciousness. Perhaps love would succeed where political revolution appeared to have failed. The sudden appearance of the mercurial and fanatical Salvador Dali only quickened the pace in this direction. His *paranoiac-critical method*, a technique of self-induced delirium in which the ego molds the images and realities of the external world to correspond to its own inner needs and desires, became one of the banners to which Breton now rallied his newly purged ranks of the faithful, thinned by defections and expulsions precipitated over the question of Surrealism's political commitments.

The development of Dali's Surrealist imagery is inextricably bound up with the figure of Gala Eluard, soon to be Gala Dali. She arrived in Cadaques, Spain, with Eluard, Magritte and his wife, Georgette, and Dali's Paris dealer, Camille Goemans, during the summer of 1929, the year of Dali's official entry into Surrealism. Although initially repulsed by his pomaded hair and love of personal adornment, she was soon won over by his intensity and emotional need, and she was finally able to convince the others that paintings like *Dismal Sport*, on which he was

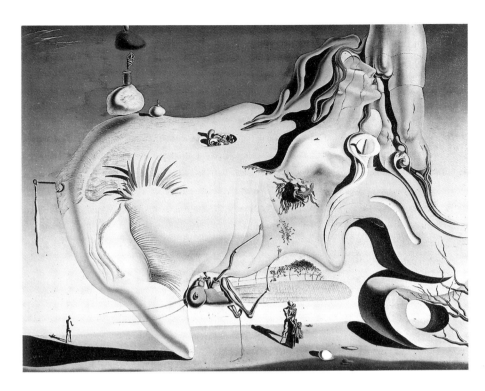

working at the time, were more than mere psychopathological illustrations. For his part, Dali soon incorporated her image and her reality into a mythologized vision of the heroine-savior. The data of his own psychic and psychological life provided him with a means of breaking free of his artistic sources and, as Dawn Ades has pointed out in her monograph, conflicts over his fear of impotence in the face of the strong erotic urges elicited by Gala's presence led directly to major Surrealist paintings like *The Great Masturbator* (1929–32), a "psychodrama of frustration and mingled fear and desire in the presence of the loved one."[5] In the painting, a monstrous head bearing Dali's features is supported horizontally by its rigid nose, a great rock formation resting on a sandy beach. The back of the head melts into an image of Gala's head caressing the flaccid genitals of a male figure. An image of erotic desire and feared impotence, the painting reveals Gala's dual roles as the stimulator of the erotic desire that initiates the delusional process, and the link between interior (here she is directly absorbed into Dali's own image) and exterior reality.

Dali credited Gala with saving him from the attacks of paralyzing laughter that prevented him from working and from achieving his "Surrealist glory" when they met in 1929. "She teaches me also the reality of everything. She teaches me to dress myself.... She was the angel of equilibrium, of proportion, who announced my classicism," he later announced.[6] She also completed his image, bringing the order and measure that he shrugged off in himself. His first major statement on the *paranoiac-critical method*, published the following year and dedicated to Gala, "the visible woman," included a series of photographs of her eyes, the eyes of the seer and medium. After their marriage he signed many of his canvases with both

22

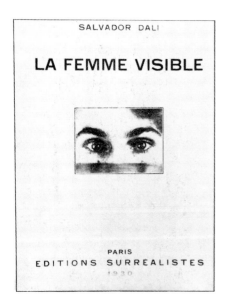

22 Salvador Dali, cover of *La Femme Visible*, 1930, showing Gala's eyes

their names, in this way continuing to acknowledge her role in his creative life. Dali's desire to universalize the image of Gala, to remove her from the real to an ideal plane where, liberated from the constraints of space and time, she would become part of an unbounded reality, stimulated his search for a mythic structure that could contain her image. She was his Penelope, his Helen of Troy, his Gradiva.

The role of woman as a creative source for the productions of male Surrealists dominates the first issue of the retitled periodical, *Le Surréalisme au Service de la Révolution*, which appeared in July 1930. As if in recognition of Surrealism's shift away from direct political action, it is not the image of the anarchist Germaine Berton around which the group arranges itself, but the reproduction of a painting by Magritte, *I Do Not See The* (Woman) *Hidden in The Forest*. Here the nude figure of a woman is reproduced at the center of a group of sixteen Surrealist painters and poets who close their eyes to the exterior world and pay silent homage to the muse within. Perhaps the reference is to *Nadja* in which Breton tells us that he had always hoped "to meet at night and in a woods, a beautiful naked woman." But when Nadja informs him of her midnight wanderings in the forest of Fontainebleau, he asks, "Who is the real Nadja?"—for he cannot separate his image of the visionary Nadja from the abused woman that she is describing. The presence of the loved woman also makes itself felt here through the presence of the handprints of seven women intimately connected with various Surrealists at the time: Suzanne Musard, Elsa Triolet, Gala, la Pomme, Jeanette Tanguy, Marie-Berthe Aurenche, and Goemans's wife. A photograph of the Surrealist group in 1930 taken by Man Ray and published in *Le Surréalisme au Service de la Révolution* shows that there were still no women in the movement's official ranks, even as the pages of the review are filled with their images: Dali's essay "The Stinking Ass," dedicated to Gala; Breton's poem "Free Union," a long descriptive paean to the loved woman; stills from Dali and Buñuel's *L'Age d'Or*, a bitterly anticlerical film celebrating erotic love; and Man Ray's first photographs of Lee Miller, the young American who was the first woman to seek an aesthetic, rather than a personal, identity through Surrealism.

Miller was twenty-two years old when she knocked on Man Ray's studio door in the summer of 1929. Tall and strikingly beautiful, she looked like a fashion model, but her carefully styled blonde hair and classical features masked a passionate and rebellious nature. Though young, she was, as Man Ray's Surrealist companions would soon learn, far from docile and dependent. Her independence and high spirits had led to her expulsion from a series of private schools in upstate New York, her parents had given in to her demand for a ticket to Europe after she threatened to pose nude for a well-known New York photographer, and her friends still speak admiringly of the uninhibited intensity with which she flung herself into life. Cecil Beaton later recalled her as a young woman who "cut short her pale hair and looked like a sunkissed goat boy from the Appian Way";[7] others remember her courage and energy when, later, she was to photograph the London Blitz and follow the advance of the Allied troops across Europe as a war correspondent.

She came to Paris after a long trip through Italy during which she had agreed to copy historical fashion details for *Vogue* magazine in exchange for a small sum of money. She was already a well-known figure in the fashion world of New York,

where she had modeled for Edward Steichen and Arnold Genthe and had frequented professional photography studios while attending classes at the Art Students' League. Her father was an amateur photographer, but it was Steichen who first suggested that she consider making photographs herself, and who offered her an introduction to Man Ray.

She came to Paris in search of adventure and a more liberated life-style, only to be informed that Man Ray had left for the summer. "I was crushed," she later recalled. "I was chasing him."[8] They met by chance in a nearby café and she introduced herself as his new student. "I don't have students and I am leaving for Biarritz tomorrow," he replied. In the end, captivated, he allowed her to accompany him. "I never looked back," she said.

She brought to photography a lingering belief that it was an art inferior to painting—a view shared by Man Ray—and she once volunteered to do all the studio photography and tedious darkroom work herself in order to free him to paint. So close was their collaboration between 1929 and 1932 that often they could not remember which one of them had made a particular image. "There are many of them which are attributed to Man, on which I helped, including the superb nude, *Primat de la Matière de la Pensée*," she later told Roland Penrose, adding, "I do not know if it was I who made them.... But that's of no importance ... we were nearly the same person at work."[9] They shared in the chance discovery that led to the first solarized photographs when Miller was working in the darkroom one day:

23 Untitled nude in a solarized photograph by Man Ray, 1940

> Something crawled across my foot in the darkroom and I let out a yell and turned on the light. I never did find out what it was, a mouse or what. Then I quickly realized that the film was totally exposed: there in the development tanks, ready to be taken out, were a dozen practically fully-developed negatives of a nude against a black background.
>
> Man Ray grabbed them, put them in the hypo and looked at them later. He didn't even bother to bawl me out, since I was so sunk. When he looked at them, the unexposed parts of the negative, which had been the black background, had been exposed by this sharp light that had been turned on and they had developed, and came right up to the edge of the white, nude body.... It was all very well my making that one accidental discovery, but then Man had to set about how to control it and make it come out exactly the way he wanted each time.[10]

Both of them continued to use the technique in their work, and several of the photographs included in her first exhibition at Julien Levy's New York gallery in 1933 were solarizations.

Miller's image, immortalized in photographs by Man Ray, is better known today than is her own work, about which she remained self-effacing for many years, finally abandoning it altogether. Like many of the women artists who came to Surrealism in increasing numbers during the 1930s, she had no interest in theory or politics, and no commitment to Surrealism's collective goals. Her photographs, particularly those made before she left Paris in 1932 to open her own studio in New York, show the Surrealist love for evocative juxtaposition.

24

LEE MILLER

Passionate, rebellious, and beautiful, Lee Miller proved too headstrong and independent to fit Surrealism's developing ideal of the ethereal and childlike woman. Her own photographs often reveal Surrealism's love for evocative juxtapositions.

24 Lee Miller, *Self-Portrait*, 1933
25 Lee Miller, *Fallen Angel—London Blitz*, 1940

26 Lee Miller, photograph of Adie, Lee Miller, and Nusch Eluard at Antibes in 1937

Her connections with the group, however, were entirely personal rather than formal and she is closer to the newly liberated woman of the 1920s than to Breton's etherealized vision of the Surrealist woman. In fact, she incensed Breton by volunteering for a small part in Cocteau's 1930 film, *Blood of a Poet*; the Surrealists despised Cocteau both for his flamboyant homosexuality and use of drugs, and for his frequent, and unattributed, borrowings from Surrealism's repertoire of themes and images. Miller's willingness to collaborate with the enemy enraged May Ray and Breton, causing bitter arguments among the group, which left her unmoved. In the film she plays the role of a Venus-like statue, simultaneously marble and flesh. She speaks to the film's hero, a young poet, instructing him to make the leap through the looking glass and into a "marvelous" and awesome world in which the laws of probability are suspended and the visionary reigns supreme. There he voyeuristically witnesses a series of scenes that derive their imagery from drug-induced hallucination and the work of Sade, Dali, Ernst, Picasso, and others. Returning from this disturbing world, the poet attacks his muse, smashing the statue into tiny fragments in a frenzy of despair. Miller's insistence on her own freedom was less sympathetically received than Charlie Chaplin's and led to a growing rift with Man Ray. The success of her own career as a fashion photographer for *Vogue* contributed to the final breakup with May Ray in 1932.

Meanwhile, relations between the Surrealists and the fashionable group gathered around Cocteau had become increasingly tense in the late 1920s. When Valentine Hugo, one of Cocteau's closest associates and "the only woman whose beauty and kindness had made him regret his homosexuality,"[11] had become Eluard's companion after the final collapse of his marriage to Gala in 1929, the long-running feud had again flared up. A year later, Breton and Hugo were lovers. His words to Tzara in 1918, "My opinion—completely disinterested, I swear—is that he is the most hateful being of our time," must have returned to haunt him as he crept past Cocteau's door on his way to visit Hugo in her apartment upstairs on the rue Vignon.

Hugo was the first woman to enter the Surrealist orbit with an already established professional reputation as an artist. Until 1929 the wife of Jean Hugo, the great-grandson of Victor Hugo, she had collaborated with him on designs for ballets during the 1920s that included Cocteau's *Mariés de la Tour Eiffel* of 1921, and twenty-five wood engravings for an edition of *Romeo and Juliette* the following year. Her lithographs included portraits of Eric Satie, Picasso, Valery, Misia Sert, Georges Auric, and the actress Falconetti in the filmed *Passion of Joan of Arc* on which she collaborated with Carl Dreyer.

Hugo was well known in Parisian literary circles before she met the Surrealists. "She was fascinating," recalled Lise Deharme, "neither beautiful nor young [Hugo was thirty-three when she became involved with Breton], but with a very unique sort of charm."[12] She dressed herself in scarves and flowing chiffon, had a striking carriage and a long, slender neck of which she was very proud, and kept a large collection of manuscripts, many of them the work of Surrealist authors, in a bureau that had once belonged to Victor Hugo. André Thirion remembered her as "adorable, intelligent ... of an inexhaustible sweetness." Cocteau called her his

"swan"; "You should come yourself, like the true angel you are, long-throated, great-winged, flying to me.... You *are* my angel, my good angel, watching over me, stimulating me," he had written to her in 1916 while in the army.

Late in her life, Hugo recalled the misery and despair of her separation from Jean Hugo and from the artistic collaboration that had sustained her work during the 1920s. "I can say here sincerely," she remarked shortly before her death in 1968, "Paul Eluard and André Breton, whose works I had admired always, saved me from despair about 1930, the darkest period of my life..., thanks to them I went back to work; their affection, their admiration and their encouragement gave me back confidence in myself."[13] Eluard dedicated his "L'Heure Exacte" to her and wrote the text "Un Doit de Regard Enfin sur le Poème" as a preface for the edition of Rimbaud's *Les Poètes de Sept Ans* that she illustrated in 1939; she painted *Les Constellations* (1932–48) in homage to the four poets (Breton, Eluard, Tzara, Crevel) whom she believed to be the brightest stars in the literary sky of the 1930s.

Hugo played out her own myth of love. Passionately in love with Breton in the early 1930s, she copied his taste for certain objects and sprinkled her works of those years with hermetic references to the poet. She illustrated an edition of Achim von Arnim's *Contes Bizarres*, published in 1933 with an introduction by Breton, and included several disguised images of their intimate relationship. In her drawing for the book's cover, she depicted him in the air pointing a flaming sword like an archangel at the ecstatic mouth of a female figure, surely meant to represent herself, who swoons on the bed below.

Hugo's grace and charm, and her undisguised love for Breton, were not enough to cast her in the role of the Surrealist woman that fueled his imagination. He responded to her with great courtesy and with the slightly reserved manner of one whose emotions were not completely engaged. Already some years older than many of the Surrealist's female companions, she had no role in the search for the *femme-enfant* into which Breton would increasingly pour his poetic energy.

Ambivalence about the role of women in Surrealism reached new heights in the 1930s. The poets continued to glorify female youth and innocence in poems that rely on woman's image to illuminate all that is obscure in the world—and in man, the painters eroticized her as a Sadeian queen, and the group admitted more women into its ranks, encouraging their creative activity and holding forth an ideal of freedom in love and in work. In a curious poem titled "Sans Connaissance," published in *La Revolver à Cheveaux Blancs* in 1932, Breton tells of a strange sexually charged encounter with a fourteen-year-old girl. The following year the revolutionary child arrived on the Surrealist scene, first in the person of Violette Nozières, a year later in Gisèle Prassinos. Violette Nozières was condemned to death in 1933 for poisoning her parents in a bizarre case complicated by overtones of incest and child abuse. The case, widely publicized in France, led Picasso to dedicate a painting to the young antiheroine; Breton soon organized a brochure containing poems and drawings by Breton, Eluard, Char, Mesens, Peret, Dali, Tanguy, Ernst, Magritte, Arp, and others. Nozières became the Surrealists' "modern Electra," a young woman who had lived out the deepest and most terrifying aspects of the Freudian unconscious.

27

28

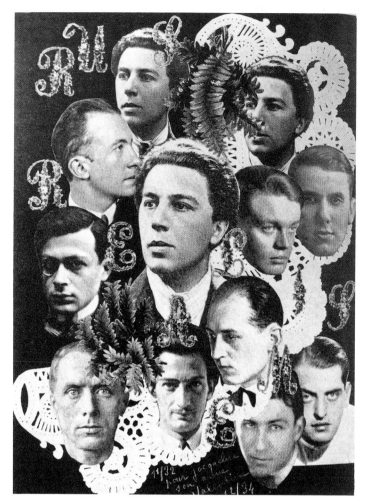

VALENTINE HUGO

Valentine Hugo shifted her allegiance to the Surrealist group around 1929. Briefly linked romantically with Eluard and Breton, she continued to illustrate Eluard's work until his death. Married to Jean Hugo until 1929, she was the first woman to enter the Surrealist orbit with a professional reputation as an artist already established. She was a major visual interpreter of Surrealist texts. Hugo dedicated her collage of members of the Surrealist group to Jacqueline Lamba Breton and in an interview published later in her life she recalled the support and encouragement provided by her friendships with Eluard, Breton, and other Surrealists.

27 Valentine Hugo, photographed by Man Ray in 1931
28 Nusch Eluard and Valentine Hugo, *c.* 1934
29 Valentine Hugo, collage of members of the Surrealist group, 1934
30 Valentine Hugo, cover of *Contes Bizarres*, by Achim d'Arnim, 1933
31 *Entretien*, letter transcribed by Valentine Hugo

Avant mon mariage en 1919 avec Jean Hugo, j'achetais et lisais les revues et les livres Dadaïstes. Et puis ce furent les revues et les livres Surréalistes que j'achetais ou qui m'étaient envoyés.

Le premier livre que je reçus d'André Breton fut Nadja en 1928, avec une dédicace assez mystérieuse qui lui ressemblait beaucoup, de l'humilité à l'orgueil, du serré au délié en quelque sorte. Ensuite les dédicaces se firent de plus en plus belles au cours des années qui suivirent jusqu'aux dédicaces

(Fortsetzung)
mit der üblichen Frische und Anmut, die
wir an ihr so bewundern. Ihre Farbgebung
dagegen ist voller Pflanzen- und Tiersäfte. Da-
rum verwahren sich ihre Bilder am besten in
kleinen Dosen und steinernen Büchsen.
Ein Komma wird in ihrer Hand zum Zauber-
stab. Beispiel:

EIN STUHL VON SEIDE, BEDECKT.

Mit fünfzehn Jahren verläßt sie Vater und
Mutter, um den halbwüchsigen Eisenbah-
nen und der von ihr wichtigsten Seezunge nach-
zujagen. Mit zwanzig verschließt sie sich
vorhin vornehm in eine Luftspalte und ver-
schluckt den Schlüssel. Nach vierzigtägigem
Fasten bricht sie plötzlich aus und
spielt seitdem gerne – warum wohl? –
mit den Gipfelvorträgen der Küstenlänge
und Vorgebirge. Die Schiffbrüchigen und
die Gichtbrüchigen ... Mit einem Wort, sie
ist ein lebendes Exempel für den wahren Lehrsatz

DAS WEIB IST EIN MIT WEISSEM MAR-
MOR BELEGTES BRÖDCHEN.

Wer übergießt die Suppenlöffel mit kostbarem
Pelzwerk? Das Meretlein. Wer ist uns über
den Kopf gewachsen? Das Meretlein. Die haben die.
(Fortsetzung folgt) Max Ernst.

32 Foreword by Max Ernst to the Meret Oppenheim exhibition held at the Galerie Schulthess, Basel, 1936

Gisèle Prassinos, on the other hand, was a poet. She was fourteen years old when she wrote most of the stories included in her first book, *La Souterelle Arthritique*, published in 1935, and was adopted by the Surrealists. The stories that she read at Surrealist gatherings, like the poems later published in *Minotaure*, move freely between the worlds of childhood and Surrealism in their spontaneous, freely associated images.

The first artist to incarnate all the qualities of the *femme-enfant* was Meret Oppenheim, whose uninhibited behavior and creative spirit seem to have made her the perfect example of the Surrealist woman. The many photographs that Man Ray took of her during her first years in Paris show a wide-eyed slender young woman with regular features, a bold gaze, and a ready willingness to defy social convention. "With Meret you are always transfixed at the exceptionally thrilling moment, where the ghosts have fled, grumbling....," wrote Peret.[14] Carrington was struck by her beauty and free spirit; Ernst, for whom she developed a "great passion," provided his own fantastic description in a preface to her first one-woman exhibition in Basel:

> At the age of fifteen, she left father and mother to seek after half-grown railways.... At twenty she decently enclosed herself in a crack of air and swallowed the key. After forty days of fasting, she suddenly burst out of her own confinement and since that time loves to play.... She is a living example of the ancient theorem *The Woman is a Sandwich Covered With White Marble*.

Born in Berlin in 1913, Oppenheim passed her childhood in Switzerland and southern Germany where her father, a doctor long interested in Jung's ideas, had a country medical practice. Her aunt had at one time been married to Herman Hesse; her grandmother had studied painting in Düsseldorf in the 1880s and later became well known as a writer of novels and children's stories and as an activist in the Swiss League for Women's Rights. Oppenheim took the latter's example to heart, decided at an early age not to marry at all or at least not until later in life, and began hiding a sketchbook inside her hymnal during long and tedious church services. At sixteen, stimulated by an exhibition of Bauhaus work at the Basel Kunsthalle that included the number paintings of Paul Klee, she produced her first "surrealist" work, an equation between X and a drawing of a rabbit in a school notebook. She would later present this first *Cahier d'une Ecolière* to Breton. Leaving school the following year, Oppenheim met some of the artists of the Neue Sachlichkeit and began making pen and ink watercolors, many of which have an air of expressive caricature not unlike that of Klee's early etchings.

She arrived in Paris in May 1932, rented a room at the Hotel Odessa in Montparnasse, and enrolled briefly at the Académie de la Grande Chaumière. Soon bored by the academic routine at the academy, she began to spend her days in galleries and cafés, writing her first poems in the Café du Dôme where she met Giacometti in 1933. Through him she met Sophie Taeuber and Hans Arp, Kurt Seligmann and Ernst. Giacometti and Arp became her first artistic mentors; Ernst and Man Ray her intimate companions.

Giacometti, who was earning a living making furniture and objects, encouraged her to make her first Surrealist object, a small piece titled *Giacometti's Ear* (1933). He and Arp invited her to exhibit with them at the Salon des Surindépendents in 1933; after that she frequented Surrealist meetings and gatherings, increasingly identifying her life and her art with the movement. Her youth and beauty, her free spirit and uninhibited behavior, her precarious walks on the ledges of high buildings, and the "surrealist" food she concocted from marzipan in her studio, all contributed to the creation of an image of the Surrealist woman as beautiful, independent, and creative. But this public persona was of little help, in fact was almost certainly a hindrance, in her search for artistic maturity. The objects that insured her place in subsequent histories of the movement offer flashes of brilliance rather than evidence of sustained artistic growth, and she was, even at that time, conflicted and uncertain about her life as an artist.

33 Jacqueline Lamba photographed in front of one of her paintings in New York in 1944, the year of her first one-woman exhibition

Meret Oppenheim's arrival in Paris marked the beginning of the most active period for women artists in the Surrealist movement. By 1933, three years before the first international exhibition, Surrealism had become a public phenomenon in Paris and Surrealist groups were springing up in other European cities. The following year, Breton left the café where he was enjoying an aperitif and began to follow a young blonde woman who had caught his eye. They struck up a conversation on the boulevard, and the woman told him she was a professional high-diver in a Montmartre music hall (an *ondine*, the personification of the waiter's call to potential diners—*"On dine ici!"*—that had driven Breton away from the café). Enchanted by this chance encounter, and recognizing in Lamba the crystallizing of the image of *la jeune femme blonde* that had haunted him since the early 1920s, he claimed her as the Elect Woman who had figured so prominently in "La Nuit de Tournesol," the premonitory poem of 1923 that anticipated their meeting the following decade. She became an image of miraculous chance, the woman, at once real and mythical, who was to excite his poetic imagination during the 1930s. "Scandalously beautiful," according to Breton, she had delicate chiseled features, abundant blonde hair, and a presence that animates love poems like "L'Air de l'Eau":

> *Ta chair arrosée de l'envoi de mille oiseaux de paradis*
> *Est une haute flamme couchée dans la neige*

("Your flesh sprinkled with the flight of a thousand birds of paradise/ Is a high flame lying in the snow").

Lamba brought her own personal style to Surrealism. Strong-willed and devoted to Breton, she went everywhere with him, adjusting her life to his needs, and finding a role for herself as the wife of Surrealism's leader (the couple married late in 1934 in a double ceremony with Nusch and Paul Eluard). She liked to dress in full skirts and large earrings, or wear a blue ostrich-feather coat and pile her hair on top of her head *à la Fontanges* (a towering headdress worn by one of Louis XIV's mistresses, Marie de Fontanges).

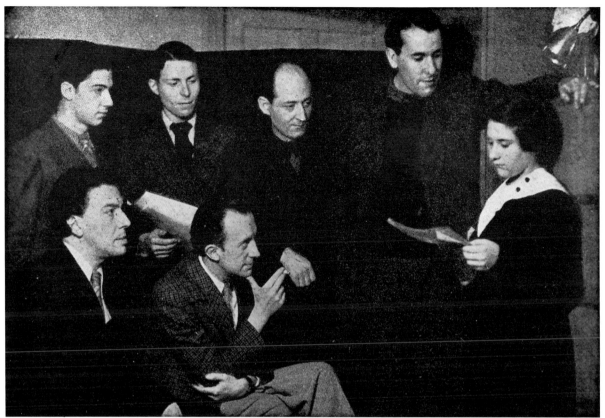

34

35

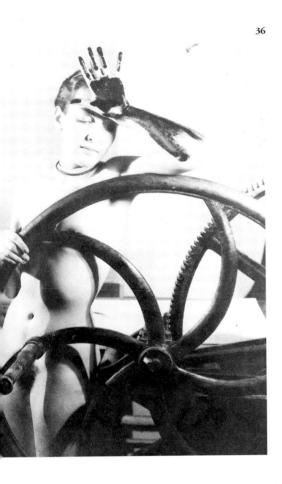

FEMMES-ENFANTS

During the 1930s the image of the femme-enfant assumed ever greater importance for the Surrealists. A creature of grace and promise, the woman-child was intuitively close to the worlds of the unconscious, the imagination, and the irrational, capable of bewitching the male artist and leading him away from the confining world of the real.

34 Gisèle Prassinos reading her poetry to the Surrealists in 1933: (*seated*) Breton and Eluard; (*standing, left to right*) Mario Prassinos, Henri Parisot, Benjamin Peret, and René Char
35 A group of Surrealists photographed in Wellfleet, Massachusetts, during the war. *Left to right*: Ann Matta, unidentified child, Robert Matta, Aube Breton, unidentified woman, Jacqueline Lamba Breton
36 *Erotique Violée*—Meret Oppenheim photographed by Man Ray in 1933
37 Ann Alpert, Surrealist fashion design, *c.* 1938

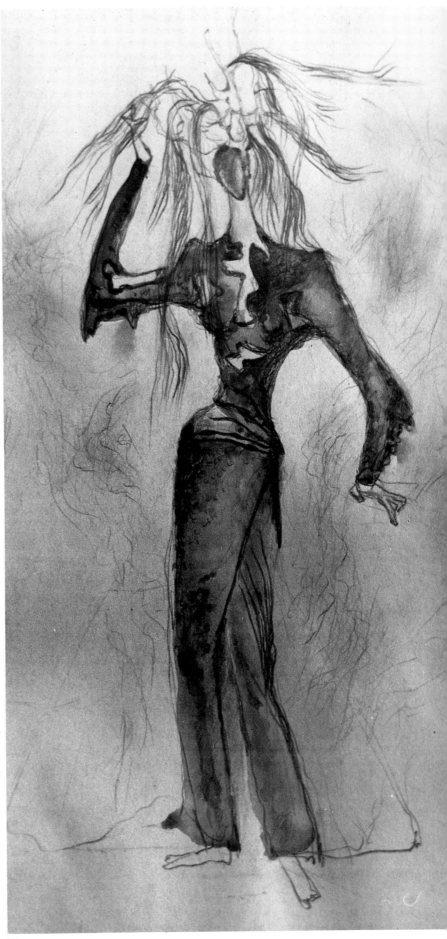

As Surrealism reached a wider public during the middle 1930s, its politics of liberation and free expression came to be increasingly associated with the life-styles of its members. When elaborate hairstyles were the rage in Paris, Dora Maar, a young painter and photographer who was close to the group in 1936 and 1937, arrived at the Café de la Place Blanche with her hair disheveled and falling down over her face and shoulders, like someone just rescued from drowning. At the Surrealists' table, relates Marcel Jean, everyone—or nearly everyone—exclaimed in admiration.[15]

Lamba, who had studied decorative arts in Paris and who produced a number of Surrealist objects during the 1930s, among them a piece titled *La Femme Blonde*, exhibited in the first international Surrealist exhibition at London's New Burlington Galleries in 1936 but had little opportunity for serious involvement in her own work while married to Breton. The couple lived in his small apartment on the rue Fontaine where there was little extra room for working and no household help; Lamba's life was dominated by Breton's needs, by the demands of Surrealism, and, after 1936, by those of the couple's small daughter, Aube. During these years the group met daily at the Café du Dôme or the Place Blanche. The women closest to the Surrealists—among them Gala Dali, Nusch Eluard, Dora Maar, and Jacqueline Lamba—were beloved for the quality of their imaginations rather than for their artistic goals. They participated in Surrealist activities and exhibited with the group after 1933, but their objects, collages, and "exquisite corpse" drawings are extensions of Surrealist practice, conceived in the spirit of group activity, and often executed in collaboration with other Surrealists. Ann Alpert, an American who met and married Matta in Paris in 1937 after two years at the Art Institute of Chicago, used automatist techniques as the starting point for fashion drawings with a distinctly Surrealist air and made objects, one of which was exhibited in the Paris exhibition in 1938, but remembers that she felt too intimidated by the better-known artists in the group to work seriously at painting. Breton called her *Parajito*, or "Little Parrot," in recognition of her fragile beauty. "He treated me like a child," she recalls, "but I accepted that as normal."[16] As the winner in a Surrealist card game, she received a poem-object from Breton in which he organized the lines of poetry around smooth polished pebbles: *Le Mirroir d'eau de Parajito*, ran the text, *La femme-enfant toute la grâce/ La mer qui a formé ces seins* ("Parajito's watery mirror/ the woman-child ever graceful/ It is the sea which has formed these breasts").

In 1937, Breton took another step toward mythologizing the image of woman as muse. Suffering financially after an offer of a teaching position on which he depended for support for his wife and daughter fell through, he decided to open a Surrealist gallery on the rue de Seine. The gallery was called Gradiva and above its glass doors, designed by Marcel Duchamp as the silhouette of a conjoined man and woman, the name Gradiva was spelled out above those of certain other Surrealist women of the decade: Gisèle, Rosine, Alice, Dora, Inès, and Violette. The word *comme* ("as in") links the names of Alice Paalen, Dora Maar, Violette Nozières, and others with that of Gradiva. The name Gradiva appears in paintings by Dali and Masson and writings by Breton and others.

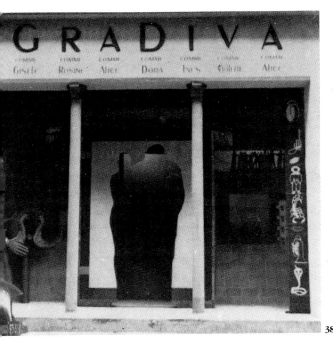

38

39

GRADIVA

*Between 1930 and 1937 images of woman as muse in
Surrealism coalesced into the mythical image of Gradiva.
Drawn from Wilhelm Jensen's novel* Gradiva: A Pompeiian
Fantasy *and from Freud's subsequent analysis of the work,
the figure of Gradiva was used by Breton, Masson, Dali,
Eluard, and others as a means of symbolically
demonstrating the dynamism of repressed erotic desire and
as a myth of metamorphosis. The mythic image of Gradiva
subsumed the lives of real women associated with the
Surrealists. "Gala is Trinity," Dali said. "She is Gradiva the
woman who advances. She is, according to Paul Eluard, 'the
woman whose glance pierces walls.'"*

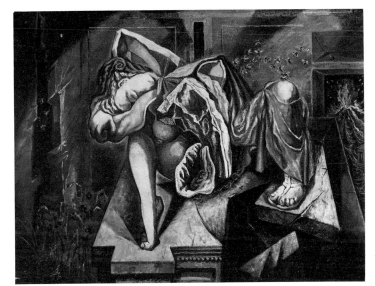

40

41

38 The Surrealist gallery Gradiva, opened by Breton in 1937
39 Marble relief in Rome, the inspiration for Jensen's novel
40 André Masson, *Gradiva*, 1939
41 Salvador Dali, *Gradiva*, 1930

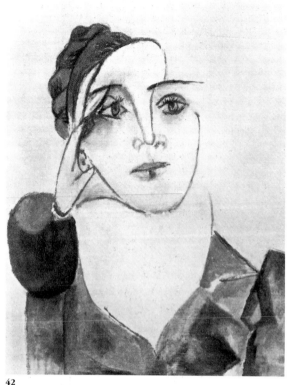

42

DORA MAAR

Dora Maar, best known today from the many Picasso paintings which contain her dark eyes and broad regular features, moved in Surrealist circles between 1934 and 1937. Lee Miller photographed her with Picasso in Mougins in 1937, and she became close friends with Eluard, Man Ray, and Jacqueline Lamba. She had been trained as a painter but, unsure of her talent, gave up painting temporarily and produced a small but brilliantly disquieting group of hallucinatory photographs, several of which were included in Surrealist exhibitions. Although she continued to paint, she later renounced Surrealism and adopted a semimonastic life.

42 Picasso, *Dora Maar*, 1936
43 Lee Miller photograph of Picasso and Dora Maar, Mougins, 1937
44 Dora Maar photograph: *Père Ubu*, c. 1936

43

The name had been used originally in a short novel by the German writer Wilhelm Jensen titled *Gradiva: A Pompeiian Fantasy* (1903). The Surrealists derived it from Freud's subsequent analysis of the work which Breton had read sometime after its translation into French in 1931.

The use of this theme by the Surrealists beautifully reveals Surrealism's search for a larger mythic structure into which real women could be absorbed. Jensen's novel drew on a classical Greek relief of a young woman that still exists today in the Museo Chiaramonti in Rome. The novel concerns a young archaeologist named Norbet Hanold who falls in love with a plaster cast of the same relief. He calls her Gradiva, "the girl splendid in walking," a feminine equivalent of the epithet accorded by the ancient poets to Mars Gradivus, the magnificent god of war. Her unusual gait captivates him, his fantasies about her become delusions, and he dreams that he witnesses her death in the eruption of Vesuvius in A.D. 79. Accepting the dream as fact, Hanold is drawn to Pompeii by the power of the delusion, meeting there a girl who closely resembles his beloved relief. He encounters her three times, and each meeting reinforces his belief that she is the spirit of his lost love, freed from the grave and allowed to wander through the streets of Pompeii each day at noon. Recognizing his mental state the girl manages to effect his cure. She then reveals herself as a childhood playmate, Zoë Bertgang, whom the young man had completely forgotten but who still lived near him in Hamburg. Hanold's amorous feelings, previously repressed and able to find expression only through his devotion to archaeology, are restored to their rightful place and the inevitable happy ending ensues.

Jensen's third-rate fiction might quickly and deservedly have faded into obscurity had not the Swiss analyst Carl Jung read it shortly after publication. It was on Jung's suggestion, contained in a letter of 1906, that Freud became interested in the idea of analyzing dreams that have never been dreamed—dreams invented by an imaginative author and ascribed to fictitious characters in the course of a story. The result was Freud's *Delusion and Dream in W. Jensen's Gradiva*, published in 1907, his first work devoted to literary analysis. Freud, who had visited Pompeii and climbed Vesuvius in September 1902, was fascinated by the analogy between the historical fate of the city (its burial and subsequent excavation) and the psychic mechanism that he himself had uncovered—burial by repression and excavation by analysis. Submitting the novel to the psychoanalytic method, Freud discovered that the laws of the unconscious observable in his patients' behavior were evident in the conscious actions of Jensen's characters.

Hanold's anxiety dream, the dream in which he saw Gradiva perish, expanded his fantasy about the existence and death of this girl into a delusion in which their life in ancient Pompeii is equated with Hanold's repressed memories of his childhood friendship. Meeting Zoë/Gradiva in Pompeii, he incorporates the real woman into the delusion and, intuitively accepting her role in the fantasy, she manages to lead him back from a distorted reality, thereby curing him. The delusion represents the struggle between Hanold's repressed erotic feelings for his childhood friend and the strength of the forces repressing them. In this way the potential strength of repressed passion is demonstrated.

Freud beautifully reveals the working of the unconscious, its relationship to conscious action, and the role played by dream in this nexus. He concludes that both scientist and artist arrive at the same understanding of the unconscious. The Surrealists were quick to seize on Freud's conclusion that science and art confirm rather than contradict one another in their explication of the unconscious, and Freud's *Gradiva* became a significant Surrealist guide during the 1930s.

Freud's essay furnished many of the themes indispensable to Surrealism's second decade: the myth of love, the primacy of desire, the mechanism of repression, and the dynamism of the repressed. But their explanation of the workings of the unconscious could not be unmediated. Only the artistic symbol could provide the necessary link between the real and the surreal. The image of Gradiva became this symbolic mediator.

Dali saw Gala as his Gradiva, the woman who had saved him from the attacks of paralyzing laughter from which he was suffering in 1929, thereby enabling him to go on and achieve his "Surrealist glory." For Eluard, Gradiva was the muselike woman who leads the poet on in his unceasing attempt to glimpse what lies ahead, beyond the real. Breton turned to the image as a symbolic expression of the unification of polarized states of consciousness, the being who existed in Jensen's novel and Freud's study both as dream image and corporeal being, belonging to the worlds of death and life, madness and sanity, fantasy and reality. Limited neither by space nor time, she participated in some form in each of these states but was bound by none of them. In an essay written in 1937 and titled "Gradiva," he reiterates these characteristics of the Surrealist muse, using the Gradiva theme as a myth of metamorphosis: from death to life, from dream to wakefulness, from the unconscious to the conscious, from the mundane to the transcendental.

Since the 1920s women, if not women artists, had found their way to Surrealism through personal, often romantic, connections with members of the group. This path remained open to women in the later years of the 1930s; Dora Maar's friendships with Eluard and Man Ray led her both to photography and to Surrealism; Leonora Carrington met Ernst at a party in London on the occasion of his 1937 exhibition at the Mayor Gallery, and neither life was ever quite the same afterwards; Remedios Varo arrived in Paris at the end of the Spanish Civil War with the poet Benjamin Peret whom she later married in Mexico. But these women, though young when they came to Surrealism, differed from many of their forerunners for they had already embarked, however tentatively, on artistic paths. Maar had studied painting at the Académie Julien, Carrington with Amedée Ozenfant in London, and Varo at Madrid's Academia de San Fernando where she was a year behind Dali.

Another path to Surrealism for women artists resulted from the movement's wide public appeal and international reputation, simultaneously provocative and fashionable, after the first of several international exhibitions beginning in 1936. Surrealist groups sprang up in centers as distinct in location and attitude as Prague, Tokyo, and Copenhagen. Women who were Surrealist "discoveries" during the latter part of the decade were all discovered through their work. That their personalities and their lives were admirably suited for Surrealism only confirmed the efficacy of the chance encounter in the eyes of Breton and others.

41

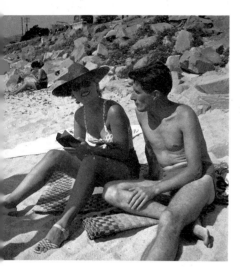

45 Eileen Agar photograph of Lee Miller, Roland Penrose, Juan les Pins, 1937

Breton's love of theoretical discussions and his extreme Romanticism alienated some women, though they continue to speak admiringly of his powerful ethical sense and his unfailing courtesy toward women; the presence of so many well-known men in the group, and the closeness of the bonds uniting them, intimidated others. Carrington ignored Breton's pedagogical tendencies; Léonor Fini found them reason enough to refuse to participate in Surrealist activities or to formally join the group, though she contributed paintings to their exhibitions. Often the women settled the problem of their relationship to the movement by establishing subgroups of friends to whom they turned for friendship and support, creating mini-networks of close bonds within the larger group, and defining their relationship to Surrealism in terms of friendship and personal affinities. "I was never a Surrealist," Carrington says; "I was with Max (Ernst)." Fini's lack of personal sympathy for Breton did not prevent sustained and nourishing relationships with Carrington, Ernst, Brauner, Magritte, and others; Varo's closest companions were the Spanish painters Esteban Francés and Oscar Dominguez.

Outside Paris, groups of Surrealists with their wives and companions traveled, relaxed, and worked together under summer skies darkened by threatening clouds of international tensions; the political instabilities of the decade sometimes seemed to mirror the social instabilities that often pursued the group that had, in many instances, rejected domestic stability. During the summer of 1937 Nusch and Paul Eluard joined Roland Penrose, Ernst and Carrington, Eileen Agar and Joseph Bard, Man Ray and his companion, in Cornwall. Lee Miller, who had returned from Egypt and met the English painter Roland Penrose earlier that spring in Paris, photographed the group as they swam, hiked, and ate together.

In September, they reconvened in Mougins, a small hilltop village above Cannes, and were joined by Picasso and Dora Maar. If Picasso's moods and ideas dominated the group, it was the women who transformed the most commonplace activities into memorable events: Agar, photographing and fashioning armfuls of shells and driftwood into quixotic marine objects; Nusch, whom Eluard had rescued from an impoverished existence posing for sentimental postcards and playing walk-on roles at the Grand Guignol, dark-haired, light in spirit, and always laughing; Miller, remembered by Agar as "a remarkable woman, completely unsentimental and sometimes ruthless"; Maar, dignified and reserved, but prone to bouts of despair and self-criticism. "It is inevitable," Agar later wrote,

> to confuse the delights of being young, with the place and the time one was young in; the south of France in summer, Surrealism on the horizon, Stravinsky in the air, and Freud under the bed.... The world was small then, the freedom of the intellectuals and the pleasure loving twenties and early thirties were the privilege of those few with avant-garde ideas.... In spite of the increasing Teutonic fury, we could still bathe, bask in the sun, eat and have a merry heart.[17]

One member of the last group of women artists to join the Surrealist circle before the outbreak of war in 1939 splintered the movement was the American painter Kay Sage. Originally from a wealthy and conservative New York State family, Sage had married an Italian prince in 1925 and lived in Rome and Rapallo.

46 Paul Eluard in front of Picasso's portrait of Nusch Eluard, in his home in the Rue de la Chapelle, 1946

46

47 Dora Maar, Nusch Eluard, Picasso, and Paul Eluard at Juan les Pins, 1937, photographed by Eileen Agar

47

NUSCH ELUARD

48 During the war the Eluards remained in Paris while many Surrealists were in America. Both were active in the Resistance, and Nusch often walked the streets of Paris with large bonbon boxes full of Communist tracts and subversive poems. Lee Miller, a war correspondent for Condé Nast publications, arrived in Paris in 1944 and photographed the Eluards in their apartment

49 Man Ray photographed Nusch as the Queen of Clubs in a deck of Surrealist playing cards that also included Jacqueline Lamba as the Knave of Hearts

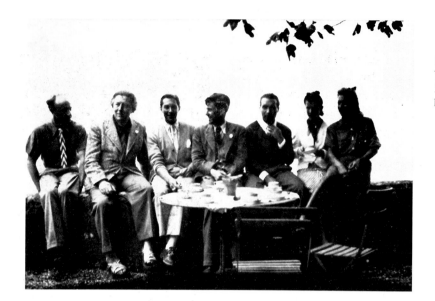

50 Surrealists at Chemillieu, 1939: (*left to right*) Yves Tanguy, André Breton, Gordon Onslow-Ford, Matta, Esteban Francés, Ann Matta, Jacqueline Lamba Breton

51 Surrealists in Connecticut, 1942: (*seated, left to right*) André Breton, Suzi Perkins Hare, Louisa Calder, Rose Masson, Sandra Calder, Charles Prescott, Mary Calder, Teeny Matisse; (*standing*) André Masson, Kay Sage, Alexander Calder

In 1937 she abandoned a life which offered few outlets for her talents and energy, and moved to Paris. She rented an apartment on the Île St. Louis, sold her jewelry to raise money, resumed her maiden name, and began work on a series of abstract and near-abstract paintings based on architectural motifs. In 1938 she exhibited a single painting at the Surindépendents exhibition. Among the Surrealist visitors to the exhibition were Breton, Tanguy, and the Greek poet Nicolas Calas. The three were sufficiently impressed by the painting to seek out the artist. Calas remembers that Breton, though quick to respond to the work's atmosphere of disquieting tension, had difficulty reconciling Sage's paintings, which he found cold and somewhat mechanical, with the more ethereal forms he preferred to associate with women's creativity, and he initially believed that the work must surely have been produced by a man.

Sage's meeting with Tanguy proved decisive and the summer of 1939 found her staying at the Château de Bourdeaux in the province of Ain near the Swiss border. Not far away, at an estate Gordon Onslow-Ford had rented at Chemillieu, were Tanguy, the Mattas, the Bretons, and Esteban Francés. Sage frequently entertained the group, and together they played Surrealist games, worked, and made expeditions into the countryside. At the outbreak of war in September, Sage returned to New York and embarked on a project to help those artists left in Paris. With the cooperation of the French minister of education, she organized a series of one-person exhibitions in New York for artists still working in Paris. Tanguy, declared medically unfit for service by the military authorities and authorized to leave the country, rejoined her in New York and inaugurated the series. They were married later that year.

In Europe, the Surrealists scattered. Eluard and Nusch would remain in Paris throughout the war, signing and distributing pamphlets and supporting the Resistance. Oppenheim was in Switzerland, Agar and Miller in London where Miller would soon become a war correspondent for Condé Nast publications. Fini moved first to Arcachon, as did Gala and Salvador Dali, then to Monte Carlo; Varo and Peret, and Breton and Lamba found their way to Marseilles and waited there for passage to New York; others, including Carrington, and Ernst, now in the company of Peggy Guggenheim, traveled via Lisbon.

52 Kay Sage in 1908

Regrouped in New York, the Surrealists struggled to keep their revolution alive in the face of much more serious political events. The October–November 1941 issue of *View*, a new review of modern poetry and art, was edited by Calas and devoted entirely to Surrealism. It served as one of the first indications of an active Surrealist presence in the United States. In the foreword, Breton again launched the Surrealist rallying cry—freedom! "The Surrealist cause, in art as in life, is the cause of freedom itself...," he exhorted his new audience.

The periodicals *View* and *VVV* and the 1942 exhibition First Papers of Surrealism provided new outlets for the work of women artists, several of whom had been forced into positions of greater independence by the events surrounding the war and the flight from Europe. Now it was Breton who was out of his element, his position as leader undermined by his refusal to learn English, his livelihood dependent upon a monthly stipend, first from Sage, later from Peggy Guggenheim. Emotionally unable to embrace the marriage of one of Surrealism's original artist-members to a wealthy American, Breton and Tanguy quarreled, precipitating Sage's and Tanguy's decision to leave New York and settle in the Connecticut countryside. Breton's own domestic situation also deteriorated as Lamba, who had acted as go-between for the non-English-speaking Breton and the sculptor David Hare, who had become the editor of *VVV*, became romantically involved with Hare. Her desire to pursue her own painting more seriously contributed to her decision to leave Breton, taking Aube with her; he would later recall to André Thirion that it was absurd details like her inability to remember to turn off the water faucets that ended the ten-year marriage. Even Aube proved recalcitrant. In Paris, Breton's favorite punishment was the threat that she would be taken to church; in New York, Lionel Abel recalls, she turned the tables and began demanding to go to church.[18]

61

53

54

KAY SAGE

Kay Sage's work is, for a Surrealist, untypically abstract but also mysterious and visionary. As a wealthy woman she was able to aid many Surrealists fleeing Europe during the war; she contributed toward Breton's living expenses after he and Jacqueline Lamba arrived in New York. Sage married Tanguy in New York in 1940 and the couple lived and worked in Connecticut, exhibiting once together at the Wadsworth Atheneum the year before his death in 1955.

53 Kay Sage in 1918
54 Kay Sage, André Breton, *chez* Pierre Matisse, New Jersey, *c*. 1942
55 Kay Sage, *A Little Later*, 1938
56 Kay Sage, *I Saw Three Cities*, 1944

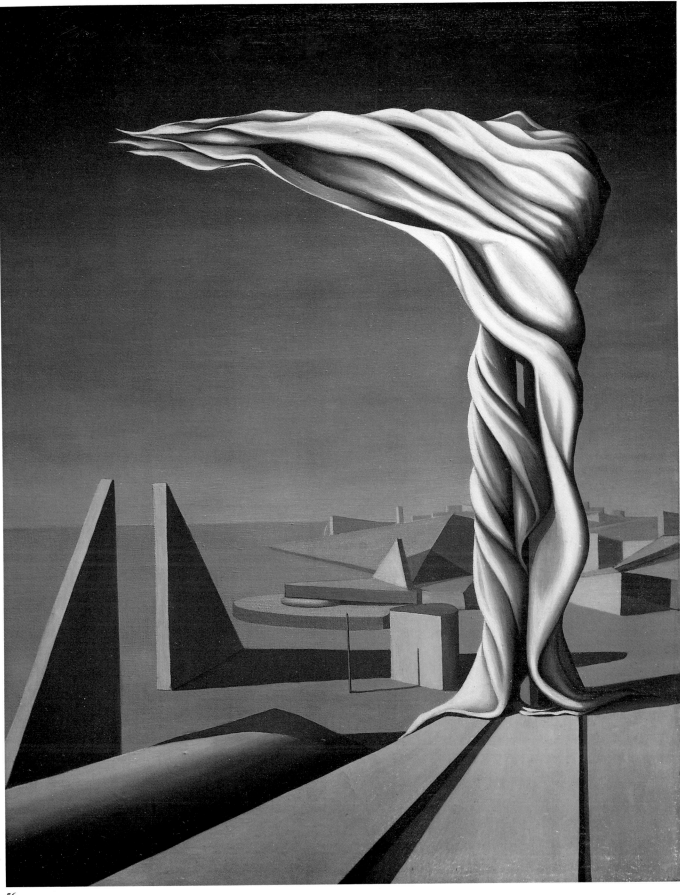

In the midst of turmoil and rapidly changing personal situations, many women forged new commitments to their art. In 1942, Peggy Guggenheim organized the first of two exhibitions of the work of women artists at her new gallery, Art of This Century. Duchamp had originally suggested the idea to her, and the organizing committee for an exhibition called 31 Women included Duchamp, Ernst, Breton, J. J. Sweeney, Ralph Putzel, and Jimmy Ernst. The work of Carrington, Fini, Kahlo, Hugo, Lamba, Oppenheim, Sage, and Tanning appeared, along with that of women as diverse as Louise Nevelson and Gypsy Rose Lee.

New York critics delighted in dismissing the exhibition, seeing it as still more of the frivolity they had come to expect from anything remotely connected to Surrealism. Henry McBride wrote that the women were better than the male Surrealists he had seen, but his remarks are not to be taken seriously as he went on to say: "This is logical now that one comes to think of it. Surrealism is about 70 percent hysterics, 20 percent literature, and 5 percent good painting and 5 percent is just saying 'boo' to the innocent public. There are, as we all know, plenty of men among the New York neurotics but we also know that there are still more women among them.... It is obvious that women ought to excel at Surrealism. At all events, they do."[19] The *Art Digest*'s critic continued in the same vein: "Now that women are becoming serious about Surrealism, there is no telling where it will all end. An example of them exposing their subconscious [*sic*] may be viewed with alarm at the Art of This Century headquarters during January." He went on to cite specific works by Tanning, Carrington, Hugo, Kahlo, and Fini.

Breton's anguish and despair over the loss of his wife and child did not enter his writings of these years; once again he turned to the mythical woman, waiting for love to release the passions of creativity. It is in his last major work, *Arcane 17*, written during the summer of 1944, that he turns his back on mature woman and reveals the *femme-enfant* as the source of creation. The book takes its title from the tarot card known as "the star," symbol of hope and resurrection, and recounts Breton's despair during the war years and his gradual progress toward a renewal of hope through the discovery of new love. The image of the *femme-enfant* is now associated with Breton's new love, Elisa, even though when they met she was a widow still grieving over the loss of her adolescent daughter and only child. He categorically affirms his choice of the *femme-enfant*, "not to oppose her to other women, but because she is the only one in whom resides the state of absolute transparency of vision...." He identifies her with the legendary Melusine, half woman, half fairy, an image intimately connected to the depths of the unconscious, to the universe of fables, to the nature of the imaginary:

> Melusine ... her belly is the whole harvest of August, her torso springs like fireworks out of the curve of her waist, molded like two sparrow's wings, her breasts are ermines taken in the trap of their own cry, all the more blinding because they light themselves with the ardent coal of their shrieking mouths. And her arms are the soul of brooks that sing and perfume. And, under the collapse of her tarnished golden hair, all the distinctive features of the child-woman are forever assembled.

Invoking Hegel and Goethe, Breton places the *femme-enfant* into a larger dialectic, that of male and female spheres of dominion. Goethe, in Faust, writes of the dread of the mysterious mothers, who belong to an ancient world of matriarchal organization now banned from the light of day, from consciousness. In a 1942 article on Tanguy, Breton had called on Goethe's mothers, suggesting that "painting and poetry, each in its own sphere, had inevitably to make an attempt one day to rediscover the path leading to the Mothers in the very deepest depths."

The description of a social organization based on the principles of equality, respect for human life, and the power of love advanced one alternative to the deeply entrenched patriarchal social and political order that had shaped the Surrealist revolt. Freud and Marx offered new political and psychological models; it remained for the Surrealists to formulate a new model for creative life.

For Breton, the female principle governed creation. His insistence that painting and poetry must belong to the "inner gods" forced man to find a way to participate fully in this inner, more fecund realm of being. In *Arcane 17*, he finally defines the artist as the unifying force in the male/female polarity. *Arcane 17* is his final synthesis, a mystical and alchemical homage to the redeeming power of love and the final reconciliation of opposites. Combining the themes of love, war, and resurrection, he drew his analogies from myth, science, and the occult. Finally it is the artist (the male artist) who will affect the synthesis, because he alone has access to both realms of being:

> The time will come when the ideas of woman will be asserted at the expense of those of man, the failure of which is already today tumultuously evident. Specifically, it rests with the artist to make visible everything that is part of the feminine, as opposed to the masculine, system of the world. It is the artist who must rely exclusively on the woman's powers to exalt, or better still, to jealously appropriate to himself everything that distinguishes woman from man with respect to their styles of appreciation and volition.

But it is the *idea* of woman that will prevail, not the real woman. "The *femme-enfant*," declared Peret, "arouses the love of the totally virile man because she completes him trait for trait. This love reveals her to herself while projecting her into a marvelous world.... She waited for love as for blossoming the sun and she welcomes it in the present, but more sumptuous than she had dreamed it. She wears sublime love ... but it is necessary that it be revealed to her."[20]

Fueling the male imagination by projecting it onto woman, Breton and Peret turn her into an abstract principle, a universal and an ideal. Passive and compliant, she waits for the world to be revealed to her. What they give us, finally, is not a role for woman independent of man, even as they acknowledge her power and her proximity to the sources of creativity, but a new image of the couple in which woman completes man, is brought to life by him, and, in turn, inspires him. The role of the woman artist as a creator in her own right can be sought only in her works.

2 | *The Muse as Artist*

I didn't have time to be anyone's muse ... I was too busy rebelling against my family and learning to be an artist.

LEONORA CARRINGTON, 1983

Surrealism's idealized vision of woman was like an albatross around the neck of the woman artist, difficult to ignore but of no help in forging a personal identity as an artist. The muse, an externalized source of creative energy and a personification of the female Other, is a peculiarly male invention. Asked how they felt about the Surrealist identification of woman and muse, Leonora Carrington responded with a single word, "bullshit," and Ithell Colquhoun commented that "Breton's vision of the 'free and adored woman' didn't always prove a practical help for women, especially painters." These insights came later, almost fifty years after the publication of the first Surrealist Manifesto, but they help us understand one reason why so many women artists have argued that they weren't really Surrealists. Frida Kahlo often said that Breton and his circle "thought I was a Surrealist, but I wasn't. I never painted dreams. I painted my own reality."[1] Léonor Fini refused to join the Surrealist group officially, although she exhibited with the group during the 1930s and early 1940s, and has steadfastly maintained that she was never a Surrealist. She has also argued that although Carrington was a revolutionary, "a true revolutionary," she was never a Surrealist.[2]

Surrealism sought to make the whole psychosexual field of human experience available to the artist. "Everything leads me to believe," Breton wrote in 1929 in an often-quoted passage in the second Surrealist Manifesto, "that there exists a certain point in the human mind at which life and death, the real and the imaginary, the past and the future, the communicable and the incommunicable, the high and the low cease being perceived as contradictions." In one sense, all Surrealist paintings are self-portraits, their sources internal rather than external, their imagery indistinguishable from the structure and functioning of their creators' minds, their goal self-knowledge, but very few of those by male artists contain recognizable self-images. The exception is Dali who focused attention on his own image, consciously cultivating narcissism as an aberrant mental state, there to be mined for its rich imagery, and then dropped. "The only difference between myself and a madman is that I am not mad," he was fond of remarking. Other painters created alter egos, like Ernst's Loplop, the Superior of the Birds, and Magritte's bowler-hatted figure. Among women artists there is a persistent anchoring of their imagery in recognizable depictions of the artist, even when the subject of the work is not the self-portrait per se. Paintings by Fini executed during the 1930s often include, among the characters that inhabit their theatrical spaces and oversee their mysterious rituals, women in whose dark catlike eyes and sensuous mouths we recognize the artist herself. Those by Varo include over and over again the delicate heart-shaped face with the long sharp nose and thick mane of hair that marked her own identity. Kahlo made her dark almond-shaped eyes and bird-winged brows a hallmark of her art. The consistency with which women artists anchored their imagery in representations of the self suggests that one might well begin with a closer examination of the self-portrait in order to better understand the sources of

80, 81, 82

66

their imagery and the particular role that Surrealism played, or didn't play, in shaping their self-images as artists.

Surrealism offered many women their first glimpse of a world in which creative activity and liberation from family-imposed social expectations might coexist, one in which rebellion was viewed as a virtue, imagination as the passport to a more liberated life. Leonora Carrington's background and life typify in many ways those of other women associated with the Surrealists and her personal rebellion began long before she met the group in 1937. She was, in effect, a kind of embodiment of all that the movement held dear in its women: young, beautiful, vivacious, uninhibited, and in possession of an imagination that knew no limits. From the beginning, her revolution was an individual one, having nothing to do with either Marx or Freud, a direct frontal assault not on the family as an institution, but on one particular family, hers, who were leading lives of Catholic piety and capitalist gain in a remote corner of Lancashire where her father was a wealthy and eccentric textile manufacturer and her mother the daughter of an Irish country doctor.

She was educated by governesses, tutors, and convent schools. A series of expulsions from school for rebellious behavior and a habit of writing backward in mirror script served to fuel her implacable adolescent loathing of Church and family. A family friend recalls that at age fourteen, introduced to the local priest, she scandalized the assembled company by pulling up her dress (she was wearing nothing underneath) and demanding, "Well, what do you think of that?"[3]

The family sent the recalcitrant child to Miss Penrose's boarding school in Florence where she learned to paint, studying the Italian masters during class trips to Rome and Siena, copying the style of the Italian *quattrocento* at the Uffizi in Florence. Her stay in Florence, and some months spent living with a family in Paris, gave Carrington her first taste of freedom, but back in England her parents planned her debut into society. Under protest, she allowed herself to be presented at the Court of King George V, but, trapped in the Royal Enclosure at Ascot, she escaped into a book and sat reading Aldous Huxley. Her decision to become an artist met with stiff family opposition, but she was finally allowed to go to London to study with Amedée Ozenfant. The first exercise involved an apple, a piece of paper, and a hard pencil; Carrington's fellow student and friend Ursula Goldfinger remembers that her painting soon revealed qualities distinctly at odds with the strict formal geometry taught by Ozenfant.

Carrington inherited, and reveled in, the spirit of revolt that carried over from the 1920s. Staying in the family suite at an exclusive London hotel, she and a friend delighted in their own version of *épater le bourgeoisie* by loudly discussing invented syphilitic symptoms as they made their way through groups of well-dressed matrons assembled in the lobby for afternoon tea. She left behind her own image of female youth in revolt, a portrait of her friend Joan Powell, painted a year or two before her first encounter with Surrealism in 1937, and owing more to the previous decade's vision of the urban *demi-monde* than to Breton's Elect Woman. In many ways it incarnates precisely that image of woman—worldly, independent, tough—against which he himself rebelled during the 1920s, and which he replaced with a more ethereal and clairvoyant vision.

58

57 Leonora Carrington at St. Martin d'Ardèche in the summer of 1939

58 Leonora Carrington, *Portrait of Joan Powell, c.* 1936

The portrait is as much fantasy as reality. The youthful clumsiness of the paint handling contributes an Expressionist air completely in keeping with the subject, a young woman standing in front of a blank brick wall. The blonde hair that escapes from her beret is bluntly cut, her print dress buttoned up to the neck. But the half-closed and heavily lidded eyes, the cigarette that droops from the corner of her mouth, and the long, talonlike hands evoke an image of sultry rebellion as surely as does the copy of Jean Cocteau's *Les Enfants Terribles* that she holds. The novel, published in 1930, was immediately adopted by a generation of adolescents as a kind of handbook for alienated youth; it provided Carrington with a talisman, an emblem of revolt both literary and bohemian. The painting's smoky palette and scabrous surface, and the masklike rigidity and exaggerated features of the face, only intensify its demonic quality.

Other women, though outwardly less insurgent than Carrington, shared her struggle for independence, a struggle that predated their encounters with

Surrealism. Oppenheim left school to become an artist, but Fini and Miller were both expelled from more than one educational institution; Varo and Agar sought escape in brief early marriages. The latter, believing it was her destiny to be an artist, also turned to the self-portrait while searching for an artistic identity; in *Self-Portrait* (1927), she hides her doubts behind a façade of determined self-composure. Agar entered the Slade School of Art in 1925 on the advice of a family friend whose prominent social position tipped the balance with her reluctant parents. Part of the University of London, the Slade was at the time filled with the children of prosperous English families, many of whom would go on to distinguished careers in the arts and architecture. Agar's parents set one condition: that the family Rolls Royce deliver their daughter to class each morning and pick her up in the afternoon. She soon began asking the chauffeur to drop her off around the corner, out of sight of her classmates. When conflicts with the family over her new life-style intensified, she ran away from home and found two small rooms in the Royal Hospital Road in Chelsea for one pound a week. Her parents retaliated by cutting off her dress allowance; she resorted to a small sum of money inherited from an uncle and set up a tiny studio in Chelsea. Running away from home proved to be the easy part of the odyssey; more difficult by far was the challenge of what and how to paint. Her cramped quarters offered few possibilities for artistic growth, and she soon took one of the few paths open to a young woman of her day, marriage to a classmate from the Slade and a move to the country where both could live more cheaply and work undisturbed. Her self-portrait, executed shortly before she left on her first trip to Paris in 1927, relies on contour line and palette knife for its strength. The face is firmly drawn, the features exaggerated, the carriage erect. With no firm place in the world and no clear image of life as an artist, the painter interrogates her own image, as if the mirror could provide the answers that the outside world does not. She rejects Carrington's choice of an invented persona and instead opts for a definition of self stripped of fantasy and pretense.

Although she spent time in Paris in 1927 where she saw her first Surrealist painting in a Left Bank gallery and met Eluard and other poets, Agar was a Surrealist "discovery." In 1936, Roland Penrose, who had heard about her work from Eluard but had not seen her one previous exhibition at a Bloomsbury Gallery in 1933, visited her studio with Herbert Read. The two were looking for work for the 1936 international exhibition in London; as Penrose remembers it, "Both of us were at once enchanted by the rare quality of her talent, the product of a highly sensitive imagination and feminine clairvoyance."[4] She exhibited three paintings and five objects and, as the only woman painter who was both English and a professional, became a celebrity almost overnight. Her work was illustrated in the *London Bulletin*, and later that same year she was selected as one of two English artists whose work was to be reproduced in the catalogue for the New York exhibition Fantastic Art, Dada, Surrealism. Belonging to the Surrealist milieu made it easier for a woman to be an artist and have her work shown and discussed; but, as with Oppenheim, recognition was followed by a period of self-doubt and confusion about how to proceed. The outbreak of war a few years later brought her career to a temporary standstill.

81

69

59

INTERNALIZING THE MUSE

The idealized vision of woman as muse was no help to the young women who came to Surrealism during the 1930s seeking an artistic identity in the movement. Rejecting the idea of the Muse as Other, they turned instead to their own images and their own realities as sources for their art. Even when the subject of the work is not the self-portrait per se there is a persistent anchoring of the imagery in recognizable depiction of the artist.

59 Rita Kernn-Larsen, *Self-Portrait (Know Yourself)*, 1937
60 Valentine Hugo, *Dream of 21 December 1929*, 1929
61 Remedios Varo, *Títeres Vegetales (Vegetarian Puppets)*, 1938

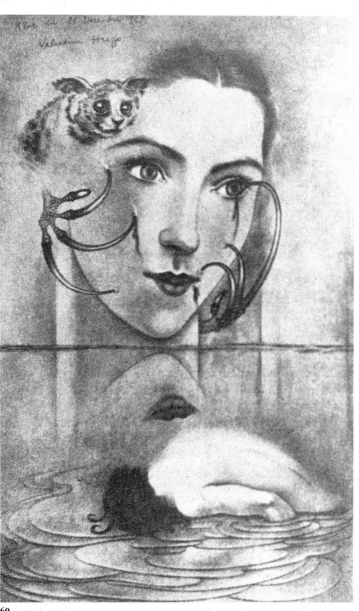

60

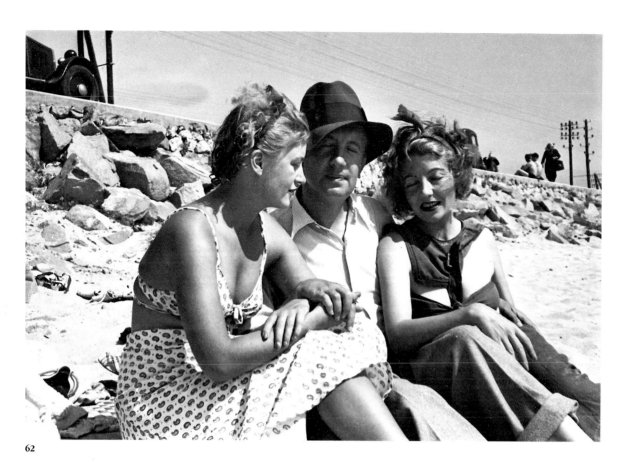

62

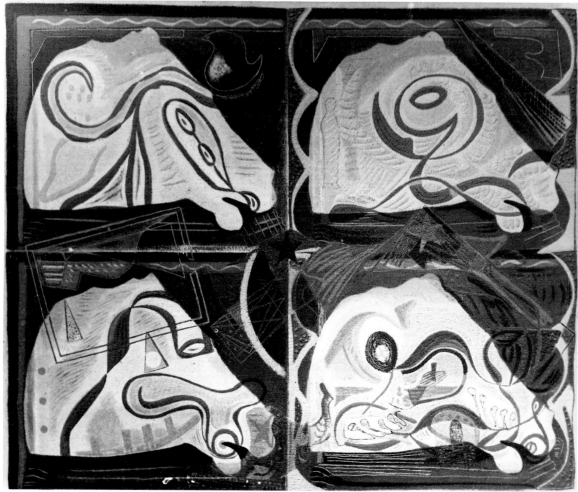

63

EILEEN AGAR

As the only professional woman painter in the 1936 international Surrealist exhibition in London who was also English, Agar quickly became a celebrity. Recognition also brought self-doubts and in later years she would regret that her lack of experience at the time made withstanding the effects of sudden success difficult. Agar's visits to the coastal towns of Dorset, Brittany, and southern France during the 1930s led to her first photographs and marine objects.

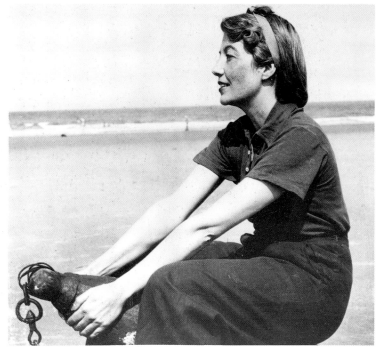

64

62 Lee Miller, Paul Eluard, and Eileen Agar at Antibes, 1937
63 Eileen Agar, *Quadriga*, 1936
64 Eileen Agar on the beach, 1939
65 Lee Miller, collage of Eileen Agar, 1937

The image of the *femme-enfant*, that volatile mix of sexual awareness and childlike ingenuousness that fired the Surrealist imagination, plagued attempts by women artists to achieve artistic maturity. Grace, charm, and a lively imagination insured artistic success within the Surrealist circle; these characteristics were of little help in building reputations outside. Alienated from Surrealist theorizing about women and from the search for a magical Other, women artists turned to their own reality. Their many self-portraits reveal their rejection of the idea of woman as an abstract principle, and a substitution of the image in the mirror as a focal point in their quest for greater self-awareness and knowledge. However fantastic their imagery, it remains firmly rooted in their experience of their own bodies and in their acceptance of their own psychic reality. Rita Kernn-Larsen's 1937 self-portrait, tellingly titled *Know Yourself*, develops its automatic line from the artist's own features; of her *Spejlets Revers* (1936) the artist has written that "it was surely related to myself descending into the unknown behind the mirror/ looking-glass inspired by Lewis Carroll's *Alice*."[5]

59
145

As an image of the Surrealist woman, the *femme-enfant* carried yet another liability for the woman artist: the element of instability, often bordering on madness, that was as much a part of her image as was her naiveté. The very childlike qualities that gave the *femme-enfant* her air of innocence and easy access to her own unconscious provided few mechanisms for mature development as an artist. Dali insisted that, despite his often aberrant behavior, he was not mad; Breton and Eluard asserted that the pathological mental states adopted in the writing of *The Immaculate Conception* (1930) were simulations, but the *femme-enfant* was allowed no such distance from her unconscious. Adopting madness as a creative pose for men and viewing it as a subject for scientific and poetic inquiry when it occurs in women (as Breton does in *Nadja* and in his writings on hysteria) renders simulated madness a source of man's creativity, real madness a source of woman's. The man's is active, the woman's passive, powerless, and at the mercy of the unconscious.

The woman artist with the most direct experience of this dichotomy was Leonora Carrington. Carrington's mother gave her a copy of Herbert Read's *Surrealism* shortly after it was published in 1936, believing that the young art student would find it of interest. A reproduction of Max Ernst's *Two Children Menaced by a Nightingale* (1924) proved a revelation; the following year she met Ernst at a party in London on the occasion of the opening of his exhibition at the Mayor Gallery. The two returned to Paris together and Ernst quickly separated from Marie-Berthe Aurenche. Carrington has spoken of her anger at Surrealist attitudes toward madness, seeing in them misplaced humor and pretense very much at odds with the anguish and pain that accompany any loss of psychological connection with the external world.[6] A series of paintings and writings executed at the end of the 1930s reveal her passage from an art fueled by the imaginative world of childhood through an encounter with madness during which she was institutionalized in a clinic in Santander, Spain, to the artistic maturity of the work produced in Mexico during the 1940s. Once again it is the image of the self that focuses the quest for knowledge.

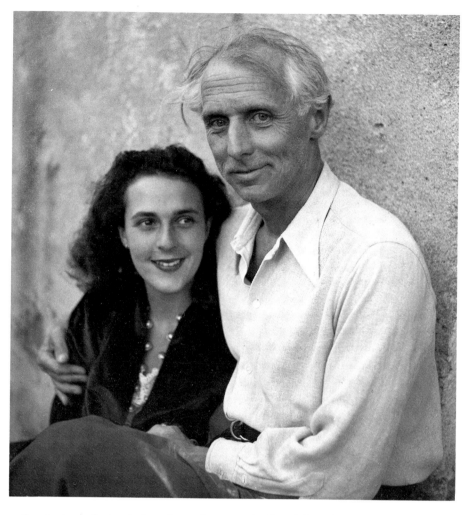

66 Leonora Carrington and Max Ernst at St. Martin d'Ardèche in the summer of 1939

Carrington's first paintings from the period of her life with Ernst contain themes and images that were drawn from childhood and often, as in *Lord Candlestick's Meal* and *The Horses of Lord Candlestick* (both 1938), presented as whimsical satires on the manners and morals of upper-class English society. Filled with animals and birds, they spin a web of mystery and fantasy in an illusionistic space borrowed from Chirico and from the early Ernst. But they replace the exaggerated perspective that lends the Italian painter's landscapes and still-lifes their vertiginous dreamlike quality with shallower enclosures that owe much to Italian wall painting, though on a miniature scale. Fairy tales and bible stories filled Carrington's childhood; their influence gives her paintings an air of gentle narrative and she herself has characterized her sensibility as caught between Catholic and Celtic.

Carrington's life with Ernst strengthened both their associations with nature. At St. Martin d'Ardèche, where they moved in part to escape the jealous surveillance of Marie-Berthe, they renovated a group of ruined buildings, covering the walls with cement casts of birds and mythical animals. Carrington's paintings of this period reveal a growing vocabulary of magical animals, at the center of which lies the image of the white horse.

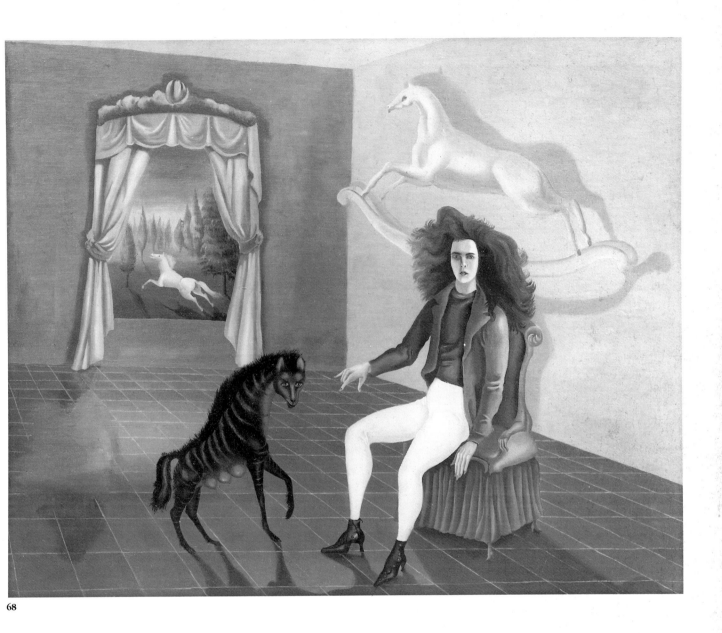

LEONORA CARRINGTON

The British writer and painter Carrington met Max Ernst in London in 1937. He left his wife for Carrington, his "Bride of the Wind." The couple lived together at St. Martin d'Ardèche until the outbreak of World War II and Ernst's internment as an enemy alien. Institutionalized following a breakdown in 1940, Carrington later fled to New York and Mexico where she developed a close and productive friendship with Varo.

Carrington's work during this period moves from themes of childhood, filled with magical birds and animals, to a mature art based on Celtic mythology and alchemical transformation. It is an art of sensibility rather than hallucination, one in which animal guides lead the way out of a world of men who don't know magic, fear the night, and have no mental powers except intellect.

67 Leonora Carrington, St. Martin d'Ardèche, in 1939, photographed by Lee Miller
68 Leonora Carrington, *Self-Portrait*, c. 1938

Although previously widely dated between 1937 and 1940, two paintings, *Self-Portrait* and *Portrait of Max Ernst*, should be regarded as companion pieces. Both were probably executed in late 1938 or early 1939, and both offer evidence of Carrington's early interest in the alchemical transformation of matter and spirit. She read her first books on alchemy while an art student at Ozenfant's academy, discovering them in used bookstalls around London. (Ernst's work of the 1930s reveals his deep interest in the occult tradition first discussed at length by Breton in the second Surrealist Manifesto of 1929.) In *Self-Portrait*, the artist depicts herself perching uncomfortably on the edge of a rather fussy Victorian chair in a room otherwise devoid of furniture. Animals surround the figure: a white rocking horse floats in the air behind the young woman, another horse gallops into a landscape outside the open window, and a small hyena, possessed of an almost human expression and three pendulous breasts, warily approaches the chair. Behind the hyena, a patch of ectoplasm indicates the animal's sudden materialization. The artist's eyes burn with intensity, her thick dark hair springs from her head like a horse's mane. The line between human and animal, the animate and the inanimate, is blurred; the shadows cast by the chair, the seated figure, and the hyena's body merge into a single form, the chair's carved arms and legs parody those of the young woman.

The images of the horse and the hyena had powerful personal associations for Carrington and would reappear in a number of later stories and paintings. The hyena makes its first appearance in an early short story titled "The Debutante," included in Breton's *Anthology of Black Humour*, published in 1940. In the story, a hyena at the zoo befriends an unhappy young woman who is seeking escape from the ball her mother has planned in her honor. The hyena, masquerading in the debutante's ball gown and the sewing maid's face (after eating the sewing maid to disguise the evidence of the face's theft) and emitting a distinctly undebutantelike odor, takes her place at the dinner table. Upstairs, the young woman reads *Gulliver's Travels* to pass the time and escape the clamor emanating from below where the hyena, insulted by a guest who has complained about the odor, has taken off its face and eaten it in full view of the assembled company before disappearing through the open window.

In the painting, Carrington places herself between the lactating hyena, a nocturnal animal belonging to the fecund world of the dream, and the white rocking horse, which remained for many years her most powerful and most personal image. As a lonely child, she had cultivated an imaginary relationship with a rocking horse that stood in a corner of the Crookhey Hall nursery; the image reappears in many later paintings and in a play titled *Penelope*, written in 1946 and first performed in Mexico in 1957. In the play, the young heroine falls in love with her hobbyhorse, Tartar (named after Tartarus, the underworld of ancient Greek mythology), and rebels against the authoritarian rule of her father who has prohibited her imaginative play with Tartar. She escapes from this feeble and bad race of men who don't know magic, fear the night, and have no powers, by becoming a white colt and flying off into an other-worldly realm, a world in which the imagination neutralizes the male enemies of magic.

The source of Carrington's magical white horse lies not in Freud's use of the horse as a symbol of male power but in the Celtic legends that nourished her childhood and that she first heard from her Irish mother (who was related to the early-nineteenth-century writer Maria Edgeworth). The horse is sacred to the ancient tribe of the Tuatha de Danaan, many references to which occur in Carrington's later work, because it is faster than the wind and can fly through the air. The horse-headed sticks or "hobbyhorses" ridden by contemporary Morris dancers are a relic of Celtic horse worship, the cockhorse ridden to Banbury Cross to see the goddess make her ritual ride as Lady Godiva. Similar horse-headed sticks appear in the rituals of central Asian shamans, for the horse enables the shaman to fly through the air and reach the heavens. The Celtic Queen of Horses, the goddess who appears in the Welsh *Saga of Rhiannon* riding a pale white horse, is the goddess of the other world, and her horse travels through the space of night as an image of death and rebirth.

Carrington's first published short story, "The House of Fear," written in 1937, contained an introduction and collages by Ernst. It introduces the horse as a psychic guide, a friendly animal who conducts the young heroine into a world marked by mysterious ceremonies and rituals of transformation presided over by the figure of Fear herself. In his introduction to the first edition, Ernst presents Carrington as "The Bride of the Wind," an image that originated in a series of frottages and paintings of the late 1920s that contain a leaping stallion. His own totem, the Bird Superior Loplop, which originated in the gallop-gallop of his son Jimmy's childhood rocking horse, is charged with banishing the figure of Fear. "Who is the Bride of the Wind?" Ernst inquires. "Does she know how to read? How to write French without errors...?" It is clear that he is speaking here of Carrington, for he continues: "She is warmed by her intense life, by her mystery, by her poetry. She has read nothing, but she had drunk everything. She does not know how to read. Meanwhile the nightingale has seen her, seated on the stone of Spring ... animals gathered around ... she is reading 'The House of Fear.'"

Carrington's animals identify the instinctual life with the forces of nature. The hyena belongs to the fertile world of night; the horse becomes an image of rebirth into the light of day and the world beyond the looking glass. As symbolic intermediaries between the unconscious and the natural world, they replace male Surrealists' reliance on the image of woman as the mediating link between man and the "marvelous," and suggest the powerful role played by Nature as a source of creative power for the woman artist (a subject discussed more fully in Chapter 4). Carrington also suggests a redefinition of the image of the *femme-enfant* from that of innocence, seduction, and dependence on man, to a being who through her intimate relationship with the childhood worlds of fantasy and magic is capable of creative transformation through mental rather than sexual power.

It was the birdman Loplop who liberated the heroine from Fear in "The House of Fear" for, as Ernst wrote in his introduction to the work, "he has no fear." In her *Portrait of Max Ernst*, it is Ernst, dressed in striped socks and the violet fur coat of the shaman and striding across a frozen wasteland, who will release the white horse that appears, as described in "The House of Fear," sitting on its haunches

with icicles dripping from its chin. In his lantern, instead of a bulb, is another horse, Carrington's magical animal of transformation.

Carrington and Ernst remained together at St. Martin d'Ardèche until 1940. Despite increasing rumors of war, the summer of 1939 was an active one. While Ernst worked on a large painting that he somewhat nostalgically titled *A Moment of Calm*, Carrington wrote and painted in a small upstairs bedroom. When not working, she cooked, tended her vineyards and garden, and took care of the birds and small animals that nested in the crumbling walls of the house and studio. For much of the summer guests overflowed the small house. Roland Penrose and Lee Miller arrived for a few days in June on their way to Antibes. Peggy Guggenheim came to visit and left with Carrington's painting *The Horses of Lord Candlestick*. Later history no doubt colored her view of Carrington as a disciple "seated at the feet of Ernst," but she also remembered Carrington showing her paintings filled with birds and animals. Léonor Fini came in the company of the writers André Pieyre de Mandiargues and Federico Veneziano and spent much of the summer. Fini began a portrait of Carrington and the two women talked for many hours during the sittings, but she abandoned the project when Carrington's attempt to mediate an unpleasant visit by Tristan Tzara angered her.

Fini and Carrington had become friends shortly after Carrington's arrival in France; the former's earlier liaison with Ernst did nothing to dim their affection and admiration for one another. Fini's early development took place entirely outside the Surrealist milieu and although her paintings of the 1930s reflect Surrealism's mingling of reality, dream, and fantasy and she exhibited with the group beginning in 1936, her associations with Surrealism remained social rather than formal.

Born in Buenos Aires of mixed Spanish, Italian, Argentine, and Slavic blood, Fini was raised in Trieste where she absorbed the multiethnic and mixed cultural heritage of that cosmopolitan center. If her formal education ended when she was an adolescent, she nevertheless traveled widely in Italy, visited almost all the museums of Europe, and read voraciously in her uncle's large library in Milan. As a young woman she exhibited her paintings in Trieste and Milan, received several commissions for portraits, and formed close friendships with several members of the group 900 Italiano. She was soon at the center of a group of Italian writers and painters who admired her talent, her beauty, and her flamboyant life-style. In Paris, she became a legend almost overnight. When one of the Surrealists saw a painting of hers in a Paris gallery in 1936 and sought out its creator, she arranged a rendezvous in a local café and arrived dressed in a cardinal's scarlet robes, which she had purchased in a clothing store specializing in clerical vestments. "I liked the sacrilegious nature of dressing as a priest," she later explained, "and the experience of being a woman and wearing the clothes of a man who would never know a woman's body."[7] With this theatrical gesture of defiance, Fini placed herself in the vanguard of Surrealist attacks against the Church such as Peret's habit of following priests through the streets of Paris and hurling insults at them. It also signaled the beginning of Fini's lifelong refusal to countenance the separation of male and female spheres of influence.

There was about Fini nothing of the *femme-enfant*; for her part, she categorically refused to submit to Breton's authority, or to participate in what she considered foolish Surrealist group activities. Tall and commanding, with jet black hair and eyes with pupils dilated like those of the cats she kept with her constantly, she lived with passion and defiance. Ernst was first drawn to her by her "Italian *fury*, scandalous elegance, caprice and passion"; Eluard dedicated a poem to her in his *Donner à Voir* of 1938. Julien Levy, the New York art dealer who organized her first exhibition there in 1937, later described his first meeting with her at her apartment in the Quartier St. Paul, where she lived in a building that had gone from palace to near ruin in a neighborhood favored by artists because of the low rents. He found the apartment on the third floor and knocked:

> Léonor was in the doorway. To illuminate her features a torch was held by a black, a black man of wood.... I dared, for an instant, to eye her fully. Her hair stood about her face like a blue mane.... Not a beautiful woman; her parts did not fit well together; head of a lioness, mind of a man, bust of a woman, torso of a child, grace of an angel and discourse of the devil. While her eyes were her most arresting feature, large and deep black, her allure was an ability to dominate her misfitted parts so that they merged into whatever shape her fantasy wished to present from one moment to the next.... She was dressed in rags, or rather a gorgeous robe deliberately torn.[8]

Fini first exhibited her work with the Surrealists in the London exhibition of 1936; during the next two years she developed close personal friendships with Ernst, Nusch and Paul Eluard, Brauner, Dali, and other members of the group. But her powerful individuality remained opposed to Surrealism's emphasis on shared and collective goals, her theatricality and love of sexual experimentation offended the puritanical Breton, and Nicolas Calas recalls rivalry between Lamba and Fini that must surely have drawn Breton into a defense of his wife.[9] As she was already familiar with the writings of Novalis, Freud, and the German Romantics when she arrived in Paris, Surrealism opened few intellectual doors for her. Her relationship with Surrealism, though she shared many of that movement's interests and attitudes—and her work clearly reflects these affinities—stands in direct contrast to those of other women who were more easily intimidated by the charismatic Breton and his intellectual companions. A *Self-Portrait* painted a few years later in 1942 or 1943, based on Mannerist conventions and containing familiar sixteenth-century exaggerations of form, aptly conveys its author's determination and sense of purpose. The pulling of the gown off the shoulders serves less to eroticize the image than to emphasize the dramatic contrast between the creamy skin and the heavy blue-black necklace that sets off the head.

The summer of 1939 was to be the last happy summer, indeed the last summer for Carrington and Ernst. Friends who visited St. Martin d'Ardèche that summer recall swimming expeditions, group games, and on one occasion a group visit to the local market to purchase a large live bird that was later discovered in the bed of an unwelcome guest. The same guest received an omelette containing several locks of Carrington's long dark hair.

CARRINGTON AND FINI

*Léonor Fini moved from Italy to Paris in 1936, but although she
formed close personal friendships with many Surrealists and
periodically exhibited with the group, her dislike of the
authoritarian Breton prevented her from joining the movement.
Carrington and Fini spent part of the summer of 1939 together
at St. Martin d'Ardèche. A close friendship developed between the
two women and Fini later included a full-length portrait of
Carrington in her painting* The Alcove: An Interior With Three
Women. *In it she reveals Carrington as a woman warrior, "a
true revolutionary," autonomous and released from the image
of femininity created by man.*

69 Leonora Carrington, Léonor Fini, and friends, St. Martin
d'Ardèche, 1939
70 Léonor Fini, *Female Nude*, 1947
71 Léonor Fini in 1947
72 Léonor Fini, *The Alcove: An Interior With Three Women*,
c. 1939

69

70

71

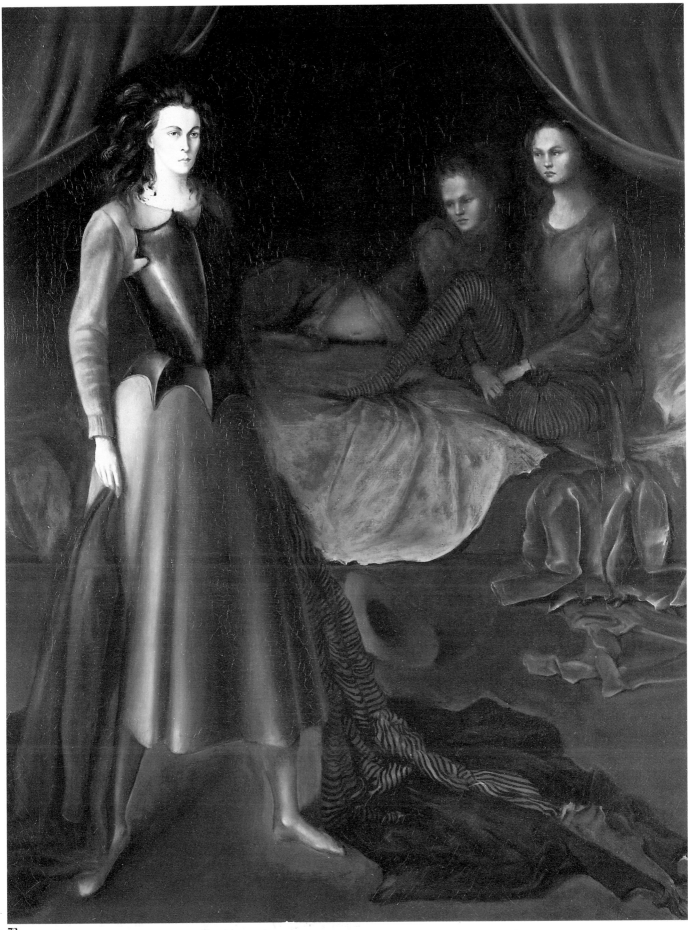

Down Below, published in New York in 1944, contains Carrington's account of her experiences during the next months, her mental breakdown, the harrowing story of the collapse of her world and her self:

> I begin therefore with the moment when Max was taken away to a concentration camp.... I wept for several hours, down in the village; then I went up again to my house where, for twenty-four hours, I indulged in voluntary vomitings induced by drinking orange blossom water and interrupted by a short nap. I hoped that my sorrow would be allayed by those violent spasms which tore my stomach apart like so many earthquakes.... I had realized the injustice of society.... My stomach was the seat of that society, but also the place in which I was united with all the elements of the earth. It was ... the *mirror* of the earth, the reflection of which is just as real as the person reflected.

For three weeks she alternately fasted and engaged in intense physical labor in her vineyards as an act of purification. Her responses at the time were those of a person weakened by physical deprivation, emotionally shocked by the collapse of a known and familiar world, and unfortunately influenced by an old friend who arrived in St. Martin d'Ardèche fleeing from Paris and who convinced Carrington that her behavior betrayed unconscious desires to rid herself of her father in the person of Ernst and that she should also flee. Fini remembers that Carrington's relations with the people of St. Martin d'Ardèche had been strained ever since she and Ernst had arrived in the village. The villagers disliked and distrusted the young Englishwoman and, when German troops occupied the village in 1940, began telling stories to the Germans to try to force her out. Confused by these events and convinced that she must flee or face certain arrest, Carrington sold the house for a bottle of brandy to the cousin of a German officer and fled to Spain with her friends, hoping to procure a visa for Ernst in Madrid. The trip became a nightmare of paralyzing anxiety and growing delusions. The final breakdown came in Madrid where she was discovered at the British embassy threatening to murder Hitler and calling for the metaphysical liberation of mankind. Institutionalized on the intervention of her family in England, she was given cardiazol, a powerful shock-inducing drug. "Have you any idea now of what the Great Epileptic Ailment is like?" she wrote in *Down Below*. "I learned later that my condition had lasted for ten minutes; I was convulsed, pitiably hideous, I grimaced and my grimaces were repeated all over my body."

Recollections of her confinement are filled with images of pain and violence: "... they tore my clothes off brutally and strapped me naked to the bed accompanied by intense pain and vivid hallucinations." She was released into the care of a nurse who accompanied her to Lisbon where her family had arranged her passage to England or South Africa in the care of a former nanny. After a ride on the funicular to a hilltop tearoom with the nanny, Carrington escaped through a back door and fled to the Mexican consulate where Renato LeDuc, a Mexican diplomat whom she had met in Paris through Picasso, arranged her refuge. She later married LeDuc as part of the arrangement that made possible her passage to New York.

The account of her breakdown published three years later tells the story of a psychic quest for autonomy in the language of the alchemist's journey to self-knowledge. Drawing heavily on the symbolism of the alchemical laboratory, she attempts to structure her understanding of psychic reality using the language of alchemical lore. Carrington had never shared Surrealism's interest in Freud and the Freudian language of the dream and the unconscious; her earliest paintings rely on a magical realism based on autobiographical detail, legend, and personal symbolism. The use of the imagery of alchemy enabled her to break away from the autobiographical and to establish more profound connections between individual experience and cosmic unity. Most fully realized in the work produced in Mexico after 1944, her interest in alchemy and the occult tradition moved her later work in the direction of an increasingly mystical quest or journey.

The real journey out of St. Martin d'Ardèche and out of childhood was not yet ended. In a Lisbon market in 1940, Carrington met Ernst, now in the company of Peggy Guggenheim. She had had no word of him since leaving France and had feared that he had not survived his internment. In fact, released during the winter of 1940, he had returned to St. Martin to discover that Carrington had given up the house and left the country. It was Guggenheim who came to his rescue and arranged his passage to New York in 1941. She later recalled two months of dreadful complications in Lisbon as she, Ernst, and Carrington attempted to regain control over their lives. Carrington was melancholy and unhappy, weakened by her recent illness and devastated by the loss of Ernst; Guggenheim was determined not to give up her new love. The years at St. Martin d'Ardèche had ended forever, but the loss of the loved one, and the reverberations of these events, left an indelible mark on Carrington's work between 1940 and 1944.

Unlike Breton who transmuted the reality of thwarted love into visionary union, Carrington allowed its pain to inform her creative work in a barely disguised manner. She arrived in New York late in the summer of 1941. Her story titled "Waiting" was published later that year in *View* magazine. In "Waiting," there is a confrontation between two women whose attachment, one present, one past, is to the same man. "Do you fondly believe that the past dies?" a self-possessed blonde woman walking two dogs asks Margaret of the unfashionable clothes, untidy hair, and rhythmic pounding inside her head. "Yes," replies the latter, "if the present cuts its throat." As the story draws to an end, the blonde woman mocks Margaret with evidence of her love-making with Fernando and a powerful sense of loss overwhelms Margaret.

Carrington's first meeting with Ernst in New York occurred by chance at the Pierre Matisse gallery. The experience caused both of them deep unhappiness. "I don't recall ever again seeing such a strange mixture of desolation and euphoria in my father's face as when he returned from his first meeting with Leonora in New York," Ernst's son, Jimmy, later recorded. "One moment he was the man I remembered from Paris—alive, glowing, witty and at peace—and then I saw in his face the dreadful nightmare that so often comes with waking. Each day that he saw her, and it was often, ended the same way."[10] Ernst recorded Carrington's presence in many of his paintings of those years, including *Napoleon in the Desert* and

Europe After the Rain; she reunited the horse and the Bird Superior of "The House of Fear" in a story called "The Bird Superior Max Ernst," which she wrote in 1942 for a special number of *View* dedicated to Ernst. The setting is the alchemical laboratory; the scene unfolds in the subterranean kitchen of the Bird Superior who stirs a large cauldron. In an elegy of poetic violence, Fear appears in the form of a horse dressed in the furs of a hundred different animals, leaping into the kitchen, throwing up a shower of sparks under her hooves. The sparks turn into white bats and flit blindly around the room upsetting pots and tins. "The Bird Superior ties Fear to the flames of the fire by her tail and dips his feathered arms in the color.... The songs of the white bats and the eagles mix with the neighs of Fear who has the flames of the fire frozen to her tail...."

The story ends in the physical transformation of the Bird Superior who preens arms that have now become wings, unties Fear from the fire, and ties himself on her back with her mane; "they escape through the war winds which leap out of the pot like smoke, like hair, like wind." The presence of the horse and the alchemical language of transmutation provide stunning metaphors for the liberation of the imagination and the release of the spirit. Once again the Bird Superior is likened to the shaman who possesses magic powers.

These stories, published in New York and filled with true-life details, address the loss of love, a loss accepted and mourned in "Waiting," resolved metaphorically through fantasy and alchemical transmutation in "The Bird Superior Max Ernst." Filled with references to a young woman's psychic quest for autonomy, the stories present symbolic barriers to self-knowledge and indicate Carrington's search for the sources of poetic expression.

Carrington and Fini were not to see each other again after the summer of 1939. Fini spent the war years first in Arcachon, then in Cannes and Monte Carlo, arriving in Rome in 1942 on the day that Mussolini surrendered and the first Allied bombs fell on the city. During the war she executed a painting, titled *The Alcove: An Interior With Three Women*, which includes a full-length portrait of Carrington. The artist appears, dressed in an unadorned garment and metal breastplate, in a setting that owes much to the conventions of sixteenth-century Italian and Spanish portraiture. In the rear of the alcove, two female figures recline on a bed, their hands clasped, their gazes directed toward the standing figure. The only suggestion of masculine presence in the room is the abandoned and sexless clothing that lies on the floor. The painting recalls Mannerist portraits of male figures in battle dress, many of which commemorate battlefield victories. But here woman is the warrior. Defended and triumphant, she is presented as an image of power and autonomy.

Fini refused to accept a world defined by male institutions and she revolted by placing not just her own image at the center of her work, but images of other women as well. She turned her back on marriage to avoid submitting to an institution she found patriarchal, and she used painting as a vehicle for creating a world animated by woman's desires; "I always imagined that I would have a life very different from the one imagined for me, but I understood from a very early time that I would have to revolt in order to make that life," she said in an interview.[11] Although they are not dreams in a literal sense, her paintings follow the

72

path of the dream, as silent and immobile, as pregnant with meaning as the works of the Italian metaphysical painters that were among her first influences: "I do not say that my painting is dreams, no, I say that it has the *mechanism of the dream*. But painting involves objectification and is, thus, the opposite of the dream."[12] By placing woman at the center of these compositions, and making her experience of the world paramount, she asserts a female consciousness that has no need of manifestos, theories, or proselytizing.

Fini based her paintings on a combination of studiously perceived and meticulously rendered reality and an invented and theatrical space dominated by fantasy and inner life. In the painting of 1939 titled *Figures on a Terrace*, the image of Fini herself, dressed in a voluminous striped skirt and velvet jacket, reigns over the multifigure composition. In comparison, the male figure appears passive and pale. But Fini subverted the tendency to read the figures as abstract principles— dominant female, passive male—by basing the work on specific individuals drawn from life. The male figure is that of Alexandre Iolas, a dancer and acquaintance of Fini's who later became a well-known gallery owner in Paris. He appears here, resting and cloaked as if for warmth at the end of a performance, a representative of the theatrical world that has for years provided the essential metaphor for Fini's work. "Festivals," she says, "are a form of liberation." Inexplicable juxtapositions of objects are used here to evoke the spirit of a drama recently completed on an outdoor stage. Signs of confrontation—a sword, a woman's high-heeled shoe, discarded articles of clothing—surround figures that have withdrawn into a kind of reverie, at once somnolent and charged with erotic energy. Images of male and female sexual confrontation prevail, but the work's erotic air is diffused throughout the scene rather than centered in specific images; at no time does the female body become objectified as it so often does in the work of Delvaux, Masson, Magritte.

The same combination of artifice and instinct that governed Fini's world underlies the self-images of Frida Kahlo. Breton, enchanted with the idea of Mexico as "the Surrealist place *par excellence*," left for Mexico City with Jacqueline in April 1938 to deliver some lectures and to meet Trotsky, whom he had long admired. In Mexico, the couple stayed with Kahlo and Diego Rivera. Kahlo was known as the dramatic wife of the famous mural painter, as the young woman partially crippled and in constant pain from the streetcar accident that had left her with a crushed pelvis and a broken spine at fifteen, and as an artist who had made her life the source of her art.

Kahlo had anticipated Breton's arrival with excitement, but did not like him when they met. She found his theorizing pretentious and boring; his vanity and arrogance offended her. He, on the other hand, was entranced by her, and wrote:

> I have long admired the self-portrait by Frida Kahlo de Rivera that hangs on a wall of Trotsky's study. She had painted herself dressed in a robe of wings gilded with butterflies, and it is exactly in this guise that she draws aside the mental curtain. We are privileged to be present, as in the most glorious days of German Romanticism, at the entry of a young woman endowed with all the gifts of seduction, one accustomed to the company of men of genius.[13]

73

74

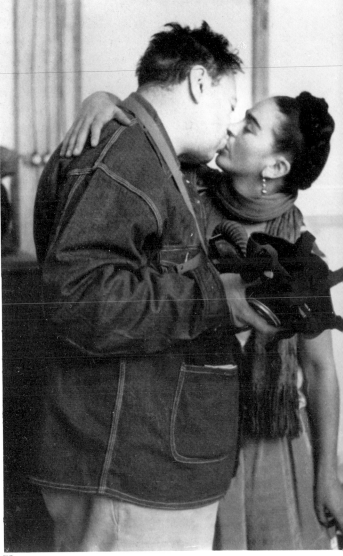

75

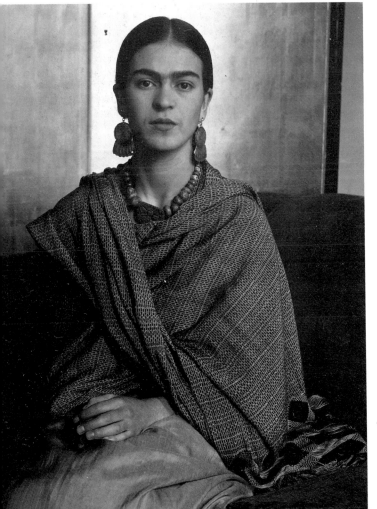

FRIDA KAHLO

Kahlo called herself a Realist who painted her own life. Much of her reality was bound up in the figure of Diego Rivera with whom she lived a rich and tempestuous life despite years of suffering brought on by an early accident. She was often photographed as an image of exotic beauty and the exquisite wife of Mexico's most famous painter; her own vision of herself was starker. In 1939 she was working on The Two Fridas *when she received final divorce papers from Rivera. The two Fridas— one loved, the other not—are joined by hearts that bleed over the loss of Rivera, included in a miniature photograph taken when he was a child and held by the Frida who wears a Tehuana skirt and blouse. In this portrait Rivera has disappeared from Kahlo's life; she is accompanied by herself and holds only mementos of their life together.*

73 Frida Kahlo in the mid-1930s, photographed by Manuel Alvarez Bravo
74 Frida Kahlo in 1931, photographed by Imogen Cunningham
75 Frida Kahlo and Diego Rivera around 1938
76 Frida Kahlo, *The Two Fridas*, 1939

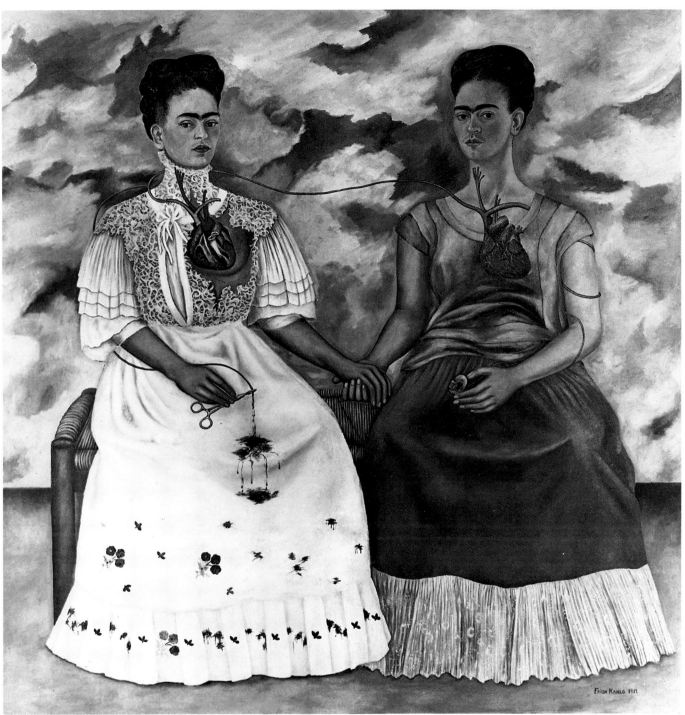

Breton also wrote a flattering introduction for the brochure that accompanied her New York debut at Julien Levy's gallery in 1938: "My surprise and joy were unbounded when I discovered on my arrival in Mexico, that her work had blossomed forth, in her latest paintings, into pure surreality, despite the fact that it had been conceived without any prior knowledge whatsoever of the ideas motivating the activities of my friends and myself."

These remarks, while genuine in feeling and in their acceptance of Surrealism as a state of mind and an attitude unbounded by spatial or temporal limitations, both flatter and patronize. Once again, the woman artist arrives intuitively at an ideological position created by man in her absence. Her work is devalued because it supports *a priori* theoretical positions without either shaping or expanding them. In this way the work of women artists is perceived as *confirming* that of male Surrealists, rather than initiating new directions. Applauding her subversive instincts, Breton refers to Kahlo as "a ribbon around a bomb," but he fails to consider her work in the context of her own culture and heritage.

As Herrera notes in her recent biography of the artist, the Surrealists were drawn to Kahlo because she was possessed, as Breton had remarked, of that magical quality of sorcery that they adored in their women: *la beauté du diable*. Calas remembers that she "fits completely the Surrealist ideal of woman...." She had a theatrical quality, a high eccentricity. She was always very consciously playing a role and her exoticism immediately attracted attention."[14] Levy saw her as "a kind of mythical creature, not of this world...."[15]

The Surrealists encouraged qualities of grace and seduction in women; they responded favorably to playacting and rewarded theatrical behavior. It is not surprising that many women incorporated this aspect of their lives into their work; more revealing is the extent to which it formed the basis of their self-images, often substituting for an image derived from their lives as artists. In Kahlo's *Portrait of Frida and Diego*, painted in 1931, several years before she met the Surrealists, it is Diego, not Frida, who holds the palette while she plays the role she loved best, that of the adoring wife of the great artist and genius. The image Kahlo chose for herself, that of a captivating personality, substituted for a definition of self as a professional artist. There is no evidence that she ever worked for exhibitions, sales, or reviews. Instead, she defined painting as something she did for herself: "Since I came back from New York," she wrote in 1935, "I have painted about twelve paintings, all small and unimportant, with the same personal subjects that only appeal to myself and nobody else."[16]

The "personal" to which she refers was her own life, the only subject of her painting. The duality of that life—an exterior persona constantly reinvented with ornament, costume, and a captivating personality, and an interior image nourished on the pain of her crippled body—invests her painting with a haunting complexity. The traditions of Mexican popular art and Mayan history, incredible suffering and brilliant invention, mingle with a sophisticated knowledge of European literature and painting. Although she insistently denied she was a Surrealist, her encounter with Surrealism in the late 1930s strengthened the psychological content of her painting and increased her reliance on symbolic imagery.

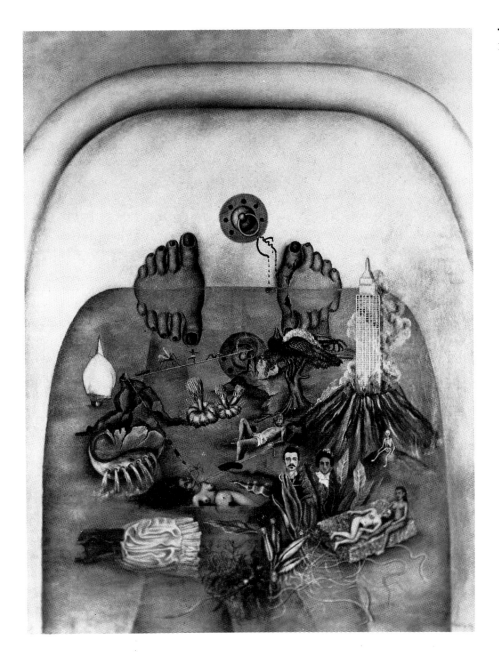

Breton selected her painting *What the Water Gave Me* (1938) to illustrate his essay on her in *Surrealism and Painting*. Confronted by the painting in her studio, a phrase of Nadja's returns to him: "I am the thought on the bath in the room without windows." If water is the medium of birth, it is mental life that is brought into being here. Daydreaming in the bath, Kahlo peoples the water with a swarm of freely associated images, many of them derived from earlier paintings. Images of sexuality, pain, and death are filtered through the history of her art, and memory, dream, and art flow together. The presence of the deformed right foot with its cracked big toe recalls the reality of physical suffering; the water becomes a Bosch-

91

like world of physical and psychological associations at the center of which appears a strangled image of the artist, naked and with flesh that has turned an ugly gray color.

In *The Second Sex*, Simone de Beauvoir holds up the image of the mirror as the key to the feminine condition. Women concern themselves with their own image, she asserts, men with the enlarged self-image provided by their reflection in a woman. Kahlo used painting as a means of exploring the reality of her own body and her consciousness of that reality; in many cases the reality dissolves into a duality, exterior reality versus interior perception of that reality, or two selves, one loved, the other not. In 1939 Kahlo painted *The Two Fridas* for the international Surrealist exhibition to be held in Mexico City in 1940. The American art historian MacKinley Helm was visiting Kahlo when the final papers announcing her divorce from Rivera were handed into the studio. It was Rivera, not Kahlo, who had insisted on the divorce and she was distinctly melancholy. "She was working then on her first big picture, a huge canvas called *Las Dos Fridas*.... There are two full-length self-portraits in it. One of them is the Frida that Diego had loved ... the second Frida, the woman whom Diego no longer loves. There the artery is ruptured. The Frida scorned tries to stay the flow of blood, momentarily, with a pair of surgeon's forceps...."[17] The two Fridas sit side by side on a bench, their hands clasped. One is dressed as a European in a Victorian dress, the other in a Tehuana skirt and blouse. Both Fridas display their pain, their love, and their sexuality against an arid landscape.

The continuing use of the mirror as a tool for the artist affirmed the duality of being, the self as observer and observed. In the work of women artists, the self-portrait became a telling metaphor for the woman artist's attempt to resolve the Surrealist polarities of inner and outer reality. Male Surrealists overcame the polarity by projecting inner reality, in the form of desire, onto an external being; women artists often turned to the self-portrait as a device for initiating the same dialogue between inner and outer reality. The theme of the self-image that derived from an uneasy juxtaposition of the worlds of artifice and nature, or instinct, formed a persistent leitmotif in the self-portraits of women artists associated with Surrealism. We have seen it functioning in the work of Fini and Kahlo; it also permeates Dorothea Tanning's *Birthday*[18] of 1942. Painted on the occasion of her thirtieth birthday, this was the second or third painting executed after her work came under the influence of Surrealism in the early 1940s, and it was first exhibited in Guggenheim's 31 Women exhibition at Art of This Century in 1943.

The second of three daughters, Tanning was born in the town of Galesburg, Illinois. The place, if not the date (1912), was to prove of exceptional importance in the development of her art; from an early age she cultivated a rich and complex fantasy life as a means of escape from the repressive puritanism of her midwestern American hometown. Her Swedish father had dreamed of becoming a cowboy in the American West, until marriage forced him to relinquish his dream; her mother invented musical or theatrical careers for her daughters, whom she dressed extravagantly in taffeta and silk. The children lived poised uneasily between the family's stern midwestern Lutheranism with its many public prohibitions and

76

Amanda Tanning's extravagant fantasies. As a child, Tanning escaped to a private world of fantasy nourished by her reading of Carroll, Andersen, Wilde, Radcliffe, and other nineteenth-century authors.

Tanning's introduction to Surrealism came with the Museum of Modern Art's *Fantastic Art, Dada, Surrealism* exhibition of 1937. Two years later she had collected letters of introduction to Ernst, Tanguy, Chaim Soutine, and Kees Van Dongen in Paris. They had all left the city when she arrived in the summer of 1939, and after three weeks spent knocking on doors in vain, she retired to an uncle's home in Stockholm, where she remained painting portraits of the family until the outbreak of war forced her to return to New York.

Tanning first exhibited her painting at Julien Levy's gallery in 1941. Shortly thereafter she met Ernst, with whom she would remain until his death in 1976. With Ernst, she discovered around herself in New York the world she had sought in vain in Paris in 1939. She met Breton, Duchamp, Masson, Tanguy and Sage, Matta, John Cage, and others at the cold-water flat Ernst rented as a studio on Second Avenue after leaving Peggy Guggenheim. Breton presided over Surrealist gatherings in New York but, intimidated by him and by her lack of fluency in French, she seldom spoke out at these gatherings and she joined with other women who saw themselves as listeners rather than active participants at Surrealist meetings.

The academic perfection of *Birthday* intensifies the effect of the interwoven strands of fantasy and reality. In the painting, Tanning wears a blouse similar to those worn by troubadours in theatrical productions, but her feet are bare and her skirt has sprouted a tangle of weeds and brambles. The elaborate ruffled blouse that covers her arms and shoulders is pulled back and torn to reveal her bare breasts, and cascades of lace fall from the wrists. Her costume, at once theatrical and drawn from nature, establishes the duality of the painting, while the torn fabric suggests a struggle between opposing forces. The fantastic winged creature at her feet belongs to the world of night and the instinctual. Although Tanning has given the beast wings and a piglike snout, it is recognizable as an image of a lemur, an animal found only on Madagascar and associated with Lemuria, the term used by the Theosophists to name the continent that preceded Atlantis. From a genus of nocturnal mammals, the lemur has long been associated with night and the spirits of the dead while Lemuria was believed to have been inhabited by a race of humans with magical powers. A similar animal appears in Valentine Hugo's *Dream of 21 December 1929* where it also accompanies a self-portrait of the artist; and lemurs can be found in the paintings of both Carrington and Varo. In each case, the lemur appears as a herald of the unconscious released through the dream; the frequency with which the image appears in the paintings of women artists suggests its adoption as a kind of talisman for woman's visionary powers.

60

Tanning stands alone, resting her hand on the knob of an open door; beyond her appears an endless series of future doors waiting to be opened and closed. Throughout the painting are the signs of another world, one we know only through glimpses into dreams. For Tanning, the doors in *Birthday* lead ineluctably to events the artist sees as if through a window; "the entire history of man," she has said, "can be seen through the window."[19] The doors usher the viewer into her "elsewhere,"

93

78 Visiting Sedona in 1946 with Roland Penrose, Lee Miller photographed Ernst and Tanning in the Arizona desert and used her camera to make a wry comment on stature and scale

a hidden world of fantasy and obsession. But behind the doors in *Birthday* lies emptiness; poised on the edge of the future, at the juncture between art and life, the artist confronts the possibility of the void.

Isolated from the shared ideology that informed the work of male Surrealists, the woman artist confronted her own reality, and the fear that its resources were finite. That the material circumstances of these artists' lives varied so widely makes even more striking the similarities in the iconography of their self-portraits, many of which use luxuriant hair as a double image of femininity and sexual or creative energy, and vegetation or the lack thereof as a metaphor for psychic reality. In Kahlo's *The Broken Column* (1944), the bleak, forbidding landscape becomes a potent metaphor for inner desolation. As in the image of Tanning in *Birthday*, the breasts are isolated, full, and exposed, but the sexuality and nurturance they imply is of little use for the woman artist. More real by far in Kahlo's painting is the broken column that she substitutes for her shattered spine; its cracks and instability are reflected in a barren landscape with deep rifts. "I paint myself because I am so often alone ... because I am the subject I know best," she wrote.[20]

This isolation of the woman artist is even more striking in Fini's *The End of the World* (1948), in which the waters of a primordial swamp rise up around the image of a naked and full-breasted woman who resembles the artist herself. The duality of the swamp, place of death and decay but also of regeneration, is reflected in the double image of the woman. The image that gazes out from the water is serene and contemplates this vision of the world's end without fear or anger; the reflected image is darker and more bestial and belongs to the world of submerged nature.

The End of the World personalizes Fini's lifelong fascination with death. By the age of thirteen or fourteen, prompted by an intense curiosity about the meaning of life and death, she had begun visiting the morgue in Trieste. One of the guards conducted her to a part of the building closed to the public where the corpses of people who died in the hospital next door were taken; there she began a daily, quasi-religious contemplation of the corpses, comparing these anonymous nude bodies, painted with tincture of iodine and tagged with identification numbers, to the dressed and adorned bodies that lay surrounded by floral tributes in the morgue's public rooms. These scenes greatly affected Fini's view of the nature of the relationship between the real and the artificial. She admired the perfection of the skeletons and the fact that they are the last part of the body to deteriorate. Images of skulls and bones enter her paintings as constant reminders of the tension between the eternal and the transitory.

Fini had come to her interest in life and death, decay and regeneration, long before meeting the Surrealists. Her childhood curiosity anticipated an important theoretical position addressed later by Masson, Georges Bataille, and other members of the Surrealist group. Although strongly influenced by the work of the German Romantics, this position also reaffirms the central role played by personal instinct in the imagery of women artists. Surrealism provided a supportive environment for women artists' exploration of inner reality; it did not furnish them with a shared set of artistic goals. As a result, most of them did not see themselves as true Surrealists; at the core of their art lay only individual reality.

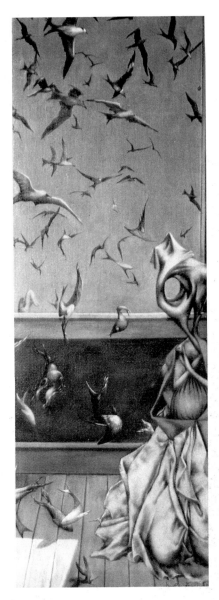

79 Dorothea Tanning, *Les Petites Annonces à Marie*, 1951

SELF-PORTRAITS

Internalizing the muse, women artists rejected the search for an idealized Other and interrogated the image in the mirror. In a self-portrait painted several years before she met the Surrealists, Agar hides her doubts behind a façade of determined composure as she struggles toward a definition of self stripped of fantasy and pretense. Fini's Self-Portrait *is an image of intense self-possession while in* The Broken Column *Kahlo exposes the shattered spine and surgical brace that dominated her self-awareness after her accident.*

81

80 Léonor Fini, *Self-Portrait*, 1942–43
81 Eileen Agar, *Self-Portrait*, c. 1927
82 Frida Kahlo, *The Broken Column*, 1944

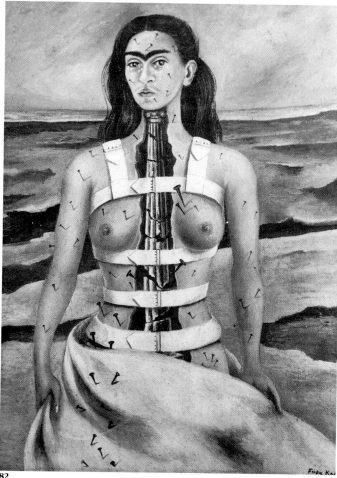

82

Looking inside herself, Kahlo found a barren, pain-filled world that she externalized in self-portraits in which she inhabits landscapes stripped of foliage, the earth rent with deep, dry cracks, the sky stormy and threatening. Tanning stands poised on the brink of maturity, her hand uneasily holding the knob of a door opening onto an emptiness waiting to be filled by the artist; Fini clothes inner reality in the costumes of the theater and public spectacles. Two late self-portraits by Kay Sage directly address the issue of psychic barrenness.

V

In the first of these, titled *Small Portrait* and painted in 1950, she replaces the organic structure of the human head and shoulders with a complex architectural scaffolding of the kind found in her paintings of the late 1940s and 1950s. The shock of red hair that springs from the featureless face introduces a single organic note into an otherwise geometric construction. A very similar mane of red hair appears in Tanguy's *Girl With Red Hair*, painted in 1926, some years before he met Sage.

150

Sage and Tanguy had settled in Woodbury, a small rural community in the rolling hills of western Connecticut in 1940. With Sage's money, they purchased a stately nineteenth-century house, once part of the town poor-farm, and gradually remodeled it. They hung paintings by Chirico, Delvaux, Man Ray, Ernst, Miro, and Magritte on walls painted pale gray, and meticulously arranged a collection of objects that included Alaskan masks, early American domestic objects, and New Mexican kachinas. Julien Levy remembered the house as a very personal "combination of the modern, the old, and the chic, set in tones of cool white and grays. A stone terrace at the back gave a splendid view over meadows where a pond was dug, shaped after a design by Yves from one of his paintings."[21]

They painted steadily, working in separate studios in a divided barn. Sage's painting achieved its greatest power and refinement in the years between 1944 and Tanguy's death in 1955. She worked on a series of complex and austere architectural vistas in which impeccable draftsmanship is sustained by a brushing of deep, rich color, set off by cool silvery blues and grays. The surfaces are smooth, individual brush strokes indistinguishable. A year before Tanguy's death, they agreed to a joint exhibition of their work at the Wadsworth Atheneum Gallery in Hartford, Connecticut. Up to this point, Sage had consistently refused to exhibit her work with that of the better-known Tanguy, although she had had numerous exhibitions of her own. Apparently somewhat embarrassed by the exhibition, she took pains to explain to a visitor who arrived in Woodbury shortly after it opened that "We are really concealed from each other in our work. He doesn't know what picture I am painting—although I take more interest in his than he does in mine—naturally."[22]

Visitors to the exhibition quickly recognized that, in spite of superficial similarities, their work had developed in different directions. Reviewing the exhibition in the *Saturday Review*, James Thrall Soby commented on Tanguy's concern with animistic forms, and Sage's with architectural constructions, "as though through some unswervable instinct for femininity she felt impelled to create poetic shelters in the landscape of her reveries." In fact, though Tanguy's work of the early 1950s sometimes incorporates isolated architectural elements

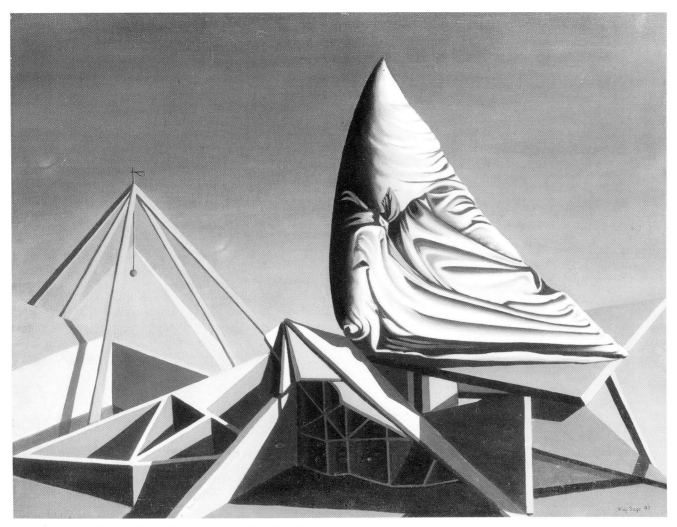

83 Kay Sage, *On the First of March Crows Begin to Search*, 1947

derived from Sage, her work after 1944 reveals a persistent attempt to free herself from Tanguy's influence by suppressing the organic. Her "shelters" or architectural scaffoldings are intellectual constructions that replace the flowing draperies and more organic forms of her earlier work. They provide the formal vocabulary that distinguishes her work from that of Tanguy in the same way that her subdued and earthy palette contrasts with the jewellike preciousness of his colors.

Jean Levy (Julien's widow) remembers Sage's fear that her work was derivative;[23] it was a fear to which she responded by making her paintings ever more elusive. In *Small Portrait* the forms are structured around emptiness and the meaning is veiled. Never overtly symbolic, her paintings contain cryptic signs of an attitude toward the world that was often epigrammatic and terse, like the poems she published during the 1950s with their riddles and contracted words. Here the structure of the human body becomes a stage set filled with scrims and rigging.

99

84

SAGE AND TANGUY

Sage and Tanguy settled in rural Woodbury, Connecticut, in 1940 and set up separate studios in a barn on their property. In 1954 they agreed to a joint exhibition of their work at the Wadsworth Atheneum in Hartford, but Sage worried about having her paintings compared with Tanguy's. In fact, both critics and the public could immediately see not only the few similarities but also the many differences in their work.

84 Surrealists *chez* Tanguy at Woodbury, Connecticut, in 1947
85 Kay Sage, *Hyphen*, 1954
86 Yves Tanguy, *Indefinite Divisibility*, 1942

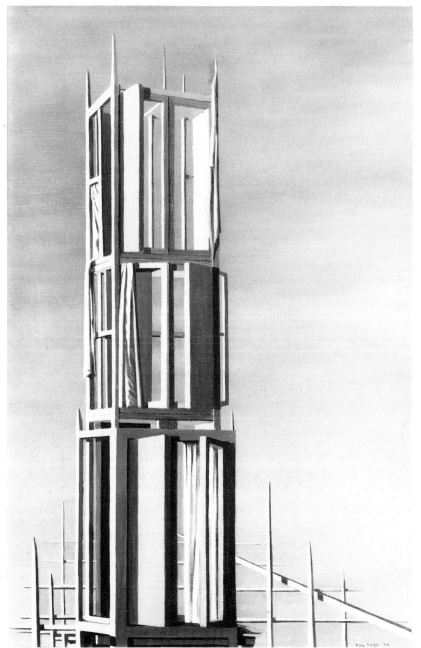

85

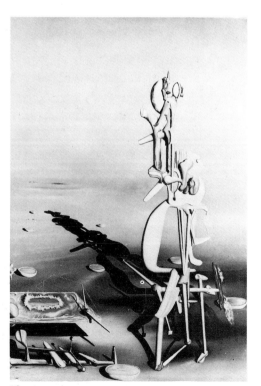

86

87 Kay Sage, *Afterwards*, 1937

III *The Passage* (1956), her last self-portrait, sustains the theme of psychic emptiness. We see the young woman from the back and, although she is naked to the waist, the sexual aspects of the thin, almost emaciated body are turned away and we see neither face nor breasts. Seated on a pile of sharp and angular blocks she contemplates a desolate landscape of broken earth and empty sky into which no sign of life nor human habitation intrudes.

The work was executed a year after Tanguy's sudden death in 1955. It was a blow from which she never fully recovered and, although their later years together in Connecticut were characterized by heavy drinking and were far from tranquil, this final loss of the loved one proved in the end unbearable. Sage's unpublished notebooks reveal that as early as 1955, depressed, suffering from loss of eyesight, and unable to contemplate a future alone, she had begun thinking about suicide. Once again, writing served as an outlet for pain and loneliness; the poems in *Demain Monsieur Silber*, published in 1957, are filled with images common to her paintings of these years. In one called "Tower," she wrote:

> I have built a tower on despair,
> You hear nothing in it, there is nothing to see;
> There is no answer when, black on black,
> I scream, I scream, in my ivory tower.

And in "Acrobatics," she evokes the quality of brittleness that increasingly came to characterize her sensibility in later years:

> When you walk
> on a tight rope,
> at the least unexpected thing
> you break your neck;
> leave me alone
> I will manage
> all by myself

She did not manage and on January 8, 1963 shot herself through the heart.

*A woman is beautiful to the extent that she most completely
incarnates the secret aspirations of man.*

<div align="right">

3 Revolution and Sexuality

</div>

BENJAMIN PERET, Anthologie de l'Amour Sublime

In the early months of 1928, Breton convened his group for a formal inquiry into sexuality, a subject long dear to the heart of Surrealism. The proceedings, later published in their entirety in the eleventh issue of *La Révolution Surréaliste*, provide a fascinating glimpse into the manners and morals of one segment of the French literary *avant-garde* at the end of the 1920s: wholehearted acceptance of onanism and sodomy, outright rejection of homosexuality and bestiality, a shared curiosity about the many and varied forms of sexual pleasure. No women were present, a fact commented upon only by Aragon, the sole member of the group who apparently felt inhibited about discussing woman's sexuality in her absence. At one or two points in the discussion the high moral tone frayed slightly. Did the members vary the positions adopted during intercourse? Breton asked. And on whose initiative? "Same as Peret," replied Pierre Unik, "I always ask the woman's opinion." "Colossal, phenomenal," exploded Breton, whose views about sexuality were no less absolute than those he expressed in other areas of Surrealist doctrine. "Talk about complications!" Asked by Unik why he found this so "colossal," Breton retreated into the feeble response that it was not the custom, and lost more ground when Unik retorted that the opposite could hardly be considered the case either!

By the time this discussion took place, the subversive power of *eros* had become one of the most consistent leitmotifs of Surrealism. Revolting against a repressive puritanism that had stripped woman of all erotic power and perpetuated a hypocritical social system in which she was wife or mistress but never both, Surrealism fought to reunite *l'amour* and *l'érotique*. Perhaps the most obvious result of the new openness in sexual matters is a lingering public perception of Surrealist life as a dizzying series of amorous liaisons reflected in an apparently rampant turnover of wives and mistresses—and, if the results of the 1928 inquiry are to be believed, a suspicion on the part of many women today that the Surrealist erotic, formulated in the absence of women, was responsive above all to male desire.

Breton emphasized that his own conception of love, one formed in early youth, excluded promiscuity, libertinage, and the sentimentality of fantasy lovers, but included an expansive knowledge of sexuality. In refusing to divorce the erotic from love, he made the act of love dependent on all forms of expression. Suddenly sex became a mode of creativity, love a means of transcending the duality of the sexes; between poetic emotion and erotic pleasure the difference is only one of degree, Breton wrote in *L'Amour Fou*.

The cultivation of *eros* in Surrealism made woman into an active sexual force in the world and in man's creative life, but the language of love, whether expressed in the romantic visions of Breton and Eluard or in the perverse images of Dali and Bellmer, was a male language. Its subject was woman, its object woman, and even while proclaiming woman's liberty it defined her image in terms of man's desires.

103

Discussions of sexuality, the display of erotic objects and paintings, and the cultivation of chance in the locating of the loved one took place in a theoretical context defined by men; even paintings by male artists that elevated woman to a position of power often did so in terms of male imagery and expectation. In Victor Brauner's *Mythotomie* (1942), woman—the muse, the magician, the transformer of the world—is nevertheless dominated by the image of the cyclopeian Janus, half man, half animal, which reigns over her head. Dali's *femme-phallique*, with her elongated pointed breasts projecting like two aggressive lances, is a creation of man's fears, Matta's *La Femme Affamée* a distinctly male vision of a woman starving for sexual pleasure. Her face is a huge vaginalike jaw, adorned with sharp hooks; her tongue, in the shape of an erect penis, is also hooked. Thrusting her two hands into her mouth in order to stretch the orifice ever wider she becomes, as Xavière Gauthier points out in *Surréalisme et Sexualité*, a carrier of the phallus.

Women artists were forced either to reject this male language of female sexuality altogether, to adapt it to their own ends, or to attempt to create a new language that spoke more directly to female experience. In "The Water Stone of the Wise," published in *New Road* in 1943, the English painter Ithell Colquhoun transformed the image of the androgyne from a Surrealist symbol for the final unification of the two sexes into a means of overthrowing a phallo-centric mythology. "But we must have liberty," she wrote:

> No more tyrants and victims, no more the fevered alterations of that demon-star which sponsored the births of de Sade and von Sacher-Masoch; but the hermaphrodite whole, opposites bound together in mitigating embrace by a silk-worm's thread.... Oedipus will be king no longer but will return to Colonnus. The new myth, the myth of the Siamese Twins will make of him a forgotten bogey.

Colquhoun's rejection of a male sexuality defined and restricted by Freud's Oedipus complex was shared by other women. Carrington viewed *l'amour passionnelle* as one of life's essential experiences, as did male Surrealists, but she refused to limit its object. "In *l'amour-passion*," she later said, "it is the loved one, the other who gives the key. Now the question is: Who can the loved one be? It can be a man or a horse or another woman."[1] But according to the 1928 inquiry on sexuality, both horses and same sex lovers were out, though the group continued to regard lesbianism with greater tolerance than homosexuality. "I accuse pederasts of a mental and moral deficiency ... paralyzing all enterprises that I respect," Breton maintained, making an exception only for the Marquis de Sade, "for whom moral liberty has been an issue of life or death."

The Surrealist commitment to dialectical resolution did not necessarily extend to resolving internal inconsistencies in behavior and attitude. For women artists, as well as for their male colleagues, ambiguity and ambivalence accompanied life lived outside middle-class and rationalist conventions. The Surrealist Revolution could not be lived independently of needs and psychological realities formed long before the first Surrealist Manifesto appeared on the streets of Paris. Most women willingly embraced sexual liberation as a fact of life, sexuality as an aspect of style.

105

They had battled their families for the right to independent lives; they had inherited the 1920s call for greater sexual freedom for women. That freedom sometimes included forming temporary sexual relationships with other women, not as a rejection of heterosexuality, but as part of a new awareness of the realities of other women's lives outside the domestic sphere and outside social conventions.

Loyalty to the Surrealist group ran deep, former lovers often remained friends, and close personal associations replaced shared ideology as a binding link. Fini emphasizes that, despite her earlier liaison with Ernst, Carrington displayed no sign of jealousy when they met in 1937 and the two women immediately became close friends. Personal rivalries generally remained subordinate to collective spirit and Marie-Berthe Aurenche's destruction of Oppenheim's object, *Ma Gouvernante, My Nurse, mein Kindermädchen*, in 1936, provoked when she saw the piece in a gallery and recognized the shoes as a pair that had belonged to her, appears to have been the exception rather than the rule. Uninhibited behavior, however, was the order of the day. Oppenheim, Fini, and Carrington all revealed themselves willing to appear naked at inopportune moments, and generally before an audience. Urged to take off her heavy fur coat on a warm evening, Fini did so, and was wearing nothing underneath. Carrington made her debut into French society dressed in a sheet, wrapped toga-style, which she soon shed; she claimed to have brought no appropriate clothes when she fled London with Ernst. On a late-night outing in Cornwall in 1937, Nusch, Carrington, Agar, and Miller all danced naked around the disconcerted figure of Herbert Read, illuminated by the glare of a car's headlamps. Alain Jouffroy recalls Oppenheim peeing into the hat of a pompous gentleman on the terrace of a Paris café. Fini was known for acts such as these and worse.

The Surrealist love of costume, or the lack thereof, proved a perfect forum for inventive, and often sexual, display. When Man Ray photographed Oppenheim in the studio of Louis Marcoussis in 1933, shortly after her arrival in Paris, Marcoussis adopted a beard to disguise his appearance, Oppenheim wore nothing but a few smears of black ink, and the photographs were rejected by the magazine for which they were intended. Miller came to Surrealist parties displaying green fingernails and the gold handcuffs that Roland Penrose had given her in the course of his long, and often complicated, pursuit of the American photographer; Tanning adopted a leopard-skin costume covered with breasts. Among the many Surrealist accounts of festive gatherings is Julien Levy's description of a party organized by Tzara for which the guests were instructed to appear nude only from chest to thigh, and to which Fini wore knee-length white leatherette boots and a cape of white feathers and Ernst a belt of iron spikes, a headdress and breastplate made from pot scrubbers, and sandals with gray wings attached to them.

Charm, style, and nonconformity were the hallmarks of the Surrealist woman, but when it came to taking a position vis-à-vis Surrealism's inflammatory erotic language, or forging new weapons in what Maurice Nadeau called "the grand battle of desire," they vacillated. Oppenheim produced objects with an elusive, often veiled, erotic content; Carrington turned to magic; Tanning transferred sexuality from the world of adults to that of children; and Colquhoun parodied the Surrealist

obsession with sexual imagery. Women artists more often than not avoided the imagery of adult female sexual experience. Among women artists there is no erotic art as confrontational, explicit, and shocking as that by Bellmer, Dali, Clovis Trouille, Freddie, and sometimes Masson: no frenzied paroxysms of erotic violence, no obsessive search for a latent, sexual content behind every image and every object, and no male love object that could be opposed to the *femme-enfant* and the erotic muse. Fini and Toyen actively participated in the Surrealist cult of the erotic, but both worked independently of the Paris group, Toyen following the lead and example of her companion and constant collaborator, Jindrich Štyrský, Fini recreating the male presence as androgynous. Tanning, Fini, and Toyen all explored the iconography of Sade, but only Fini can be said to have made a distinctive contribution to a perverse Sadeian imagery in Surrealism with her series 92 of drawings for a 1944 edition of *Juliette*. Toyen, who also illustrated Sade, chose *Justine*, the most servile and abused of all Sade's female victims.

The figure of Donatien-Alphonse-François, Marquis de Sade, Lord of the Château la Coste, libertine and sexual revolutionary, philosopher and pornographer, had inflamed the Surrealist imagination from the beginning. Even before Surrealism, Apollinaire, who edited a series of pornographic texts beginning with selections from Sade in 1909, had extolled "…this man, who appeared to be of no importance throughout the whole of the nineteenth century, [but] well may dominate the twentieth"; Breton claimed him as "Surrealism in Sadism" in the second Surrealist Manifesto. Attacking the eighteenth century's lingering cult of romantic love, he built a revolutionary mandate on perversion and abolished woman's reproductive and maternal roles by obliterating her organic specificity through sodomy, which he asserted as the key to the principle of metamorphosis. The abuse heaped upon the bodies of Sade's victims renders them objects, their wombs and breasts tortured and destroyed, their bodies torn apart and re-created. The ravaged female, denied her normal sexual, emotional, and procreative functions, became the theoretical basis of the Surrealist object and of the word images of Magritte. In both cases, the traditional relationships between word and image or object and function/meaning are violently disrupted in order that a new, more poetic meaning might emerge.

Sade's mythology of slavery and violence, in which chains and whips eroticize older traditions of the passive and subservient woman, has long repulsed women. Nevertheless, as Angela Carter points out in *The Sadeian Woman*, Sade was unusual in his period for claiming rights of free sexuality for women, for creating Juliette and other women as beings of power and dominance in his imaginary worlds, for scoffing at woman's bondage to motherhood and reproduction, and for rejecting the stereotypes of his day that viewed women as the inarticulate victims of an uncontrolled sensibility.

From its earliest days, Surrealism had sought ways to transcend the particular, to define a level of existence in which the contradictions of everyday life were resolved. They were drawn to Sade for the same reasons that they were drawn to the Orphic cults of Dionysos and the erotic excesses of Don Juan—the search for an all-consuming passion that would carry within it the seeds of a new reality. If the demand for a free sexuality, detached from all social restraints, was accompanied

89

90

91

THE MARQUIS DE SADE

Of all the Surrealist women, only Fini and Toyen developed an erotic imagery directly related to Sade. In 1944 Fini used images from Sade's Juliette *to portray the sexual power of women. Support for Toyen's belief in sexuality as a form of revolution came from Jindřich Štyrský and other members of the Czech avant-garde. Her ink drawing for* Seules les crécerelles . . . *uses a motif also found in Jindřich Heisler's frontispiece for Sade's* Philosophy in the Bedroom.

89 Jindřich Heisler, photo-collage frontispiece for Sade's *La Philosophie dans le Boudoir*, 1944
90 Jean Hugo, Paul Eluard, and René Char: one of several Surrealist pilgrimages to Sade's ancestral home, 1931. Photographed by Valentine Hugo
91 Toyen, illustration from *Seules les crécerelles pissent tranquillement sur les Dix Commandements*, by Jindřich Heisler, 1939
92 Léonor Fini, illustration from Sade, *Juliette*, 1944
93 Léonor Fini masked, in 1948

92

93

by a myth of innocence and original purity, its antithesis—the locating of desire in the notion of the forbidden and the need for transgression—led to images of perverse sexuality.

The erotic violence that Sade viewed as essential to corporeal metamorphosis finds expression in Surrealism in images that isolate, and often objectify, the female body in a manner quite unlike that of Breton's poetic cultivation of woman as subject. Man Ray's photograph *Homage to D.A.F. de Sade*, published in the second issue of *Le Surréalisme au Service de la Révolution*, imprisons a woman's head in a bell jar; his *Monument to D.A.F. de Sade*, published in the fifth issue of the same review, isolates the cleft in a woman's naked buttocks, the seat of Sadeian pleasure.

102, 103 But it is in Bellmer's *Dolls* that the idea of corporeal metamorphosis and violent attacks on the integrity of the female body find their most concrete and literal expression. Beginning in 1934, and stimulated by the writings of Sade, he arranged the bodies of dolls into frankly erotic reconstructions. The first *Doll* contained a hollow womb filled with a series of six "scenes," which could be activated by pushing a button on its breast; among them, a boat sinking through the ice of the North Pole, a handkerchief supposedly adorned with the spittle of little girls, and several illuminated pictures. Later versions disassembled the dolls into poses of lewd abandon.

The air of cruel eroticism that permeated Bellmer's drawings and objects finds a parallel among the women only in Fini's illustrations for Sade's *Juliette*. In the Sadeian world of female victims, Juliette is a powerful exception. As an incarnation of feminine desire, her presence rebuts the eighteenth century's image of woman as a being without physical desires, and proves that woman's sexual needs may be even more demanding than man's, her capacity for cruelty and power greater than his.[2] Fini uses Juliette as a vehicle for the frank expression of woman's sexual power and dominance. Wielding the whip, women become in these drawings an active, bestial presence. The lust that transforms their faces into masks of depravity is manifested in a nervous charged line that flickers across the page like the tip of a lash. In the face of woman's power, men become apes with giant engorged phalluses, or skeletal death's heads.

In her life as well as her art, Fini continually advanced the notion of the autonomous, absolute woman; beautiful, imperious, and governed by passion. She turned her back on marriage, and on the Surrealist replacement—serial monogamy in search of unique love—and lived communally, often with two men, "one more lover than friend, the other more friend than lover." Her demand for a sexual freedom that may include bisexuality has often been misinterpreted, but she herself is very clear about the difference between a woman's desire to experience the love of another woman and the choice of lesbianism as a life-style: "I am a woman, therefore I have had the 'feminine experience,'" she has said, "but I am not a lesbian."[3] But if the strength of her commitment to sexuality as the connecting link between inner and outer reality links her work with that of Surrealists like Bellmer, Masson, and Dali, her refusal to subjugate the image of woman to man's desires invests these erotic images with new meaning. Nevertheless, Fini's use of sexual imagery is not without an element of conflict and ambivalence. As her friend

Jean Genet suggested in a letter to the artist written in 1950, the use of artifice and theatricality in these works has sometimes served to diffuse the impact and power of their erotic content:

> If you hold so fast to the bridle of the fabulous and misshapen animal that breaks out in your work and perhaps in your person, it seems to me, Mademoiselle, that you are highly afraid of letting yourself be carried away by savagery. You go to the masked ball, masked with a cat's muzzle, but dressed like a Roman cardinal—you cling to appearances lest you be invaded by the rump of the sphinx and driven by wings and claws. Wise prudence: you seem on the brink of metamorphosis.[4]

On the brink of metamorphosis, but not over the edge. Interestingly, the only woman artist who participated fully in the Sadeian universe of the male Surrealist is the one who refused to give herself over to Surrealism's collective goals: "I was hostile first because of Breton's puritanism; also because of the paradoxical misappreciation for the autonomy of woman—characteristic of this movement which pretended to liberate men."[5]

Profound belief in the ability to shape the exterior world according to one's desires is rare among women of Fini's generation. Cultivating her own individuality, she placed her self-image at the center of her painting, asserting her own freedom and autonomy to a degree that seems the embodiment of the Surrealist ideal, but that was, in fact, equaled by few Surrealists. "The small child believes that it is the center of the world," she wrote. "But I, I accept this officially. I have lived and celebrated it."[6]

Fini demanded the right to explore areas of consciousness still alien to many daughters of the middle and upper classes: sexual power and dominance by women, female sexual imagery, perversion. Her commitment to sexuality as a form of revolution was shared by Toyen, whose support in this area came from Štyrský and from the historical circumstances that made Prague a true meeting ground of political and artistic revolution in the years after the First World War. In the 1920s her work was nourished by two intellectual and aesthetic climates. In Prague, the Czech avant-garde, uniting the most radical tendencies in painting, poetry, architecture, theater, art, and criticism, bore the clear imprint of her personality and her politics; Paris supplied a new vision of the work of art as the resolution of inner and outer reality.

Štyrský's many poetic and theoretical texts, his active publishing life, and his systematic monitoring of his dreams provide numerous clues to the meaning of his images. Of Toyen's interior life and the sources of her inspiration we know almost nothing. The situation is not much better with regard to her real life. Robert Benayoun has called her "the daughter of herself"; Breton left a moving description of her in an essay of 1953 published in *Surrealism and Painting*: "Toyen, who catches my heart every time I think of her: the mark of nobility that stamps her face, the deep tremor within her coexisting with a rock-hard resistance to the fiercest attacks, her eyes which are cardinal points of light."[7] But neither Benayoun's epithet nor Breton's description do much to clarify her origins and development.

FINI

In her life as well as her art, Fini continually advanced the notion of the autonomous, absolute woman: beautiful, imperious, and governed by passion. Committed to life as an artist from adolescence, her independence kept her from ever formally joining the Surrealist movement.

94

94 Léonor Fini in her studio in 1949
95 Léonor Fini, *Nu au Sphinx*, 1945
96 Léonor Fini, *Composition with Figures on a Terrace*, 1939

95

97

TOYEN

Toyen shared Fini's commitment to sexuality as a revolutionary imperative. In the 1920s her work was nourished by two intellectual and artistic climates: Prague and Paris. Poetic compositions like Fjord *evoke dreamlike feelings; later works like* Abandoned Corset *hint at a latent sexual content in representational images that are suspended against cracked and dripping surfaces. Toyen's erotic humor is evident in an undated drawing from the 1930s.*

97 Toyen, *La Tanière Abandonée* (*The Abandoned Corset*), 1937
98 Toyen, *Fjord*, 1928
99 Toyen, *Erotic Drawing, c.* 1936

98

99

Born Maria Čerminová in 1902, she turned her back on her family while still an adolescent, baptized herself with an obscure and genderless patronymic that may or may not derive from the French word for citizen, *citoyen*, and joined the anarchist milieu of Prague. As the center of new life and energy in a modern Czechoslovakia born out of the ruins of the Hapsburg empire in 1918, Prague was experiencing an artistic and cultural revolution. The Devětsil group, which united these avant-garde tendencies in all the arts, was formed by individuals as diverse as Franz Kafka and Jaroslav Hasek, the author of *The Good Soldier Schweik*. The Devětsil review, *Red*, was both the organ for a new generation of Czech artists and poets and a source of information about the arts in Western Europe, publishing numerous translations of French poets such as Lautréamont, Rimbaud, Apollinaire, and Jarry. After taking a short course in painting at the Ecole des Beaux-Arts in Prague, Toyen joined the Devětsil group with Štyrský, whom she had met in Yugoslavia the previous year.

In the fall of 1925 Toyen and Štyrský left for three years in Paris where the Cubist syntax of their earlier work gradually gave way to quasi-abstract compositions. In Paris, Toyen's work became somber, sometimes melancholy in tone, heavily impastoed, and filled with corrugated surfaces and structures. She emphasized process and used encrusted surfaces in paintings that attempt a visual realization of poetic Artificialism in which impressions, feelings, and images—lived or dreamed—leave their imprint in abstract traces and vibrating color sensations. Toyen and Štyrský exhibited their first Artificialist compositions at the Galerie de l'Art Contemporain in 1926; a year later they organized a joint exhibition at the Galerie Vavin. Philippe Souphault wrote the preface, commenting on the strength and power of Toyen's work, which "respects neither charm nor tenderness, nor the kind of affectation which wears away like the smiles of mature women...." Response to the work by other Surrealists has gone unrecorded, and Toyen's name does not appear in Surrealist periodicals of those years.

Back in Prague, however, her work quickly began to move in a Surrealist direction, gradually giving up nature in favor of the kind of disturbing visions that originate in the dream and the unconscious. Images pregnant with latent eroticism began to appear in paintings that suggest hidden dangers at about this time. The search for a means of anchoring psychic reality in the forms and processes of nature underlies Toyen's transition from poetic Artificialism to Surrealism in the early 1930s. Artificialist compositions like *Fjord* (1928) evoke dreamlike feelings through the identification of color and semiabstract form with inner states of feeling. The dense blues and greens and the highly suggestive use of forms in *Fjord* direct the viewer's attention toward mysterious places and hidden depths. The same motifs—fissures and curves, cracked and stained surfaces—are the starting point for the more disquieting works after her return from Paris.

The experiments of the Devětsil group, of which Toyen and Štyrský were members, were made possible because of the spirit of freedom in the newly independent Czechoslovakian Republic that allowed a split between official art and the avant-garde. The world economic crisis, soon to usher in the forces of Hitler and Stalin, forced the Devětsil group to make their ideas concerning social

revolution and art complete and explicit. In October 1929, Toyen, Štyrský, Karel Teige, and others founded the group Front Rouge as a first step in this direction. Although the group had reservations about Surrealism (disagreeing with the movement's anarchism and fearing that its views about the imagination brought it too close to the social irresponsibility of Artificialism), Štyrský's and Toyen's painting now began to move closer to Surrealism's internal model.

It was at this moment in the early 1930s that Štyrský discovered Lautréamont and Sade, two of Surrealism's most celebrated precursors. He wrote a short, unpublished sketch titled "La Vie du Marquis de Sade," and then, in 1932, published in his erotic *Edition 69* a Czech translation of *Justine* illustrated by Toyen. The text, chosen by Štyrský, tells the story of Juliette's sister, Justine, the eternal victim of male lust whose reward for being a good woman is rape, humiliation, and endless beatings. The tale is notable for its lack of appeal to women; for Toyen it took its place in a nexus of revolutionary artistic acts that defined personal liberty in opposition to official structures.

Fueled by his recent discovery of the modern world's most inflammatory sexual revolutionary, Štyrský made a pilgrimage that same year to the ruins of Sade's ancestral home, the Château la Coste. He returned with a group of strange photographs of crumbling and overgrown walls and doors. These images, suffused with an air of mystery and menace, soon found their way into Toyen's painting. Sade became the patron of Štyrský's erotic prose, and ten explicitly sexual photomontages accompanied his publication of "Emilie vient au moi" in 1933.

Although the initial impulse toward the conscious exploration of erotic forces came from Štyrský, it would be erroneous to conclude that Toyen merely adopted his new enthusiasm as her own. Not only does she firmly integrate the erotic into the emotional content of her painting, but she also uses eroticism as the basis for a new language of psychological association and suggestion. Apparently at ease with the avidity and passion for excess that accompanied the Surrealist search for a new lucidity, she surrounded herself with erotic objects, pornographic photographs, and body parts cut from magazines. The poet Annie le Brun relates that at the age of seventy years Toyen continued to go several times a week to the cinema to see x-rated films.[8]

Toyen's erotic works are gentler, more veiled and mysterious, than those of Štyrský. Their sexual content is hinted rather than made explicit. In Štyrský's *L'Homme et la Femme* (1934) the sexes are replaced by symbolic objects—an open seashell and a hard, dark, anatomical mass; in Toyen's *Prometheus* (1934) and *Abandoned Corset* (1937) the images float against fissured and dripping surfaces that recall natural forms. In these spaces of poetic reverie and suggestion, both the barbed wire that binds Prometheus and the pink corset shock because of their specificity and alienation.

Toyen may well be the *only* Surrealist to have developed an erotic humor, at once charming and playful. In one of a series of erotic drawings executed during the 1930s and published in Štyrský's *Revue Erotique*, the sexual encounter of two women on a bed is all pleasure; in another, gloved fingers milk a penis of its seminal fluid with extraordinary gentleness. For Toyen, as for Hans Bellmer, sexual

97

99

116

curiosity was a poetic necessity, a means of gaining access to the hidden side of life, but her work in this genre has none of the lewdness and cruelty of Bellmer's *Dolls*.

Comparing Toyen's eroticism with the few works by Tanning based on Sadeian themes, we see immediately the skill with which the Czech artist integrated the speculative and philosophical with the personal and emotional. Tanning wholeheartedly admired Sade for his beautiful prose style and his revolutionary ideas, if not for his scorn for women,[9] but the admiration did not translate easily into paint. Paintings like *Voltage* (1943) and *Le Petit Marquis* (1947) are remarkable primarily for their self-conscious use of Sadeian images and the almost complete absence of the erotic energy that fueled her best paintings of the 1940s. In *Le Petit Marquis*, a bewigged and costumed male figure cracks a long whip at four flowing heads of hair imprinted on the lid of the Pandora's box in which he stands. Water reaches the edge of his ruffled frock coat; the whip's lash pierces the lid and snakes against a vaulted roof. But the images read as a pastiche: theatrical rather than shocking, illustrative rather than revealing.

Toyen did not return to Sade in her painting until 1943. In the intervening years, Surrealism had officially come to Prague, but so had occupation, war, and the death of Štyrský in 1942. Toyen's work was banned; she lived clandestinely during the war years. *Relâche* (1943) and *Au Château la Coste* (1946) reaffirm her commitment to XI, XII psychic liberation in the face of monstrous oppression. By the time these paintings were executed, the cruelties of Sade's imagination had been magnified a thousand times in reality and Toyen had plotted her own path through this spiritual wasteland in two powerful cycles of drawings, *Tir* (*The Rifle-Range*) (1939–40) and *Cache-toi Guerre!* (*Hide Yourself War!*) (1944) (discussed in Chapter 6).

Relâche in ordinary usage means "no performance." In Toyen's painting of that title a young girl hangs upside down in an attitude often assumed by children playing on a gymnastic bar. The folds of her skirt hide the head and upper body, the feet merge imperceptibly with the fissured and stained wall, and the flesh and exposed lace-trimmed panties lend a virginal air reminiscent of that of Balthus's young dreamers. But the figure has become terrifyingly impersonal and the objects that surround her—a riding crop and an empty paper bag—introduce an air of perverse danger into this erotic tableau in which nothing happens, but everything is suggested. In *Au Château la Coste*, Toyen's homage to Sade and perhaps also to Štyrský, the predator crushes its prey in front of a cracked wall reminiscent of Štyrský's photographs of the château.

Toyen incorporated Sade's philosophical message into her erotic reveries, Tanning flirted with his image, but Carrington rejected him outright and argued vehemently with Breton in New York over his place in the Surrealist pantheon; she called him "an eternal bore, pornographic but not a revolutionary anything."[10] Embraced or rejected, the former marquis left an indelible impression on Surrealist art and life. Surrealist objects produced during the 1930s often reveal a mingling of Freud and Sade; Surrealist memoirs, though often highly fanciful as to detail, make a point of the group's studied tolerance of aberrant social behavior. Surrealism set out to shock the public; it took Dali's flirtations with coprophagy and Fascism to shock the Surrealists.

100 Man Ray, *Object of Destruction*, 1932

A faint air of amused indulgence flavors Man Ray's account of a visit he and Lee Miller made to the apartment of William Seabrook in 1930. Invited to "babysit" a woman kept there in chains for the owner's pleasure, they immediately violated their instructions by unfastening her, and spent the evening discussing bondage. Man Ray later noted in his autobiography that "Lee Miller told me she had met a man who liked to whip women—it was nothing new for her."[11] Two years later, his anger at Miller, who had decided to leave Paris and open her own photographic studio in New York, would erupt metaphorically in the so-called *Object of Destruction* (1932). Cutting out a photograph of Miller's eye, the photographer's most vital and most vulnerable organ, he attached it to the arm of a metronome with an invitation to the spectator to "destroy this object."

The Surrealist object, born out of Lautréamont's famous metaphor, "beautiful as the chance encounter of a sewing machine and an umbrella on a dissecting table," and stimulated by Dali's arrival on the Surrealist scene in 1929, dominated Surrealist expression during the 1930s. Capturing the images of the dream in reality, crystallizing the objects of desire, and affirming the magic link between the unconscious and the real world, the Surrealist object became the perfect meeting point of Surrealist theory and practice. By the time the International Exhibition of Surrealism opened its doors at the Galerie des Beaux-Arts in 1938, the object had become essential to the creation of the Surrealist universe, a world designed to disorient and to scandalize. Visitors entering the exhibition along a Surrealist "street" lined with mannequins in various stages of disguise and erotic display found sacks of coal hanging from the ceiling and piles of twigs covering the floor. Large beds covered in stained and rumpled sheets stood at each corner of the main gallery. The actress Hélène Vanel, dressed in a torn nightgown, cavorted in one of them in an environment that included paintings, a pool filled with water and surrounded with potted palms, and a gramophone trumpet out of which issued a pair of woman's legs.

Many Surrealist objects resulted from collaborations; others incorporated gifts or found objects with personal and symbolic significance. All Surrealists constructed, or found, objects; women appear to have excelled at this very important group activity. As much a process of discovery as creation, the Surrealist object depended more on imagination than technical training and did not require the privacy and solitude of the studio.

Surrealist objects by male artists often have an explicitly erotic content (Bellmer's *Dolls*, Duchamp's *Please Touch*), disturb by means of violent juxtapositions (Man Ray's *Gift*, Dominguez's *Conversion of Energy*), or combine both functions (Dominguez's *Arrival of the Belle Epoque*). Those by women artists tend toward the more personal and more gently associative. Among the earliest objects by women is Hugo's *Surrealist Object* (1931) in which two gloved hands, one black and one white, hold a single die above a roulette wheel. Here eroticism and chance join forces in a moment of mystery and allure.

The discovery and making of Surrealist objects soon spilled over into the arena of fashion and jewelry design, a reactionary development in the eyes of some and one that increasingly worried Breton as the decade progressed. In 1935 and 1936,

101 Phantom of Sex Appeal event, Sheila Legge in Trafalgar Square, in 1936. (Cover of *International Surrealist Bulletin*, no. 4, September 1936)

Dali created a series of eccentric designs for the house of Schiaparelli, including a hat shaped like a shoe and an evening dress printed with lobsters and parsley (only with difficulty was Dali convinced to leave out the mayonnaise); a few years later, Oppenheim proposed a number of curious pieces of jewelry including mother-of-pearl buttons on which were engraved tiny human footprints. The Exposition Surréaliste d'Objets, held in 1936 at the Charles Ratton Gallery in Paris, brought together found objects, primitive sculpture, and "Surrealist Ready-mades Assisted," all designed or chosen to provoke, mystify, or otherwise demonstrate a crystallizing of unconscious desire. Included were objects by Fini, Maar, Oppenheim, and Lamba; the London International Surrealist Exhibition, which opened later that year, also included objects by Gala Dali, Agar, Sheila Legge, and several other women whose work is known today only through the objects they exhibited with the Surrealists. One of the most popular objects from the public's point of view was Agar's *Angel of Anarchy* (1936), which perfectly embodies the spirit of mysterious subversiveness and faintly disguised eroticism. The title refers to the Anarchist struggles in Spain, then widely reported in the English press; the object itself began as a white plaster cast of her husband's head. Disturbed by the purity and specificity of the object, she began wrapping it with printed scarves and embellishing it with feathers, beads, and shells. The result disturbs because, although the form remains human, we are no longer sure what, exactly, lies beneath its brilliant exterior.

Ever since the 1937 New York exhibition Fantastic Art, Dada, Surrealism, one object above all others has dominated the Surrealist imagination. Meret Oppenheim's *Object* of 1936 originated in a chance remark in a café where Oppenheim, Maar, and Picasso had met.

119

103

Surrealist objects by male artists often have an explicitly erotic content, as in Bellmer's Dolls. Hugo's 1931 object has two gloved hands holding a single die above a roulette board; eroticism and chance join forces in a moment of mystery and allure.

104

102 Hans Bellmer, *The Doll*, 1936
103 Hans Bellmer and *The Doll*, 1936, as arranged by Hans Bellmer
104 Mannequins from the International Surrealist Exhibition, Galerie Beaux-Arts, Paris 1938
105 Valentine Hugo, *Surrealist Object*, 1931

105

Picasso and Maar admired a bracelet Oppenheim had made from a piece of brass covered with fur, and Picasso commented that anything might be covered with fur. In some accounts he is reported to have mentioned a teacup specifically; Oppenheim recalls only that when her tea grew cold she requested *un peu plus de fourrure* ("a little more fur"), and an idea was born. Leaving the Café Flore, she went directly to a nearby Uniprix department store and purchased a demitasse cup and spoon. The finished object was presented to Breton for his exhibition at the Charles Ratton Gallery.

The fur-lined teacup is neither as fortuitous a discovery nor as germinal an event as recent accounts of Oppenheim's career have sometimes suggested. Perhaps these points account for some of the artist's own ambivalence toward the piece, and toward the public adulation that followed its first appearances in Paris and New York. The object is both a by-product of Surrealism's flirtation with *haute couture* in a society with a keen eye for the marketability of scandal, and a testament to the imagination of a young artist seeking artistic identity in the Surrealism of the 1930s.

By 1936 Oppenheim's father, a doctor of Jewish descent, had lost his job in Germany, and the family was unable to send money to their young daughter in Paris. Influenced by the Surrealist cult of the object generally, and by Ernst specifically, she began producing objects of her own. Ernst provided the shoes, discarded by Marie-Berthe that found their way into *Ma Gouvernante, My Nurse...* and he affirmed her search for creative sources in nature and in archetypal imagery; his presence and personal choice of the bird as an alter ego may be seen in the 1936 object *Table With Bird's Feet*, discussed in Chapter 4. But it was probably Giacometti who first encouraged Oppenheim to produce some fashion accessories and jewelry for Schiaparelli. Dali, Fini, and Elsa Triolet were already making designs and accessories and selling them to the fashion designer; Giacometti himself was earning his living designing furniture and other objects for her with his brother Diego. The Italian designer bought the first fur-covered bracelet for about five dollars; later designs were less successful and Oppenheim soon abandoned this potential means of making ends meet.

Oppenheim's *Ma Gouvernante, My Nurse...*, a woman's shoes bound together on a platter in a position simulating that of a nude woman on her back with her legs spread and "dressed" with paper frills, caused almost as much of a furor as the fur-lined teacup when it was exhibited at Charles Ratton's in 1936. To Oppenheim, the piece was a way of "getting even" with a childhood nurse by tying her shoes together; to the public its content was titillating, erotic, and bordered on the obscene. The truth probably lies somewhere in between. Both pieces are created from quite ordinary objects; both are charged with enough latent content to have led at least one critic to refer to the teacup as "the archetypal Surrealist object." But for Oppenheim, they neither led to new explorations into the use of the object as a means of subverting function and meaning, nor did they seem to integrate with her other work of that period.

However great the Surrealist love of objects during the 1930s, the reputations of Surrealist artists have never rested solely on the found objects they produced and transformed. Even as a young woman Oppenheim was not unaware of this fact.

Unable to embrace and openly acknowledge the erotic content that everyone else—Surrealists and public alike—saw in the pieces, she continued to think of herself as a painter, and the fur-lined teacup as a joke, a product of a youthful rebellion. But her paintings of 1936 were still the work of a talented student and only her so-called jokes were taken seriously. At least one New York critic attributed the teacup to "Mr. Oppenheim," but the object's enormous popularity soon thrust Oppenheim into the limelight and resulted in many requests for new objects to repeat the triumph. The publicity only depressed Oppenheim, intensifying her self-doubt and artistic confusion. She found her new public role as the darling of Surrealism difficult to accept and, by 1937, she was severely depressed. Less than a year after her triumphant "success," she left Paris and returned to Basel where she spent two years in art school but was unable to overcome the loss of direction that would keep her from working throughout much of the 1940s and early 1950s.

The fur-lined teacup takes its place in the Surrealist love of alchemical transformation: from mineral to organic matter, from the rich and sensuous to the repellent. Its erotic content arises from the richness of its visual associations and from a language that embraces the idea of "having a furry tongue." More often than not, women artists approached the issue of eroticism obliquely, focusing attention on aspects of eroticism other than woman's sexual appetites, creating works that reveal their content indirectly and that rely on disguise to obscure meaning.

There is no eroticizing of the male image by women artists comparable to that of the female image in Surrealism.[12] Fini executed a number of paintings during the late 1930s and 1940s that reveal a somnolent world of sexual transference and in which passive, androgynous male figures sleep under the watchful eyes of female divinities who convey the power of the earth and nature, of life and death (see Chapter 6). Many of these works contain parodies of sixteenth-century paintings like Cranach's *La Nymph à la Source* (1509), but replace the allegorical female 108
nude, image of fecundity and nature's bounty, with male nudes who are at the mercy of nature. Others reinterpret familiar themes, often having to do with male potency, for example *The Operation I* (1939) in which a young Delilah trims the 110
luxurious locks of a shrouded Samson. Based on reinterpretations of male and female sexual roles throughout the history of art, these paintings represent a fresh and personal look at sexual representation in the history of art, but they do not address the central issue of Surrealism: the desire to present the image of the erotic female as a key to the revolutionary transformation of consciousness.

Equally chaste and desexualized are the nude figures that appear in the paintings of Rita Kernn-Larsen, the Danish Surrealist and the only woman artist (with the exception of Nusch Eluard whose collages are discussed in Chapter 4) to include representations of the female nude in her work. In *Somnambule* (1936), an 112
academic nude reminiscent of the figure studies executed by Kernn-Larsen while a student of Leger's in Paris helps to anchor in reality the flow of images that arise from the automatic process with which she begins her work. No attempt is made to re-create the female nude as an erotic image, nor to use her as a mediator between sexually repressed, and therefore dynamic, desires and exterior reality.

THE MALE NUDE

The paintings of Colquhoun and Fini often parody the Surrealist obsession with the image of the erotic female. Fini replaces the allegorical female nudes of sixteenth-century paintings like Cranach's Nymph of the Source *with androgynous male figures. Often they sleep under the watchful gaze of female deities who represent the force of earth and nature, of life and death, as in* Chthonian Divinity Watching Over the Sleep of a Young Man. *Colquhoun's paintings suggest a mocking denial of the metamorphic process that is at the heart of Surrealist theory. In* Gouffres Amers, *death leads only to decay, and the Surrealist search for the perfect androgyne, the ultimate myth of love and mystical fusion, finds expression in* The Pine Family's *sinister hermaphroditic forms.*

106 Ithel Colquhoun, *The Pine Family*, 1941
107 Léonor Fini, *Chthonian Divinity Watching Over the Sleep of a Young Man*, 1947
108 Lucas Cranach, *The Nymph of the Source*, 1509
109 Ithell Colquhoun, *Gouffres Amers*, 1939

106

107

108

109

Given the amount of time and energy devoted to the erotic by male Surrealists, it is interesting to see how tentative are most women artists' incursions into this domain. And this suggests that Freud's writings, which played so powerful a role in the formulation of Surrealist doctrine, were of little interest to women artists. The work of the English painter Ithell Colquhoun contains several almost-mocking parodies of the Surrealist obsession with eroticism as the basis of the metamorphic process. Colquhoun was first introduced to Surrealism while living in Paris in 1931 and remembers having seen several of Dali's paintings at that time. But it was not until the 1936 London exhibition that Surrealism began to affect her own work dramatically. She attended Dali's lecture at the New Burlington Gallery and watched, fascinated, as he almost suffocated inside the heavy diving suit he had insisted on wearing for the occasion. Captivated by his remarks on paranoiac phantoms, she started to paint a series of exotic plant studies in which a magic realism began to dominate her earlier naturalism. In 1939 Colquhoun exhibited *Scylla*, painted the previous year and heavily influenced by Dali's affinity for

88

126

111

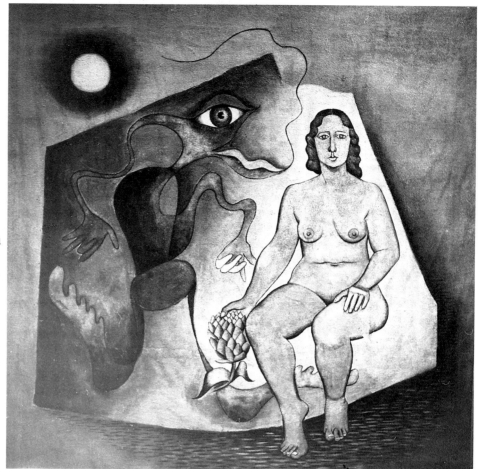

112

RITA KERNN-LARSEN

*Nude female figures appear
frequently only in the collages of
Nusch Eluard and the paintings of
the Danish Surrealist, Rita Kernn-
Larsen. In* Somnambule *and* Festen*,
academic nudes reminiscent of the
figure studies executed by Kernn-
Larsen while a student of Léger's in
Paris help to anchor in reality the
flow of images that arise from the
unconscious.*

111 Rita Kernn-Larsen, 1936
112 Rita Kernn-Larsen,
Somnambule, 1936
113 Rita Kernn-Larsen, *Festen*, 1937

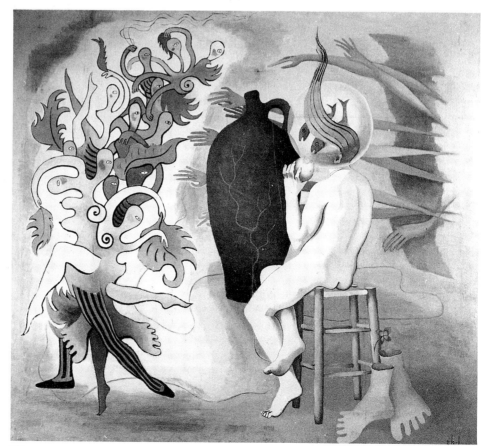

113

Ithell Colquhoun, *Bride of the Pavement*, 1942

"phantasmic presences." Dali is the source of the technique, and the personifica-tions of natural forms recall his *Metamorphosis of Narcissus* (1938) as well as Masson's female earth landscapes of the 1930s, but the element of mockery is new. The forms of the ambiguous image of a sexualized Scylla and Charybdis are reminiscent of the draped female forms of Magritte and Chirico, but their organic sexual uncertainty is devoid of life and they are more ironic than poetic.

109 The imagery of Colquhoun's *Gouffres Amers* (1939) derives from Shakespeare's *The Tempest*, but the title and inspiration come from Baudelaire's poem depicting *le navire glissant sur les gouffres amers* ("the ship slipping into the bitter whirlpool"). Many of the same images recur in Colquhoun's story "The Volcano," where:

128

… below the proud surf lie images of the perpetual terror of earth and sea … more recently the brothers from Lumio drowned in each other's clasp, the one trying to save the other—dragged from translucent depths, so fast were they locked that no one could separate their last embrace and they were buried in the one grave; and finally the corpse he had seen half-eaten by worms at the cemetery—his ribs still echo with the horror of their tawny hue.

Unlike Masson's telluric paintings, Colquhoun's work is unrelieved by any promise of rebirth and new life; here the metamorphic process glides only toward decay.

Bride of the Pavement (1942) and *The Pine Family* (1941) covertly parody the previous decade's great Surrealist myths of love. It was not unusual for English women who joined the Surrealists after the London exhibition to have had little or no contact with the Paris group. Emmy Bridgwater never met Breton and "did not feel any particular affiliation with the French group";[13] Colquhoun visited Breton at his apartment during the summer of 1939 and came away skeptical about his professed "adoration" for women, but profoundly impressed by their discussions of automatism. Her *Bride of the Pavement* develops its imagery from *sfumage*, a technique in which the surface of the work is first smoked and then allowed to suggest freely associated images. The title is a pun, a play on Ernst's *The Bride of the Wind*; its cynical matrimonial reference reappears in a painting of the same year titled *The Bride Carried a Bunch of Tethered Flies*. Colquhoun not only kept her distance from the Surrealist cult of love, but she also used it to fuel an imagery in which well-known Surrealist images and ideas are transformed, either visually or verbally, and their meaning once again inverted. In *The Pine Family*, three somewhat sinister truncated limbs, simultaneously treelike and human, lie next to one another as if freshly felled. Written labels neatly identify each grotesque form with its obscene indications of pubic hair and castration. The Surrealist search for the perfect androgyne, the ultimate myth of love and mystic fusion, finds corporeal expression here in "The Circumsized Hermaphrodite." A second limb becomes "celle qui boite," the one who limps, an ironic playing with the theme of Gradiva, referred to by Dali and by Breton in his 1937 essay "Gradiva" as "the one who advances," an epithet originally ascribed to the magnificent god of war Mars Gradivus as he strode into battle.

Colquhoun's parodies of Surrealist eroticism, exceptional in their severity and visual punning, reveal an alienation from the Surrealist cult of desire shared by other women. When it came to sharing in the collective mythology of Surrealism, women experienced themselves as outsiders. Unmoved by Surrealist theorizing on the subject of erotic desire, and by Freud's writings on female sexuality, women artists appear to have found little support for a more liberated understanding of female sexuality. Working within a Surrealist context committed them to the fullest possible exploration of their own psychic reality, and that necessarily included the sexual. Turning to their own sexual reality as source and subject, they were unable to escape the conflicts engendered by their flight from conventional female roles. Adult female sexuality necessarily includes woman's role as the bearer of life, but the imagery of the sexually mature, sometimes maternal woman has almost no

106

place in the work of these artists. Their conflicts about this aspect of female sexuality reflect the difficult choices forced upon women of their generation who attempted to reconcile traditional female roles with lives as artists in a movement that prized above all else the innocence of childhood and violently attacked the institution of family life. When the Surrealists rose up in defense of Charlie Chaplin in 1927 they bitterly attacked his wife's position "… with her two babies … which she brandishes like the filthy evidence of her own private demands.… Everything appears criminal to this woman who believes or pretends to believe that her sole reason for existence is the procreation of brats who will beget future brats.… 'What do you want to do—repopulate Los Angeles?' Chaplin asks, outraged."

The Surrealists themselves continued to marry, finding in serial monogamy a resolution of the conflict between unique love and personal liberty. But only Jacqueline Lamba and Rita Kernn-Larsen bore children during the 1930s, and in each case only one child. For Lamba, the demands of motherhood combined with Breton's insistence that his projects and desires shape their life together, effectively kept her from painting for much of the decade; she did not exhibit her work until after she and Breton separated in the early 1940s. Carrington's two children were born in the late 1940s; Miller's son in 1950. This movement that extolled the *femme-enfant* as the perfect embodiment of femininity had little room for the rigors of maternity; women who were striving to liberate themselves from conventional lives and become artists had little inclination toward domestic life with children. Agar says her resistance to motherhood dates from long before she met the Surrealists. As an adolescent she read about Malthus's ideas on the population explosion and sighed with relief at her escape: "For it was almost unheard of in those days for young girls not to want children and, as one cousin said to me, 'What else is there?'"[14] Oppenheim determined at age seventeen not to marry at all, or at least not until late in life; Kahlo looked upon Diego Rivera as a child, but thought that having a child might solidify an often tempestuous marriage. Fini has spoken eloquently of the spiritual exile from convention that made possible her creative life:

> I have never been attracted by fecundity. It is the refusal of utility: participation in the continuity of the species is an abdication. In order to have children, a humility nearly inconceivable in the modern world is necessary, a brutalized passivity or a mad pretension.… Myself, I know that I belong with the idea of Lilith, the anti-Eve, and that my universe is that of the spirit. Physical maternity instinctively repulses me.[15]

Less than positive views of maternity also carry over into the work of these artists. Oppenheim's *Votivbild (Würgengel)* (1931), a tusche and watercolor drawing executed when she was about sixteen years old, depicts a demonic angel clutching a dead baby in her arms, while *Ein Knabe mit Flügeln saugt an der enterförmigen Brust einer Frau* (1933) shows an obscene winged child attached by its teeth to a misshapen maternal breast.[16] If nothing else, these youthful works indicate an early awareness of artistic revolt as a flight from conventional life and conventional domestic roles.

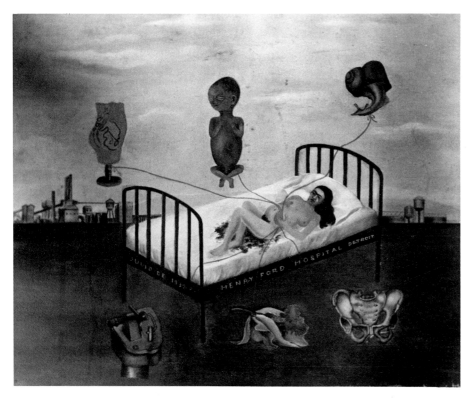

The works of Varo, Tanning, and Kahlo also contain powerful and disturbing images of maternal reality. Dorothea Tanning's *Maternity*, painted in 1946, the year that she and Ernst married and settled in Arizona, depicts a young, barefooted woman holding an unhappy child in her arms. Her gaze is vacant and introspective and the sulphurous glow that pervades the scene intensifies the feeling of isolation and alienation. A small dog with a baby's face lies on a rumpled blanket at her feet and a strange puppetlike figure with swollen breasts and belly made out of billowing sails appears in an open door near the horizon. Art historian Linda Nochlin has located the source for the mother's pose in a photograph of Tanning's own mother holding the artist as a young child,[17] but the malevolent and suffocating air that hangs over the scene is new. Tanning herself has consistently denied autobiographical content in her painting, but friends of the artist recall both her refusal to consider having children and the devotion that she and Ernst lavished on their Tibetan dogs.

118

Varo's *Celestial Pablum* of 1958 reveals a similar image of maternal isolation in the face of infantile demand. An early abortion, probably necessitated by the economic realities of her life at the time, prevented Varo from becoming pregnant again, and although she remained devoted to the children of friends and relatives, she presents here an image of the maternal woman, pale and exhausted, trapped alone in a tower room where she mechanically grinds up stars and feeds the purée to a caged moon. Tanning's and Varo's paintings are remarkable for their powerful imaging of conflicts inherent in maternity: the giving over of the sexual being to the production of milk and the nurturing of the infant, the dramatic physical changes initiated by pregnancy and lactation, the mother's exhaustion and feared loss of autonomy.

XVIII

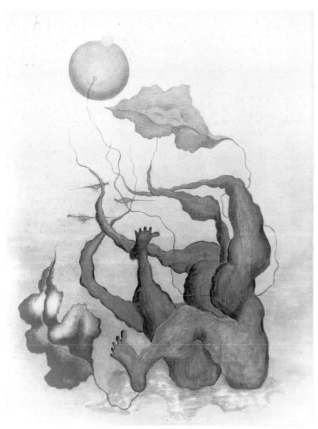

IMAGES OF MATERNITY

It was often difficult for women artists to reconcile traditional feminine roles with their lives as artists in a movement that prized the innocence of childhood and violently attacked the institution of the family. The few images of the maternal woman that appear in their paintings reveal a powerful awareness of the conflicts inherent in childbirth and maternity. And they introduce an element of erotic violence, now directed against the self, not the Other.

Kahlo's My Birth *is one of very few paintings in the entire history of Western art to depict the act of childbirth. This powerful image takes its place in an iconography that stresses the cyclical relationship between fertile eroticism and death by placing the self at the center of the cycle. Kernn-Larsen's* And Life Anew, *the first painting executed after the birth of her daughter, contains within the twisted forms of the tree a memory of the primal nature of giving birth, while Tanning's* Maternity *emphasizes the mother's frightening isolation.*

116 Rita Kernn-Larsen, *And Life Anew*, 1940
117 Frida Kahlo, *My Birth*, 1932
118 Dorothea Tanning, *Maternity*, 1946

116

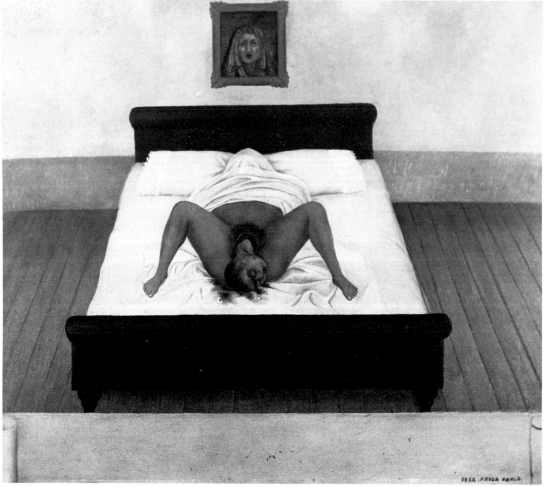

117

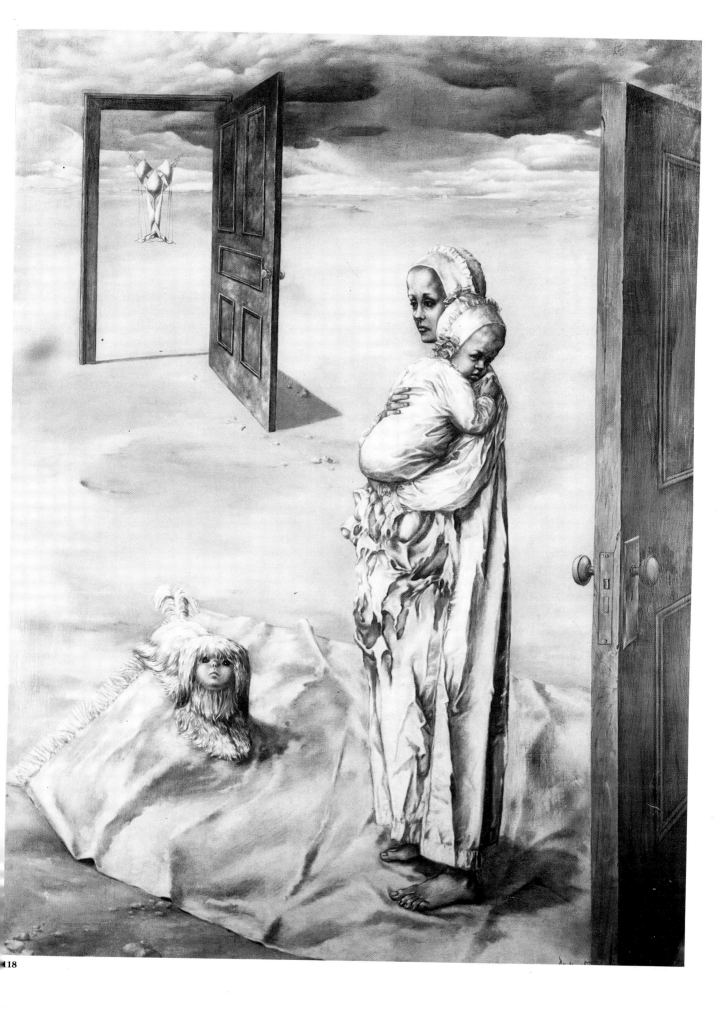

The element of erotic violence so prevalent in the work of male Surrealist artists and until now largely missing from the work of the women, makes its first appearance in this context, in the torn and shredded nightgown worn by the female figure in Tanning's *Maternity*. Here it is violence directed against the self, not the other, violence inseparable from the physiological realities of woman's sexuality. It is Frida Kahlo who elevated this violence, and the suffering it engenders, into a cycle of bloody and terrifying self-portraits in which childbirth rather than the Surrealist act of love forms the connecting link in an eternal cycle of love and death.

As early as 1932, Kahlo had expressed something of the conflict between art and motherhood when she depicted herself caught between palette and fetus in a lithograph responding to her abortion that year. A second pregnancy the same year, while she and Rivera were living in Detroit, threw her into an agony of indecision about whether to try and carry the child to term and a cesarean delivery or to have another abortion: "In the second place I am not strong and the pregnancy will weaken me more," she wrote in a letter to her doctor:

> I do not think that Diego would be very interested in having a child since what preoccupies him most is his work and he is absolutely right. Children would take fourth place. From my point of view, I do not know whether it would be good or not to have a child, since Diego is continually traveling and for no reason would I want to leave him alone and stay behind in Mexico, there would only be difficulties and problems for both of us....[18]

115 Miscarriage solved the problem and in *Henry Ford Hospital* (1932) Kahlo depicts herself naked on a hospital bed, bleeding onto a white sheet. The veinlike ribbons she holds against her swollen stomach terminate in objects symbolic of her emotions at the time of the miscarriage, one of which is a fetus. Torn between her recognition of Rivera's childlike need for her and her desire to bring life into the world, Kahlo would try three more times to have a child, meanwhile expressing her fear of barrenness in paintings dominated by immense empty plains and dry, cracked earth. Painting became her antidote: "My painting carries within it the message of pain ... painting completed by life. I lost three children.... Paintings substituted for all this. I believe that work is the best thing."[19]

Constantly aware of the relationship between her own experience of her body and her painting, absorbed by the act of creating out of suffering, she left at least one image of the physical act of childbirth that in its frankness is almost unique in
117 the history of Western art. In *My Birth* (1932), she depicts a female body in the act of childbirth from a directly frontal position. Between the woman's spread legs appears the head of the child Frida, bathed in blood and apparently lifeless. A sheet, wrapped like a shroud, hides the woman's head and upper body. Above the bed the image of a weeping Madonna, her body pierced by daggers, joins the lament. At the bottom of the canvas a scroll stands ready to receive an inscription of supplication and thanksgiving like those found on the retablos that influenced so much of Kahlo's work. But here there is to be no divine intervention, no joyous outcome, no message of thanksgiving, and the scroll is left blank.

Kahlo's awareness of the relationship between her experience of her body and her painting led her to affirm that she painted only her own reality. Exaggerating that reality, she placed her body at the center of the polarities that governed her life and her awareness: art and nature, pain and salvation, birth and death. She shared the belief of Surrealists like Masson and Bellmer, and near-Surrealists like Bataille and Leiris, that fertile eroticism and death are always coexistent: "That is to say," wrote Masson, "...[that] eroticism and death are always coexistent. That is the grandeur of eroticism."[20] In Kahlo's work this belief arises, not from the ancient Greek myths promoting the eternal and cyclical nature of life that powerfully influenced Masson and Bataille, nor from Freud's casting of this awareness into the language of a new psychological reality, but from her own cultural heritage and her identification with the Mexican belief in the indivisible unity of life and death. *The Dream* (1940) shows Kahlo sleeping in bed below a grimacing skeleton clutching a bouquet of lavender flowers in its arms. Wires and explosives encircle the skeleton's form, turning an image of death into a threat of annihilation. In the bed below, vines printed on the yellow bedspread sprout leaves that encircle the head and shoulders of the sleeping Frida. As is frequently the case in the work of the women artists, the language of generation is that of nature and the cycles of the earth's renewal, rather than that of erotic desire. In Freud's writings, *eros* transcends the specifically sexual and becomes a more generalized and powerful urge toward life in all its forms. A powerful and mysterious life force characterizes the paintings of both Kahlo and Tanning. The surfaces of Kahlo's paintings are jewellike, their forms precise and suffused with rich deep light and brilliant color. The impression is always one of confronting life, and there is a diffused sexual energy, even in the face of a specific imagery of pain and death. Her view of the universe was one of a "harmony of form and color" in which "everything moves according to only one law—life," and it is the search for this intangible law that lies at the heart of her painting.[21]

Sexuality as life force, identified with creativity, more emotional and psychological than genital, also animates Tanning's major paintings of the 1940s. In a short story titled "Blind Date" she wrote, "Today you have been born out of abysmal sorrow and knowledge, out of symbols, destructions, warnings, wounds, pestilence, instruments sacred and obscene, spasms, defilements; out of hates and holocausts, guts and gothic grandeurs, frenzy, crimes, visions, scorpions, secretions, love and the devil." Often the expression of these powerful emotions is given over to pubescent and prepubescent girls. Tanning continues to regard these paintings as the carriers of emotions that cannot be specified as sexual, but their erotic content appears undeniable.

Long fascinated by the difference between the clarity of written description and the elusiveness of visual memory, which may be simultaneously precise and vague, Tanning has situated her work at the juncture between visible reality and a convulsive emotionalism that is less easily defined. "My dreams," she remarked recently, "are bristling with objects which relate to nothing in the dictionary. On waking, they lose their clarity. Dreams one reads in books are composed of known symbols [but] it is the strangeness of dreams that distinguishes them."[22]

119

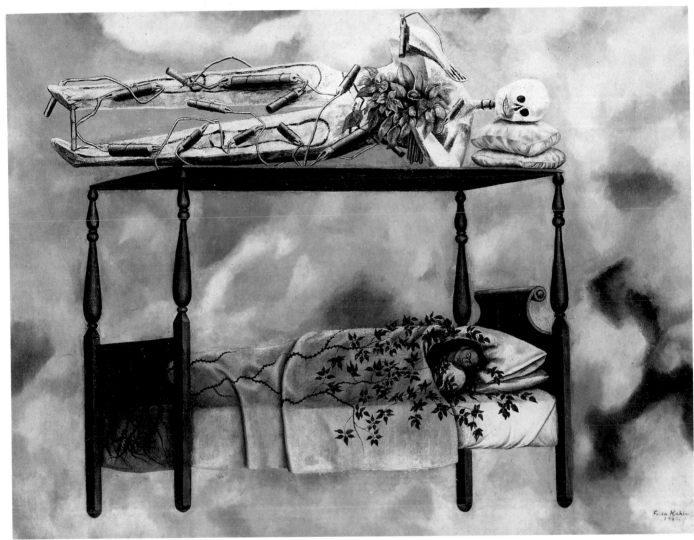

119

Kahlo and Fini shared the Surrealists' belief that fertility and death are coexistent. The eternal and cyclical nature of life was central to Surrealism but in the case of the women artists, the language of resolution and regeneration is one of nature and the cycles of the earth's renewal, rather than one of erotic desire and fusion with the loved one. In Kahlo's Dream, the artist sleeps beneath a grimacing skeleton wired with explosives while in Fini's Umbrella, a discarded umbrella decays like the vegetal matter around it.

119 Frida Kahlo, *The Dream*, 1940
120 Léonor Fini, *L'Ombrelle*, 1947

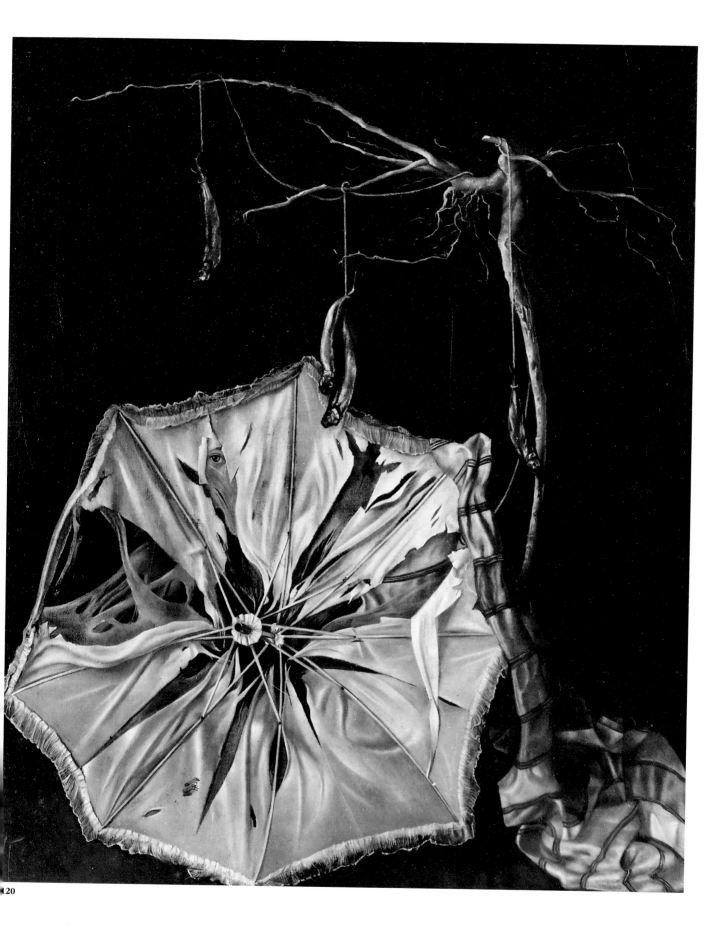

This strangeness, arising in part from the fine line Tanning treads between attraction and repulsion, between the erotic impulse as the affirmative and mentally liberating force recognized by the Surrealists and the fear that inevitably accompanies any descent into the instinctual recesses of the human mind, has permeated all of her work. For Tanning, the path into the unconscious is not the collective and well-documented journey of the Surrealists with its group productions and dictionaries of symbols, but the deeply personal and intuitive exploration of the inner life that insured her psychological survival as a child and as a young woman.

Tanning saw her first Surrealist works at the Museum of Modern Art's Fantastic Art, Dada and Surrealism exhibition of 1936. Works like Ernst's *Two Children Menaced by a Nightingale* (1924) and Pierre Roy's *Danger on the Stairs* (1927) left a clear imprint on her early Surrealist compositions. The exaggerated perspectives that Ernst derived from Chirico, and the child who swoons in response to the nightingale's sudden appearance linger on in *Children's Games*. Two nubile girls are playing with fire in a tunnellike corridor while a third, only her legs and feet visible in the foreground, appears senseless and prone. The wallpaper that these faceless young girls in their pseudo-Victorian dress tear from the walls bursts into fire that is transformed into the streaming hair of one of them and also consumes the forms of a woman's torso and pubic area revealed beneath the wallpaper that is torn away by the other. Tanning once referred to her hometown of Galesburg, Illinois, as a place "where nothing happens but the wallpaper." Here a cozy domestic image becomes the source for the powerful forces that the painter uses to propel the viewer into the unknown.

Roy's *Danger on the Stairs* provided the theme for *Eine kleine Nachtmusik* (1946) and was also an important stylistic source for Tanning's meticulous realism. Tanning removes the snake with its Freudian symbolic content, and replaces it with a torn and writhing sunflower, an image strongly identified with Tanning's midwestern origins, close to nature and capable of conveying impressions of both fecundity and menace.

Tanning's imagery fluctuates between a heightened awareness of the visible world and a sensitivity to the unconscious forces that animate and transform that world. In his essay "Surrealism: Yesterday, Today and Tomorrow," Breton once again addressed the issue of Surrealism's commitment to the complete expression of psychic reality "thanks to which there will be nothing but the dizzy descent to within ourselves, the flooding with light of our secret places and the gradual blotting out of the others: a perpetual sauntering through wide spaces hitherto out of bounds." It is these psychic forces and hidden areas of consciousness that fuel Tanning's painting. Behind every appearance lie violent winds; she refers to her birth as "a day of high wind. A regular hurricane that blew down one of the three poplars in front of our house. My mother was terrified. So I was born."[23] These winds transform the world, snatching us out of our preconceptions and whirling us into an ecstatic maelstrom, just as they rip the children from their beds and pull them into a dizzying vortex of beating wings and flying drapery in *Guardian Angels* (1946).

121 Pierre Roy, *Danger on the Stairs*, 1927

122 Dorothea Tanning, *Eine kleine Nachtmusik* (detail), 1946 XIV

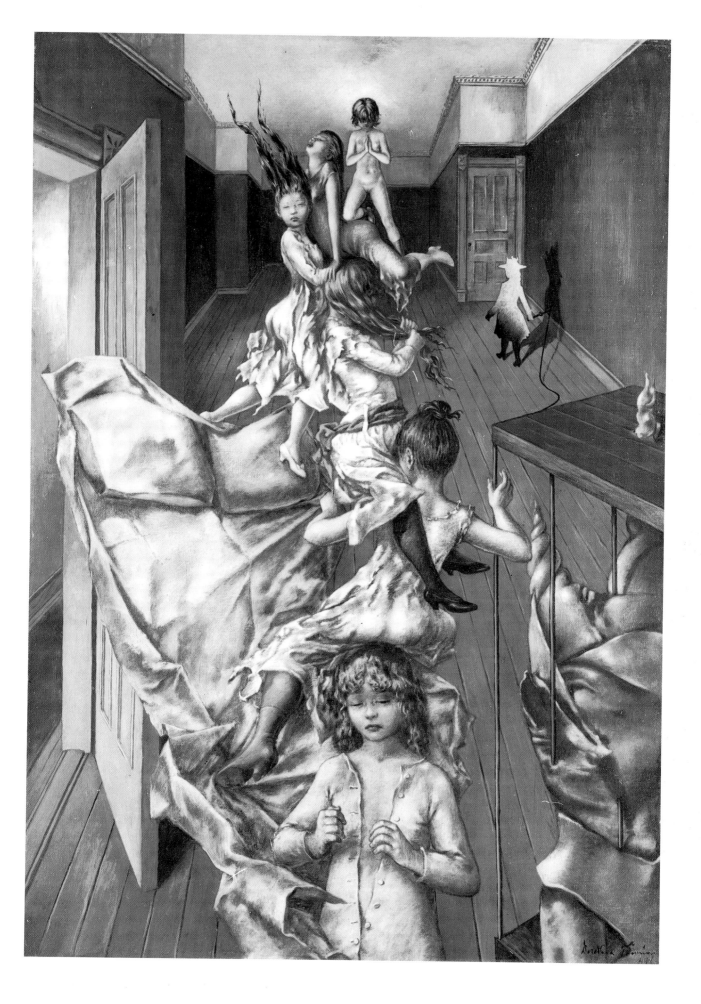

124 Tanning and Ernst at home in Huismes, France, around 1950; photograph by Lee Miller

123, 186

In Tanning's work, the body defines this violent transformation. She views these bodies as an affirmation, perhaps symbolic, of voluptuousness and of the search for a ferocious and ecstatic connection with the "marvelous." In *Palaestra* (1949) a sleepy child dressed in unbuttoned nightclothes supports a pyramid of ecstatic childish figures. At the top a naked child presses its hands together in prayer. Another naked child, somewhat older, stands at the entrance to *The Guest Room* (1950–52) gazing expressionlessly into the distance. Inside the room an adolescent girl lies sleeping, one arm flung across the body of the oversize doll that, with staring eyes and broken arm, shares her bed. In the shadowy recess behind these figures, a hooded figure balances a wand, witchlike, in one hand; in the foreground a dwarf, dressed in cowboy boots and spurs, his head obscured by a folded and draped cowl, stands beside a night table that holds four broken eggs in egg cups. The shells of these and other eggs litter the floor around the figures.

The image of the egg, pagan emblem of creation and the rejuvenation of the earth after the winter sleep, Christian symbol of the Resurrection, combines with the naked child's closed face and unseeing stare (reinforced by the blindfolded shadow that appears on the other side of the door) to form a powerful and disquieting image of the turbulence of puberty and sexual awakening. To the child's body are attached the hands and feet of the adult. The egg, a common initiation symbol in European folklore, is echoed in the dwarf's embryolike form.

The broken eggs, the maimed doll, the blindfolded figure, and the room's disorder (the crumpled rug under the bed and the agitated drapery that parodies a bridal canopy over the bed) are all evidence of struggle. But the struggle here, though it leaves signs throughout the room, is an inner struggle, the struggle between the powerful forces of emergent sexuality with their overtones of fear and danger, and the sick girl's need for dolls and bedtime drinks. The doll recalls Bellmer's *Dolls*, but his obsessive and sadistic portrayal of the woman-child as erotic seductress is transformed here into an image of slightly maimed solace. The tension between the clarity of forms isolated by harsh contrasts of light and shadow and the ominous sulphuric glow that pervades the room, along with the power of the forces unleashed across the scene, give life and meaning to the work.

The lack of an erotic pictorial language that evolved, at least in part, from woman's own experience inhibited their participation in this important aspect of Surrealism. Alienated both from conventional social roles as women and from Surrealism's cultivation of woman as *femme-enfant* or perverse seductress, they were forced either to adopt the themes and motifs of male Surrealists or to replace them with images that derived from personal experience rather than collective goals. Toyen identified free sexuality with political revolution and fused her aims with those of Štyrský; Kernn-Larsen, Colquhoun, Tanning, Kahlo, Hugo, and Oppenheim struggled to integrate the erotic into other aspects of their work. Only Fini endeavored to create a new language that spoke directly to woman's experience of her own sexual reality; it was an attempt that could succeed only by remaining independent of Surrealism.

140

My wife with the armpits of marten and beechnut
And Midsummer Night
Of privet and wentletrap nests
With the arms of the sea-surf and mill-dam foam
And of wheat and mill mixed

<div align="right">ANDRÉ BRETON, from "L'Union Libre," 1931</div>

In "L'Union Libre," Breton lyrically extolls the parts of a woman's body as herbs, fruit, trees, and plants. This identification of woman and nature is, as Xavière Gauthier points out in her *Surréalisme et Sexualité*, a theme to which he and other Surrealists poets constantly return, comparing women, especially their sexual organs, to flowers, metaphorically surrounding them with luxurious vegetation. One of Breton's rare allusions to Nadja's appearance is to her "fern-like eyes," while his last wife, Elisa, the loved woman of *Arcane 17*, has the "rosiness of flowers" and reincarnates the legendary fairy-woman Melusine.

The theme of the Eternal Feminine has haunted modern poets from the Romantics to Breton, and all Surrealist visions of woman, from the *femme-enfant* to the sorceress, converge in the image of the fairy Melusine, immortalized in Jean d'Arras's fifteenth-century account. "Melusine," wrote Breton in *Arcane 17*, "always the lost woman, the one who sings in the imagination of man ... Melusine ... it is she whom I invoke, I see that she alone can redeem this savage epoch." Part of a very old Indo-European myth, the legend of Melusine identifies the figure of woman with the mysterious forces and regenerative powers of nature, the source of the Surrealist myth of metamorphosis: "... nature is also secret forces, invisible violences, germinations, metamorphoses, good and bad omens, death, blood, the marvels of night and bad dreams," wrote Masson.[1]

According to the legend, Melusine was one of the daughters of Pressina, the mysterious fairy who married the widower King Elinas of Albania. The queen transmitted a curse of not being totally human to her daughters, dooming Melusine to a weekly return to a state of half-woman, half-serpent. Should a lover happen to see her during her day of metamorphosis, she will be forced to relinquish her human form. When the young Raimondin, son of a Breton lord and protégé of the count of Poitiers, the area of France with which her myth is most strongly identified, sees Melusine by the light of the moon near a spring and is seduced by her beauty, they marry, with one condition: that he will never try to see her on a Saturday. When the promise is broken and the secret divulged, Melusine can no longer remain among the living. Despite Raimondin's remorse, she flings herself through the window and disappears into the winds where she must wander until the end of the world.

The legend of Melusine entered Celtic myth as part of a larger body of nature beliefs centered around the worship of the being whom Robert Graves refers to as "the White Goddess." The image of the woman-serpent is bound to nature; closer kin to the human than to the animal world, Melusine concentrates the telluric forces of nature in herself. Identified with water and the spring that gushes from the earth, she incarnates the fertility of the soil and guarantees the riches of the

harvest. Mother of a large family, she insures fertility among humans. On another level, the symbolism of Melusine's transformation into a serpent that must remain hidden relates her to female sexuality and the mystery of woman's identification with hidden forces in the earth. Even the Dionysus myths reveal traces of this same symbolic language, for the god, a bull on earth, was a serpent in his subterranean, regenerating phase. Endowed with supernatural powers, Melusine holds the key to mysteries forbidden to men and inaccessible to the world of reason and logic.

As we have seen, the Surrealists had little interest in the results of actual fecundity. But they remained fascinated by and they symbolically equated an art generated from interior sources with the mysterious germinations of the natural world. "Art is a fruit that grows in man, like a fruit on a plant or like a child in its mother's womb," Jean Arp wrote in 1948.[2]

Women artists were quick to recognize and appropriate this identification between woman's creative powers and those of nature. Having little need for a magical or symbolic Other, for a Melusine or a Lilith, they identified their own psychic reality with the barren or fruitful earth. And they replaced Surrealism's concern with latent eroticism with an intuitive identification of the unconscious with a nature that is always implicitly, and sometimes explicitly, female.

> *Et cependant dessinant l'arabesque*
> *des bras des fleurs*
> *femmes bruissant de feuillages*
> *un seul luxe reste s'achevait dans les branches*
> *un seul luxe sonnait sa fine de monde. Ici ce point*
> *entre deux doigts*
> *ici la main*
> *puissant le grain*

("And yet she inscribes the curve traced/ by arms by flowers/ rustling woman of foliage/ a single remaining splendor accomplished between the branches/ a single splendor chimed its world's end. Here that point/ between two fingers/ here the hand/ shredding the grain"), wrote Valentine Penrose in one of the many poems from *Herbe à la Lune* (1935) in which the image of woman stands at the very core of nature. In his preface to the book, Eluard linked Penrose's use of language to the mysterious transformations of the natural world: "The blood trickles through the grass, is mingling with the dew, it evaporates and is replaced by the wind."

Meret Oppenheim was one of the first to identify the woman artist with these secret forces and regenerative powers. She had been named after the Meretlein or "Little Meret" of Gottfried Keller's story *Green Henry* and this fact, along with her grandmother's fantastic stories, helped to create her earliest self-image. Keller's story was based on the life of an actual eighteenth-century child who was believed to be a witch because of her unconventional ways. Beautiful, intelligent, and free in spirit, she danced naked in the woods bewitching men and wild animals. She was both admired and feared and many believed that she ensnared grown men, seducing them with a glance so that they fell in love with the child. She began to exercise evil powers over the birds, to cast spells on the fish in the water, and to

threaten the peace and security of the villagers. In the end, she experienced a magical death from which she rose to run away once more with the village children following her, before finally dying and being stroked and caressed by the children who surrounded her.

Oppenheim empathized with this "child of nature" who lived outside society until suspicious and uncomprehending man brought about her death. Among the first drawings executed after her arrival in Paris in 1933 is one called *The Abduction*, which recalls the Melusine legend and depicts a female figure in the grasp of a figure with the upper body of a woman and the lower body of a snake. Oppenheim's father had studied Jung's psychological theories and attempted to apply them to the problems of loneliness and alienation that he encountered among his rural Swiss patients.[3] As a result of listening to his conversations about Jung's ideas, Oppenheim arrived in Paris predisposed toward Jung's mythic view of archetypal male and female consciousness. During the 1930s she was virtually the only member of the Surrealist circle to choose the path of the more animistic and less phallocentric Jung over that of the favored Freud. Her predilection for nature images was further encouraged by her close personal relationship with Ernst. Both turned to the same primitive sources in nature for creative sustenance; both saw nature peopled with spirits and symbolic personages. Ernst's *frottages* and forest paintings evoke the totemic forms of nature and identify them with the forces of the unconscious; Oppenheim's objects reveal her belief in nature as the dwelling place of the female creative spirit. "Woman is close to the earth," she remarked in an interview in 1973, after a period of Jungian analysis had further confirmed her youthful direction. "One could imagine that the first state was matriarchal.... And the big old snake Nature in the Tree of Knowledge told Eve to give the apple to Adam (she eats too!). The old snake Nature wanted him to take the way of intellectual development. Eve has been damned, and the snake with her—by men."[4]

Millennia before the serpent was given an evil reputation by the patriarchal gods of Olympus, it was widely revered as the divine aspect of Nature and, as we have seen from the Melusine cycle, an image of fertility. In a poem from *Herbe à la Lune* that celebrates woman's mystery and autonomy, Penrose places this image in a magic circle:

> *en cercle*
> *touchera le serpent touchera le rocher*
> *au fille de la terre*
> *au ciel son capricorne*

("in a circle/ it will touch the serpent touch the rock/ daughter of the earth/ at her zenith the capricorn").

A linear coil, the abstract and archetypal sign of the snake, appears in Oppenheim's object *The Green Spectator* (1933) where it combines with the two budding horns of a ram or bull, the goddess's male consort. The object's title may refer to Keller's *Green Henry*, the source of the Meretlein image and itself related to the Celtic nature image of the Green Knight or Green Man of the Forest.

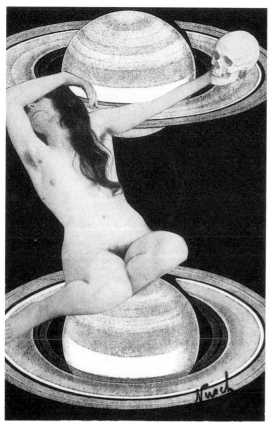

125

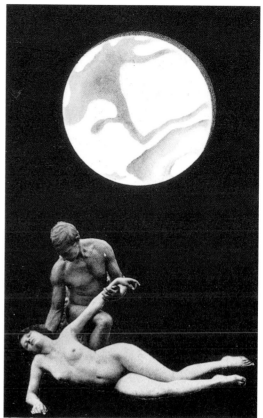

126

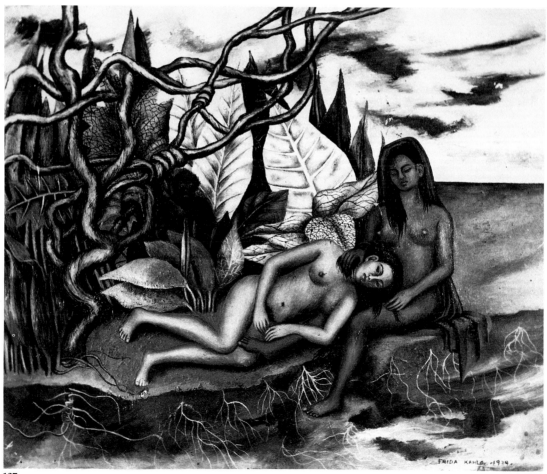

127

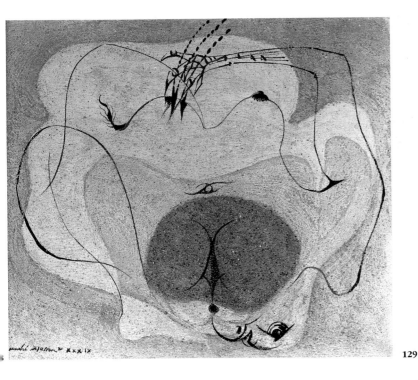

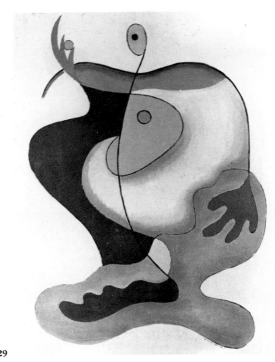

129

NATURE AS METAPHOR FOR WOMAN'S REALITY

Masson's The Earth, *an automatic drawing, depicts the sensuous contour line of a female body which is also the contour of the earth itself, redolent with associations of fertility and death. Kernn-Larsen's femme-arbres, Eluard's collages, and the many paintings by Kahlo that identify her self-image with the nurturing and binding aspects of a fertile nature reveal a more personal identification between woman's reality and the forces of nature. Intuitively identifying the unconscious with a nature that is always implicitly – and sometimes explicitly – female, women artists found a powerful metaphor for artistic creation in the mysterious germinations of the natural world.*

125 Nusch Eluard, *Photo-collage, c.* 1935
126 Nusch Eluard, *Photo-collage, c.* 1935
127 Frida Kahlo, *Two Nudes in a Forest,* 1939
128 André Masson, *La Terre,* 1939
129 Rita Kernn-Larsen, *The Apple,* 1934
130 Rita Kernn-Larsen, *Les Deux Demoiselles,* 1940

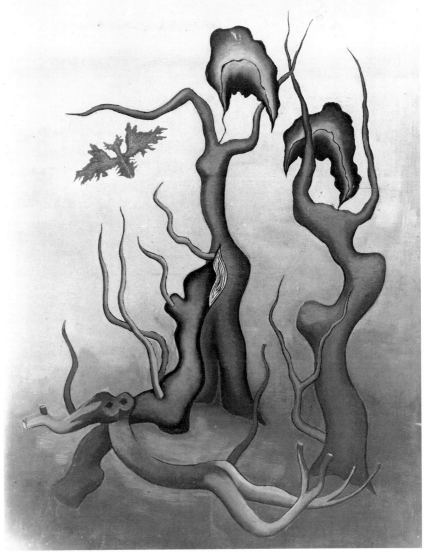

In a similar fashion, Oppenheim's *Primitive Venus* (1933) recalls the prehistoric fertility rites associated with stone carvings like the well-known Willendorf Venus, while her *Table With Bird's Feet*, an object created for Leo Castelli and René Drouin in 1939 and reflecting the influence of Ernst's bird paintings and collages, mingles the images of nature with man-made archetypal forms like the circle.[5]

125, 126

A series of photocollages produced by Nusch Eluard around 1935 further confirms this intuitive identification of woman with the forces of nature. Urged to write down or make drawings of her dreams during a period of troubled sleep, she chose instead to visualize them through the medium of collage, a technique Paul Eluard was also using at the time. In each of her collages, a nude female figure is the focal point of the composition; and in each of them plant and animal life, the planets and the stars, revolve around her supine form. There is a dreamy, hallucinatory quality to the imagery, but the overwhelming impression is one of nature animated by *eros*. Whether caressed by a male lover or recoiling from an image of death, the women in these collages reflect, and are reflected in, the movements of the heavens and the languid transformations of nature.

Surrealism's desire to project psychic reality onto the natural world, to transform landscape according to the dictates of inner life, was curiously inverted by English Surrealist painters. More often than not, their work uses the forms of the natural world as a source, eliciting from them disquieting or disturbing moods and feelings in a manner that some have argued is more akin to Romanticism than true Surrealism.[6] In his preface to the 1936 London exhibition, Herbert Read went so far as to argue that Surrealism was quickly acclimatized in England precisely because English audiences, steeped in the work of the nineteenth-century landscape poets, were already thoroughly familiar with a program that reasserted the primacy of feeling over intellect, emotion over reason. The pivotal figure in the English group's identification of emotion and feeling with the forms and forces of the natural world was the painter Paul Nash, whose interest in nature objects, animism, and the "spirit of place" led him directly, if somewhat reluctantly, to Surrealism. His visionary landscapes, beginning around 1928, expose the power of nature to stimulate and reveal, and form the most direct link between the work of the Romantic school of English landscape painting and Surrealism. He wrote in an autobiography published in 1949:

> It is unusual in English Surrealism for the place to provide the phenomenon....
> But here in the Avon Gorge, I had no doubt whatever that it was the natural
> features and spirit of the place that inspired irrational dreams ... these elements
> (of nature) brewed a magic for the imagination which mounted to the brains of
> prosaic engineers unsettling their equilibrium and releasing into their troubled
> thoughts poetic visions and schemes of paranoia.

If Nash's ideas are closer to Wordsworth's notions of the influence of site than to the Surrealist idea of paranoia, they nevertheless laid the groundwork for an animistic view of nature that profoundly affected the work of Agar and other women painters of the English Surrealist group. Agar met Nash in 1935 while he was living on the Dorset coast, painting, and working on the essay "Swanage or

Seaside Surrealism" (published the following year in *The Architectural Review*) in which he documented his discovery of the Dorset coast as surrealist in its disquieting and dreamlike aspects. "It has a strange fascination like all things which combine beauty, ugliness, and the power to disquiet," he wrote.

Agar settled in Swanage for the summer because, as she later recalled, "a great many of my childhod memories were sunk in Dorset."[7] Introduced to Nash, she was surprised when he seemed to know her name because at that time she had exhibited only at the London Group where Henry Moore had made her a member in 1933. Nash, who was then compiling a shell guide of Dorset, began bringing her curious stones that he picked up on his beach walks. They quickly found their way into her first objects as did "a long snaky monster with a bird's beak clothed in stones, shells, and all sorts of marine accretions" that she uncovered while digging in the sand one day. "It was an old anchor chain, metamorphosed by the sea into a new creation, 'a Bird Snake' or, as Paul called it, a 'Seashore Monster.' The sea and the land sometimes play together like man and wife, in order to achieve astonishing results. I did a watercolor of it and Paul put it into one of his photo collages."[8]

Agar's painting had already shifted from the straightforward portraits of the late 1920s to creations with a more lyrical and imaginative content. An earlier visit to Paris had inspired the transition; the meeting with Nash confirmed the new direction and helped her anchor it in nature as well as the imagination. Two objects fashioned in 1936, *Precious Stones* and *The Wings of Augury*, mingle references to nature, in the form of marine objects collected in Dorset the previous summer, with allusions to classical civilization. Agar's world of nature, its roots deep in the classical tradition, sustains a strong mythic dimension. Her paintings of the 1930s and 1940s include *The Centaurs* (1943), *Mythological Landscape* (1938), and *Aegean Pastoral* (1944) and, although the genesis of her works is frequently automatic, her colors often combine a Mediterranean intensity with a vivid personal sensibility that inclines toward rich hues and acid tonalities. In paintings like *Winter* (1935) (exhibited the following year in the London Surrealist exhibition) and *The Garden of Time* (1939/47) fragments of the past combine with memory shapes of flowers, fruits, and leaves. An oblique and fragmentary quality pulls the spectator into enchanted gardens in which allusions to germination and decay combine with a mythic sense of time and history. In *Garden of Time*, references to past civilizations reside in pieces of human bone juxtaposed with mythical animals and lush vegetation. In her unpublished autobiography, Agar locates the sources of these paintings in a mystical communion between nature and human sensibility:

136

135

> You see the shape of a tree, the way a pebble falls or is formed, and you are astounded to discover that dumb nature makes an effort to speak to you, to give you a sign, to warn you, to symbolize your innermost thoughts.
>
> I am a secret painter, painting for me is a very private occupation, I hardly like to talk about it, it is something that germinates like a seed, in the dark soil and recesses of the living coral of the mind.... They [paintings] grow like a plant, slowly putting out shoots, they need pruning, meditating on, while the roots grow in the dark.[9]

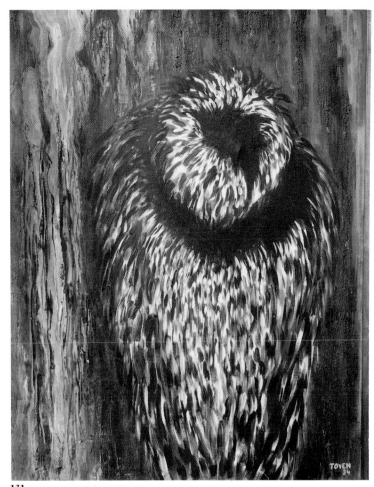

THE FEMALE EARTH

The search for correspondences between the unconscious and the natural world pervades the work of many women artists. Toyen's Voix de la Forêt *characteristically establishes mysterious connections between nature's pulsating forms and inner states of feeling, while in* Roots, *Kahlo's blood nourishes the barren earth and leaves sprout from her veins. Attracted by disquieting forms in nature, Agar took up photography while on holiday in Brittany in 1936, and Miller escaped Cairo's confining upper-class social life by going into the desert with her camera.*

131 Toyen, *Voix de la Forêt*, 1934
132 Frida Kahlo, *Roots*, 1943
133 Rocks, Ploumanach, Brittany, 1936; photograph by Eileen Agar
134 Egypt, near Siwa, 1936; photograph by Lee Miller

131

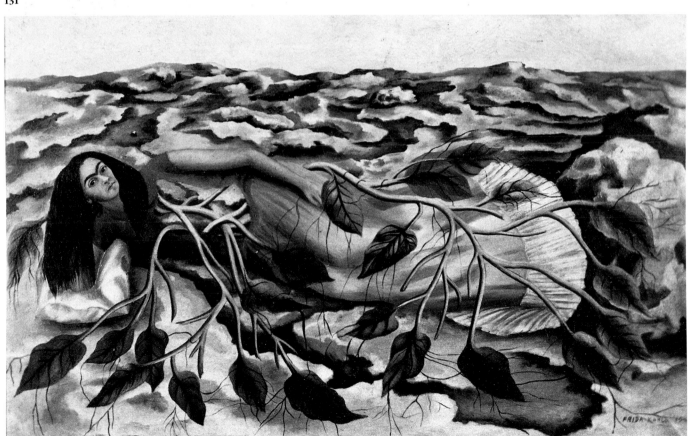

132

133

134

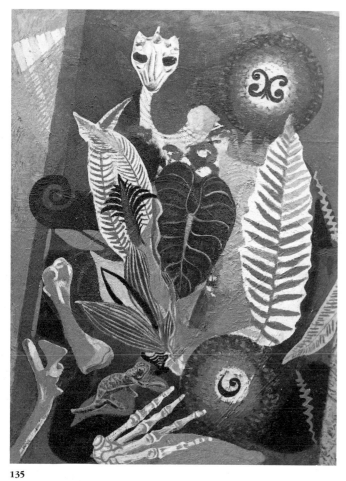

135

136

137

135 Eileen Agar, *The Garden of Time*, 1939/47
136 Eileen Agar, *The Wings of Augury*, c. 1936
137 Eileen Agar, *The Muse Listening*, 1934
138 Eileen Agar in her studio in 1938

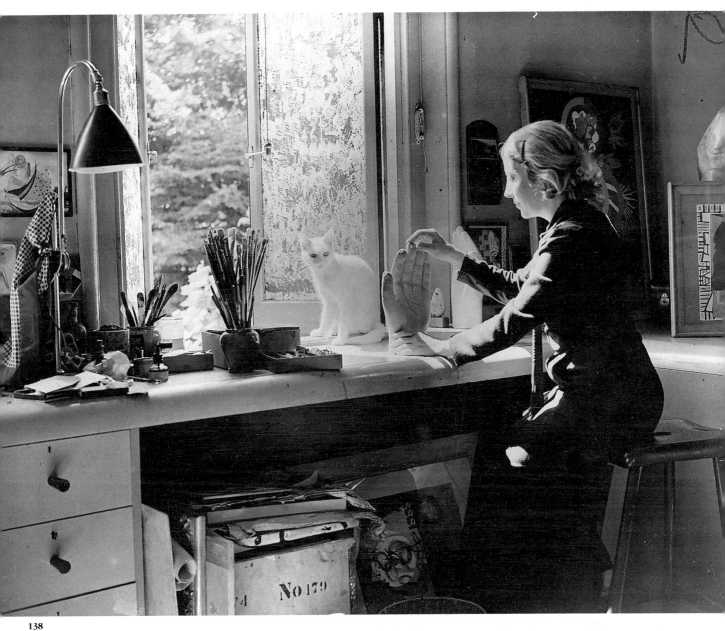

138

EILEEN AGAR

Agar's style had already begun to move away from the straightforward portraits of the 1920s when she met Paul Nash; influenced by his work, she began to look to nature for inspiration. She started making marine objects while spending the summer of 1935 in Dorset, near where Nash was living. In her paintings, she began combining references to the classical past with mythical animals and lush vegetation.

139 Ithell Colquhoun, *Sea-Star I*, 1944

Others were quick to recognize Agar's grasp of a metaphor that beautifully expresses Surrealism's search for a language that gives form to an inner life that can only be evoked, never described. Nash, in his foreword to her 1942 exhibition at London's Redfern Gallery, referred to the "element of poetic mystery" that lurks in these landscape forms. "Her figures are interwoven with patterns reflected from the kaleidoscope changes of the world around them," wrote Penrose who, with Read and Nash, was instrumental in bringing her into the Surrealist circle; "As they dance together they penetrate body and soul."[10]

It was the English painter Ithell Colquhoun who transformed this identification of woman's creative powers with those of generative nature into an intuitive alchemy of natural forms. Her paintings, based on automatic processes, and her writings, which use natural forms as a starting point for divinatory explorations, make a strong argument for the woman artist's tendency to link the unconscious with the mythic power of an occult nature rather than with latent sexual desire. During the summer of 1939 Colquhoun visited the Bretons at 42, rue Fontaine. She found the walls of the small apartment covered with Surrealist works and cases of tropical butterflies. A new group of young painters, including the young Chilean Roberto Matta Echaurren, now surrounded Breton; once again discussions centered around automatism, and a Surrealist technique they called psychomorphology, which Colquhoun recalls as "an effort to tap that level of consciousness sometimes perceptible between sleeping and waking which consists of coloured organic (non-geometric) forms in a state of flux."[11]

From the beginning, Colquhoun's work had shown a strong predilection for the study of natural forms and a profound, almost pagan, appreciation of landscape. "As I was scrambling over the rocky ridges of a valley I came upon a wide fissure slanting down towards the centre of the earth," begins one of her Surrealist texts published in *New Road* in 1943. It is a journey fully cognizant of the chthonic origins of woman's legendary power:

> I looked in and found that its distant floor was water. I began to climb down inside, taking hold of a natural bannister here, stepping on an un-hewn stair tread there, which the uneven surfaces provided. This descent was not easy, as the rock was green with damp and patched with a viscous wine-coloured growth.
>
> I had now penetrated to a vertiginous depth; if I looked upward, the walls rose above me in a cool shaft; turning downward, I could see a cave filled with water the colour of crysolite, illumined from some hidden source and darkened where a turn of wall or jutting rock threw a shadow. . . .

This symbolic journey deep into the earth leads Colquhoun to a point at which earth and sea blend together and fantastic fishlike flowers grow directly from stones. She pursued this submarine iconography in a novel titled *The Goose of Hermogenes*, written during the 1940s but not published until 1961 and inspired by her interest in alchemy and the occult, and in paintings like *L'Ancre* and *L'Helice*, both executed in 1939, in which she fixes marine and navigational images with the precision and clarity of a Dali or a Magritte.

153

Colquhoun believed that it is through the exploration of the unconscious and the projecting of the dream state into reality that the artist reaches new levels of creative imagination. During the early 1940s, influenced by her earlier discussions with Breton, she began to experiment with automatic techniques as a means of releasing images from the unconscious. She used *sfumage* or smoking, *decalcomania*, and *frottage* or rubbing as the initial sources for abstract forms that could then be elaborated by the conscious mind. "It is only at the approach of the fantastic, at a point where human reason loses its control, that the most profound emotion of the individual has the fullest opportunity to express itself," she wrote in 1947. *Sea-Star I* (1944) and *Guardian Angel* (1946) began as *decalcomania*, in which paint-covered sheets of paper or canvas are pressed together and then pulled apart to reveal the imprint of a richly textured surface. Both paintings reveal forms hallucinated from an abstract landscape similar to that of Dali's *paranoiac-critical* paintings, but Colquhoun leaves the image in a semiabstract state suggestive of natural forms and makes no attempt to realize it in a veristic manner.

139

With her publication of "The Mantic Stain" in the October 1949 issue of *Enquiry*, Colquhoun became one of the few women to contribute a theoretical text to Surrealism, and the first Surrealist to write at length in English about automatism. However, by the time she published "The Mantic Stain" she had left the English Surrealist group to pursue her occult investigations independently. The starting point for Colquhoun's discussion is the example of the stained wall recommended first by Leonardo da Vinci, and later by Ernst, as a source for visual hallucinations. Staring fixedly at the stained surface, da Vinci suggests in his sixteenth-century *Treatise on Painting*, the observer will begin to see all manner of strange and wonderful forms. Similar automatic techniques, developed by the Surrealist group in Paris during the 1920s, are later revived by Colquhoun. But in pursuing the mantic or divinatory characteristics of the stained surface, and in proposing a kind of visual alchemy of transformation, she elaborates a position new to discussions of automatism. She concludes that the Surrealist practice of automatism is close to that of the clairvoyant who turns to ink splashes, sand, tea leaves, or a crystal globe, "and all have an august ancestry in that they are traceably allied to the 'great work' of alchemy. The Reign of the Moon," relates the seventeenth-century alchemist Eirenaeus Philalethes in *An Open Entrance to the Closed Palace of the King*, "lasts just three weeks, but before it closes, the substance exhibits a great variety of forms; it will become liquid and again coagulate a hundred times a day; sometimes it will present the appearance of fishes' eyes, and then again of tiny silver trees, with twigs and leaves." Colquhoun derives her identification of the automatic techniques of *sfumage, écremage, decalcomania*, and powdering, with the four elements—earth, air, fire, and water—from this and other alchemical texts.

Emmy Bridgwater was another English artist who shared Colquhoun's belief in automatism as a means of capturing the phenomena of the natural world in a constant state of metamorphic transformation. She joined Mesen's group in London around 1940, collaborated on the reviews *Arson* and *Free Unions Libres*, and contributed work to the 1947 exhibition at the Galerie Maeght in Paris. Her automatic texts, for example "The Birds," are visionary narrations peopled with

AUTOMATISM, DIVINATION, AND NATURE

Bridgwater, Lamba, and Rahon used automatic techniques to liberate the imagery of the unconscious, and they recognized the affinity between automatism and the mysterious transformations of matter and form that take place in nature. In the 1940s when she was living in Mexico, Alice Rahon Paalen began chipping paint from Paalen's old palettes and using it as a ground on which she scratched visionary landscapes. Bridgwater contributed automatic stories and drawings to English Surrealist publications during the 1940s.

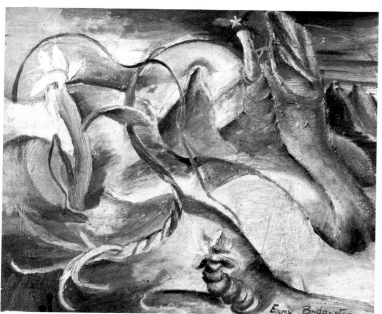

140 Alice Rahon Paalen, *Crystals of Space*, 1943
141 Emmy Bridgwater, *Remote Cause of Infinite Strife*, 1940
142 Alice Rahon Paalen in Mexico in 1944

143 Edith Rimmington and Emmy Bridgwater *c.* 1976

spiders and birds of the kind that haunt the dreams of children. Younger than many of the artists already discussed, and a later adherent to Surrealism, she was less influenced by the illusionism of Dali and Magritte that dominated Surrealist painting in the early 1930s and, like Colquhoun, more directly affected by the late 1930s renewed interest in automatism. Her *Remote Cause of Infinite Strife* (1940) relies on a ropy automatic line not unlike that of Masson's early automatic paintings to suggest the energy of conflict and transformation. Amidst a dense bright surface, and against a landscape of mountainous forms and furrowed fields, vivid flowers spring to life as if in response to an unseen hand cracking a seasonal whip.

The psychomorphologies of Matta and Paalen also influenced the work of Jacqueline Lamba and Alice Rahon Paalen, a poet who while living in Mexico in the 1940s began scraping the leftover paint from Paalen's discarded palettes and using it as a ground on which to scratch visionary landscapes. Lamba's painting of the 1940s also has something of this visionary quality though its origins are quite different. Her landscapes, or moonscapes, contain the shattered prismatic forms familiar from Matta's painting of the early 1940s, but they are based on a clearly articulated desire to build an abstract language of space and light out of automatism, which she viewed as the key to successful communication. "This key," she wrote in 1944, "in liberating the unconscious, must yield the most coherent message of emotion." After looking at the individual properties of light, space, and object, she concludes that "the secret would be to capture on canvas each form in its special light, that is to say at the precise moment in which the light becomes form. This would be like seeing a rainbow in the fullness of night."[12] Like Colquhoun, Lamba recognized an affinity between automatism, used as a device for freeing the unconscious to release its images, and the mysterious transformations of matter and form that take place in nature. As crystals become liquid and fire smoke, so do the tendrils of memory, dream, and reflection intertwine in the unconscious to form new images.

Equally fascinated by the process through which the unconscious erupts into the world of nature, Rita Kernn-Larsen and Edith Rimmington conceptualized this mental journey using not the metaphor of the hero's advance into the labyrinth found in the work of Breton, Masson, and others, but that of the sea, surrounding the unconscious with a watery bath capable of giving birth to works of art rather than to goddesses of love. Kernn-Larsen used aquatic terms in describing the path by which material from the unconscious works its way into the painting:

> One time I was on vacation in Normandy with my husband, [and] an equinoxial storm had drowned two men. It was a small village and I remember how they searched with lanterns. It was lugubrious.... Some months later (after I had forgotten this event) I made a work [*Fantomer*] ... where two forms like fish, descend into the water, into depths marked by horizontal bands of different colors, which no doubt recalls this event.[13]

147 Rimmington's *Oneiroscopist* (1942) may contain a reference to Dali's famous London appearance dressed in a diving suit, but its Surrealist content resides in the fantastic biomorphic image of the birdlike creature preparing for its descent into

156

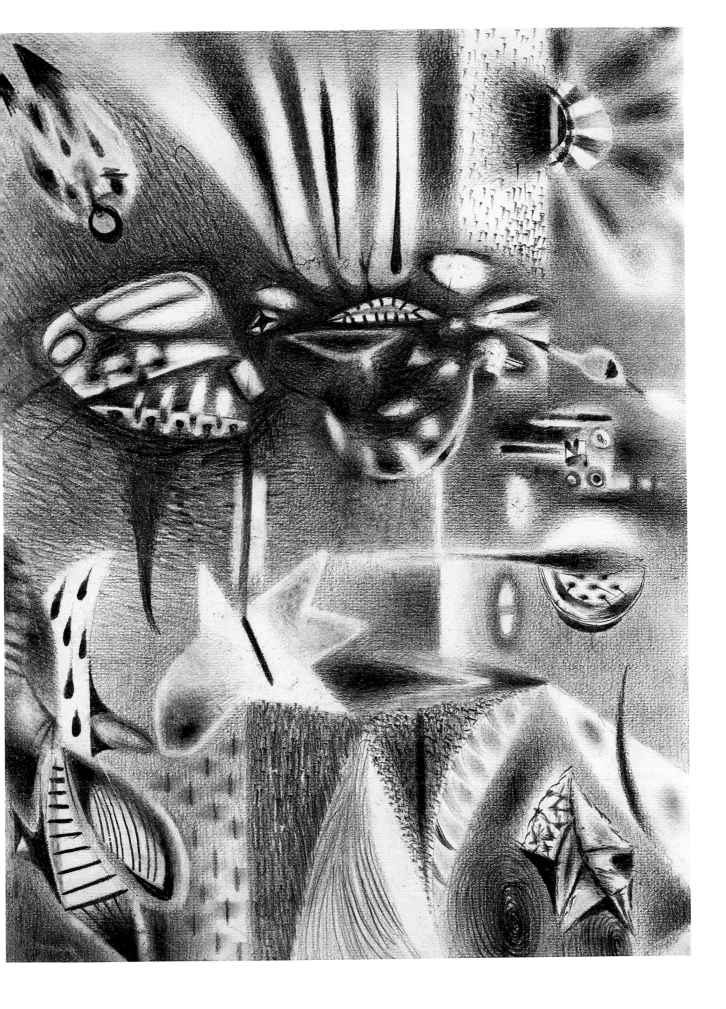

the world of the dream. The skeletal feet recall the oracular use of bones in ancient civilizations; the shapeless cloak confirms the figure's associations with divination and the joining of nature and psychic reality that take place in this process.

It is not only woman's psychic life that is identified with the forces of nature in the work of women artists associated with Surrealism. Nature as a sexual metaphor, or a context within which female sexuality may be freely expressed, pervades the painting of Frida Kahlo. In *Two Nudes in a Forest* (1939), a tapestry of exotic foliage forms a verdant backdrop for the figures of two nude women, one of whom caresses the other. Like many of Kahlo's paintings, the work is concerned with dualities: the large, leafy forms are paired, the women share similar features, though a disparity in flesh tone marks one as more Indian, the other as more European, a duality shared by Kahlo whose roots lay in both cultures. The painting alludes to Kahlo's lesbianism, or bisexuality, a subject discussed by Herrera in her biography of the artist, but nature's involvement here lends the caress an uneasy flavor. As the lighter-skinned figure presses her knees together and cups a hand around her genitals as if shielding her sex, the cutaway earth in front of the figures isolates them as if on an island, disconnected and awkward. The branches of the vines and trees behind the figures wrap together in a strangling embrace, a monkey witnessing the scene from behind a tree appears shocked by what he sees, and nature stands a silent, perhaps even brutal witness (the stripped ground exposes veinlike roots that have been torn from the earth) to a gentle caress.

The tension between nature and sexuality finds more explicit expression in works like *Flower of Life* (1944) in which tropical flowers are transformed into male and female genitals in an explosive encounter witnessed by the moon, and by a jagged streak of lightning in the heavens. The sexuality expressed in these and other paintings is more than genital sexuality; it is an all-pervasive sense of life communicated through the use of rich dense color and vibrant atmosphere, an assertion of the act of painting itself as an act of love that connects the artist to a living, breathing nature. In a work on a similar theme by the English painter Emmy Bridgwater, titled *Budding Day* (1948), a woman's head, surmounted by two cooing lovebirds, becomes a solar image of rejuvenation; while in Kernn-Larsen's *And Life Anew* (1940), the first painting executed after the birth of her daughter, the twisted and tormented tree trunk arises as an unconscious memory of the act of birth.[14]

Kernn-Larsen pursued the theme of the *femme-arbre* throughout her Surrealist period. Influenced by the Danish Surrealist Freddie, as well as by Ernst and Tanguy, her *femme-arbres* reflect an appreciation for the densely wooded landscapes of northern mythology and display a close kinship with Delvaux's paintings on the same theme. "I had made a drawing of a tree," she later recalled in an interview, "which little by little became a *femme-arbre* who wished to liberate herself. This had a double meaning: I wanted to liberate myself from Surrealism or perhaps from the composition of Leger...."[15] In *The Primrose Path* (1938), woody knots in the bark of a tree are transformed into eyes and then eggs, recalling Ernst's use of the eye/egg image as a metaphor for the generation of an image from an interior source, while in *Les Deux Demoiselles* (1940), sprouting twigs and branches gradually transform the image of the tree into that of a woman.

SUBMARINE SOURCES

The work of many women artists acknowledges the chthonic origins of woman's legendary powers. Colquhoun pursued a submarine iconography in paintings like L'Ancre *and* L'Helice *(both 1939) and in an occult novel titled* The Goose of Hermogenes. *Kernn-Larsen and Rimmington conceptualized the Surrealist's mental odyssey using a new metaphor, that of a descent into the depths of the sea. Kernn-Larsen has said of* Spejlets Revers: *"It is surely related to myself descending into the unknown behind the mirror."*

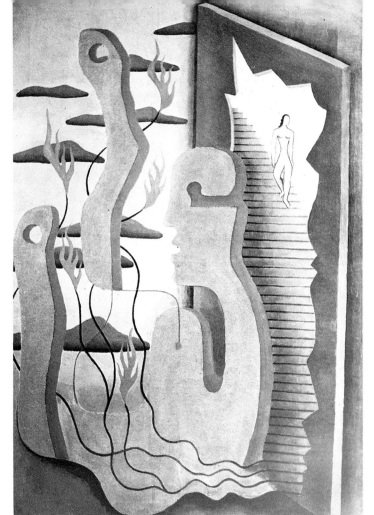

145

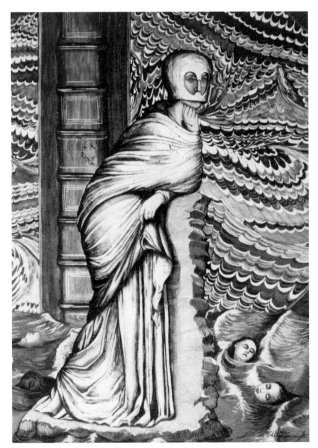

146

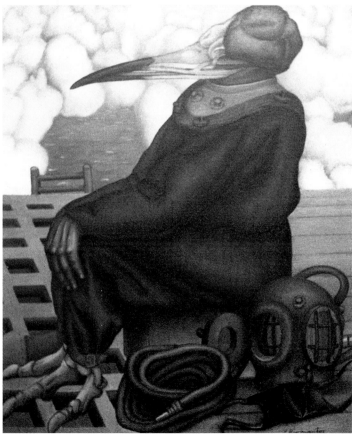

147

145 Rita Kernn-Larsen, *Spejlets Revers*, 1936
146 Edith Rimmington, *Washed in Lethe*, 1938
147 Edith Rimmington, *L'Oneiroscopist*, 1942

Kernn-Larsen met Peggy Guggenheim in Paris in 1937 and was invited to exhibit at Guggenheim's London gallery the following year. The exhibition opened in June and coincided with an exhibition by Paul Delvaux at E.L.T. Mesens's London Gallery next door. "He [Delvaux] came to my vernissage," Kernn-Larsen recalls, "and during the lunch he made me a very nice drawing on the back of my invitation card, a naked woman with feathers in her hair, lying near the sea."[16] Among the paintings Delvaux exhibited that year were several on the theme of the *femme-arbre*, paintings that recall Masson's female landscapes in their specific identification of woman's body with natural forms.

Woman's lunar and reproductive cycles have long fascinated male artists and poets who have often turned their backs on the physical and psychological realities of these biological facts in order to invest them with a mythic meaning that may deny woman's real experience. The self-portraits of Frida Kahlo redefine this romanticized vision of woman as nature goddess by mocking its simplistic vision. In *Self-Portrait* (1940), painted the year of her divorce from Rivera, and in *Tree of Hope* (1946), she places herself at the center of a group of images that symbolically play out a cyclical drama of life and death. The foliage behind the tired and worn image of Kahlo in *Self-Portrait* is lush and bursting with life, but a dead hummingbird, an image with which she often identified, hangs from a tangle of thorny branches that bind and pierce her neck. Blood drips from her wounds and the brambles, like veins, trace the flow. This pattern is repeated in the transparent wings of the dragonflies and foliage behind the figure. While a black cat stares at the dead bird with predatory fascination, Kahlo's pet monkey perches behind her other shoulder, a creature of the jungle braiding the thorns that bind her image. This image of Kahlo at a moment of deep personal loss reads as an image of life about to be choked off and bled dry. In *Tree of Hope* (1946), Kahlo's experience of the polarities of her life is reflected in the appearance of the sun and moon, a duality that first appears in *Self-Portrait on the Borderline Between Mexico and the United States* (1932), painted after watching a solar eclipse in Detroit and reflecting the Aztec notion of the eternal war between dark and light. In ancient Mexican mythology, as in that of many Indo-European cultures, the sun is a masculine principle, the moon female. Kahlo depicts herself twice in *Tree of Hope*. As the sun beats relentlessly down on the cracked earth and on Kahlo's cracked body lying on a hospital trolley, its scarred back exposed and dripping blood, the moon illuminates the sexually alluring Kahlo, dressed in Tehuana dress and made up as if for an evening of pleasure. Kahlo's life as a wounded figure at the mercy of male doctors and hospital technology is placed under the sign of the sun; the sexual Kahlo, although she shows evidence of the orthopedic corset that supported her spine, lives under the domain of the moon. In her hand she holds a banner bearing the words from the first line of a song she liked, "Tree of Hope keep firm."

Kahlo's obsession with her own physical reality dominates her self-identification with nature. In *Roots* (1943), she depicts herself lying at the intersection between barren and fertile nature. The land behind her body lies fallow, but green vines and leaves spring from her heart and womb while blood drips from the leaves into veins that take root in the soil in front of her. Here woman nourishes the earth with

160

her own body, rather than the more conventional reverse, and Terry Smith has convincingly argued that *Roots* is a deeply ironic variation on Diego Rivera's mural *The Fertile Earth* (1926–27), at Chapingo, and a biting commentary on fertility and nature.[17]

There are, in fact, many works by women artists that reject conventional designations having to do with nature as female and nurturing. Agar and Miller were both attracted to bizarre and unusual forms in nature, Toyen saw it as a political metaphor for man's inhumanity, and Sage turned it into a mirror, reflecting back an uncompromising vision of psychic aridity.

The sight of strange rock outcroppings near Ploumanach in Brittany moved Agar to purchase a camera and temporarily shift her attention from making Surrealist objects to recording nature in some of its more bizarre manifestations. She had left London in July 1936, after the closing of the Surrealist exhibition at the New Burlington Gallery, and had her first view of Ploumanach's megaliths from the window of a train:

> They lay like enormous prehistoric monsters sleeping on the turf, above the sea, a great bum ending in an enormous thumb, or a gigantic head tuned with organ pipes, a crowd, or a foot rearing up like a dolmen, all sculpted by the sea that master worker of all time. Our surprise and delight at the discovery came as a bonus after the excitement of the exhibition in London. It was as if nature had arranged a show of sculpture in the open air by the sea, just to show these mortals what she could do.[18]

Purchasing a Rolliflex, she began to photograph, often capturing in a single photograph the discordant images of prehistoric nature and contemporary holiday life. "For me, photography has always meant truth to the objective image or reality, while painting should lean toward the beauty or ugliness of the subjective idea or symbol," she later recorded.[19] The photographs taken at Ploumanach recall the eroded and sea-washed rocks on the beach at Port Lligat that stimulated many of Dali's paranoiac visions, but in Agar's photographs natural forms are unaltered. Although quick to capture bizarre form and fortuitous juxtapositions, she reveals herself responding to nature rather than projecting her dreams or fantasies onto it.

Miller's visualization of space took a more abstract form. After leaving Paris in 1932, she had opened a photographic studio specializing in portrait and fashion photography in New York with her brother Erik. At that time her fashion work was better known in Paris than New York, many of her contacts from her earlier days at Condé Nast publications were lost, and after struggling for two years to keep the studio open, she agreed to marry Aziz Eluoi Bey, a wealthy and sympathetic Egyptian whom she had met two years earlier while recovering from pleurisy in a St. Moritz sanatorium. Miller soon found that life among the conventional and pampered Egyptian upper class was dominated by the management of large domestic staffs and the pursuit of the sporting life. Neither activity interested her and, accompanied by a car and driver, she began to escape into the Egyptian desert with her camera. Her photographs from this period reveal a feeling for the disquieting image, a strong awareness of formal relationships in nature, and an

133

134

ability to capture in black and white the abstract qualities of objects bleached by the powerful desert sun or rendered artificial by intense contrasts of light and dark. The desert provided physical and psychological escape for Miller who, camera in hand, pursued in nature a vision formulated during her years with Man Ray and one unrestricted by social convention. Few of the photographs that resulted from these expeditions were exhibited during her lifetime though *Portrait of Space*, reproduced in the *London Bulletin* in June 1940 after she had left Egypt and gone to live with the English painter and writer Roland Penrose, is said to have influenced Magritte's *Le Baiser*.[20]

The intuitive anchoring of psychic reality in the forms and processes of nature also underlies Toyen's transition from poetic Artificialism to Surrealism in the early 1930s. The inspiration for her first use of fantastic forms came from her discovery of the secret kinship between nature and inner need. The first exhibition of Czechoslovakian Surrealist work, which opened in Prague in 1935, included a number of works by Toyen in which spectral forms and oneiric phantoms are elicited from an ambivalent and mysterious nature in which larval forms grow like mirages in a psychic desert. In paintings like *Yellow Specter* (1937), *Magnetic Woman* (1934), and *Prometheus* (1934), bizarre forms and personages emerge as symbolic crystallizations of latent psychic content. Egglike forms and shells coexist uneasily with eroded driftwood in *Gobi* (1931) while *Voice of the Forest* (1934) translates the object into a pulsing vegetal phantom, a cyclopean orifice that dominates the painting. Though recalling certain objects, it remains, in the last analysis, unidentifiable, while the lack of a pictorial context within which to situate it forms the basis for a new and disquieting mood.

Toyen transforms a personal iconography of psychic desolation into a political metaphor directly responsive both to the dictates of Surrealism and to the social realities of the late 1930s. On March 29, 1935, Breton lectured in Prague at the invitation of the Czech Surrealist group. His topic was "The Surrealist Position With Regard to the Object, or Surrealism in Poetry and Painting." Two weeks later, Toyen, Štyrský, Nezval, and their associates joined with Breton and Eluard in Prague for the signing of a text to be published in the first issue of the *International Bulletin of Surrealism*. The manifesto articulated the common concerns of the French and Czech Surrealist groups: freedom of artistic expression as a revolutionary activity; total liberation, psychic as well as economic; opposition to Nationalist Socialism and to certain Marxist ideologues who wanted to utilize artistic freedom for propaganda purposes. Between 1918 and 1938 independent Czechoslovakia's first republic celebrated its finest moment as a model of constitutional democracy in the midst of a Europe teetering on the brink of destruction. But by 1935 Czech artists and intellectuals were well aware of serious threats to existence from within: from unassimilated nationalities, extremist groups, and the economic ravages of the Depression. Growing threats from outside, among them Fascism, the end of hope in Spain, the German-Soviet nonaggression pact, and the beginning of Hitler's march across Europe, left little time for the Czech Surrealist group to affirm its own directions between 1935 and 1938. They were able only to organize their collective activity, including the exhibition of 1935 that brought Breton and Eluard to Prague,

draw up a list of objectives, and publish some translations of French Surrealist works. The last collective publication was a monograph on Štyrský and Toyen brought out in 1937 or 1938.

A new pictorial conception responsive to these political realities is clearly evident in Toyen's work by 1936 as latent psychic content and external reality meet to form threatening phantasms and bizarre objects. In *Message of the Forest* (1936) the specter of an owl plunges its too-real talon into the pale face of a young somnambulist, and in *Rêve* and *La Dormeuse* of 1937 spectral figures in the process of dissolution confront an empty landscape stripped even of insect life. In his "Introduction to the Work of Toyen" (1938), Breton called attention to the claw marks of birds of prey that had recently appeared in her work and to the influence of Lautréamont's famous metaphor, in which a sewing machine and an umbrella meet on a dissecting table, which surely influenced Toyen's choice of a setting for these spectral forms.

When, at the end of the war, life began to return to these barren landscapes, it did so in the form of the small butterflies that nestle on the stony graves in *L'Avant Printemps* (1945) and in other works, an image of hope and rebirth at the end of night, for it is the butterfly that sheds its larval life to emerge transformed into the light.

Toyen's use of the desolate landscape as a metaphor for political reality viewed as inseparable from psychic reality finds a personal echo in the work of Kay Sage, for whom physical place became the final resting place on an inner journey that led her from a personalized abstraction to a more cosmic vision.

Shortly after the end of World War I, Sage's father, having discovered his daughter's affair with a married man, sent her off to join her mother, then living in Italy. Sage was soon bored by the lack of social life in Rapallo and moved to Rome to study art. She rented a villa in one of the most depressed areas in the city and began painting in earnest for the first time. Not long after the move, she met an older artist named Onorato Carlandi and began to accompany his group, called "I venticinque della Campagna Romana," on their weekly painting trips to the Roman Campagna:

> I think that these were the happiest days of my life. I was the only woman in the group, which was very dangerous among a bunch of Latins, but Carlandi watched me with a jealous eye, and there was never anything except good-hearted fun as far as I was concerned. I had a passion for the campagna and must not have minded the discomforts of getting there. The awakening at dawn to catch a street car to the station, laden with heavy painting equipment, the jostling and smells of the third class compartment and sometimes the long rides in a two-wheeled cart driven by some old peasant along stony and bumpy roads. I scarcely remember any of this. I only remember the hot sun after the mist had risen, the crystal air and delirious meals of pasta, ricotta, and sour Italian bread and still more sour wine. I made no friends in Rome outside of these. I saw no one except the people I worked with. I think I was almost completely happy.[21]

163

SAGE AND LANDSCAPE

The scope and planar expanse of Sage's abstract Surrealist paintings originate in her attachment to the long open vistas of the Roman Campagna where she had often painted while living in Italy and which can be seen in early works like Landscape with Poplar. *Her mature work translates a personal iconography of psychic desolation into an austere vision of nature stripped of human habitation.*

148 Kay Sage, *Landscape with Poplar*, 1923
149 Kay Sage, *Danger, Construction Ahead*, 1940

148

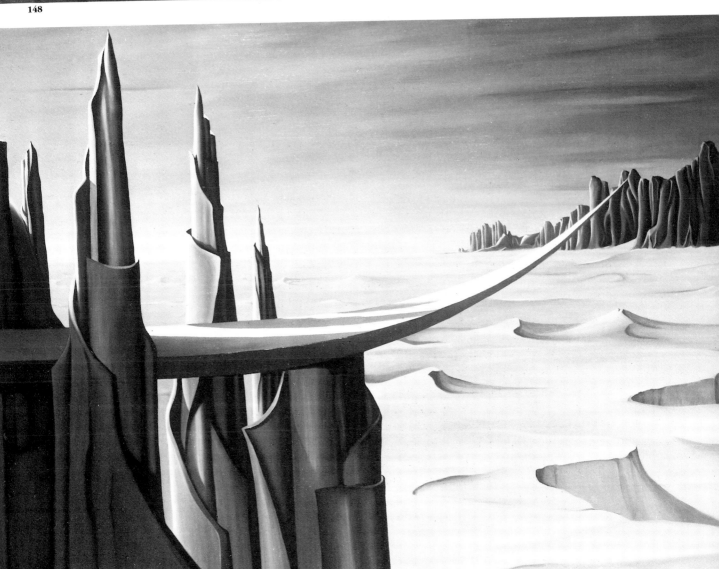

The few paintings that survive from these years show no evidence of the imagination later liberated by Surrealism, but they reveal a sense of freedom in nature and an attachment to the long open vistas of the Roman Campagna. Relating this period to her later Surrealist work, she said in 1961: "I think my perspective idea of distance and going away is from my formative years in the Roman Campagna. There is always that long road and the feeling it gives that it goes a long way, and living near the Mediterranean, the sea and the boats, the feeling of the sun."[22]

Sage's development as a painter was neither simple nor linear. The life of a Roman princess was ill-suited to her active mind, but she found herself unable to paint with any seriousness. Like Miller, she soon escaped, but into writing rather than photography. Her first volume of poetry, a book of children's verse titled *Piove in Giardino*, is illustrated with charming watercolors of animals, musicians, and circus people and appeared in 1937, shortly after she had left her husband and moved to Paris.

In Paris, she began work on a series of abstract and near-abstract paintings, many of them based on architectural motifs. In *Afterwards*, a transitional work of 1937, 87 wooden boards and strips of planking are overlaid in an uneasy geometric composition based on strong diagonal and orthogonal lines. The cast shadows, the exaggerated perspectives and spatial ambiguities, and the strong contrasts of light and dark throw the forms into an uneasy equilibrium that owes much to the early paintings of Giorgio de Chirico who, along with Tanguy, was one of the first painters whose work she admired in Paris. The trancelike quality of her work also harks back to Chirico; according to James Thrall Soby, she was most impressed with Chirico's ability to "endow walls, arches and piazzas with an oneiric intensity."[23] As her brush stroke tightened, the paintings assumed a precisionist air overlaid with strong feelings of mystery and melancholy.

Sage's paintings of 1938 and 1939 reveal that in addition to being strongly influenced by Chirico and Tanguy, she must have also seen Man Ray's photographs of the period around 1936; many of the same motifs find their way into paintings like *A Little Later* (1938). Among them is the recurring image of the egg, the purity 55 of which fascinated Man Ray, and he included it in many of his pictorial and graphic works of the mid 1930s. In 1938, the primary motif in Sage's painting is the egg, an image she shared with many other Surrealists (see Chapter 5). Sage's father had a collection of rare and unusual birds' eggs, which he kept on white sand in a box. Her childhood fascination with these objects surely influenced her adult habit of keeping china eggs, rocks, and shells in baskets throughout her house, but there is no evidence that she was interested in pursuing the symbolic significance of the egg. As Stephen Miller has pointed out, her attachment to the shape and texture of the egg must have influenced her choice of the title "China Eggs" for her autobiography, a choice reflecting her feeling that china eggs are no more real than was her life before she became a painter. The autobiography terminates with her arrival in Paris and the beginning of her "real" life.[24] Like many images in Sage's painting, the egg's meaning is ambiguous. Introduced as a formal device, it becomes a means of relieving the strict geometry of her compositions. But it also

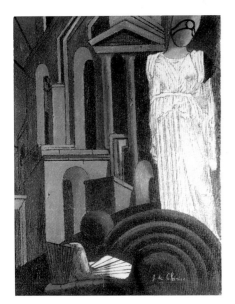

150 Sage owned Chirico's *The Torment of the Poet*, 1914, and many of Chirico's forms appear slightly modified in her early Surrealist compositions

introduces mystery into these visionary landscapes, implying life in landscapes otherwise devoid of human presence. The egg also points to the Surrealist preoccupation with symbolizing the process by which an image is generated from interior sources. Pagan emblem of creation and the rejuvenation of spring after the winter sleep, Christian symbol of the Resurrection, alchemical vessel of transformation, the egg has always symbolized creation; it is the source of life and, by extension, the source of all art. There is no evidence that Sage shared Carrington's, Fini's, and Varo's alchemical identification of the egg with woman's creative powers, but the image is so persistent in the work of women artists at this time as to become almost archetypal.

Sage's paintings are among the most abstract produced within a Surrealist circle that embraced symbolic figuration as the key to the working of the human mind. Whether realized through the automatism of a Miro or a Masson, with its biomorphic forms and insistent references to metamorphosis, or the illusionism of Dali and Magritte, with its hallucinatory crystallizing of mental process, Surrealist painting tended toward the organic rather than the geometric. Breton's biases in this respect are well known, but he was quick to recognize Sage's grasp of an all-important atmosphere of disquieting tension. In *My Room Has Two Doors* (1939), an oversized egg rests on a corrugated flight of stairs. A curving wall that constructs nothing, an arched doorway with the sea beyond, and the long shadows cast across the scene by invisible objects contribute a condensation of images and a feeling of spatial dislocation that closely approximate the structure of the dream as realized in the work of other illusionistic Surrealist painters.

Sage's grays and blues are cool and muted, her surfaces even and slightly forbidding. For all that these early Surrealist paintings recall Chirico and certain Vorticist works, and utilize iconographic elements common to Surrealist painting of the 1930s, they are imbued with an aura of purified form and a sense of motionlessness and impending doom found nowhere else in Surrealism.

Sage's first American exhibition opened at the Pierre Matisse Gallery in 1940 and included the paintings *Danger, Construction Ahead, I Walk Without Echo, Lost Record, Kleben* and *Night Goes Walking*, all executed that year. Her paintings at this time parallel the formats of Tanguy's painting, with long-sweeping grounds receding to distant horizons. Some of their similarities arise from the shared influence of Chirico, others from a common decision to establish a barren planar ground as the setting for the imagery. But Sage quickly developed a personal set of forms with which to people these landscapes and her imagery rejects the suggestion of organic metamorphosis that underlies Tanguy's pastel shapes. *Danger, Construction Ahead* and *Lost Record*, both painted in 1940, include expansive landscapes that fill half to two-thirds of the picture plane. Against these simplified grounds, individual forms or clusters of forms stand out in sharp relief. As early as 1940, Sage's works reveal a spareness of form, an austerity, and a rejection of the limpid biomorphic shapes that people Tanguy's paintings. Her rejection of biomorphism sets her work apart from that of all other Surrealists working in an abstract manner. Instead, her images stand out with an intense clarity made all the more disquieting by her predilection for sharp, spiny forms,

184

149

166

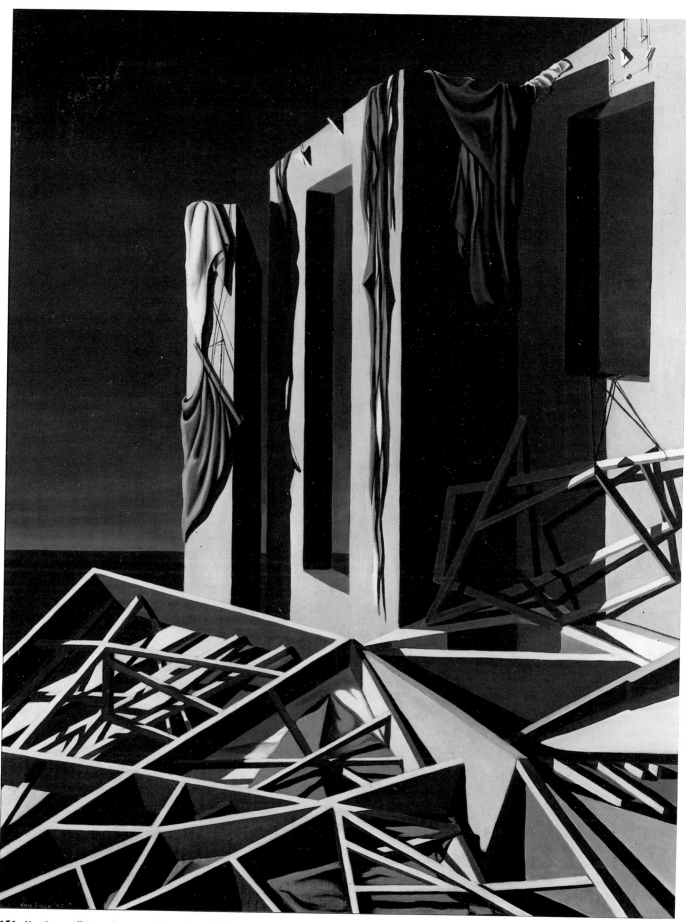

151 Kay Sage, *All Soundings Are Referred to High Water*, 1947

mysterious melancholy light, subdued colors, and by the air of emptiness and abandonment that hangs over these oneiric landscapes. Her use of shrouded figures drives from Chirico's phantoms (she owned *The Torment of the Poet*, 1941),[25] her barren plains from Dali and Tanguy, but her painted world is more tensely constructed than theirs, her clarity of form a means of obscuring content.

150

Sage identified strongly with these barren vistas stripped of human habitation. "I suppose I start with some sort of composition," she related in an interview in 1950. "I see it in a way in advance, but very often it changes as I go along. I do know that while I'm painting I feel as though I were living in the place."[26] Referring to a painting called *The Instant* (1949), she said, "I can't tell you what it would mean to most people, but I do know what it means to me. It's a sort of showing what's inside...."[27] The comment is revealing, for Sage struggled against a fear that her painting was derivative of that of the better-known Tanguy. She often covered up the fear, relying on irony, intellect, and humor to defer emotion. Her landscapes contain objects that appear responsive to the manipulations of a giant and unseen hand; her poetry is equally veiled and carefully constructed. Her painting *In The Third Sleep* (1944), which won the Watson F. Blair Purchase Prize when exhibited at the Art Institute of Chicago in 1945, uses the motif of the game board familiar from Giacometti sculptures of the early 1930s like *No More Play*. In fact, one of Sage's first objects, constructed in 1937 and now in the collection of Gordon Onslow-Ford, was a piece called *Rat Race* in which two yellow marbles raced around a track. *In The Third Sleep* is an austere composition illuminated by a dazzling light that casts slatey shadows across the surface of an inclined plane. In the distance, a parched and cracked landscape appears as if seen from a high-flying airplane, while in the foreground a piece of furled drapery rises dramatically into the sky. The clarity of form, the absence of all movement, and the subdued palette create a mood stripped of anecdote and sentiment. There is something uncompromising about these works, reflecting as they do a vision striving for absoluteness of feeling. In succeeding works, Sage moved toward greater architectural complexity, while refusing to sacrifice clarity of form or the powerful sense of place that suffuses these paintings. *All Soundings Are Referred to High Water* (1947) begins the exploration of the structural theme of scaffolding that would mark her painting after that date. Here, in an immobile landscape that dares the spectator to seek solace in this place of spiritual exile, architectural forms, draped with tattered cloth, arise as if from the midst of a shipwreck, and desolation reigns.

IV

151

Artists like Sage, Tanning, Varo, Carrington, and Fini worked in a meticulous manner, highly conscious of craft and technique, and often building up their surfaces with layers of small and carefully modulated brush strokes while remaining faithful to the unconscious as a powerful motivating factor in their work. Their painstaking attention to the details of painting suggests that in their work an almost obsessive preoccupation with personal reality would be joined by an equally intense attention to the natural world that in many cases provided their most powerful metaphors. Their paintings seem to bear out this hypothesis. For these artists nature is often built up from a multiplicity of details, each as minutely observed and carefully rendered as the next.

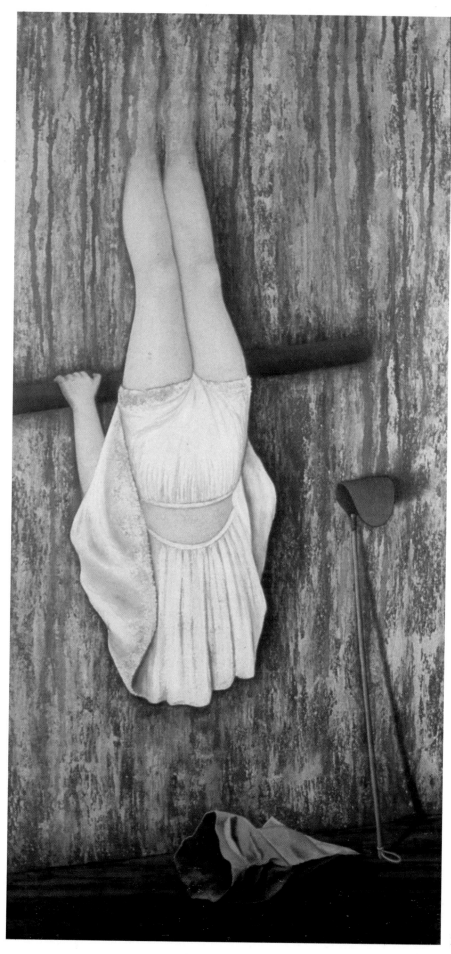

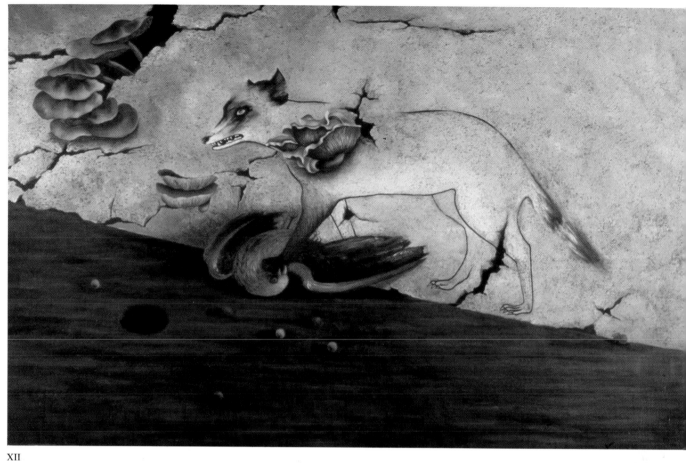

XV

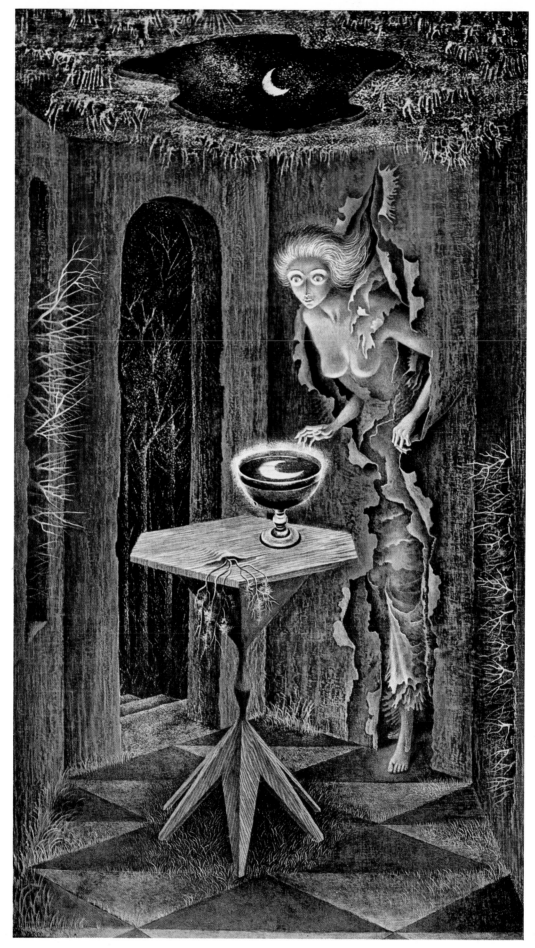

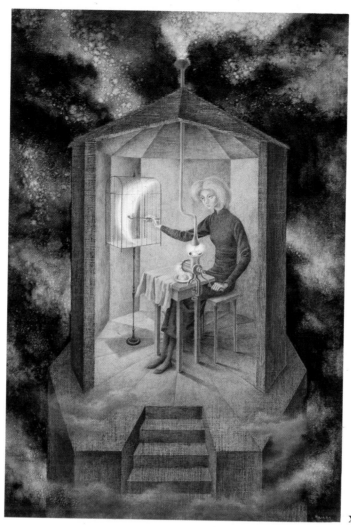

XVIII

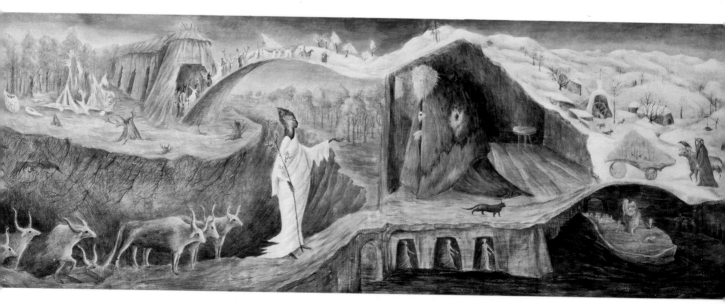

XIX

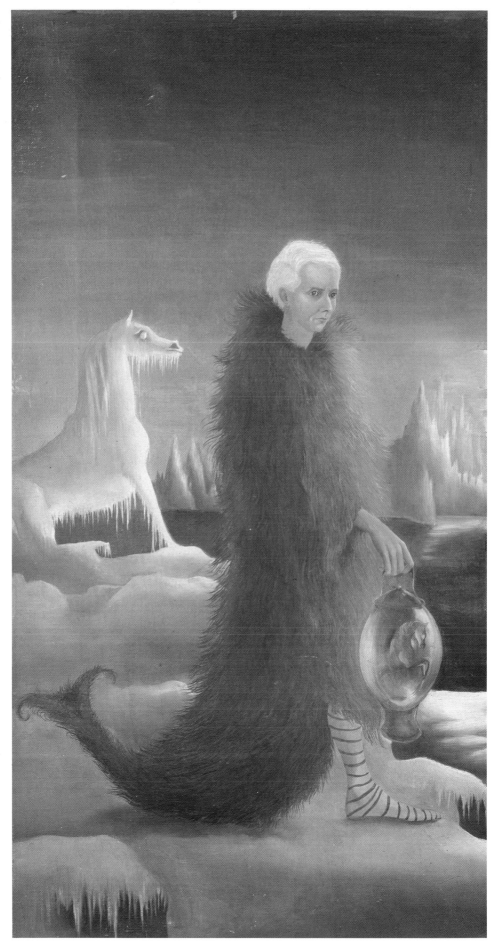

The refusal to differentiate, to assign certain images and areas of the painting a greater weight and clarity than others contributes to the disturbing effect created by many of these works, an effect caused by the fact that although we often see everything in these small canvases in glowing detail, we leave the encounter feeling that we have missed the crucial key that would reveal with clarity their meaning to us.

If, for example, the visions of Varo's and Fini's paintings have a fluid and hallucinatory feel, the technique with which they are realized implies long hours in the studio and a willingness to work with small brushes and exercise great control and manual precision. Varo's vision of the Surrealist "marvelous" is built on the principle of scientific illustration. Like Dali, she sought to render the visions of her imagination with the clarity of the camera's relentless gaze. She worked out the designs for her paintings in her head; once the mental picture was clear she transferred it, detail by detail, first to large sheets of translucent paper and then to prepared canvas or masonite. During the late 1940s Varo journeyed to Venezuela to visit her brother; while there she took a job with the Department of Public Health for which she made drawings of microscopic enlargements of disease-carrying organisms. it was only one of many jobs held by Varo over the years that demanded the highly developed skills of the illustrator. Indeed, so skilled was she at rendering that she is reported to have been able to produce forgeries of paintings, particularly Chirico's, on demand. An almost microscopic scrutiny of natural form pervades paintings in which every blade of grass is visible, every fissured surface mapped. In *The Flutist* (1955), the music from a young man's flute causes building stones to fly into place on the side of a tower drawn against the sky. Each stone carries on its surface the fossilized imprint of a leaf, a shell, or an insect. Varo seems to suggest that nature and its past underlie every act of artistic creation.

153

Fini remained equally dedicated to a vision inseparable from the phenomena of the natural world. Each of her paintings of the 1940s is a creation out of a primordial chaos, an intuitive searching for form and lucidity, and a gradual revealing of that mental point so earnestly sought by Breton, the point at which past and present, conscious and unconscious, real and unreal fuse in a single blinding moment of clarity. As a young woman she pursued nature in the tidal pools of the seashore around Trieste, home of seashells, small crabs, and algae; on the small deserted islands of the Adriatic she collected bleached goat skulls, bird skulls, and fantastic rocks. These objects find their way into her painting of the 1940s, reappearing not as nostalgia for forms known and loved in childhood, but filtered through adult consciousness and endowed with new meaning because of their importance for the poets and artists whose work shaped her mature vision. Her adolescence was dominated by admiration for North German and Austrian post-Romantic and Symbolist painters like Max Klinger, Hans von Marées, Arnold Boecklin, and Gustave Klimt. Ernst has mentioned her as one of the first artists he met in Paris who shared his interest in Caspar David Friedrich;[28] her almost mystical appreciation for the latent energy that resides in decaying vegetation and her interest in nature's cycles of generation and decay derive from the German Romantic and Symbolist painters whose work she first saw in Trieste.

COLOR PLATES

XVI Remedios Varo, *Alchemy or the Useless Science*, 1958
XVII Remedios Varo, *Born Again*, 1960
XVIII Remedios Varo, *Celestial Pablum*, 1958
XIX Leonora Carrington, *Palatine Predella*, 1946
XX Leonora Carrington, *Portrait of Max Ernst*, c. 1939

ANALYTICAL INVESTIGATIONS OF NATURE

Artists like Sage, Tanning, Varo, and Fini combined personal reality with an intense examination of the natural world in their work. Nature is often shown by means of the accumulation of carefully painted details. Fini, in paintings like Sphinx Regina, *interrogates the flora and fauna of nature with a scientist's analytical gaze, while in Varo's* Flutist, *nature and its fossilized past underlie all artistic creation.*

152 Léonor Fini, *Os Ilyaque*, *c.* 1948
153 Remedios Varo, *The Flutist*, 1955
154 Léonor Fini, *Sphinx Regina*, 1946

152

153

155 Remedios Varo, Bayer Aspirin Promotion, 1943–48. This early gouache stores the sun, clouds, and rain inside the mountains where they are released through open windows like birds from a cage

In the winter of 1943, Fini spent six months on the Isola del' Giglio off the Tuscan coast between Italy and Corsica. There she began to paint still lifes and very detailed and analytic compositions based on flowers, plants, insects, and debris thrown up by the sea. Reminiscent of Arcimboldo, these organic compositions, remarkable for their precision and clarity, introduce the principle of metamor-

152 phosis into her work. In *Os Ilyaque* (*c*.1948), she juxtaposes bleached bones, all that remains of organic life after the process of decomposition has run its course, and

120 the curving tendrils of new plant life; in *The Umbrella*, painted a few years later in 1947, she stages an eerie encounter between a discarded and tattered umbrella and a few tiny dead fish hanging like bait from the bare branches of a small tree against a stygian darkness. Only the presence of a single eye glowing through a tear in the umbrella's fabric lends the scene a human dimension. Into these landscapes of the mid-1940s Fini soon introduced the image of the sphinx, a chthonic figure and intermediary between the human and the bestial, which presides over a nature in constant process of decomposition and regeneration. Fini's sphinx, as we shall see, poses a question not about man, but about the woman artist's place in the natural and metamorphic process that lies at the heart of the Surrealist vision of an art of fantasy, magic, and transformation.

180

There is the fire it burns and I am the water I drown
o icy girl
Earth is my friend
also the moon her servant
thus we meet at the end of our caverns

VALENTINE PENROSE, *from* Herbe à la Lune, 1935

5 | Women Artists and the Hermetic Tradition

Endlessly linked to the mysterious cycles of nature, and to the four elements that govern them, the image of woman that emerges from Surrealist poetry is a being controlled by, rather than in control of, her childlike vision and magical powers. "Women were like magic objects to the Surrealists," Malitte Matta recalls; Roland Penrose saw his first wife, the poet Valentine Boué Penrose, whom he met in about 1923, as "a goddess of feminine mystery and charm such as I had never dreamed of...."

> When living in our remote stronghold, the Chateau de Pouy, she would return naturally to her underlying temperament of the benign witch. I would wake up to find my bed deserted until early dawn, when a lithe naked dew-soaked girl would come to me and whisper the adventures she had had with a family of badgers among the rocks and the black oaks.[1]

Wintering in Egypt in 1929, the couple rented a small house within a few hundred yards of the Sphinx, and there Valentine Penrose began her study of the strange eremitic Spanish Count Galarza de Santa Clara. Adherence to the philosophy of this master of arcane studies led her first to a course of study in Oriental philosophy at the Sorbonne and then to India where the count had settled. She liked to think of herself as a witch, Noma Copley remembers, and references to mysticism, alchemy, and the occult pervade her poetry. It is always woman who pursues the visionary quest and whose powers unite the four elements. She wrote in 1937:

> *Faible papillon petite la femme*
> *petites ses mains posées comme ignorante*
> *sur les jouets de la flamme*
> *Qui monte et qui monte*
> *aux himalayas*
> *l'echelle de soie*
> *à nouveau sortie*
> *brillait dans la cave*[2]

("Helpless butterfly delicate the woman/ delicate her hands laid unaware/ upon the playthings of flame/ Who ascends/ in the Himalayas/ the silken ladder/ newly flung/ glittered in the cave")

"Witches they are by nature. It is a gift peculiar to woman and her temperament," wrote Jules Michelet in *La Sorcière*, an imposing study of the witch in medieval society that profoundly influenced Breton's thinking on the subject of woman. He

156 Valentine Penrose in India in 1934, photographed by Roland Penrose

read and absorbed the book's antipositivist message, and its thesis tracing the witch's historical origins to a time in which labor was divided between men who hunted and fought and woman who worked by her wits and her imagination, and he was quick to adapt Michelet's conclusions to Surrealism. Among them was a view of the sorceress as a being endowed with two creative gifts: the *inspiration of lucid frenzy* and the sublime power of parthenogenesis or *unaided conception*. Both characteristics would become essential aspects of the act of creation in a Surrealist context; both pointed toward a seminal role for woman in the creative process. In recognizing her intuitive connection with the magic realm of existence that governed creation, Surrealism offered the woman artist a self-image that united her roles as woman and creator in a way that neither the concept of the *femme-enfant* nor that of the erotic muse could.

In *Arcane 17* Breton clarified the need to resolve the inherent conflict between male and female principles. In the end it is the artist who will effect the synthesis, for he alone (Breton clearly refers here to the *male* artist) has access to both realms of being: "It is the artist who must rely exclusively on the woman's powers to exalt, or better still, to jealously appropriate to himself everything that distinguishes woman from man...." Breton, like Masson and other Surrealists, was influenced by the nineteenth-century German writer J. J. Bachofen, who had traced the development of ancient Greece through a matriarchal period characterized by the primacy of the blood relationship, the equality of all men, and a fundamental respect for human life and the power of love. The presence of a powerful female principle in the work of male Surrealists finds its final resolution in images of the couple or the androgyne. As a glorification of spiritual fecundity, the myth of the androgyne becomes a celebration of spiritual procreation. Brauner's *Number* (1934) presents a gravid androgynous figure. Here male and female sexual organs are attached to the ends of a boxlike womb, in which a tiny sculpted figure resides. For Brauner, as for other Surrealists, the metaphysical fusion of male and female into the perfect being had a physical and spiritual counterpart in the sexual act—an ecstatic union that blurred the distinction between the sexes and moved the male artist to greater and greater creativity.

Unlike the male Surrealist, who absorbed the image of woman into his own image through the metaphor of the androgyne or couple, women artists have often chosen to emphasize the fundamental biological and spiritual forces that distinguish woman's experience from that of man, and that place her in direct contact with the magic powers of nature. Writing in the 1940s, Colquhoun related:

> One day in the translucent water I felt strange and found that my body was exuding a dark glue, not quite a blood. I knew what had happened: the revelations on the Plain years before had told me what to expect.... Certain wise savages still put their women in a hut of reeds, away from the village ... the tribe thus gives each woman a few days each month of rest and solitude, for contact with the night side of her own nature. Will no one listen? This is what must be done, though it makes civilization turn over. It is harmful to attempt a normal appearance—business, housework, the catching of trains—when normality is

absent, and its place taken by intensified sensibility to hidden springs. It is the mood to divine buried treasure, to speak the oracular words, to consummate the ritual marriage. It is a natural break in outward routine; and to neglect this rhythm brings age, harshness, irritation, the loss of beauty and peace. Through retirement I become reconciled to the moon.[3]

In directing attention toward the internal, the hidden, and the mysterious, to all that was inaccessible to the illumination of the sun and to rational control, Surrealism followed a path that led inexorably toward the domain of Faust's Mothers. Women artists were quick to recognize the implications of the varied and legendary associations between woman's powers and the spheres of night and the moon. Penrose wrote in 1935 in one of the poems from *Herbe à la Lune*:

> *Il est le feu il brûle et je suis l'eau je noie*
> *ô froide fille*
> *La terre est mon ami*
> *la lune aussi sa servante*[4]

("There is the fire it burns and I am the water I drown/ o icy girl/ Earth is my friend/ also the moon her servant") The encrusted surface and mute echoing forms of Agar's *Mask of Night* (1945) invoke the mysteries of night while in Rimmington's pen and watercolor drawing of 1938, *Washed in Lethe*, the classically draped image of a woman presides over the sleeping figures of young women who float through the underworld waters of oblivion.

160
146

Among the earliest paintings produced by women artists associated with Surrealism are a number that refer directly or indirectly to woman's possession of these secret powers. In the two years before she joined the London Surrealist group in 1936, Eileen Agar had executed several paintings containing classical allusions to the ancient muse of poetry. *The Modern Muse* and *The Muse Listening*, both painted in 1934, treat this theme using the traditional iconography of female personification. In addition, the object called *The Muse Listening* juxtaposes the forms of the sacred harp or lyre and the heart, objects instrumental in the release of creative passions. But the 1936 collage *My Muse*, executed under the growing influence of Surrealism, suggests that the muse has ceased to exist as an external principle and has now been internalized, absorbed into the practice of automatism that allows the artist direct and unmediated access to the imagery of the unconscious. No longer an external metaphor, the muse has become part of an active internal creative principle, and although the idea of an art responsive to internal realities was shared by all Surrealist artists, male and female, it came to have specific meanings and associations for women artists.

159,137

158

Agar's *Mysterious Vessel* (1935) places its mythic references to the horses that draw the chariot of the sun and the entwined serpents of the underworld on the surface of a large urn that is set against the resonant ground of a Grecian blue sky. A few years later, discussing a painting titled the *Muse of Construction* (1939), she articulated the connection between the concept of the muse and an inner, private, and mysterious realm of being that is evoked through the image of the urn or vessel with which woman's body has so often been identified:

157

158

LEGENDARY SOURCES OF WOMAN'S POWERS

Surrealism's concern with the internal, the hidden, and the mysterious led ineluctably to the legendary sources of woman's powers. Agar's Mask of Night *explores the mysteries of night, while in* My Muse *and* The Modern Muse *she uses mythic references to call forth the ancient muse of poetry. Fini's* Ceremony *is one of a group of paintings that refer to an ancient world in which a system of rites defined the passing of time and placated the powers of gods and ancestors.*

157 Eileen Agar, *Ma Muse*, 1936
158 Léonor Fini, *Ceremony*, 1939
159 Eileen Agar, *The Modern Muse*, 1934
160 Eileen Agar, *The Mask of Night*, 1945

159

When I called the painting the Muse of Construction I wanted to emphasize the fact that although the word *construction* is usually associated with buildings, architecture and things mechanical, I wished to associate it with the human form which is a marvellous construction, built and assembled over millions of years, adaptable and flexible. Although its skeleton is worn inside and the soft-ware outside, it goes through many changes and holds a lot of secrets in its trunk. At one time I thought of calling the painting the "Urn Goddess" as I have always been interested in the shape of a vessel, but somehow the Muse of Construction seemed more mysterious and poetic.[5]

Myth, magic, and the occult joined together in shaping the Surrealist image of woman as the repository of hermetic knowledge. Breton's vision was influenced by the importance attributed to woman by Simon the Magus, the New Testament sorcerer who bewitched the people of Samaria, and Eliphas Levi, a French nineteenth-century occultist, who had defined for her the role of an intermediary and who saw her as endowed with the power to intervene in tragic circumstances and to transform anguish into ecstasy. Both saw the need for a balancing of opposites and influenced Breton's notion of a union of man with woman and her powers that would bring man into closer contact with the elemental transforming agents of the universe. For Breton, love was the means by which man moved into the circle of woman's magic powers. Michelet's *La Sorcière* had provided him with one guide; occult studies, particularly alchemy, which had fascinated modern poets from Baudelaire to Rimbaud and Apollinaire, offered another: an alternative to rational control, a means of reinvesting poetic language with a sense of mystery and coded meaning, and a vision of a poetic landscape brought into being through the transmutation of material and spirit. The Surrealist poet became an alchemist of language, the painter worked a metamorphosis of form and color, and the resulting work possessed the power to transform consciousness, life, and the world.

In Tanning's novel *Abyss*, written in 1946 during the first year of her stay in Arizona with Ernst, the main character is a painter named Albert Exodus who is described as "hiding behind his colors like an alchemist behind his fiery liquids, his sulphurs, his loathsome fumes." A linking of alchemy and the erotic offered the male Surrealist the surest means to the reconciliation of opposites and the unveiling of the "marvelous"; for the woman artist myth, alchemy, and the occult became a means of repossessing creative powers long submerged by Western civilization.

"Reading *The White Goddess* was the greatest revelation of my life," recalls Carrington, who read Robert Graves's monumental mythic study of the God of the Waxing Year's losing battle with the God of the Waning Year for love of the capricious and all-powerful Threefold Goddess who reigned over poetic creation, shortly after its publication in 1948, but who had for many years drawn her imagery from the same sources.[6] "The reason," wrote Graves, "why the hairs stand on end, the skin crawls and a shiver runs down the spine when one writes a true poem is that a true poem is necessarily an invocation of the White Goddess, or Muse, the

Mother of All Living, the ancient power of fright and lust—the female spider or the queen bee whose embrace is death."

Whether conceptualized as the Celtic White Goddess who governed poetic inspiration and who presided over the tribe of the Tuatha de Danaan, the fertility and moon goddess Isis, the goddess of magic in Old Kingdom Egypt, or the female substance necessary for the commencement of the alchemical Work, the existence of an ancient female principle governing creation/fertility and death pervades much mythic and hermetic literature. Between 1939 and 1950, Fini, Carrington, Varo, and others executed numerous paintings that locate the origins of woman's creative consciousness in this ancient tradition. Their quest was not a conscious search for the archetypal Great Goddess whose reclaimed existence has formed the core of much recent feminist writing, for she was then, in the 1930s and 1940s, a shadowy presence at best. But because they believed in fairy tales, legends, and the magical properties of artistic creation, and because they followed the threads of that creation deep into their own dreams and unconsciouses, and derived specific and potent images from stories that, whether theosophical, legendary, or alchemical, confirmed these inner searches, they forged the first links in the chain that has more recently been used to reconnect contemporary feminist consciousness with its historical and legendary sources. "In earliest times painting was magical," Alice Rahon wrote in 1951: "It was a key to the invisible. In those days the value of a work lay in its power of conjuration, a power that talent alone could not achieve. Like the shaman, the sybil and the wizard, the painter had to make himself humble, so that he could share in the manifestation of spirits and forms."[7]

Léonor Fini's *Ceremony* (1939) is one of the first of a group of paintings that recall this world in which ceremonies and rituals marked the cyclical passage of time, and in which life, death, the seasons, gods, and ancestors were observed with appropriate respect for the hidden powers that their presence called forth. The spectator arrives at Fini's *Ceremony* as if coming into the middle of an event which, despite the clarity of its outward presentation, remains shrouded as to inner meaning. The main protagonist is woman, her image at the center of a mysterious ritual enacted before a stone altar and under the sign of nature, present in the leafy branches laid over the altar. The figures, one kneeling, one standing, one viewed from the back and naked to the waist, the other seen from the front and protected by a curved breastplate, reinforce the tension between interior and exterior, the protected and the vulnerable, the visible and the veiled. Colors are somber and details minutely rendered; Fini's meticulous draftsmanship serves to heighten the sense of mystery and unapproachability that pervades the work. Gestures are slow and pregnant with meaning, but the work is devoid of overt symbolism or narrative content; "painting is immobile and silent and I love it thus," the artist has said.

In other paintings, Fini situates her female figures at the juncture between a theatrically conceived external world in which the painting is a kind of staged set, and an inner world of stygian darkness and primordial chaos, and between a state of consciousness dominated by social interaction and one ruled by instinctual drive and animal need. Once again, it is Graves's world of the *White Goddess*, and that of Michelet's *La Sorcière*, which Fini had also read, that is being evoked. In *Chthonian*

157

107 *Divinity Watching Over the Sleep of a Young Man* (1947), a figure of darkness, night, water, and earth presides over the living. The passive androgynous male figure sleeps under the watchful eyes of a female sphinx who conveys the power of the earth and nature, of life and death. The sleeping figure is almost a parody of Mannerist reclining nudes, but the acid colors and ominous nocturnal glow shroud the figure with an air of menace.

The hybrid sphinx mediates between the human and the bestial in Fini's work. The image, which first appears around 1942, had deep personal significance for the painter, serving as a symbolic reunification of a human and civilized world that she views as lacking passion and animality, and an animal world in which the magical powers of animals may help humans to understand their own loss of connection to a more primordial nature. Although the image has sources in the stone beasts that decorated the public gardens in Trieste and that she liked to ride as a child, her beasts have only a tangential parentage in antiquity, and replace the hermetic features of the Egyptian and Renaissance sphinx with the unkempt and pouting look of contemporary female figures. For Fini, woman is sorceress and priestess, beautiful and sovereign; by assuming the form of the sphinx she exercises all the powers that have been lost to contemporary woman. In her novel *Abyss*, Tanning also explores the powers that belong to the woman who acknowledges her connections to the world of nature and animals. The novel can be read as a kind of revenge of the *femme-enfant*, for in it the protagonist, Albert Exodus, meets his death through the magical powers of a child who is in secret communion with the world of animals.

Fini's refusal to depict woman as submissive or subordinate to man has often led critics to view her works as polemical or separatist statements, or to assert their lesbian content. Both readings have been emphatically refuted by the artist who, despite her dislike for orthodox Surrealism, has always adhered to the underlying Surrealist principle of the unification of opposites and the reclaiming of lost powers. She rejects the idea of social matriarchy as "a little grotesque," embraces an ambivalent sexuality rather than the Surrealist myth of the androgyne, and has argued that because she is a woman and finds woman's physical form more beautiful than that of man, she has placed the responsibility for "Being" in the hands of woman. Sympathetic to Jung, she has accepted his notion of the soul, "l'âme," as feminine. To man belongs the animus and it is this which controls the constructed and social world, which slumbers in her paintings under the watchful eyes of a female being who embodies the intuitive world and who is willing to wait for man's reawakened consciousness. "The man in my painting sleeps," she recently explained, "because he refuses the animus role of the social and constructed and has rejected the responsibility of working in society toward those ends."[8]

Fini's sphinxes belong to the animal and the civilized worlds. Often situated in a nocturnal nature in the process of decomposition and regeneration, as in *Sphinx Philagria* (1945) and *Sphinx Regina* (1946), they exist in a world described by Fini's friend Jean Genet as one of "cruel kindness" and "swampy odors."[9] Nature dominates these visions, but it is a nature both destructive and regenerative, unlike

that of Ernst's *Une Semaine de Bonté* (1934) in which the ancient sphinx appears at an open train window surrounded by images of decay and desolation: an arid desert, rotting corpses, and the rats that fill the lifeless carriage.

The image of the sphinx had entered Greek mythology carrying with her the earth/mother/female/life/death associations of her Near Eastern origins. Under her domain the earth lay fallow and drought covered the land. The ancient Greek sphinx also held in her hands the power of life and death. Her riddle, the answer to which reveals Oedipus's understanding of the nature of human existence, became, in Surrealist hands, an inquiry into the role of love. She appears in Breton's essay *Le Château Etoilé* (1936) as a guardian beast before whom all who wish to enter the château (the Surrealist universe) must answer a question about the future of love. Her riddle tests each Surrealist's commitment to love's liberating power. "Every time a man loves, nothing can prevent his taking on himself the feelings of all men," Breton himself answered. In Fini's representations the sphinx awaits a reawakening of consciousness, not unlike the historical reawakening that was taking place in Europe in these years immediately after the end of the Second World War. During the war years in New York, Breton had initiated a new Surrealist game in which the members of the group were to rate according to personal preference a group of mythical creatures that included the griffin, sphinx, succubus, and chimaera. The responses were tallied and the results published in *VVV*. Perhaps not surprisingly, the sphinx, creature of mystery and enigma, emerged as the clear winner.

Fini's *Small Guardian Sphinx* (1948), however, recalls the figure of the sphinx as sorceress and image of death. Here representations of necromancy and death surround the hybrid creature: a triangle, broken eggs, and a hermetic text.

The use of alchemical and divinatory images by Surrealist painters and poets served to reinforce the idea of an imagery conveying a body of ancient knowledge accessible only to the initiated. To enter the Surrealist world one had only to renounce the dictates of reason; to participate fully in Surrealism's revolutionary message the believer had to accept the existence of a new, and often coded, language that led the mind to make the leap from the communicable to the incommunicable. Not everyone shared Breton's interest in the role of the occult in Surrealism. Colquhoun's insistence on pursuing her interest in occult studies led directly to her break with E.L.T. Mesens and other members of the London Surrealist group. As a result of their objections to Mesens's program—which included a stated adherence to the Proletarian Revolution, an agreement not to join any professional group other than Surrealism (including any secret societies), nor to exhibit or publish except under Surrealist auspices—Herbert Read, Grace Pailthorpe, Reuben Mednikoff, and Colquhoun were not invited to participate in the Surrealism Today exhibition held at the Zwemmer Gallery in June 1940. The prohibition against secret societies was widely believed to have been directed against Colquhoun and others who were interested in the occult, for unlike Breton, Mesens actively opposed such arcane pursuits.[10]

Excerpts from Colquhoun's occult Gothic novel, *The Goose of Hermogenes*, published in 1961, had first appeared in *The London Bulletin* in 1938. The novel,

161 Max Ernst, photo-collage, an illustration from *Une Semaine de Bonté*, 1934

II

which borrows heavily from Grail literature and from the traditions of the Gothic novel, recounts the story of the heroine's visit to an island castle presided over by her alchemist uncle who has devoted himself to scientific experiments aimed at creating the *homunculus* or new life that will overcome death. Colquhoun derives much of her arcane lore from the secret doctrines of Abra Melin, a philosopher of ancient Egypt whose secrets were supposedly passed on to the fourteenth-century alchemist Abraham the Jew, and from Eirenaeus Philalethes' *Brevis Manductio ad Rubrem Coelestem* of the seventeenth century. The book, which reads like a long dream in which each scene fades imperceptibly into the next, mingles the alchemist's search for the substance that will transform matter, with Satanic ritual and symbolic purifications. Its heroine, an unnamed young woman, traces her ancestry to the alchemists' "White woman, *lunar progenetrix*," or White Goddess, and to the statue-woman, Vellanserga, the tall heroic daughter of Atlantis, "the hero-woman, both mother and warrior, debased long since as Britannia, but stemming from the ancient line of foundered Atlantis."

The true subject of the alchemical Great Work was the reconciliation of opposites through a process aimed at material and spiritual purification in the creation of divine harmony on earth and in heaven. "As above, so below" read the inscription on the emerald tablet of Hermes Trismegistus, the semimythical founder of alchemy; on the material level, the process involved an analogous refining of base metals into gold. In the process of transmuting metals, the catalyst was the Philosopher's Stone, which contained the secret not only of transmutation but also of health and life, for through its agency could be distilled the Elixir of Life. The first substances were mixed in an egg-shaped vessel in the presence of the Philosopher's Stone and slowly warmed over a fire to produce a liquor called "chaos," containing the elementary qualities of cold, dryness, heat, and humidity. The liquor was then allowed to putrefy to a black material called the "crow's head," or "raven," after which it was once more boiled in a white vase to obtain a white liquor called the "swan," which could then be broken down into white and red (gold). Alchemy became one aspect of a body of hermetic literature drawn from Neo-Platonism, Philonic Judaism, and Kabbalistic theosophy through which secret knowledge had been communicated for centuries. Often its secrets were hidden in vivid symbolic images that pointed the initiate toward the final goal of reconciliation and transformation. When, in the second Surrealist Manifesto, Breton called for the "occultation of Surrealism," he claimed his twentieth-century movement, which sought nothing less than the transformation of human consciousness, as heir to the secrets of this hermetic doctrine. The works of Ernst, Masson, Brauner, and other painters are filled with images that give voice to various aspects of secret doctrine.

Women artists in particular seem to have recognized an affinity between the hermetic tradition and woman's creative powers, powers that were often disdained or repudiated by male-dominated society. Out of the possession of these powers they began to forge a new self-image for the woman artist. Colquhoun's and Tanning's novels, as well as an unpublished short story about the adventures of one "Lady Milagra" written by Varo sometime after her arrival in Mexico in 1941,[11] offer

glimpses of a world in which man possesses knowledge, generally gained through study and scientific or pseudoscientific experimentation (in Tanning's and Colquhoun's novels he is an alchemist, in Varo's story the "master" hidden in his cell studying the mysterious properties of an ore necessary for the first step of the alchemical Work), but in which woman is in intuitive possession of magical powers without which his knowledge is useless (Colquhoun and Varo) or through the exercise of which his knowledge is rendered ineffectual (Tanning).

162 Varo's portrait of her grandmother, Doña Maria Josefa Cejalvo, painted in 1926 when the artist was thirteen years old

The most intense and far-reaching attempt to develop a new language through which the woman artist's "other" reality might be communicated occurred in Mexico during the 1940s and 1950s. In November 1941, after a long and difficult journey, Remedios Varo and her partner, the poet Benjamin Peret, arrived in Mexico. Prevented from traveling to New York with other Surrealist emigrés because of Peret's leftist political affiliations and support for the Loyalist cause in Spain, the penniless couple had waited months in Casablanca because they didn't have the right papers. Varo, remembering from childhood trips to North Africa with her father that Moslem dead must be wrapped in white for their final meeting with God, had raised small sums of money for the voyage by selling the few white bed sheets she had been able to pack. Finally, influential friends, working through Varian Frye's French Relief Committee in Marseilles, managed to secure steamer passage for the couple. They arrived in Mexico with no money other than the small allowance paid to Spanish political exiles by the Mexican government, and settled in a decaying apartment building on Gabino Barreda, not far from the ancient Aztec center of Mexico City and near the more recent Monument to the Revolution. Varo immediately began the wearying task of providing an income for the couple, an undertaking dictated by necessity, but one that would drain much time and energy from her own painting for the next ten years. Some months later, Leonora Carrington's long odyssey also ended in the land that Breton had called the "Surrealist place *par excellence*"; she and Renato LeDuc moved into an apartment on Rosa Moreno, just a few blocks from Varo and Peret.

The huge apartment on Rosa Moreno was in a building that had once served as the Russian Embassy but had since been abandoned. Now the marble floors and curving staircases lay in a state of near ruin, and a tangle of tropical vegetation theatened the exterior. To Carrington, Mexico seemed extraordinary, an exotic locale pulsing with bright colors and life, filled with the evidence of past civilizations untouched by Western classical tradition. Many of LeDuc's friends were bullfighters; the apartment was often filled with people. Even after the amicable end of the "marriage of convenience" that had allowed Carrington to leave Europe in 1941, the couple remained close friends.

Carrington and Varo soon became the center of a group of European artists that included the Hungarians Günther Gerzso and Enrique "Chiqui" Weisz, who would become Carrington's second husband, the photographers Kati Horna and Eva Sulzer. Luis Buñel was there periodically, as were former Surrealists now settled in Mexico like Wolfgang Paalen, Alice Rahon, and a few years later, Gordon Onslow-Ford. Paalen, who had arrived in 1939, had organized the 1940 International Exhibition of Surrealism with the Peruvian poet Cesar Moro and had founded *Dyn*.

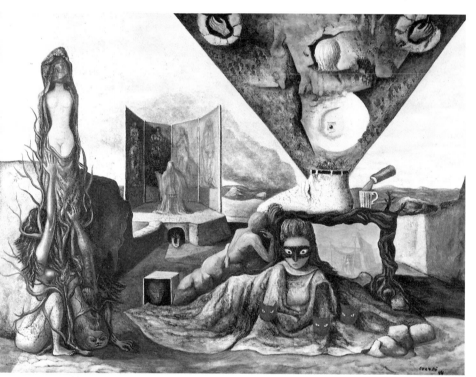

163 Photograph of Remedios Varo
164 Günther Gerzso, *Los Dias de la Calle de Gabino Barreda* (*The Days of the Calle de Gabino Barreda*), 1944. This painting includes a portrait of Varo (surrounded by cats) with Leonora Carrington, Peret, and Esteban Francés
165 Photograph of Varo and Benjamin Peret
166 Remedios Varo, *Rheumatism, Lumbago, Sciatica* (Bayer Aspirin Promotion), mid-1940s; gouache
167 Photograph *c.* 1943 of unidentified man, Remedios Varo, Gerardo Lizzáraga; British Anti-Fascist Campaign, Mexico
168 Remedios Varo, *Resurrected Still-Life*, 1963

163

164

165

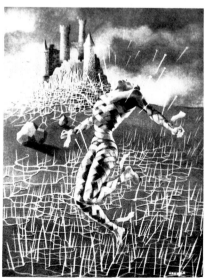

166

167

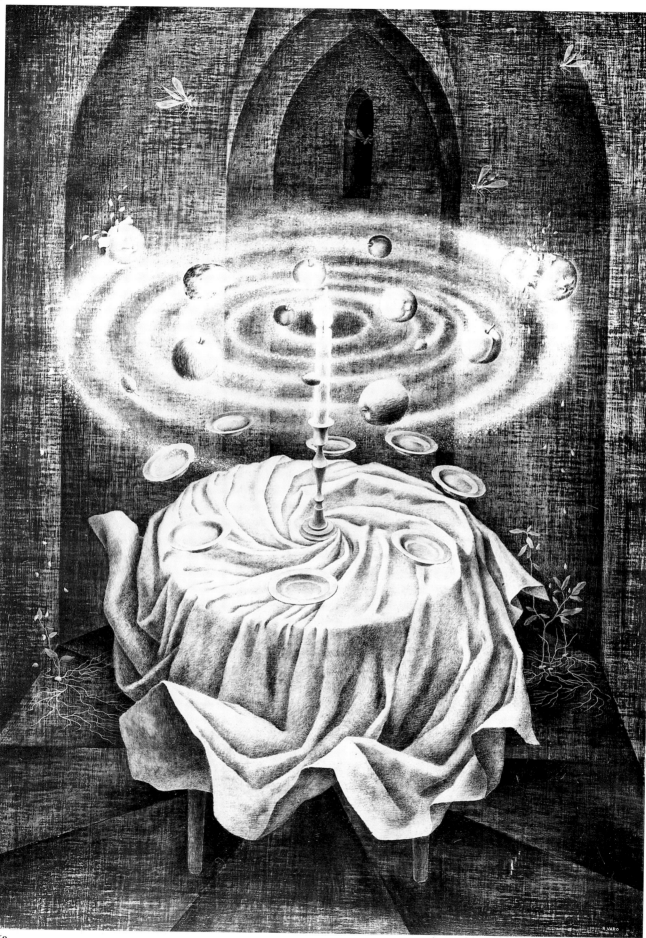

This new periodical published the work of many Surrealists living in Mexico, although the group around Peret, Carrington, and Varo kept their distance from the new publication and there was little contact between Paalen and Peret. Gerzso's 1944 painting *Los Dias de la Calle de Gabino Barreda* (*The Days of the Calle de Gabino Barreda*) pays homage to the little band of exiled Surrealists with portraits of Carrington caught in the tendrils of a rapacious vine, Varo surrounded by cats, Peret, Esteban Francés, and on the reverse, a self-portrait of the artist. Varo and Carrington saw little of Kahlo and Rivera, however. Carrington recalls that the Mexican artist was already in deteriorating health, while Peret's belief that Rivera had sanctioned an early attempt on Trotsky's life by a group that included the Mexican painter David Siquieros inhibited contacts.

164

The existence of an active group of exiled painters and writers in Mexico during the 1940s set the stage for the creative activity that flourished there during the next decade. More significant for the history of the women artists we have been discussing were the artistic results of the close emotional and spiritual relationship that developed between Carrington and Varo at this time and that propelled their work into a maturity distinguished by powerful and unique sensibilities newly independent of earlier influences of other Surrealist painters. The two, once friends in France, now became fellow travelers on a long and intense journey that led them to explore the deepest resources of their creative lives. For the first time in the history of the collective movement called Surrealism, two women would collaborate in attempting to develop a new pictorial language that spoke more directly to their own needs. "Remedios's presence in Mexico changed my life," Carrington recently recalled, adding that she saw Varo and Peret almost every day.[12]

During their first few years in Mexico neither woman produced many paintings. Carrington seems to have found writing a better exploratory medium for her new imagery, and her serious production of paintings did not begin again until 1945; Varo's works were first exhibited in 1954 and their dates of execution remain questionable. The meticulousness of her working methods indicates that at least some of the many paintings exhibited in 1954 may have been produced before that date. During the 1940s Varo worked at a variety of jobs, none of which paid particularly well, and all of which inhibited her own painting. She assisted in the building of small pro-British anti-Fascist dioramas documenting Second World War battles and designed to show the Mexican people that the Allies were winning the war; worked for Paalen secretly restoring pre-Columbian pottery for sale; designed costumes for Chagall's 1942 production of *Alekko*, which had been moved to Mexico because of the war raging in Europe; and worked as a commercial artist designing advertisements for Bayer aspirin and painting furniture and screens for Clar Decor, an interior design showroom and the site of Carrington's first exhibition in Mexico. There is no indication that either woman looked forward to professional careers or public acceptance of their art. "I painted for myself," Carrington later said; "I never believed that anyone would exhibit or buy my work."[13] But work they did. Carrington wrote plays and short stories, executed dozens of watercolors, many of them covered with the mirror writing that had led to her expulsion from school many years earlier, and began experimenting with

167

155, 166

egg tempera on gesso panels; Varo filled notebooks with accounts of dreams and with short stories, invented games, and magic formulas. Together the two women built and furnished a small model living room, perhaps as a *maquette* for a design project but perhaps just for pleasure, filling it with painted cardboard and papier-mâché furniture, and they appear to have co-authored at least one Surrealist play during this period.

Among the many watercolor sketches executed during Carrington's first years in Mexico, a number of which contain messages to friends, is one addressed to Varo with the words, "Remedios, I told you that I made a spell against (the evil eye) there it is—yesterday evening I had 38° of fever, auto-suggestion perhaps—I don't feel well enough to go out—Come see me if you can? Both of you come to drink some of our tequila? . . . Leonora."

170

The friendship between the two women extended to the sharing of dreams, stories, and magic potions. What would later become some of Varo's most persistent images—among them fantastic locomotor conveyances, particularly boats powered by the wind and sun, complex alchemical apparatus, towers with conical roofs and deep interior spaces reminiscent of Chirico, and landscapes based on the technique of *decalcomania*—can be found in Carrington's transitional works of the mid 1940s, in paintings like *Les Distractions de Dagobert* (1945) and *Tuesday* (1946), but disappear from the later works. Varo's stories of the period often include aristocratic English characters, at least one dream jotted into her notebooks contains a reference to "Leonora," and her paintings of the 1950s sometimes include motifs from Carrington's work as in *Mimesis* (1960), in which human figures mimic the forms of furniture, and the work as a whole reworks the strange encounters and formal parodies of Carrington's *c.*1938 *Self-Portrait*. Nevertheless, the works executed by Carrington and Varo after 1946 are totally and unmistakably the products of different sensibilities even though they share a vision of painting as a recording of life's many voyages: physical, metaphysical, and spiritual. In the works of both, reality is constantly being transformed and symbolic journeys undertaken. The women in Varo's paintings, many of them depicted with the heart-shaped face and delicate features of her own image, are alchemists, magicians, scientists, and engineers who travel through forests, along rivers, and above the clouds in jerry-built conveyances that run on stardust, music, and sunlight. Carrington's female protagonists are like the sibyls, sorceresses, and priestesses of some ancient religion; their journeys are mythic voyages into magical worlds that unravel like fairy tales. It is as secret journeys to enlightenment, proceeding despite obstacles and despair, or bursting with creative life, that the works produced in Mexico by Carrington and Varo must be considered.

190

68

Carrington's one-act play *Une Chemise de Nuit de Flanelle*, written in Mexico in 1945, contains important themes and motifs that would soon find their way into her painting. Its five scenes take place simultaneously in the five rooms and subterranean cave of a large house. The characters—Dwyn, Nud, Arawn, and Prisne—derive their names from the ancient Celtic gods of Britain: Gwyn, Nudd, Arawn, and probably Pryderi. According to legend, Arawn, King of Annwn, was the King of Hades, and Gwyn, the son of Nud, was the ancient god of the Other World.

169

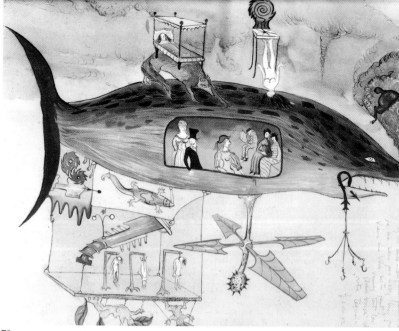

170

CARRINGTON AND VARO

*In Mexico Varo and Peret joined an active group of
expatriate painters and writers that soon included
Carrington. A close relationship developed between Varo
and Carrington, and together they created a new
pictorial language more relevant to their own styles and
requirements. They became absorbed in mysticism,
sharing dreams, stories, and magic potions, as well as
using painting as a recording of life's journeys. As can be
seen in the photograph of Carrington at work, their visual
languages also show many parallels, and Carrington has
at least one drawing,* Tiburon, *on which she has written a
message to Varo. Varo's* Ascension to Mount Analogue
*alludes to the various journeys—physical, metaphysical,
and spiritual—undertaken by both artists in Mexico.*

169 Leonora Carrington in her studio in Mexico, 1944
170 Leonora Carrington, *Tiburon, c.* 1942
171 Photograph of Remedios Varo in the 1940s
172 Remedios Varo, *Ascension to Mount Analogue,*
1960

171

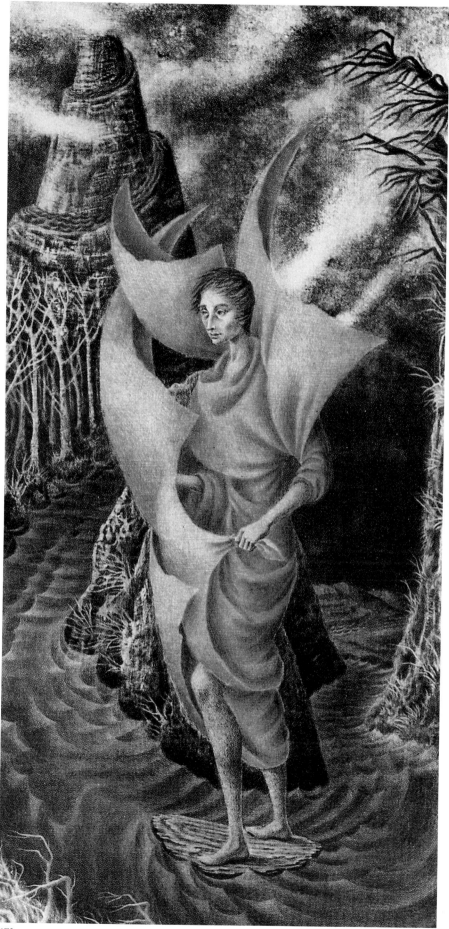

172

This "non-ordinary" world is linked to the observable world in Celtic tradition through a comprehensive cosmological scheme. It was the bardic Druid or Seer who perceived and understood the existence and interrelatedness of both worlds. In some accounts, Gwyn is also Gwion, the poet Taliesin of Graves's *White Goddess* who, as a boy, accidentally tasted the brew from the cauldron of Cerridwen and was reborn as a great poet.

On first reading, Carrington's play bears little overt relationship to the Celtic stories that generated its cast of characters. It unfolds in a series of scenes that involve a young woman who sits knitting in a ground-floor shop (Dwyn), a solitary traveler in search of a flannel nightgown (Nud), a sick child (Arawn) who repeatedly and symbolically murders his parents in an upstairs bedroom by throwing darts into a mannequin, a servant who belongs to both the world of the living and that of the dead (Prisne), a dead body, a banquet of cadavers in the cave, a white goose, a black swan, and assorted other minor characters. However, the play restates a theme common to alchemy, magic, and Celtic legend: the progression of spirit and matter. Its figures are in states of transition from one world to the next and are accompanied by a parallel and more symbolic evolution that relates to the alchemical rite of purification, which takes place in an egg-shaped vessel in the presence of the Philosopher's Stone. At the stroke of nine—a number that as the highest single digit is often used to indicate great mental and spiritual achievement and that appears in paintings such as *Nine, Nine, Nine* (1948)—a black swan in the attic lays a giant greenish egg and a white goose presides over an underworld banquet at which the guests are served boiled eggs. As the black swan delivers the alchemical egg into Prisne's waiting hand, the white goose attends the cadavers in the subterranean cave, and a kitchen fire burns around a corpse dressed in a flannel nightgown (shroud) as if to signal the transposition of one material into another. Black and white swans or swans and geese are often paired in Carrington's work, for example in the *Carved Decorated Woman* of 1951, and both images have long associations with death and rebirth. In ancient Rome, geese sometimes followed the souls of the dead instead of dogs, and the swan, sacred to the goddess of fertility and death, often accompanies the souls of the dead in ancient religions. Carrington has identified the black swan as the sacred sign of the goddess of the old religion. It refers to a secret song once sung by the bards: "I am the Black Swan, Queen of them All."[14] The gods of the ancient Celtic religion had originally worshipped the White Goddess, Danu, from whom the whole hierarchy of Celtic gods received its name of Tuatha de Danaan. She was the universal mother, the mother goddess who finally emerged in a debased form as the Mother Goose of children's fairy tales. As Arawn instructs Dwyn to "adore and serve these things under the earth," Dwyn comes upon the corpse of her husband and, kissing him on the mouth as his skin takes on the appearance of a plant, exclaims, "Now you are with me and I am the most powerful creature in the world."

The Celtic Gwyn, son of Nud, becomes the female Gwyn of Carrington's play, a play that, in the end, reveals the evolution of woman's consciousness while that of man dies; this evolution takes place in the presence of the ancient gods who owed their existence to the goddess Danu. In the opening lines of the account of her

173 Leonora Carrington, *Carved Decorated Woman*, 1951

mental breakdown and institutionalization, published in New York prior to her departure for Mexico, Carrington had indicated her growing interest in probing the sources of the female creative spirit:

> Later, with full lucidity, I would go "Down Below," as the third person of the Trinity. I felt that, through the agency of the Sun, I was an androgyne, the Moon, the Holy Ghost, a gypsy, an acrobat, Leonora Carrington and a woman. I was also destined to be, later, Elizabeth of England. It was she who revealed religions and bore on her shoulders the freedom and the sins of the earth changed into Knowledge, the equal between them. . . . The son was the Sun and I the Moon, an essential element of the Trinity, with the microscopic knowledge of the earth, its plants and creatures.

Orenstein, following a Feminist model that has attempted to revise traditional definitions of madness and sanity as they relate to woman's experience, has argued that Carrington's "breakdown" might be more accurately viewed as a "break-through" to new levels of psychic awareness.[15] The paintings and writings produced in Mexico during the mid-1940s reveal the search for a pictorial language adequate to the task of communicating this psychic evolutionary process. In them, interior and exterior, upper and lower spaces are organized in relationships that suggest physical passages, the presence of the world of the dead (spirit) parallels that of the living (matter), and mythic and hermetic signs and symbols are used to trace the passage of the spirit.

Among Carrington's early paintings from the Mexico period are many, including *The Old Maids*, *Night Nursery Everything*, and *Neighborly Advice* (all three date from 1947), that use the image of the house and the domestic activities that take place within its walls as metaphors for woman's consciousness. In *Crookhey Hall* (1947), the house from which a young girl flees represents the stifling world of Carrington's own childhood home; in *Night Nursery Everything*, painted in honor of the birth of Carrington's second son that year, the magical life of childhood takes place in its own domestic domain. In life as well as in art, Carrington grounded her pursuit of the arcane and the hermetic in images of woman's everyday life: cooking, knitting, and tending children. Edward James, who met Carrington in Mexico in 1944 and who soon became her most important collector, later recorded his impressions of her studio of the period:

179

> Leonora Carrington's studio had everything most conducive to make it the true matrix of true art. Small in the extreme, it was an ill-furnished and not very well lighted room. It had nothing to endow it with the title of studio at all, save a few almost worn-out paint brushes and a number of gesso panels, set on a dog-and-cat populated floor, leaning face-averted against a white-washed and peeling wall. The place was a combined kitchen, nursery, bedroom, kennel and junk-store. The disorder was apocalyptic: the appurtenances of the poorest. My hopes and expectations began to swell.[16]

In Mexico, Carrington began painting with egg tempera on gessoed wooden panels, reviving a medieval technique that yielded jewellike tonalities and bright

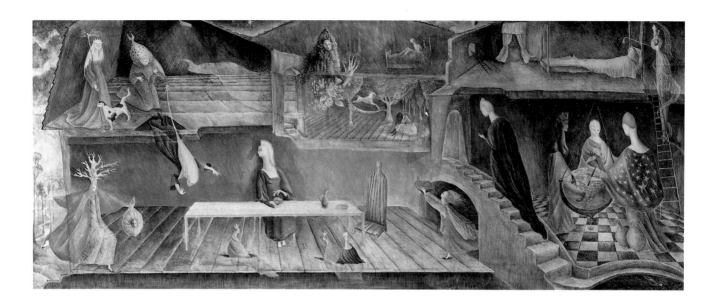

174 Leonora Carrington, *The House Opposite*, c. 1947

surfaces. Her friend Gerzso recalls that as she became more conscious of the work of painters like Bosch and Breughel, she became more interested in the technical aspects of painting; the fact that mixing egg tempera seemed to mimic culinary procedure further enhanced its use in her eyes. Experimenting with rapid dislocations of space and scale, she filled her paintings with friezes of tiny figures and fantastic animals. It is only upon careful inspection that one becomes aware of the microscopic worlds of activity that unfold around the edges of her major images, like stories within stories that continually assert the simultaneous existence of more than one world, more than one reality. In *The House Opposite* (1947), she presents another Celtic-inspired Other World, this one filled with images of resurrection and creation and devoted to a world of women that mirrors that of men. Here the domestic world of the house is presented as a metaphor for the world and conveys suggestions of interior and exterior worlds, higher and lower regions, nature and the firmament (embroidered onto the cape of one of the three figures who stirs a large cauldron). Carrington's world is a world of fantasy and the imagination in which men are often the enemies of women's magic powers. In *Penelope*, a play written in Mexico in 1946, the conflict is between a young girl who inhabits the world of the nursery with her magic rocking horse, Tartar, and the social world of the lower floor of the house presided over by her patriarchal father. In it Carrington refers to a feeble and bad race of men 'who don't know magic, fear the night, and have no magic powers of their own.

The House Opposite includes the world of childhood, also inhabited by a white rocking horse, that of night and the dream, figures who wait and others who are caught in a moment of metamorphosis from plant to human, and finally, a space devoted to the cauldron, prominent in Celtic myth as the cauldron of fertility and inspiration upon which the legend of the Holy Grail was founded. The cauldron in *The House Opposite* contains a bubbling broth; a small child carries an offering from it to a seated figure who casts a shadow in the form of a horse, suggesting that

200

she already participates in more than one realm of being. The prominent place given to the cauldron in Celtic myth and Grail literature had long fascinated Carrington, as had alchemical descriptions of the gentle cooking of substances placed in egg-shaped vessels. She has related alchemical processes to those of both cooking and painting, carefully selecting a metaphor that unites the traditional woman's occupation as nourisher of the species with that of the magical transformation of forms and colors in the artist's creative process.

It was during this period of close personal exchange of ideas that Carrington and Varo evolved their highly personalized vision of the woman creator whose creative and magical powers were a higher development of traditional domestic activities like cooking. Cooking and eating play decisive roles in both women's writings; in one of Varo's unpublished stories, the characters are instructed to follow recipes (formulas) carefully to avoid bad consequences. Her notebooks contain recipes designed to scare away "the inopportune dreams, insomnia and the deserts of sand moving under the bed," and those arranged to encourage other kinds of nocturnal experiences. A recipe designed to provoke erotic dreams calls for ingredients that include a kilo of strong roots, three white hens, a head of garlic, four kilos of honey, a mirror, two calves' livers, a brick, two clothespins, a corset and stays, two false moustaches, and hats "to taste." The instructions that follow parody exactly those of the traditional cookbook.

In all of these stories and paintings, women cook the magic brews, tend the alchemical fires, and oversee the cauldron of fertility and inspiration. "The invisible speaks to us, and the world it paints takes the form of apparitions; it awakens in each of us that yearning for the marvelous and shows us the way back to it...," wrote Rahon in 1951.[17] Rahon, previously known to Surrealist audiences as a poet, began painting in earnest in Mexico. Her first semi-automatic works originated in a decision to scrape and reuse the surfaces of Paalen's discarded palettes. She often threw sand and cement over these multicolored grounds in a technique not unlike that of Masson's sand paintings of the 1920s, and then scratched through the surface layers with a nail to evoke the forms of fantastic architectural vistas, animals, primitivistic stick figures, and hieroglyphic signs. The use of abstract signs by Rahon and others continually reaffirmed the origins of painting in ritual and magic. Of all the European Surrealists working in Mexico, Rahon appears to be the one most directly influenced by the country's indigenous art, for although Varo was an avid collector of pre-Columbian art, its forms and content play little if any role in her own work and Carrington does not seem to have consciously drawn from this source until the late 1950s.

Many of Varo's paintings reuse and sometimes parody images and themes from Carrington's work. The black and white tile floor of the alchemist's chamber in Carrington's *The House Opposite* reappears in Varo's later *Alchemy or the Useless* XVI *Science* (1958): a solitary woman has gathered the black and white squares into a cloak in which she huddles while turning the crank that sets in motion an elaborate mechanical apparatus designed to distill precious liquid from raindrops. Behind her rise the blocky forms of a medieval tower containing a Rube Goldberg-like set of gears and pulleys that suspend the alchemist's alembic over a conical fire.

Whether the drops of liquid falling from the sky actually pass through the transforming alembic remains in doubt; they may simply go directly from funnel to spout, water turned into water. Varo has used the Surrealist technique of *decalcomania*, and the work is bathed with the yellow light described by medieval alchemists. But unlike other Surrealists, she never allowed automatism to dominate her creative process, instead choosing a working method that was meticulous to the point of obsession. When painting she often sequestered herself in her studio for seven or eight hours a day for upwards of a month. The making of the finished work was a matter of meticulous craftsmanship in the deliberate application of tiny brush strokes of color.

A feeling that elaborate expenditures of energy and complicated mechanical procedures may, in fact, only lead to the obvious, the unchangeable, pervades many of Varo's works. In *Alchemy or the Useless Science* we are left guessing as to what is "useless," while in *Encounter* (1959) we are confronted with the uselessness of attempting change. Here a somber young woman opening a box in search of a new persona finds only her own face peering out. On the wall behind are other boxes in varying sizes, but the woman's unfocused gaze and troubled mien suggest that they also contain the same reality.

In other Varo paintings, alchemical apparatus reappears as a device to be used in the creation of both art and life. In *The Creation of the Birds* (1958) the artist, personified as a wise owl, is seated at a drawing table. With one hand she holds a magnifying glass that transforms the light from a star into the form of a bird on a piece of drawing paper; with the other, she paints in its tail feathers with a brush that is connected to the strings of a violin hanging around her neck. Beside the artist an alembic receives stardust and transmutes it into colored pigment that falls onto a palette. On the wall behind the artist/alchemist two suspended vessels pass their contents back and forth—perhaps a reference to Breton's *Les Vases Communicants* in which the contents of dream and reality are viewed as constantly feeding one another like the contents of two beakers in a chemical laboratory—and newly created birds fly around the room. Varo's woman/creator creates life as well as art, without the need for the inspiration of the muse or the Surrealist intervention of the loved one, for she herself possesses the secret of all creation. "Remedios Varo believed in magic," records Janet Kaplan:

> She had an animistic faith in the power of objects and in the interrelatedness of plant, animal, human, and mechanical worlds. The story is told that one evening on a Mexican street she found a plant being sold that produced fruits that looked like eggs. Fascinated, she brought one to her apartment, set it in the center of her plant-filled terrace in the moonlight, and placed her tubes of paint around it. She felt that this special plant, her paints, and the moon were harmonious together and that their conjunction would prove auspicious for the next day of painting.[18]

Varo's *Creation of the Birds* turns woman into an image of knowledge and the possessor of secret alchemical powers. It also incorporates ideas drawn from Islamic, specifically Sufi, philosophy, an important source for Western knowledge

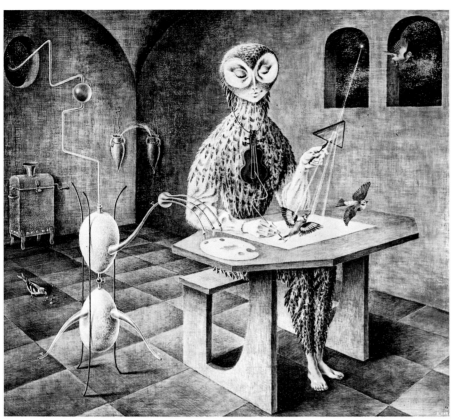

of medieval alchemy and one surely familiar to the Spanish Varo; her notebooks contain Arabic names and Islamic references and she was a follower of the philosophy of G. I. Gurdjieff, whose belief in the spiritual powers of music and dance had been shaped by Sufi mysticism. According to Sufi belief, light and vibration, or sound, are together the source of all creation. In Varo's *Solar Music* (1955), a woman plays a stringed sunbeam with her bow, and the resulting music releases the birds in the trees from their cocoonlike nests and causes grass and flowers to spring from her cloak and the earth to sprout new life where it is touched by the sun's rays. Through the magical correspondences that exist between light and sound woman becomes the instrument for creating life as well as art.

176

Without these correspondences creativity runs amok. *Harmony* (1956) depicts the struggle to create musical harmony; the crystals, leaves, and seashells manipulated on the staff by an androgynous figure seated at a table, and by the ghostly image of a woman who breaks through the wallpaper, are mirrored by the series of odd events taking place in the room. Drawers spring open to release their contents, floor tiles are pushed aside and plants and bits of drapery spring into movement in response to the sounds emanating from the two staffs. Confusion reigns in this monastic room, but we sense that it is only a matter of time until the proper correspondences are achieved and a medieval order (harmony) reigns.

177

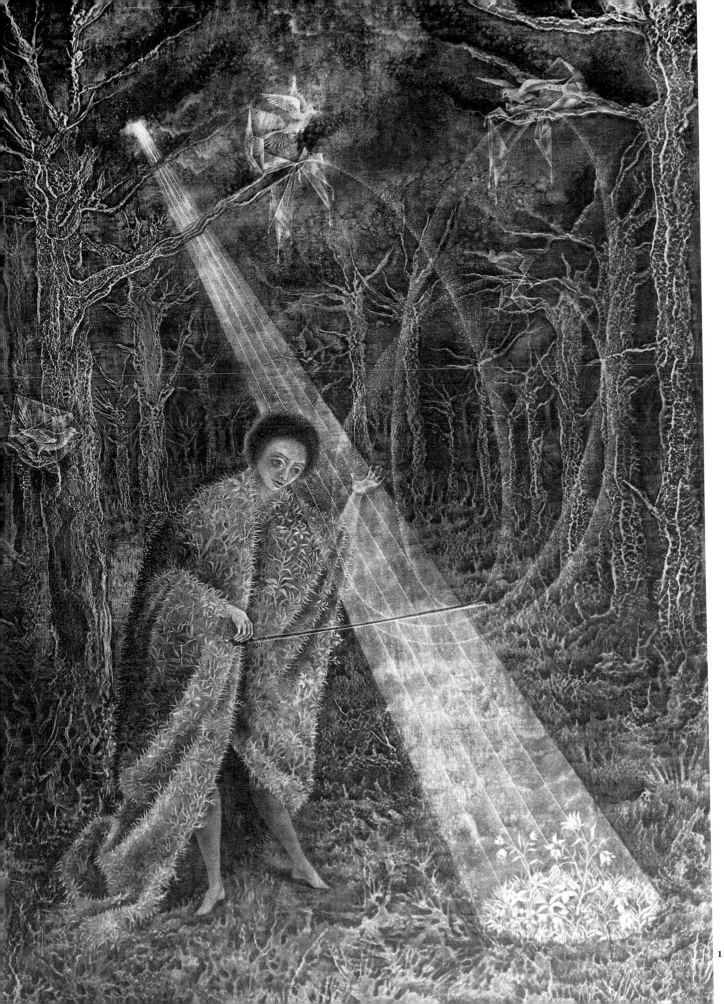

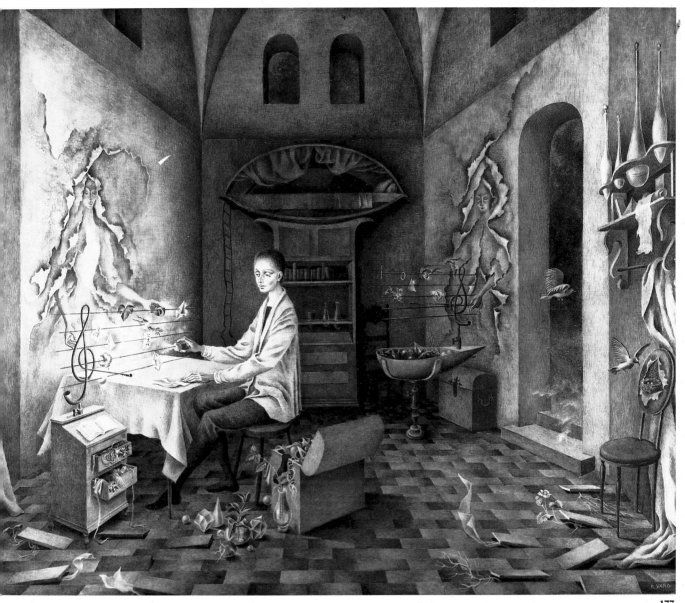

VARO AND SPIRITUAL HARMONY

Varo shared a vision of creative and spiritual rebirth and evolution with Carrington. Both cast the artist in the role of a seeker of truth; both shared a vision of life at once material and spiritual. Under the influence of the followers of Gurdjieff who believe in a progression from matter to spirit, Varo's voyages gradually turned away from memories of the many journeys she herself had taken as a child and as an adult to visions of journeys to enlightenment and spiritual purification. In Harmony *and* Solar Music, *magical correspondences between light and sound insure order and creation in the natural world.*

176 Remedios Varo, *Solar Music*, 1955
177 Remedios Varo, *Harmony*, 1956

180,181 The theme of woman's role in the creative cycle also underlies much of Carrington's work of the 1940s. *Kitchen Garden on the Eyot* (1946) and *Amor que move il sole e l'altre stella* (1947) contain numerous references to a female creative spirit. *Amor que move il sole e l'altre stella* depicts a procession of robed women and young girls who conduct a chariot of the firmament filled with sunlight and stars. The chariot is drawn by a horse whose wings, sprouting from its head in the form of curved horns, suggest the presence of the horned god, a traditional consort of the goddess in ancient religions. The presence of the two fantastic beasts who accompany the chariot suggests that the image has sources in the Tarot pack: the seventh card in the pack is the Chariot card, which indicates the triumph of the higher principles of human nature and which has on it a chariot accompanied by black and white sphinxes. Behind the chariot is a double being, both sun and moon, identified by the crescent shape on the top of one head and the solar rays that radiate from the other. In one hand it holds a fish from the sea in a cradle-

179 shaped net; the same cradle shape reappears in *Night Nursery Everything*.

Carrington's triumphal procession rolls along as if part of a medieval pageant celebrating the birth of the cosmos, an impression enhanced by the use of delicate blues and golds. In the Celtic legends to which Carrington so often turned, the horned god is the lord of animals and an image of fecundity, an allusion difficult to ignore in this context as the painting is signed and dated July 12, 1946, two days before the birth of Carrington's first son. It was an event that she had anticipated with great excitement and one that may well be intimated here in this triumphant female procession bearing new life and attended by the sun and the moon.

Kitchen Garden on the Eyot contains at least one of the same figures, the woman robed in a gown reminiscent of Renaissance dress. The presence of other similar female figures, one of whom, eyes closed, brings her vision to the others, also hints at a connection with *Amor que move il sole e l'altre stella*. The subject, fertility, encourages further comparison. Kitchen gardens, usually adjacent to or within easy access of the kitchen, provide fresh produce and herbs for the household. Carrington's kitchen garden is walled like the Virgin's *hortus conclusus* and filled with neatly planted rows of fruits and vegetables. Outside its walls, birds sit on nests full of eggs, fat quail peck for grain, a robed figure holding a large egg sprinkles stardust on its head in a symbolic act of fertilization that is repeated in other Carrington paintings—see, for example, *Again the Gemini Are in the Orchard*—and a white-robed female figure who appears to grow out of the trunk of a fruit tree plucks fruit while cradling a large egg under one arm.

The image of the garden, a recurrent motif in alchemical literature, is often used to emphasize the significance of sprouting and procreation. Hermetic parables by Christian Rosenkreutz and others give a central place to the walled garden as one of the oldest and most indubitable symbols for the female body. At least one alchemical practice consisted of putting some gold into the mixture to be transmuted. The gold dissolved like a seed and produced more gold (the fruit); the matter into which the seed was placed and in which germination took place was known as the earth, or mother. Evidence for the existence of similar ideas in Carrington's work can be seen in *Again the Gemini Are in the Orchard* (1947).

178 Leonora Carrington, *Again the Gemini Are in the Orchard*, 1947 ▷

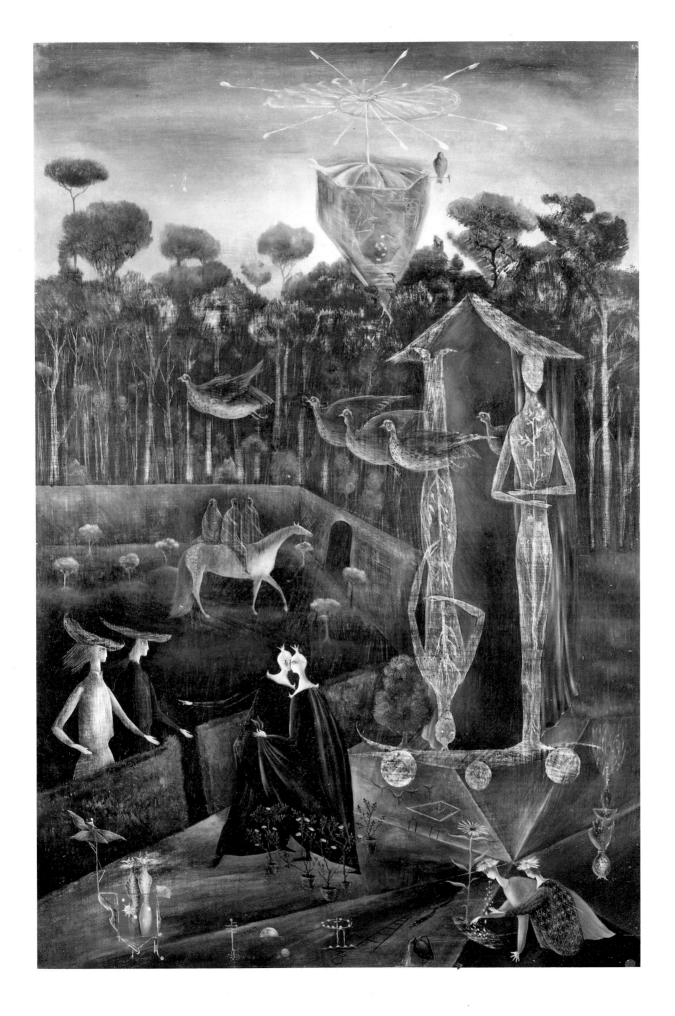

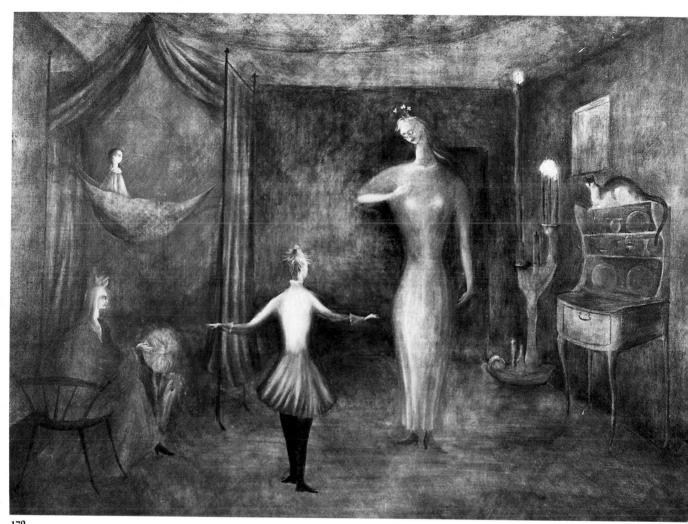

179

A NEW SENSIBILITY

In Mexico Carrington developed a mature body of work heavily influenced by magic, alchemy, and the Celtic tradition. Her female protagonists are like the sibyls, sorceresses, and priestesses of some ancient religion; their journeys are mythic voyages into magical worlds that unravel like fairy tales. But in life as well as in art, Carrington grounded her pursuit of the arcane and the hermetic in images of woman's everyday life: cooking, knitting, tending children. Night Nursery Everything, Kitchen Garden on the Eyot, *and* Amor que move il sole e l'altre stella *celebrate the birth of Carrington's son and contain many references to a female creative spirit.*

179 Leonora Carrington, *Night Nursery Everything*, 1947
180 Leonora Carrington, *Kitchen Garden on the Eyot*, 1946
181 Leonora Carrington, *Amor que move il sole e l'altre stella*, 1947

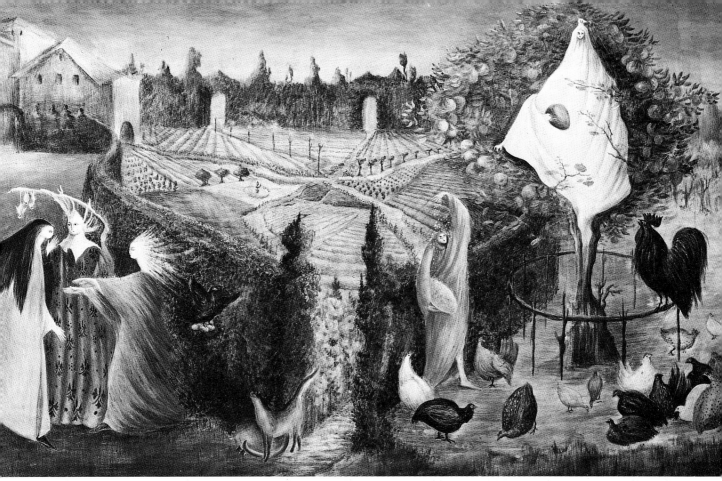

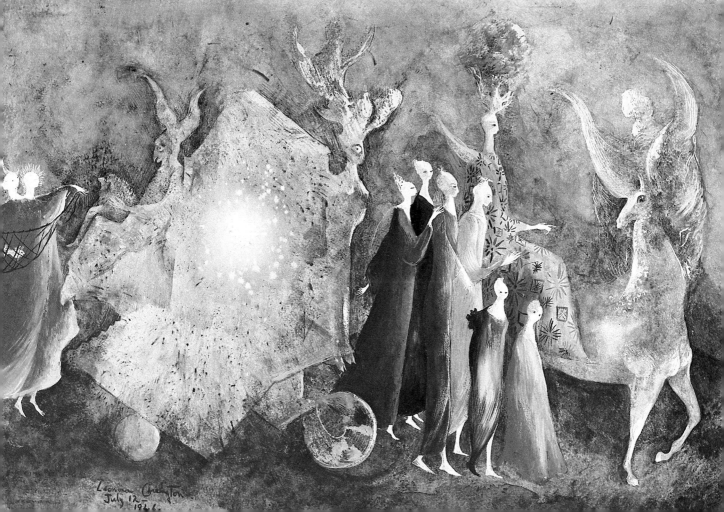

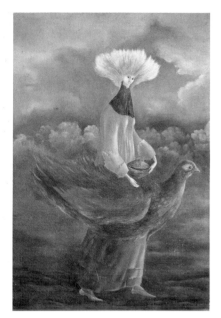

182 Leonora Carrington, *Portrait of the Late Mrs. Partridge*, 1947

In this work the Gemini or Twins, a dual astrological sign for the creative and destructive life forces, stand on a magic ground in which a tiny vessel waters the earth and two small figures wearing flowers on their heads fertilize another flower, just as in Varo's *Solar Music* light and sound fertilize the earth.

Images of eggs and partridge or quail also appear consistently in Carrington's work. Despite the presence of identifiable images such as these drawn from a variety of sources, the paintings are never mere illustrations of the ideas of others; instead images are combined and recombined in order to confound conventional readings and elicit new meanings. In ancient times the partridge was variously identified with the sun or the moon, and was often sacred to the love goddess because of a reputation for licentiousness pointed out by both Aristotle and Pliny; in Carrington's work it is sometimes used to affirm the earth's bounty, at other times it becomes a wry comment on country life, and it may even appear as the source of the alchemical egg of rebirth and transformation. Similar images also appear in the work of other artists at the time; Colquhoun's "Translated from the Galvanese" in *Osmazone* contains a mystical partridge: "One evening I was standing by a lake when just below the surface of the water a large bird like a pheasant darted very swiftly by. It was golden-brown with colour and luminous, with markings like pale crescents on the tail feathers; my companion said, 'The sun and the moon are the light of air, this is the light of water.'"

The partridge reappears in Carrington's work the following year in a somewhat ironic painting titled *The Late Mrs. Partridge*. Asked by Edward James who this Mrs. Partridge was, Carrington is reported to have replied: "She lived highly respected, and is still remembered as 'the better half' of poor Colonel Partridge.... When she died the neighbors sighed, 'She was fay, but she was country.'"[19]

The late Mrs. Partridge travels with her bird, and also with an egg-shaped handbag. The egg or egg-shaped vessel, a form never far from Carrington's mind, is one that she shared with many other Surrealists for whom the egg, or egg shape, had alchemical, psychological, or creative significance. The painting called *Baby Giant* (*c.*1947) contains two lilliputian worlds in a landscape reminiscent of Breughel. One is of the sea and filled with whales and Viking ships; the other is a hunting scene the ritual and magical aspects of which are indicated by the fantastic animal that flees from the hounds and by the woman who rides in from the left astride a strange horselike creature. The figure of Baby Giant gently cups a speckled egg in his hands, birds fly out of his cape, and a halo of golden wheat surrounds his head and replaces his hair. These images of generative nature have sources in paintings that also emphasize the image of the egg, such as *Kitchen Garden on the Eyot*.

Carrington's *Who Art Thou White Face*, painted in 1959, gives an even more prominent place to the egg; a chimaera, the fabulous winged beast on which, according to Graves, Zeus flew up to heaven binding heaven and earth, and which is always present at the poet's creative act, stands watch over a large egg. In Fini's *Guardian of the Phoenixes* (1948) and *Guardian With the Red Egg* (1955), woman presides over a secret ceremony of rebirth in which the egg becomes an essential metaphor for the creative process. But the image also appears in other paintings in

contexts that may suggest aridity and desolation rather than creation. Fini's *Petite Sphinx Ermite* (1948) contains a guardian sphinx, dressed in black and with eyes closed, that lies in the doorway of an abandoned and ruined building in which plaster peels from ocher walls and somber vegetation crawls over the door sill and threatens to engulf the silent watching figure. In front of the door, a pelvic bone and a broken eggshell, stripped of any sign of life, lie on the ground. The only sign of life is a fleshy pink flower suspended from above on a long string and pulsing in sinister fashion with the sense of life which is otherwise almost entirely missing from the painting.

The egg is the name of the alchemical vessel of transmutation or the alchemist's oven and is often used as a symbol of the female's role as a universal vessel of creative or spiritual rebirth. But it is an image often used also by male artists in a Surrealist context, most frequently by Ernst. In his *Beyond Painting*, published in New York in 1948, Ernst offers some autobiographical comments concerning his origins: "The second day of April (1891) at 9:45 A.M. Max Ernst had his first contact with the sensible world, when he came out of the egg which his mother had laid in an eagle's nest and which the bird had brooded for seven years." Ernst's mention of the number seven confirms the image's alchemical origins, for in alchemy there are seven metals involved in the Work. Seven is also the number of planets of the universe and the macrocosm. In Carrington's essay "The Bird Superior Max Ernst," the alchemical transformation that takes place requires seven turns; the number reappears in her short story "The Seventh Horse," in which the seventh horse is an image of transformation. For Ernst, the eye and the egg were closely related, and his series of paintings titled *At the Interior of Sight: The Egg* (1929) identify the forms of eye and egg as interchangeable images indicating the sources of creation as interior. Ernst's reference is to the process of bringing the work of art into existence through a semi-automatic process of visual hallucination in which the eye is allowed to suggest images that derive their power from their mental correspondences. In *Kitchen Garden on the Eyot* and other works by women artists, the image is a potent metaphor for creative life or, sometimes, for the loss of creative powers.

The significance of alchemy, over and above its chemical and pseudoscientific phases, lay in its identification of the true subject, the prima materia, as man. The alembic, furnace, philosophical egg, and so on in which the work of fermentation, distillation, and preparation took place was man; the alchemist Alipili explains: "The highest wisdom consists in this, for man to know himself, because in him God has placed his eternal Word.... Therefore let high inquirers and searchers into the deep mysteries of nature learn first to know what they have in themselves, and by the divine power within them let them first heal themselves and transmute their own souls...."[20]

For Carrington and Varo, the path of spiritual evolution was woman's. During the early 1950s both women became involved with the followers of Gurdjieff, and with Tibetan Tantric and Zen Buddhism; prior to these involvements, however, their work was already revealing a sensitivity to the idea of an evolutionary feminine consciousness and to seeking out the sources of woman's creative impulses.

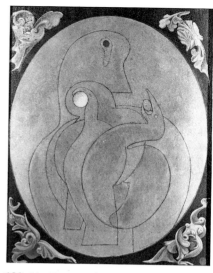

183 Max Ernst, *At the Interior of Sight: The Egg*, 1929

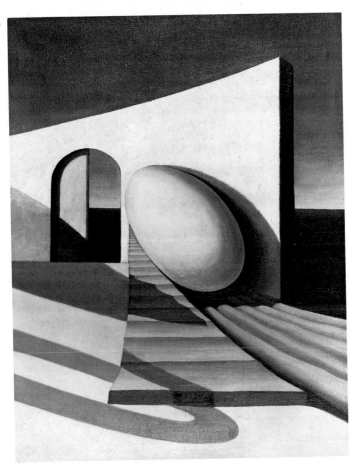

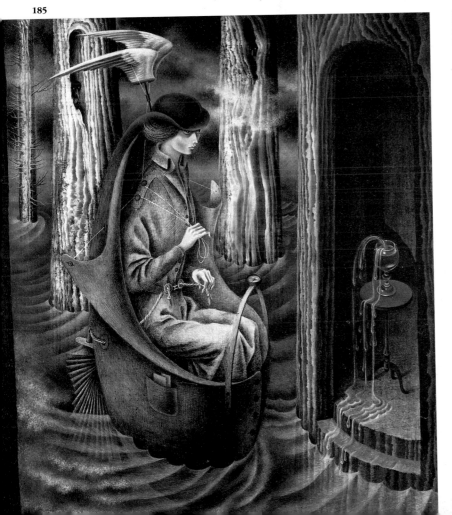

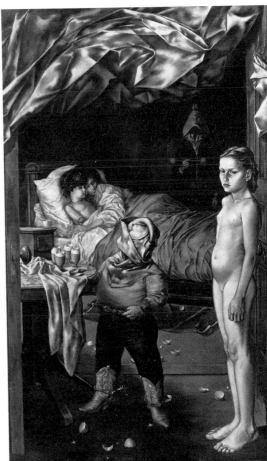

SYMBOL OF THE EGG

*The image of the egg, with its alchemical,
psychological, and creative associations, appears
frequently in Surrealist art. Sage, who was no doubt
influenced in her choice of this image by Chirico and
who denied its symbolic significance, nevertheless
titled her autobiography "China Eggs" and included
the image in many paintings such as* My Room Has
Two Doors. *The egg finds its way into paintings like
Tanning's* The Guest Room *and Carrington's* Baby
Giant. *In Varo's* Exploration of the Sources of the
Orinoco River, *a bowler-hatted young woman travels
in an egg-shaped vessel in search of the Source.*

184 Kay Sage, *My Room Has Two Doors*, 1939
185 Remedios Varo, *Exploration of the Sources of
the Orinoco River*, 1959
186 Dorothea Tanning, *The Guest Room*, 1950–52
187 Leonora Carrington, *Baby Giant*, c. 1947

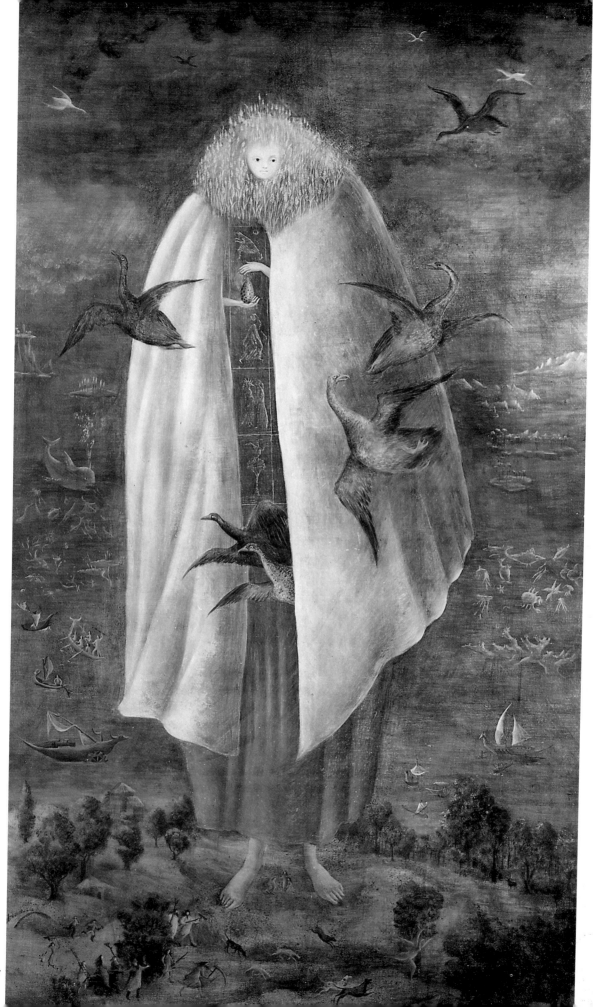

Carrington's 1948 exhibition at the Pierre Matisse Gallery in New York, arranged by Edward James, included a number of paintings on themes already discussed here as well as several that deal more specifically with the image of woman as a seeker after spiritual enlightenment. Among the latter were *Pilgrimage to Syrius* (1947) and *Palatine Predella* (1946), both of which make reference to the Egyptian moon goddess Isis and her cult. *Pilgrimage to Syrius* and the later *Are You Really Sirius?* (1953) refer to the dog star, Sirius, under whose ascendancy Isis brought forth her five children and which, recalled for modern readers by T. S. Eliot in "Sweeney Among the Nightingales," was associated with the flooding of the Nile and the fertility signaled by that annual event.

Palatine Predella, a friezelike presentation reminiscent of early Renaissance predellas with their scenes from the lives of the saints, offers simultaneous visions of several different worlds. In the middle layer of the painting, a white-robed woman ascends from a fiery underworld followed by a procession of sacred horned beasts bearing the familiar lyre-shaped horns of the goddess consort. In one hand she holds a leafy stave, in the other a flame that she offers to a bearded anchorite in a bare monastic cell. The fact that the flame does not burn her hand suggests that she has magic powers; she holds it forth as if it were a sacred flame of enlightenment, perhaps the very one that he had been seeking through prayer and fasting, but which can be revealed only by woman. Where the earth is cut away, tree roots are exposed like veins, a motif frequent in the works of Kahlo from this period; the roots trap nocturnal birds like the owl. Arching over the hermit's cave is another landscape, this one snowy and containing another procession, beginning its ascent following a fabulous beast. Carrington's palette fluctuates between intense reds and yellows and a deep rich green, imparting to the landscape something of a seasonal feeling. Springlike vegetation, the deep reds and yellows of autumn, and a wintery landscape combine in a drama that reads like Proserpina's return from the underworld, but is more likely meant to evoke the figure of the Egyptian goddess Isis.

Carrington's figure may not be a specific representation of this goddess, but there are a number of images in the painting that indicate references to this myth, long viewed as a parable of inner life and spiritual quest. The image of the Egyptian Isis, the goddess of the moon, sister and spouse of the moon god, Osiris, was revived during Hellenistic times as one of the mystery cults; in ancient Egypt, the Book of the Dead contained instruction in the mystery religion of Osiris. Osiris, who died and went to the underworld, was later restored to life by the power of Isis, who had wandered the earth searching for the dead god. Her attribute, curved animal horns with the full moon between them, appears in Carrington's painting *Professional Ethics* (1955), where the presence of a horned cow bearing the moon and a black-robed figure casting a spell outside a sick child's bedroom recall the black-robed Egyptian goddess who was reported to brew a medicine that could raise the dead. In *Palatine Predella* the procession of horned cows indicates the presence of the goddess, and the snowy landscape indicates the winter season associated with her wanderings. Madame Blavatsky's *Isis Unveiled*, published in 1877 and surely familiar to Carrington with her abiding interest in arcane

traditions, used the goddess Isis, the goddess of magic, as an image of the Eastern origins of the sacred doctrines of the theosophists and their unending quest for spiritual purification through the progression from material reality to higher levels of awareness.

Carrington shared her vision of creative and spiritual rebirth and evolution with Varo. Both cast the artist in the role of a seeker of truth; both shared a vision of life as an odyssey at once material and spiritual. The imagery of their voyages is never far from that of the medieval search for the Holy Grail, a spiritual goal representing inner wholeness, union with the divine, and self-fulfillment. Like the alchemist walking through a landscape rich with the bounty of nature from which he, or she, hopes to distill the divine essence that will yield eternal life and spiritual understanding, the seeker after the Grail hopes to become one of the chosen few who overcome the obstacles that stand in the way of true enlightenment.

Among Varo's early paintings is a work executed in Paris in 1938 and titled *Spirits of the Mountains* in which we see, above the clouds, a line of light that touches the tops of the mountains, several of which have their summits cut away to reveal female figures trapped inside in attitudes of reverie or meditation. It is as if the spirits called forth from the highest peaks are female and waiting for release from the material that binds them. In 1947, she again painted an image of woman's journey; *The Tower* depicts a woman balancing precariously above a small vessel afloat in a ruined tower and searching the horizon for a land that lies ahead. Perhaps a reference to the war-torn land Varo left behind when she embarked on the final leg of her physical journey from Europe to Mexico, the painting in any case implies that land, and by implication salvation, is always ahead, out of sight. Thirteen years later, under the influence of the followers of Gurdjieff—who believe that when an individual dies, most of the baser, coarser elements are left behind while the spirit advances to another, purer sphere—she painted *Ascension to Mount Analogue*. The title is taken from René Daumal's unfinished novel posthumously published in 1952. Daumal, under the influence of Gurdjieff and Eastern philosophy, wrote a spiritual parable of the journey to enlightenment and spiritual purification as an expedition to Mount Analogue, a mountain the bottom of which is approachable by man, the top of which remains hidden and inaccessible. Varo chooses the spiral form of the sacred mountain, for the pilgrim, ascending in a spiral fashion, sees both what has been accomplished and what lies ahead still to conquer. Her single traveler raises the folds of his monkish habit to use them as a sail, propelled along by the wind on a tiny chip of wood that is surely too small and insubstantial to support the weight of a human, but which may well stand for the tiny crystal chips or "paradams" that are the only thing valued by the guides of Mount Analogue and which may be used as currency in the ascent.

Such questings after spiritual essence are the stuff of which Grail literature is made. Echoes of the Holy Grail with its elixir of life are found throughout the later paintings and writings of Carrington and Varo. The image appears in Varo's *Born Again* (1960) in which the figure of a naked woman with full breasts bursts through the wall into an inner sanctum where a chalice stands on a small table. Leaning over its luminous surface, she sees not her own reflection but that of the new moon.

189

188

172

XVII

215

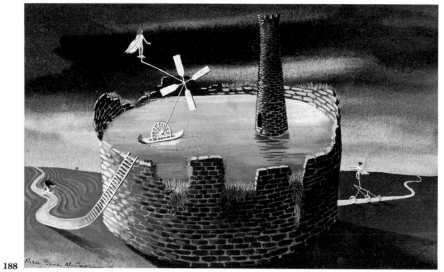

188

189

SPIRITUAL JOURNEYS

Varo and Carrington pursued occult and esoteric studies in the search for higher levels of spiritual life. References to her physical flight from Europe at the outbreak of World War II are contained in Varo's The Tower, *while in* The Spirits of the Mountains, *painted in Europe, images of women animate a mountain landscape where their spirits coil around the peaks. Early works of Carrington's, like* The Temptations of Dagobert, *often include references to Varo's most persistent images—among them fantastic conveyances, towers, alchemical apparatus, and landscapes based on the technique of* decalcomania.

188 Remedios Varo, *The Tower*, 1947
189 Remedios Varo, *Las Almas de los Montes* (*The Spirits of the Mountains*), 1938
190 Leonora Carrington, *Les Distractions de Dagobert*, 1945

185 Themes of spiritual travel and enlightenment combine in paintings like *Exploration of the Sources of the Orinoco River* (1959). In late 1947, Varo traveled to Venezuela to visit her brother. She remained for two years, during which time Peret, from whom she had grown increasingly estranged, returned to Paris. During her stay in Venezuela, she made a trip to the source of the country's major river in search of gold and discovered that the river arose in a forest that was completely flooded during certain times of the year. That this alchemical journey was associated in Varo's mind with the search for the Grail is suggested by her painting of the expedition. Her pictorial version shows a well-dressed female traveler manipulating the flaps of a fantastic aquatic vessel that combines aspects of her trench coat and hat as she sails along the Orinoco with silent determination. The voyage through the flooded forest brings her not to gold but to a goblet, the metaphysical source, which holds an eternal and inexhaustible jet of water.

The constant search for enlightenment and spiritual development, for planes of existence that more fully unified spirit and matter and that offered an escape from baser realities, propelled Varo and Carrington into a variety of occult and esoteric studies. Toward the end of her life, Varo's search was directed toward dispelling the despair and depression that often threatened to overwhelm her. Carrington's path led, finally, to the conscious articulation of her concerns through the Feminist movement of the early 1970s. In a commentary written on the occasion of her 1976 retrospective exhibition at the Center for Inter-American Relations in New York, she, like Breton, but toward different ends, invoked the domain of Faust's Mothers in laying claim to woman's legendary powers:

> The furies, who have a sanctuary buried many fathoms under education and brain washing, have told females that they will return, return from under the fear, shame, and finally through the crack in the prison door, Fury. I do not know of any religion that does not declare women to be feeble-minded, unclean, generally inferior creatures to males, although most Humans assume that we are the cream of all species. Women, alas, but thank God, Homo Sapiens.... Most of us, I hope, are now aware that a woman should not have to demand Rights. The Rights were there from the beginning; they must be Taken Back Again, including the mysteries which were ours and which were violated, stolen or destroyed, leaving us with the thankless hope of pleasing a male animal, probably of one's own species.[21]

The lives of our ancestors, when we look back to them, appear to have been infinitely less troubled and momentous than our own—it is rather as if Fate had designed us for the denouement of the drama in which we are acting.

ANDRÉ BRETON, "Introduction to the Work of Toyen"

6 | *Cycles of Narrative Fantasy*

Surrealist artists have often been accused of being overly "literary," more concerned with the illustrative and ideational than the pictorial and sensate. As latecomers in a movement that before 1925 had no defined role for the visual arts and that even after that date often contested the potential relationship between Surrealism and painting, Surrealist artists faced a double challenge: that of keeping their work free of the taint of aesthetic preoccupations while at the same time honing their artistic skills in the search for self-knowledge and discovery. "This is why it is impossible for me to envisage a picture as being other than a window, and why my first concern is then to know what it *looks out* on," Breton wrote in his 1928 essay "Surrealism and Painting."

The line between verbal and visual expression in Surrealism remained fluid: Dali wrote a long poem to accompany his 1936 painting *The Metamorphosis of Narcissus*, as well as a novel and an "autobiography"; Ernst provided elements for a biography, several treatises on art, and the prose fragments that accompany the text in his three collage "novels"; Masson and others wrote essays, poems, and descriptions to accompany paintings. Literary expression played an even more central role in the lives of women artists associated with the group; in many cases it shaped their pictorial conceptions, in others it became the true *métier* through which they evolved their Surrealist vision. Carrington, Tanning, and Colquhoun all wrote novels during the period of their involvement with Surrealism and, along with Fini, Pailthorpe, and Sage, published plays, stories, poems, and texts. Sage, Kahlo, and Varo poured their fantasies, their ideas, and their dreams into diaries; Penrose was a poet who turned to collage as a means of creating another dimension in the richly textured landscape of her poetry. Only Toyen and Agar seemed largely to have confined themselves to visual expression. Even more important than their use of literary as well as visual media is the extent to which a literary imagination gave form to their visual expression, turning Varo's and Carrington's symbolic quests into narrative journeys, Kahlo's self-portraits into autobiography, Hugo's illustrations into visual commentaries on Surrealist texts. This is not to say that their work is illustrative of Surrealist ideas; in fact, their general lack of interest in Surrealism's theoretical side seems to have saved their work in many cases from the trap of the overly illustrative that plagued Dali, Masson, and others, particularly during the 1930s when illusionism dominated Surrealist art.

Many factors influenced the predilection of women artists for an art in which personal narrative, however fantastic, dominates. The art of male Surrealists was shaped by their acceptance of a Freudian unconscious and by their search for the

means of effecting the link between the contents of the dream and the unconscious and an exterior reality. The link was often a woman, whose "convulsive beauty," to use Breton's term, was sufficiently compelling and disturbing to break through the conscious mind's restrictive control, and onto whose image could be projected the secret, and often forbidden, desires and obsessions lodged in the unconscious. Defining the creative act in accordance with the violent disjunctions of Lautréamont's famous metaphor—"beautiful as the chance encounter of a sewing machine and an umbrella on a dissecting table"—that bound opposites into a new poetic reality, and allowing *hasard objectif* to dictate their action in the world, they created an art intended to shock and disturb. There is no parallel external being in the work of the women artists discussed here who functions as a repository for the projection of erotic desire, no wholehearted embracing of Sade and Freud, no externalized violence, and very little commitment to a public art of disruption. Once the muse was internalized she became part of an inner landscape, one revealed through streams of associated images. Moreover, the erotic violence that does exist in the work of women artists tends to be absorbed into their images of themselves rather than directed out into the world and lodged in an image of the Other. In Kahlo's painting erotic violence is self-directed; in Tanning's it is displaced onto the world of childhood where it is muted by its associations with children's games and stories.

The art of the women associated with Surrealism is an art of sensibility rather than hallucinatory disjunction. Its mysterious interiors, continuous rather than fragmented spaces, combining of precise drawing and deep chiaroscuro, and figures given over to somnolent reverie recall certain early-twentieth-century painters often identified with Magic Realism and Neo-Romanticism. Although Surrealism had clearly overshadowed Magic Realism in Paris by the late 1920s, and Neo-Romanticism is most often associated with painting in America during the 1920s and 1930s, both tendencies marked the Surrealism of Pierre Roy, Paul Delvaux, René Magritte, and others. Roy, who refused to join the Surrealist group officially, remained on friendly terms with many Surrealists, and his work was often included in Surrealist exhibitions. Elements from paintings like his *Danger on the Stairs* (1927), exhibited at the Museum of Modern Art in New York in 1936, found their way into Tanning's Surrealist compositions, where they are used both as formal devices and as a means of asserting an air of suggestive narrative and faint menace. Likewise, Fini's close friendship with Pavel Tchelitchew, whom she first met in 1937 while traveling to New York for the opening of her first exhibition at Julien Levy's gallery, probably influenced her move toward more theatrical multifigure compositions in the late 1930s. The works of Hugo, Carrington, and Varo reveal similar, though perhaps less direct, affinities.

Recent histories of women artists and of writers of the nineteenth and twentieth centuries, from the Brontës to Virginia Woolf, have indicated that the group of successful writers is larger than that of painters. To write one needs only pen and paper and a corner of the family table; the act of reading requires nothing other than books and leisure time. But the woman who aspired to the life of an artist had to have both technical training of a kind often not available in secondary schools

121

and access to the history of art—the freedom to visit and absorb painting in museums and studios. These factors certainly account for the disproportionate number of women artists prior to the nineteenth century who came from artist families and who had fathers, brothers, or uncles who took over their training in the years when women were not allowed access to workshops and art schools. By the 1920s and 1930s many more women had that freedom. Nevertheless, few of the women artists associated with the Surrealists had had art training comparable to that of Arp, Dali, Masson and others. Fini, Oppenheim, and Sage were largely self-taught though each had attended painting and drawing classes; Agar and Colquhoun pursued formal courses of study at the Slade School of Art, Tanning at the Art Institute of Chicago, although the latter cut short her studies. Carrington and Kernn-Larsen enrolled in the academies of Ozenfant and Léger, but their courses of study were relatively brief. It is not unlikely that their somewhat limited exposure to academic training, combined with almost universal family disapproval of art as a career for young women, and the presence of a group of male artists whose careers were already well established worked to create an environment in which many women drew greater sustenance from reading and writing than from discussing art. The narrative content of Florentine and Sienese early Renaissance fresco cycles, which she had first seen while a student at Miss Penrose's boarding school in Florence, profoundly influenced Carrington's development as a painter, but Tanning turned to Poe and to the Gothic novels of Ann Radcliffe. When it came to communicating something of their own inner reality in painting, women artists reverted naturally to their own lives and perceptions. Although the personal and self-revelatory have often been associated with women's creativity, the origins of this tradition in late-nineteenth- and early-twentieth-century art lie with men—from Edvard Munch who painted out his own psychological torment to Egon Schiele who made his sexuality the source for his imagery. The self-referential nature of the work of these women, isolated as it is in most cases from the shared theoretical positions and commitments of the Surrealist group, almost guarantees an art in which personal reality dominates and narrative flow, rather than abrupt dislocation and juxtaposition, provides structure.

An examination of the work of women artists who have not relied on personal biography but whose work has nevertheless developed a strong narrative thrust reveals other aspects of this tendency. Grace Pailthorpe used Surrealist images to support her psychological investigations; Valentine Hugo created a role for herself as an illustrator of Surrealist texts and an interpreter of the Surrealist spirit. Out of the uses to which they put Surrealist texts and images both women created bodies of work that are unique in the history of Surrealism.

Pailthorpe, born in Surrey in 1890, studied medicine at the beginning of the century and then worked as a surgeon during the First World War. The photograph of her published in the "Living Art in England" section of *The London Bulletin* in 1939 shows a middle-aged woman with a straightforward, almost severe, expression, an image far removed from the childlike and erotic female forms that dominate Surrealist periodicals of that decade. At the end of the war Pailthorpe set out to work her way around the world, returning to England in 1922 where she

191 Grace Pailthorpe, *Oil*, 1938

took up the study of Freudian psychoanalysis. The following year she began five years of research into criminal psychology, an undertaking that resulted in a report titled *Studies in the Psychology of Delinquency*. The report, which earned her an international reputation, was not without controversy, for in it she advanced a radical vision of the relationship between environment and psychological health, and she argued, in a manner made popular by R.D. Laing many years later, that normal adults have much to learn from children, the insane, and the delinquent. In 1928 she founded the first institute in the world devoted to the scientific treatment of delinquency. Even before coming in contact with Surrealism, Pailthorpe, in publications like the study titled *What We Put in Prison and in Preventive and Rest Homes*, which appeared in 1932, had made a strong case for the need for an integrated human consciousness and one in which conscious and unconscious desires were not perceived as warring factions in a repressive struggle.

Interested in the art of the insane, and in automatism, Pailthorpe and her disciple, collaborator, and, later, husband, Reuben Mednikoff, began to experiment with automatic drawing and painting around 1935; they soon concluded that art has an essential psychological function. Three works from a series by Pailthorpe titled *The Ancestors* were included in the international exhibition at the New Burlington Galleries in 1936, where they attracted Breton's admiration, but it was not until the publication of "The Scientific Aspect of Surrealism," which appeared in *The London Bulletin* in December 1938, that Pailthorpe made clear the extent to which she viewed painting as the raw material of psychological inquiry.

In her article, Pailthorpe argues that the final goals of Surrealism and psychoanalysis are the same: the liberation of the individual. But in submitting the results of her experiments with automatism to psychoanalytical investigation, and in viewing art as raw data for scientific experimentation, she provoked one of the few full-scale theoretical battles to break out among the members of the English Surrealist group.

Accepting the existence of the unconscious in Surrealist works of art that result from the use of automatic techniques, Pailthorpe set about making this content manifest and intelligible by following the analytic model laid down by Freud in his "Gradiva" and "Leonardo" essays. She rejected the works of Surrealists such as Dali, Miro, and Tanguy as "interesting but unreliable" (they were apparently too closely linked with the history and traditions of art to be considered free of conscious "inhibitions") and turned instead to examples produced by herself and Mednikoff during their "research" sessions. "This drawing of a man having his eye gouged out has in it the wish to get into the father to find a safe place from an unsafe external world," she wrote of one of her own pen drawings in a long analysis of its psychological content. The liberation of the unconscious through the act of drawing or painting suggested to her that "Surrealism is ushering into the world an art greater than has hitherto been known, for its potentialities are limitless. And this art of the future will arrive when completely freed fantasy evolves from uninhibited minds. It will be the dawn of a new art epoch."

Although Breton had been quick to seize on Freud's conclusion in the "Gradiva" essay—science and art confirm rather than contradict one another in their

192 Grace Pailthorpe, *The Spotted Thrush*, 1942 ▷
193 Grace Pailthorpe, *Midnight Flight*, 1936

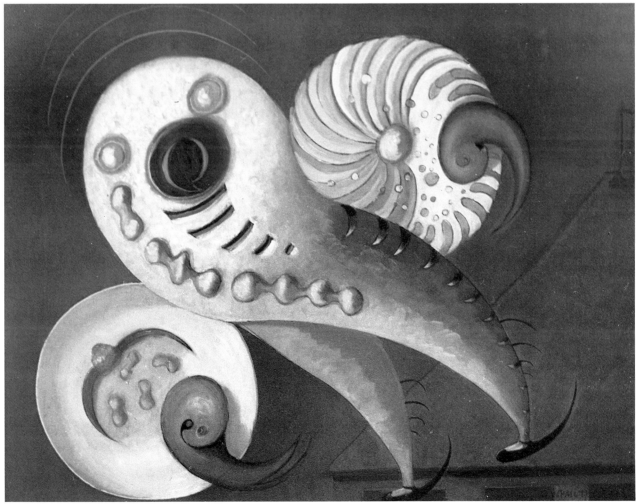

explication of the unconscious, the one proceeding through conscious observation of abnormal mental processes in others, the other directing his/her attention to his/her own unconscious and giving it artistic expression—Mesens and others recognized in Pailthorpe's work an explicit threat to Surrealist autonomy. Pailthorpe's own painting suffers from a lack of technical skill and visual complexity and nuance and is, in the end, dangerously close to being illustrative, although the illustrations are a delightful whimsy. In *Midnight Flight* (1936) an embryonic form differentiates into a distinctive personality that launches itself into the sky accompanied by two green satellites that may well point toward primal fertilization (if one applies the interpretative model that Pailthrope herself endorsed), while in *The Spotted Thrush* (1942) she restages the original trauma of birth, separation, and the search to reunite with the mother through the act of feeding.

193

192

Pailthorpe's hope that through the act of painting the unconscious could be externalized, conceptualized, and subsequently reintegrated with the conscious as an act of psychic liberation gave her art both a strongly depictive and a secondary function. In visual terms, Pailthorpe's automatic drawings and paintings and Hugo's illustrations have little in common. Yet the works of both reveal an acceptance of the interpretative function of the image, as well as a willingness to imbue the visual image with a strong story-telling content.

"Agile, fine and strong, the hands of Valentine Hugo rediscover the object in the word," Eluard wrote in "Un Droit de Regard Enfin Sur le Poème," his preface to the edition of selections from Rimbaud's *Les Poètes de Sept Ans* that she illustrated in 1939. "Not arrogant, but ambitious, they depict, invent, describe the object in which one cannot doubt that ancient magic rises up anew." Hugo occupied a unique place in Eluard's life, for although briefly linked romantically after his separation from Gala in 1929, they maintained a close and confidential friendship and working relationship until his death in 1952. She was the illustrator he most trusted with his work, and at his death her painting *Le Harfang des Neiges* (1932), originally inspired by a poem of Breton's, was hanging above his bed. Her many portraits of Eluard are well known, and she also illustrated, among many other texts, his long poem titled *Medieuses* (*mes Dieuses*, feminine of the word God), which he viewed as a "sort of feminine mythology," beginning from very precise directions given to her by the author. She is equally well known as an illustrator of Char, Achim von Arnim, and Lautréamont, as well as Rimbaud. Responding to an interviewer's question about why she had largely stopped exhibiting with the Surrealists after 1935, Hugo answered, "First because I wasn't painting much, but was illustrating books and music and then I wanted finally to feel free to do and love what I wanted to make and love.... Eluard understood that so well that he was my 'elective' brother."[1]

Hugo had begun her study of wood engraving in 1926 and the technique, which encouraged a sinuous linear flow of images, almost immediately moved her work in the direction of fantasy and the dream. Her work quickly revealed qualities indispensable to successful literary illustration—a recognition of the intimate interrelatedness between word and image and a sensitivity to the challenge of bringing a text to life visually without overwhelming it with pictures. She saw

194 Valentine Hugo, *Le Harfang des Neiges*, 1932

herself as one who works an alchemy in which, as Eluard suggests in his Un Droit de Regard Enfin Sur le Poème, the magical correspondences between words and objects are revealed through the image. In a drawing for Eluard's Voir (1948), the touch of the poet's hand animates a world redolent of sexuality. The spiral at the center of the composition reverberates in the flamelike tongues of hair and in the swirling bodies of the three female nudes.

Transformation and an ecstasy bordering on the mystical, in which human and celestial worlds meet and join forces, animate Hugo's work. But although Surrealism freed her imagintion to pursue the specters of her dreams (during the 1930s she also illustrated a series of dated dreams), the structure of her work owes more to the linear elaborations of Symbolist and Art Nouveau prints than it does to Surrealism's collagelike juxtapositions. The sources of Hugo's drawing style lie in the history of late-nineteenth-century illustration, in the works of Beardsley and Redon rather than Chirico, and in the Symbolist search for an "alchemy of the verb." During the 1930s she worked to immortalize the poets in whom she believed most deeply—Breton, Crevel, Char, and Eluard—in paintings and collages in which the four elements work their magical transformations on matter and in which images are swept up in a continuous process of transformation. In these images Hugo comes closer than any other woman artist to offering a vision of the Elect Man, an image that might be opposed to that of Breton's Elect Woman and a being of grace and promise whose creative intelligence identifies him with the stars in the heavens and the light that radiates from the sun. But the differences between Breton's Elect Woman and Hugo's veneration of the Surrealist poets are more striking than the similarities and once again reveal fundamental discrepancies in Surrealist visions of male and female. Hugo celebrates the Surrealist poet because of his own creative achievement, not because he inspires creativity in others. In representing only the heads of her male figures, she places them directly into the history and traditions of portraiture, and recalls the largely commemorative function of that tradition. Although the history of art is filled with allegorical, symbolic, and erotic portraiture, Hugo's images are set apart from these associations by their isolation and lack of connection to a corporeal reality.

The contrast between these disembodied male figures elevated to a celestial sphere and the female images that fill the collages of Valentine Penrose's Dons des Feminines is striking. Published in 1951, the book contains a long cycle of poems recounted by a woman to the beloved woman, the mysterious Rubia, who moves through the landscape drawing the forces of love and of nature into her image:

195, 197

> Les cheveaux s'ensanglanteront qui avaient lié Rubia
> Les baisers s'abattront par lesquels succombait Rubia
> La feuille a suivi sa fleur
> Tandis qu'au ciel se lamentent et se destinent
> L'eau l'heure la planète et toutes choses feminines.
>
> They will be bloodied the tresses that chained Rubia
> They will fall away those kisses Rubia accepted

Leaf has followed its flower
While in the sky lamenting and foretold
The water the hour the planet and everything feminine.

The collages that accompany these poems belong to the Surrealist tradition initiated by Ernst in his collage "novels" *Dream of a Young Girl Who Wished to Enter a Convent, The Hundred-Headed Woman*, and *A Week of Kindness* and rely on the juxtaposition of apparently unrelated images and dislocations of time, place, and scale to construct an unreal, hallucinatory world. The sources for the images lie in English Victorian fashion magazines, and scientific and architectural journals that Penrose had collected while living in London during and after the Second World War; the vision realized through them, however, is inseparable from the theme of the feminine quest. It is always the figure of woman who travels through these landscapes. Contemplating vast natural panoramas or walking through urban streets in the company of bolting horses and predatory tigers, she pursues love, brings gifts to the beloved woman, watches over the feminine embrace, adores, pursues, and contemplates. The lyrical delicacy of the encounters that take place between women throughout these pages led Eluard to note in his preface: "That which is recounted to the beloved woman holds graver charms than similar words between men. The understanding of women belongs to the woman."

Penrose's collages differ from those of Ernst in their refusal to violate the integrity of the human form which is then placed in a landscape of fragmented images and manipulated space and scale. Ernst's account of the origins of his use of collage bears a striking resemblance to the model for artistic creation proposed by Freud—a model in which an actual experience triggers an old memory (in Ernst's case, a confusion of the events surrounding the almost simultaneous death of a beloved pet bird and birth of a sister that precipitated disorientation and violent hallucinations in the susceptible youth) that is then elaborated into artistic form through the mechanism of wish fulfillment. The collages of *The Hundred-Headed Woman*, and the accompanying text, fix a series of freely associated images and themes that derive from the original experience and the hallucinations provoked by it: the worlds of day and night, light and darkness, birth and death, suspended falling or flying figures, the eye, the egg, conception, torture, powerful and menacing male figures, little girls, nightmare, hallucination, violence, and sexual confusion. In contrast, however odd and unreal the landscapes into which Penrose places her female figures, they seem to belong, moving through them with a studied grace and casual elegance. The use of female figures in each of her collages provides a sense of continuity missing from Ernst's more violently disruptive and psychologically loaded vision, and it establishes a narrative flow that implies a story-telling content despite the fact that the reader is left without the logical links between one scene and the next that have traditionally established plot. In *Dons des Feminines*, as in so many other works by women artists, an implied narrative built out of freely associated images replaces the Freudian model of erotic disjunction.

196

VALENTINE PENROSE COLLAGES

Valentine Penrose was a poet who, inspired by Ernst's collage "novels" like La Femme 100 Têtes, *turned to collage.* Dons des Feminines *contains a cycle of poems related by a woman to the mysterious Rubia and accompanied by photo-collages in which images of women travel through a hallucinatory landscape.*

195 Valentine Penrose, collage from *Dons des Feminines*, 1951
196 Max Ernst, collage from *La Femme 100 Têtes*, 1929
197 Valentine Penrose, collage from *Dons des Feminines*, 1951

196

197

It is in Toyen's three great drawing cycles, *The Spectres of the Desert* (1937–38), *The Rifle-Range* (1939–40), and *Hide Yourself War!* (1944), that the psychological and emotional power of the fragmented or violated image is combined with a sustained vision of a reality now at the mercy of the forces of unreason. The Nazi occupation of Prague in 1939 initiated a new phase in the life of the Czech Surrealist group, one in which the realities of political occupation and war gradually replaced the apparitions of the Surrealist unconscious. This bleak scenario, which began with the public banning of the work of Toyen and others, the death of Štyrský, and Toyen's retreat to her apartment and studio where she successfully hid the young poet Jindrich Heisler, would not end until the 1950s when it was brought to a horrifying end by the execution of Zavis Kalandra after a forced "confession" and the apparent suicide of Karel Teige, a founder and leading spirit of the Czech Surrealist group, while standing in front of his apartment in the company of the police.

199, 200

As the image of intellectual and artistic freedom cultivated first by the Devětsil group and then by the Czech Surrealists gave way to overwhelming despair, Toyen turned to an anguished interrogation of the idea of human liberation in three cycles of drawings. *The Spectres of the Desert*, printed in Prague under an imprint of Albert Skira's obtained through the intervention of Benjamin Peret, is a relentless examination of the precise forms assumed by the specters that had first appeared in her painting during the 1930s and that now haunted her mental landscape, a landscape that would become ever more severe and forbidding in subsequent cycles of drawings. As the world around her crumbled into war, Toyen began to assert a terrifying precise clarity in her drawings that begins to suffocate all vestiges of life around her, freezing birds and animals into cracked shells from which all life and vitality has long since been extruded. These specters, unlike the earlier phantoms of her painting, do not suggest the gradual coming into being of forms and images; her process is one of slow paralysis and unrelieved decay.

Women artists responded powerfully and without sentimentality or squeamishness to the reality of the war. Of those artists who remained in Europe, many stopped working. Agar, who stayed in London throughout the war, later explained that the urge to create from within was all but obliterated by the destruction visited from without; Kernn-Larsen, who had gone from Denmark to London in 1939 in order to attend the opening of her exhibition at Peggy Guggenheim's gallery and was forced to remain there when war broke out because her journalist husband was Jewish, moved away from Surrealism during these years. In an interview in 1977, she recalled that the hallucinatory and terrifying reality of life during the Blitz moved her away from Surrealism and toward an art based on nature and abstraction.

Among the writings by women artists produced during these years is Pailthorpe's poem "The Corpse," with its unrelieved vision of death:

> Don't go! Don't go! Don't Go There!
> 'Tis only a dead man's bones.
> You wouldn't wish to see that—

a corpse and putrefaction.
Don't go! Don't go!—Whose is that corpse?
Who knows—can't tell—but none from here.
You pale. Why so? Your father's far away
in distant lands—
What can it be that you should pale at the
 corpse of an old man?
He is old, is he?
Then that is good, it can't be he of whom
 I thought.
He can't be dead.[2]

Images of death and decay also found their way into two automatic texts published by Edith Rimmington in *Fulcrum* in 1944. In "Time-Table," images of the Holocaust fight with metaphors of musical harmonies:

Death is alive in rhythm at the screech of the siren like a calm box pouring out music, projecting a life-time through endless rooms.... In the dark tunnel above two musical boxes fight to be heard, heart against hub. On the ground the death chimneys vomit and always there is birth. When the music dies down life runs on wheels of search, probing for the last thought even though it is dead. After the silence of relaxation the flower buds open, exhausted, only to die from rhythm eaten roots. As death moves slowly oh the torture of waiting for a new rhythm.

It was Lee Miller who found her ultimate artistic challenge in the war. Living in London during the early 1940s, she worked as a staff photographer for *Vogue* magazine (a Condé Nast publication) photographing an endless series of fashion accessories and, after proving herself once again, full-page and color advertisements. Miller took time off from her fashion assignments to photograph the streets of London during the Blitz. The result was a small book, *Grim Glory: Pictures of Britain Under Fire*, in which many of the photographs capture the bizarre juxtapositions and poignant details of an urban landscape rendered surreal by reality. The work moved the *Times Literary Supplement*'s reviewer to comment that "This book is dedicated to the Prime Minister [Churchill] and something of his splendid rhetoric has passed into its phrases."[3]

In December 1943, Miller was accredited by the United States Army as an official war correspondent and, irritated by the weaknesses she found in *Vogue* staff members' captions for her photographs, she determined to become a full-fledged photojournalist. She landed in Normandy a few weeks after D Day with an assignment from *Vogue* to do a story on the nurses in the field evacuation hospitals. Five days later, she returned to London carrying thirty-five rolls of film and the ten-thousand-word text that established her as *Vogue*'s preeminent writer for the next eighteen months. The editor, recognizing that with Miller as a journalist the magazine had found its way into the war, offered her support and complete freedom in future assignments. It was a challenge Miller rose to immediately, and

198

within a few weeks she had once again set off for the Continent. Beginning with the siege of St. Malo, where she was adopted by the U.S. troops and remained with them throughout the battle, under constant fire from mortars, shells, machine guns, and bombs, she followed the Allied advance across Europe, arriving in Paris on Liberation Day and going immediately to look up old friends like Picasso and Nusch and Paul Eluard in the flat where they had hidden from the Gestapo. Her photographs of Picasso in his studio were the first evidence to reach England that he had survived the war in good health and had continued to work.

Joining other war correspondents at the Hotel Scribe, Miller settled herself happily into an environment of gasoline cans, guns, bayonets, camera equipment, and crates of cognac and assorted loot. From Paris, after helping to reorganize *Vogue*'s French office, she was off once again: Luxembourg, the German surrender at Beaugency, Brussels, Strasbourg, Alsace, Cologne, Frankfurt, Ludwigshafen, Torgau, and then into the final horrors which were revealed in the concentration camps at Dachau and Buchenwald, an experience that turned the war from high adventure to nightmare in Miller's eyes and one that would haunt her for years afterward. Among the thousands of negatives in the recently organized Lee Miller

Archive in Sussex, England, are a number of renowned images documenting the opening of the camps that first appeared in Condé Nast publications without Miller's name on them. She arrived at Berchtesgarten the day before the Armistice was signed and had herself photographed in Hitler's bathtub. When she finally returned to England, Condé Nast welcomed her with a blaze of publicity before sending her off to a heroine's welcome in New York.

The end of the war was also the end of Miller's professional life as a photographer. Although she published an article in *Vogue* in 1953, and took many of the photographs for books written by Roland Penrose, including *Picasso—His Life and Work*, she told Penrose that she was bored by photography and intended to give it up. "You can't be an amateur when you have been a professional," she commented when asked to take pictures informally. Increasingly, Miller devoted her creative talents to cooking and entertaining at the couple's farm in Sussex, and her photographs disappeared into cardboard boxes where they remained until after her death.

Miller's response to the war was to become caught up in its action and drama; Toyen, driven underground, marshaled her creative forces for a more private assault. The drawings contained in *The Rifle-Range* and *Hide Yourself War!* cycles were not published until 1946. The first editions, published in Prague by Borovy, included a text by Teige and two poems by Heisler. In these cycles, Toyen neither describes nor attempts to evoke the specifics of war. They are unlike either Käthe Kollwitz's expressionist depictions of individual human suffering or the more mythic response captured in Picasso's *Guernica*. Instead, Toyen chooses the metaphors of the playing field and the shooting gallery, empty stages on which are recorded the traces left by death as it travels across human consciousness. In both cycles, she carefully selects an impersonal draftsmanship of the type often seen in the illustrations in scholarly and scientific manuals. The rendering is clear and simple, line is unmodulated, and nuances of shading are replaced by simple linear schemas. The horror projected into *The Rifle-Range* poisons an innocent world of children's play in which little girls twirl batons and the pages of a child's school notebook petrify into targets bearing the imprint of blinded and mute figures. These drawings sometimes recall Giacometti's game boards of the early 1930s, works like *No More Play* in which the game is war. The world they create is one of silence and immobility in which forms are sharply silhouetted against empty expanses of land and sky. The world of predatory nature becomes a powerful metaphor for human brutality, the vestiges of which can be seen in the empty shell casings that dot the landscape. The psychic desert imposed upon Toyen's shooting gallery is realized with even more frightening clarity in the nine drawings that comprise *Hide Yourself War!* Now it is as if a black wind of destruction has blown across the land, shredding the flesh from human bones and setting schools of fish and flocks of birds into panicked flight. Fantasy and reality meet in these drawings, not on Lautréamont's Freudian dissecting table, but in a psychic desert that has become the playing field for man's most inhumane impulses. There are few other places in Surrealist art where the meeting of the real and the unreal so powerfully challenges our perceptions and our understanding.

Toyen's three great drawing cycles, The
Spectres of the Desert, The Rifle-Range, *and*
Hide Yourself War!, *portray a reality beset
by the forces of irrationality. The Nazi
occupation of Prague in 1939 led to the
public banning of Toyen's work and
during the war she lived a clandestine life.*

199 Toyen, illustration from *The Rifle-
Range*, 1939–40
200 Toyen, illustration from *Hide Yourself
War!*, 1944

By 1945 Toyen was once again able to return to public activity; the work
executed clandestinely during the war was exhibited that year at the Topičuv Salon
in Prague. At the beginning of 1947, Toyen, in the company of Heisler, left for Paris
in order to prepare an exhibition of her work organized by Breton at the Galerie
Denise René. She contributed work to the first major postwar Surrealist exhibition,
which opened later that year at the Galerie Maeght in Paris, and she remained in
Paris until her death in 1980.

Breton, who had returned to France by way of Haiti at the end of 1945, had
decided that the Maeght exhibition should have myth as its theme, and the
installation was designed to conduct the visitor along a path of spiritual progression
and into a labyrinth dedicated to a being, a category of beings, or an object capable
of being endowed with a mythic life. Included, among others, were the "Worldly
Tiger," after a story by Jean Ferry about an imaginary animal-training act, the Gila
monster, Ernst's Bird Superior Loplop, Brauner's wolf-table (a Surrealist object
with a wolf's head and tail attached at either end), and the window of "Magna Sed
Apta" from George du Maurier's novel *Peter Ibettson*. Works poured in from
Europe and the Americas. A staircase of "sacred books" led to the Hall of
Superstitions, designed in the shape of an egg by the architect Frederick Kiesler
and containing paintings sent by those Surrealists still living in America. Breton
installed an altar, covered by a green net spotted with flies, in honor of Rimbaud's

poem *Devotion*. A bizarre series of paintings, sculptures, esoteric objects, symbols, and totems filled the remaining rooms.

In the catalogue, *Le Surréalisme en 1947*, Georges Bataille, Pierre Mabille, Nicolas Calas, Jacques Brunius, and Ferdinand Alquié all raised the issue of liberty in their essays. It was an issue that Breton had fought to keep in the forefront throughout the period of Surrealism's exile in New York and a theme to which he returned again and again in the pages of *View* and *VVV*. For Sartre, whose existentialist philosophy would soon push Surrealism aside in the Parisian intellectual avant-garde, man is free everywhere, even in prison, because it is he who gives meaning to the situation; for Alquié and other Surrealist writers, it is the creative act, in life and in art, that gives meaning to the world. No longer concerned with the adaptation or creation of specific myths, as had been the case throughout the 1930s, Surrealism would increasingly become its own myth, the myth of the integrated spirit set free along the path of liberty and truth.

The 1947 exhibition and catalogue included the work of Bridgwater, Carrington, Lamba, Miller, Rimmington, Sage, Tanning, Toyen, and Varo. Other women had moved away from Surrealism—physically or spiritually—by that date: Colquhoun did not exhibit again with the Surrealists after the quarrel with Mesens; Fini, Hugo, Kahlo, and Kernn-Larsen pursued interests that no longer intersected with those of Breton and his colleagues; Maar turned to religion and renounced Surrealism. The

235

presence of work by the painter Marie Wilson and the sculptors Isabelle Waldberg and Maria in the exhibition of 1947 heralded the arrival of a new generation of women artists whose presence animated and helped to shape Surrealism's postwar development.

The story of the first generation of women artists to be associated with Surrealism presents a study in contradiction. Dedicated to the overthrow of values perceived as inseparable from a patriarchal and capitalist social organization, the Surrealist revolution sought to liberate the individual from the tyranny of rational thought, economic slavery, and the coercive control exercised by the institutions of family, church, and state. The means to this end was through the reintegration of those human values long suppressed by Western civilization: personal freedom and autonomy, intuition, emotion, and the irrational. Breton clearly recognized, for he articulates as much in *Arcane 17*, that these qualities had come to be identified with the female half of the species, and had been subsequently devalued because of their identification with the politically and economically powerless. It is surely this recognition that lies behind the Surrealist cultivation of antiheroines like the anarchist Germaine Berton, and women like Violette Nozières and the Papin sisters who, forced beyond the limits of rational control, had risen up and murdered their oppressors.

Surrealism legitimized an art in which personal reality dominates, one in which the images of the dream and the unconscious are at least as valid, if not more so, as those derived from "reality." The same social conditioning from which women artists were struggling to liberate themselves during the 1920s and 1930s had perpetuated an image of woman in which emotion dominated reason, intuition replaced thought, and dependence was rewarded. Women artists were already conditioned to accept the validity of the interior and personal sources of Surrealist imagery; they did not need manifestos or collective games to legitimize their search, and they often regarded the antics of their male colleagues with a bemused air. There is a contemporary feminist phrase that states that "the personal is political." Attacking the exclusion and repression of personal experience in male-dominated societies, the statement redefines woman's private individualized oppression as a collective—that is, political—reality. Surrealism sanctioned so-called personal exploration for men as well as women; it was too much to hope that in so doing they would not bring into play the ambivalences and conflicts that had led originally to the separation of these spheres of experience and existence. Even today there exists among the women artists discussed here a powerful commitment to integrating these polarities of thought and feeling. It is this belief that led Oppenheim to request that she be omitted from a book that purports to discuss the subject of women and Surrealism "because it is exactly thus that women bury themselves in their millenarian ghetto," she wrote. "In my texts I have again and again written, 'the spirit is androgynous' (I discovered in the book of a French thinker of the seventeenth century, Poulain de la Barré, the phrase 'the mind has no sex')."[4] Fini also regrets her inclusion in a "false country," and she has clearly stated her position, writing that "Men have tried to exile, to imprison, women. A study exclusively devoted to women is still a sort of exile."[5]

236

The paths followed by male and female artists seeking the reintegration of all aspects of the human spirit in the work of art have often diverged. Neither side could shed layers of history and conditioning at will. The fear that male Surrealists have of woman's natural proximity to the inner sources of creation is frequently expressed in images that symbolically attack woman's creative, reproductive function. David Gascoyne's poem "Charity Week" celebrates "the great bursting womb of desire," while Dali's *The Bleeding Roses*, a painting of 1930, replaces the traditional metaphoric "fruit of the womb" with a bouquet of bleeding roses with their symbolic associations of passion, pain, and death, and Brauner's *Totem of Wounded Subjectivity* (1948) captures a small fetal figure between two rows of sharp teeth. Conflict over woman's closeness to the inner sources of creation, in life as well as in art, served to perpetuate contradictory roles ascribed to women in Surrealism. In the external world, women were extolled for their courage and daring, praised for their uninhibited behavior, and encouraged to create and exhibit their work. But when it came to internalizing an image of woman, the *femme-enfant* and the erotic muse prevailed, images that could be absorbed into the male act of creation, completing it without competing with it.

Women artists also struggled with this conflict. Recognizing, as Gloria Orenstein has pointed out, that the needs of the *femme-enfant* and those of the mature artist are incompatible, and often isolated from the theoretical, ideational, and political issues that provided focus and group support for their male colleagues, they asserted their own inner reality as paramount and defended themselves against the fear that its resources might prove finite. Their work originates in the "telling" of this reality, and it is this need that provides narrative thrust and structure to the work of many women artists. Although they believed in an androgynous creative spirit, their work reveals a sensibility that arises, at least in part, from their own understanding of the reality of their lives as women. Their exploration of the personal sources of artistic creation marks a milestone in the development of twentieth-century painting and sculpture and has validated the path taken by many women artists in later generations.

That the creative work of the men and women associated with Surrealism sometimes reveals conflicts between the theoretical and the practical, between a revolutionary demand for a fully integrated creative consciousness and an outer world still polarized in its attitudes toward male and female is not a mark of ideological failure. It is rather a testament to Surrealism's pioneering exploration of creative waters previously left largely uncharted.

Notes

INTRODUCTION

1 R. Benayoun, *Erotique du Surréalisme* (Paris, 1965), p. 87.
2 Interview with Nicolas Calas, New York, April 1983.
3 Cited in H. Herrera, *Frida: A Biography of Frida Kahlo* (New York, 1983), p. 250.
4 Cited in J. Kaplan, "Remedios Varo: Voyages and Visions," *Woman's Art Journal* 1 (Fall 1980/Winter 1981): 17.
5 Herrera, *Frida*, p. 263 and *passim*.
6 Letter from Meret Oppenheim to Thames and Hudson, 1984. Quoted with permission.

CHAPTER 1

1 Cited in *Valentine Hugo: Peintures, Gravures, Dessins*, Exhibition Catalogue (Troyes: Centre Culturel Thibaud de Champagne, 1977).
2 G. Orenstein, "Women of Surrealism," *Feminist Art Journal* 2 (Spring 1973): 15–21.
3 M. Nadeau, *The History of Surrealism*, trans. R. Howard (New York, 1965), p. 25.
4 From an unpublished autobiography by Lou Straus-Ernst; cited in J. Ernst, *A Not-So-Still Life* (New York, 1984), p. 12.
5 D. Ades, *Salvador Dali* (London, 1982), p. 76.
6 S. Dali, *The Secret Life of Salvador Dali*, trans. H. Chevalier (New York, 1942), p. 283.
7 From A. Penrose, *The Lives of Lee Miller* (London, forthcoming).
8 M. Amaya, "My Man Ray," An Interview with Lee Miller, *Art in America* 63 (May–June 1975): 55.
9 Cited in *Atelier Man Ray: Abbott, Boiffard, Brandt, Miller, 1920–1935*, Exhibition Catalogue (Paris: Musée National d'Art Moderne, Centre Georges Pompidou, 1982), p. 56.
10 Amaya, "My Man Ray," p. 57.
11 M. Haslam, *The Real World of the Surrealists* (New York, 1978), p. 168.
12 "Extracts of a Conversation with Jacqueline Trutat (Valentine Hugo)," in *Cahiers Bleus*, no. 10 (Troyes: Centre Culturel Thibaud de Champagne, 1977).
13 Ibid.
14 *Surrealist Intrusion in the Enchanter's Domain*, Exhibition Catalogue (New York: D'Arcy Galleries, 1960), p. 10.
15 *The History of Surrealist Painting*, trans. S. W. Taylor (New York, 1960), p. 280.
16 Private conversation with Ann Alpert, New York, 1984.
17 "A Look at My Life," an unpublished autobiography by Eileen Agar; quoted with the author's permission.
18 Private conversation with Lionel Abel, New York, 1984.
19 H. McBride, "Women Surrealists," *New York Sun*, January 15, 1943.
20 B. Peret, *Anthologie de l'Amour Sublime* (Paris, 1956), p. 25.

CHAPTER 2

1 Cited in H. Herrera, *Frida: A Biography of Frida Kahlo* (New York, 1983), p. 254.
2 Interview with Léonor Fini, St. Dyé-sur-Loire, June 1982.

3 Interview with Sir Philip Powell, London, June 1983.
4 Cited in *Eileen Agar: A Decade of Discoveries*, Exhibition Catalogue (London: New Art Centre, 1976).
5 Letter from Rita Kernn-Larsen to the author.
6 Interview with Leonora Carrington, New York, April 1983.
7 Interview with Léonor Fini, St. Dyé-sur-Loire, June 1982.
8 J. Levy, *Memoir of an Art Gallery* (New York, 1977), p. 170.
9 Interview with Nicolas Calas, New York, April 1983.
10 J. Ernst, *A Not-So-Still Life* (New York, 1984), p. 214.
11 N. Winter, *Interview with the Muse* (Berkeley, California, 1979), p. 57.
12 X. Gauthier, *Léonor Fini* (Paris, 1973), p. 8.
13 A. Breton, *Surrealism and Painting*, trans. S. W. Taylor (New York, 1972), p. 143.
14 Cited in Herrera, *Frida*, p. 234.
15 Ibid.
16 Ibid., p. 255.
17 Ibid., p. 278.
18 Reproduced in *Dorothea Tanning, XXe Siècle*, sp. no. (Paris, 1977), p. 39.
19 Cited in "Dorothea, Ses Jeux, Son Enfer...," in *XXe Siècle* (Paris, 1977), p. 9.
20 Herrera, *Frida*, p. 74.
21 Levy, *Memoir*, p. 267.
22 J. Levy, "Tanguy, Connecticut, Sage," *Art News* 53 (September 1954): 27
23 Telephone interview with Jean Levy, April 1983.

CHAPTER 3

1 Interview with Leonora Carrington, New York, 1983.
2 For an extended discussion see A. Carter, *The Sadeian Woman and the Ideology of Pornography* (New York, 1980).
3 Interview with Léonor Fini, St. Dyé-sur-Loire, June 1982.
4 Reprinted in *Léonor Fini* (Paris, 1981), p. 12.
5 "Lettre à Roger Borderie," in "La Femme Surréaliste," *Obliques*, sp. no. 14–15, p. 115.
6 Cited in X. Gauthier, *Léonor Fini* (Paris, 1973), p. 72.
7 A. Breton, *Surrealism and Painting*, trans. S. W. Taylor (New York, 1972), pp. 207–14.
8 "A l'Instant du Silence des Lois," in *Štyrský, Toyen, Heisler*, Exhibition Catalogue (Paris: Musée National d'Art Moderne, Centre Georges Pompidou, 1982), pp 57–65.
9 Letter from Dorothea Tanning to the author, May 1982.
10 Interview with Leonora Carrington, New York, 1983.
11 M. Ray, *Self-Portrait* (Boston, 1963), p. 192.
12 *Obliques*, sp. no. 14–15, p. 52.
13 Letter from Emmy Bridgwater to the author, January 1984.
14 "A Look at My Life," unpublished autobiography by Eileen Agar; quoted with the author's permission.
15 Gauthier, *Fini*, p. 74.
16 Reproduced in *Meret Oppenheim* (Zurich, 1982), pp. 134 and 140.
17 *Women Artists: 1550–1950*, Exhibition Catalogue (Los Angeles: Los Angeles County Museum of Art, 1977), p. 338.
18 Cited in H. Herrera, *Frida: A Biography of Frida Kahlo* (New York, 1983), pp. 138–39.
19 Ibid., p. 148.
20 A. Masson, *Entretiens avec Georges Charbonnier* (Paris, 1958), p. 138.

21 Herrera, *Frida*, p. 328.

22 Cited in *Dorothea Tanning*, Exhibition Catalogue (Paris: Centre National d'Art Contemporain, 1974), p. 52.

23 *10 Recent Paintings and a Biography*, Exhibition Catalogue (New York: Gimpel-Weitzenhoffer Gallery, 1979).

CHAPTER 4

1 Cited in G. Limbour, "André Masson et la Nature," in *André Masson* (Rouen, 1941), p. 938.

2 M. Jean, ed, and G. Neugroschel, trans., *Arp on Arp* (New York, 1969), p. 241. See also my "*Eros* or *Thanatos*: The Surrealist Cult of Love Reexamined," *Artforum* 14 (November 1975): 46–56.

3 J. Withers, "The Famous Fur-Lined Teacup and the Anonymous Meret Oppenheim," *Arts* 52, no. 3 (November 1977): 90.

4 L. M. Tillman, "Don't Cry: Work: Interview with Meret Oppenheim," *Art and Artists* 8 (October 1973): 25.

5 Reproduced in *Meret Oppenheim* (Zurich, 1982), pp. 139, 141, and 146.

6 P. Ray, *The Surrealist Movement in England* (New York, 1971), p. 200.

7 "A Look at My Life," unpublished autobiography by Eileen Agar; quoted with the author's permission; p. 107.

8 Ibid.

9 Ibid., p. 132.

10 *Eileen Agar: Retrospective Exhibition*, Exhibition Catalogue (London: Commonwealth Art Gallery, 1971).

11 Cited in *Surrealism—Ithell Colquhoun*, Exhibition Catalogue (Cornwall: Newlyn Orion Galleries, 1976).

12 *Jacqueline Lamba*, Exhibition Catalogue (New York: Norlyst Gallery, 1944).

13 J. Vovelle, "Entretien avec Rita Kernn-Larsen," in *Obliques*, sp. no. "La Femme Surréaliste," 1977, p. 52.

14 Letter from Rita Kernn-Larsen to the author, February 1984.

15 Vovelle, "Kernn-Larsen," p. 51.

16 Letter from Rita Kernn-Larsen to the author, February 1984.

17 T. Smith, "From the Margins: Modernity and the Case of Frida Kahlo," *Block*, no. 8 (1983), p. 14.

18 Agar, "A Look at My Life," p. 132.

19 Ibid.

20 E. Jaguer, *Les Mystères de la Chambre Noire* (Paris, 1982), p. 103.

21 "China Eggs," an unpublished autobiography by Kay Sage. Owned and filmed by the Archives of American Art, Smithsonian Institution, January 1971.

22 J. Levy, "Tanguy, Connecticut, Sage," *Art News* 53 (September 1954): 27.

23 J. T. Soby, "Double Solitaire: Retrospective Exhibition at Wadsworth Atheneum," *Saturday Review*, September 4, 1954, pp. 29–30.

24 Letter from Stephen Miller to the author, December 1983.

25 S. Miller, "The Surrealist Imagery of Kay Sage," *Art International* 26, no. 4 (September–October 1983): 34.

26 "Serene Surrealist," *Time*, March 13, 1950, p. 49.

27 Ibid.

28 E. Roditi, "An Interview with Max Ernst," *Arts* 35, no. 6 (March 1961): 40.

CHAPTER 5

1 R. Penrose, *Scrapbook 1900–1981* (New York, 1981), pp. 31 and 42.

2 Reprinted in V. Penrose, *Poems and Narrations* (Manchester, 1977), p. 41.

3 "Divination," reprinted in I. Colquhoun, *Osmazone* (Örkeljunga, Sweden, 1983).

4 Reprinted in Penrose, *Poems and Narrations*, p. 21.

5 Cited in *Women's Art Show: 1550–1970*, Exhibition Catalogue (Nottingham: Nottingham Castle Museum, 1982), p. 71.

6 Conversation with Leonora Carrington, New York, April 1984.

7 *Alice Rahon*, Exhibition Catalogue (New York: Willard Gallery, 1951).

8 Interview with Léonor Fini, St. Dyé-sur-Loire, June 1982.

9 "Lettre à Leonor Fini" (1950), reprinted in *Léonor Fini* (Paris, 1981), pp. 11–15.

10 P. Ray, *The Surrealist Movement in England* (New York, 1971), p. 228.

11 Material from Varo's unpublished notebooks quoted with the permission of Walter Gruen; I am grateful to Janet Kaplan for making this material available to me.

12 Private conversation with Leonora Carrington, New York, April 1984.

13 Ibid.

14 Cited in G. Orenstein, "Leonora Carrington's Visionary Art for the New Age," *Chrysalis* 3 (1978): 74.

15 Ibid., p. 68.

16 In *Leonora Carrington*, Exhibition Catalogue (New York: Pierre Matisse Gallery, 1948).

17 *Alice Rahon*, Exhibition Catalogue.

18 Cited in J. Kaplan, "Remedios Varo: Voyages and Visions," *Woman's Art Journal* 1, no. 2 (Fall 1980/Winter 1981): 13.

19 In *Leonora Carrington*, Exhibition Catalogue (New York: Pierre Matisse Gallery, 1948).

20 Cited in H. Silberer, *Hidden Symbolism of Alchemy and the Occult Arts*, trans. S. Jelliffe (New York, 1971), p. 153.

21 *Leonora Carrington: A Retrospective Exhibition*, Exhibition Catalogue (New York: Center for Inter-American Relations, 1976).

CHAPTER 6

1 Valentine Hugo, Interview with Jacqueline Trutat, published in *Valentine Hugo: Peintures, Gravures, Dessins*, Exhibition Catalogue (Troyes: Centre Culturel Thibaud de Champagne, 1977).

2 Published in *Third Front*, London, 1944.

3 "Divination," in I. Colquhoun, *Osmazone* (Örkeljunga, Sweden, 1983).

4 Letter from Meret Oppenheim to the author.

5 Letter from Léonor Fini to the author.

Biographical Notes

Major international Surrealist exhibitions between 1935 and 1947, in some of which the artists below participated, are indicated at the end of each biographical note.

Exposition Surréaliste, Ateano Gallery, Santa Cruz de Tenerife, 1935

International Kunstudstilling: Kubisme-Surréalisme, Copenhagen, 1935

International Surrealist Exhibition, New Burlington Galleries, London, 1936

Fantastic Art, Dada, Surrealism, The Museum of Modern Art, New York, 1937

Album Surréaliste, Nippon Salon, Tokyo, 1937

Exposition Internationale du Surréalisme, Galerie Beaux-Arts, Paris, 1938

Exposition Internationale du Surréalisme, Galerie Robert, Amsterdam, 1938

Exposicion Internacional del Surrealismo, Galeria de Arte Mexicano, Mexico City, 1940

Surrealism Today, Zwemmer Gallery, London, 1940

First Papers of Surrealism, Coordinating Council of French Relief Societies, New York, 1942

Le Surréalisme en 1947, Galerie Maeght, Paris, 1947

AGAR, Eileen

English painter. Born 1899 in Buenos Aires, died 1991. Her family returned to England in 1911. Studied with Leon Underwood in 1924, attended the Slade School of Art in 1925 and 1926, and studied art in Paris from 1928 to 1930. She saw her first Surrealist work in a gallery in Paris around 1929; met the poet Paul Eluard at that time. A member of the London group since 1933, her work was selected by Herbert Read and Roland Penrose for the 1936 Surrealist exhibition in London, and she was one of two English artists whose work was illustrated in the catalogue of the Fantastic Art, Dada, Surrealism exhibition the following year. After 1936, she experimented with automatic techniques and new materials, made collages and objects, and exhibited with the Surrealists in England and abroad. The war disrupted her painting and she did not start working seriously again until 1946; thereafter she had numerous one-woman exhibitions, some of them at the New Art Centre in London. In 1984 the Tate Gallery purchased her object *Angel of Anarchy*, first exhibited in 1936.
Exhibitions: London (1936), New York (1937), Tokyo (1937), Paris (1938), Amsterdam (1938), London (1940).

BRIDGWATER, Emmy

English painter. Born 1902 in Birmingham. Studied fine arts in Birmingham, Oxford, and at the Grosvenor School of Modern Art in London. Exhibited in Birmingham with the Birmingham Group, including Conroy Maddox and John Melville. Through them she met E.L.T. Mesens and other members of the London Surrealist Group in 1940. Contributed automatic poems and drawings to the reviews *Arson* and *Free Unions Libres*. Now lives in London.
Exhibition: Paris (1947).

CARRINGTON, Leonora

English painter and writer, Born 1917 in Lancashire. Attended schools in England, Florence, and Paris before enrolling at the Amedée Ozenfant Academy, London, in 1936. Met Max Ernst in London in 1937 and moved to Paris with him. The couple lived for two years at St. Martin d'Ardèche where Carrington wrote her first short stories, "The House of Fear" and "The Oval Lady," published with illustrations by Ernst. She fled St. Martin d'Ardèche in 1940 after Ernst's internment as an enemy alien, suffered a nervous breakdown, and was institutionalized in Spain. Reunited with the Surrealists in New York, she contributed drawings and stories to *View* and *VVV* before settling in Mexico in 1942. First one-woman exhibition at the Pierre Matisse Gallery, New York, in 1948; retrospective exhibitions held at the Museo Nacional de Arte Moderno, Mexico City (1960) and the Center for Inter-American Relations in New York (1976). In addition to having had numerous exhibitions of her paintings, she is the author of two novels, two plays, and several collections of short stories. In 1963 she painted a large mural, *The Magic World of the Mayans*, for the National Museum of Anthropology in Mexico City. Now lives and works in Mexico and New York.
Exhibitions: Paris (1938), Amsterdam (1938), New York (1942), Paris (1947).

COLQUHOUN, Ithell

English painter and writer. Born in 1906 in Assam, India, died 1988. Educated at Cheltenham College and the Slade School of Art, but was largely self-taught. After joining the English Surrealist Group in 1939 and participating in the Living Art in England exhibition, she contributed to the *London Bulletin*, but refused in 1940 to abandon her work on occultism and left the group. She experimented with automatism, *decalcomania*, *sfumage*, *frottage*, and collage, publishing the results of her investigations in "The Mantic Stain" (*Enquiry*, 1949). First one-woman exhibition at the Cheltenham Municipal Gallery in 1936; subsequent exhibitions included a retrospective in 1976 at the Newlyn Orion Galleries in Cornwall. She is the author of a Surrealist occult novel, *The Goose of Hermogenes*, published in 1961 by Peter Owen Ltd., travel books on Cornwall and Ireland, and several volumes of poetry.

ELUARD, Nusch
German. Born 1906 in Mulhouse, died 1946 in Paris. Met Paul Eluard in 1930 while working as a model for sentimental postcards and as a walk-on at the Grand Guignol. Married Eluard in 1934. Associated with the Surrealists during the 1930s. Model for Man Ray and author of a series of photomontages between 1934 and 1936. Collages published in 1978 by Editions Nadada, New York.

FINI, Léonor
Painter. Born in 1918 in Buenos Aires of Spanish/Italian/Argentine parents; raised in Trieste from the age of two years, died 1996 in Paris. As an adolescent she studied Renaissance and Mannerist painting during visits to European museums; in her uncle's large library she discovered the Pre-Raphaelites, Aubrey Beardsley, Klimt, the German and Flemish Romantics. She exhibited for the first time at the age of seventeen in a group exhibition in Trieste and was invited to Milan to execute her first portrait commission. While there she became friends with the painters Funi, Carrà, Tosi. Arrived Paris in 1936; friendships with Eluard, Ernst, Magritte, and Brauner moved her close to the Surrealist circle. Participated in Surrealist exhibitions though not a member of the group; first one-woman exhibition at the Julien Levy Gallery, New York, in 1939. Spent the war years in Monte Carlo and Rome, returning to Paris in 1946. Continued to pursue an active career as a painter, theater designer, and illustrator. Retrospective exhibitions at the Casino Communale, Knokke-le-Zoute (1965), Japan (1972), Musée Ingres, Montauban (1981), and the Palazzo dei Diamanti, Ferrara (1983).
Exhibitions: London (1936), New York (1937), Tokyo (1937).

HUGO, Valentine
French painter and illustrator. Born 1887 in Boulogne-sur-Mer, died 1968 in Paris. Studied painting in Paris; in 1919 married Jean Hugo, great-grandson of Victor Hugo. Collaborated with him on designs for the ballet including Cocteau's *Mariés de la Tour Eiffel* (1921); in 1926 executed twenty-four wood engravings after maquettes by Jean Hugo for *Romeo and Juliette*. Met the Surrealists around 1928 and actively participated in the movement between 1930 and 1936. The foremost illustrator of Eluard's work, she first exhibited with the Surrealists in the Salon des Surindépendants of 1933. Her many illustrations include: Lautréamont, *Chants de Maldoror* (1933); Achim d'Arnim's *Contes Bizarres* (1933); Rimbaud, *Les Poètes de Sept Ans* (1939); Eluard, *Les Animaux et Leurs Hommes* (1937). A retrospective exhibition of her work was held at the Centre Culturel Thibaud de Champagne, Troyes, in 1977.
Exhibitions: Tenerife (1935), Copenhagen (1935), New York (1937), Tokyo (1937).

KAHLO, Frida
Mexican painter. Born in Coyoacán, a suburb of Mexico City, in 1910 of German/Indian/Spanish parents; died 1954 in Mexico. A devastating streetcar accident when she was fifteen years old left her crippled and in pain for much of the remainder of her life. Taught herself to paint while convalescing; married painter Diego Rivera in 1929. Breton discovered her work in Mexico in 1938; in 1939 he claimed her as Surrealist in his introduction to her first exhibition, at the Julien Levy Gallery in New York. The following year he and Duchamp arranged her first Paris exhibition at the Pierre Colle Gallery. Thought of herself as a Mexican artist and a realist rather than a Surrealist. First major exhibition in Mexico at the Gallery of Contemporary Art, Mexico City, in 1953; a retrospective exhibition was held at the Instituto Nacional de Bellas Artes, Mexico City, in 1977.
Exhibitions: Mexico City (1940), New York (1942).

KERNN-LARSEN, Rita
Danish painter. Born in Hillerod, Denmark, in 1904. Studied at the Art Academy of Copenhagen and in Paris with Leger (1930–31). First one-woman exhibition Copenhagen (Kunsthandel Chr. Larsen) in 1934; that year met the Danish Surrealist group. Exhibited with the Surrealists beginning 1935 in Copenhagen, Oslo, Lund, London, and Paris. Lived in London during the Second World War where she attended meetings and participated in exhibitions of the London Surrealist Group. Now lives and works in Denmark, England, and in the south of France.
Exhibitions: Copenhagen (1935), Paris (1938), London (1940).

LAMBA (BRETON), Jacqueline
French painter. Born in Paris in 1910. Studied decorative arts in Paris. Married André Breton in 1934 and was the subject of many of his poems of those years including "La Nuit de Tournesol" which anticipated their meeting. Began exhibiting objects and drawings with the Surrealists. Arriving in New York, she developed automatism into a series of intense prismatic paintings close in spirit to the abstract work of Matta and Masson. Separated from Breton in 1943 and later married the American sculptor and photographer David Hare. First one-woman exhibition at the Norlyst Gallery, New York, in 1944. Also exhibited at the San Francisco Museum of Modern Art (1946) and Galerie Pierre, Paris (1947). Now lives in Paris.
Exhibitions: London (1936), Tokyo (1937).

MAAR, Dora
French photographer and painter. Born in Tours in 1909 of a Yugoslavian father and a French mother. Studied painting in Paris at the Ecole d'Art Décoratif, Académie de Passy, Académie Julien, and with André Lhote. Gave up painting for photography during the mid 1930s; associated with the Surrealists between 1934 and 1937. First photography exhibition at the Galerie de Beaune, Paris, in 1937. One-woman exhibitions of painting in Paris at Jeanne Bucher (1943) and Pierre Loeb (1945). After a period of semimonastic life devoted to mystical experience, began exhibiting her paintings again during the 1950s. Has renounced her earlier association with Surrealism and now lives in Menerbes (Vaucluse).
Exhibitions: Tenerife (1935), London (1936), New York (1937), Tokyo (1937), Amsterdam (1938).

241

MILLER, Lee

American photographer. Born in Poughkeepsie, New York, in 1908, died 1977 in Sussex, England. Studied at the Art Students League in New York before moving to Paris in 1929. Worked with Man Ray from 1929 to 1932. Opened own photo studio in New York in 1932; first one-woman exhibition the following year at Julien Levy Gallery. Returned to Paris in 1937 after marriage to a wealthy Egyptian; met Roland Penrose at a Surrealist costume party. Moved to England in 1939 and began photographing for *Vogue*. *Grim Glory*, her photographs of the London Blitz, published in 1941 in London and New York. Worked as a war correspondent for Condé Nast publications. Gave up photography after the war and turned her attention to cooking.
Exhibitions: London (1940), Paris (1947).

OPPENHEIM, Meret

Swiss painter and sculptor. Born 1913 in Berlin-Charlottenburg, died 1985 in Berne. Moved to Paris in 1932 where she studied briefly at the Académie de la Grande Chaumière before being introduced to the Surrealists by Alberto Giacometti and Hans Arp the following year. First exhibited with the group in the Salon des Surindépendants in 1933 and participated in Surrealist meetings and exhibitions until 1937 and again, more sporadically, after the war until shortly before Breton's death in 1966. First one-woman exhibition at the Galerie Schulthess, Basel, in 1933. Her fur-lined teacup, exhibited at the Museum of Modern Art, New York, in 1937, was chosen by visitors to the exhibition as the quintessential Surrealist symbol. Oppenheim's return to Basel in 1937 marked the beginning of an eighteen-year period of artistic crisis and redirection. In 1939 she took part in an exhibition of fantastic furniture with Léonor Fini, Max Ernst, and others at the Galerie René Druin and Leo Castelli in Paris. A major retrospective of her work was organized by the Moderna Museet in Stockholm in 1967.
Exhibitions: Tenerife (1935), Copenhagen (1935), London (1936), New York (1937), Paris (1938), Mexico City (1940), New York (1942).

PAILTHORPE, Grace

English physician and painter. Born in Surrey in 1890, died in 1971. Studied medicine and worked as a surgeon during the First World War. Traveled around the world, returning to England in 1922 where she took up the study of psychological medicine. Published *Studies in the Psychology of Delinquency* and, in 1928, founded the first institute in the world devoted to the scientific treatment of delinquency. Began research into the psychology of automatism in 1935 with Reuben Mednikoff and the following year began exhibiting drawings and paintings with the Surrealists. Published "The Scientific Aspect of Surrealism" in the *London Bulletin* in December 1938.
Exhibitions: London (1936), New York (1937).

PENROSE, Valentine

French poet. Born in Gascony in 1898, died in 1978. Married Roland Penrose in 1925 and moved in the Surrealist milieu of the late 1920s and early 1930s without officially joining the movement. Published her first volume of poetry, *Herbe à la Lune*, in 1935 with a preface by Eluard who also contributed an introduction to her *Dons des Feminines*, a cycle of poems and collages published in Paris in 1951. A selection of her poems and other writings, *Poems and Narrations*, was published in English in 1976 by Carcanet Press.

RAHON (PAALEN), Alice

French poet and painter. Born in France in 1916. Married to Wolfgang Paalen; associated with the Surrealists during the late 1930s. In 1939 she and Paalen settled in Mexico where she began to paint and contribute poems and drawings to *Dyn*. First one-woman exhibition in 1944 at the Galeria de Arte Mexicano in Mexico City; subsequent exhibitions at Stendahl Art Galleries, Los Angeles (1945); Nierendorf Gallery, New York (1946); Willard Gallery, New York (1948 and 1951). Now lives in San Angel, a suburb of Mexico City.
Exhibition: Mexico City (1940).

RIMMINGTON, Edith

English painter. Born in Leicester in 1902. Began making automatic drawings around 1937 or 1938. Introduced to E.L.T. Mesens and the London Surrealist Group in 1939 by Gordon Onslow-Ford. Attended most weekly meetings of the group at the Barcelona Restaurant in Soho or the Horseshoe Pub in Tottenham Court Road. Did very little painting during the war but contributed automatic drawings and texts to the *London Bulletin, Arson, Fulcrum, Message From Nowhere, Free Unions Libres* between 1940 and 1946. Now lives in Bexhill-on-Sea, East Sussex.
Exhibitions: London (1940), Paris (1947).

SAGE (TANGUY), Kay

American painter and poet. Born in Albany, New York, in 1898, died in 1963 in Woodbury, Connecticut. After her parents' separation in 1900 lived abroad with her mother; in 1925 married Prince Ranieri di San Faustino and for ten years lived in Rome and Rapallo. First one-woman exhibition at the Galeria del Milione, Milan, in 1936. Divorced and living in Paris, she exhibited a single painting in the 1937 Salon des Surindépendants and was discovered by the Surrealists. Returned to the United States after the outbreak of World War II and, in 1940, married Yves Tanguy in New York. First American exhibition in 1940. Exhibited regularly from 1940 to her death by suicide. A joint exhibition of the work of Sage and Tanguy was held at the Wadsworth Atheneum, Hartford, Connecticut, in 1954; retrospective exhibitions at the Catherine Viviano Gallery, New York (1960), and at the Herbert F. Johnson Museum of Art, Cornell University (1976). Sage was also the author of four volumes of poetry.
Exhibitions: New York (1942), Paris (1947).

TANNING (ERNST), Dorothea

American painter. Born in Galesburg, Illinois, in 1910. Attended the Art Institute of Chicago in 1932. Moved to New York where the 1937 exhibition Fantastic Art, Dada, Surrealism decided her future as a painter. Traveled to Europe in 1939 with letters of introduction to several Surrealist painters but found Paris deserted. Returning to New York she met Max Ernst in 1942; first one-woman exhibition at the Julien Levy Gallery in 1944. Married Ernst in 1946 and the couple lived in Sedona, Arizona, Huismes, and Paris until Ernst's death in 1976. Numerous one-woman exhibitions since 1944; retrospective exhibitions of her work held at the Casino Communale, Knokke-le-Zoute (1967) and the Centre National d'Art Contemporain, Paris (1974). Now lives and works in New York.
Exhibition: Paris (1947).

TOYEN (Marie Cěrmínová)

Czech painter. Born in Prague in 1902, died 1980 in Paris. Attended the Ecole des Beaux-Arts in Prague and in 1922 met Jindrich Štyrský in Yugoslavia. Štyrský and Toyen became members of the Czech avant-garde group Devětsil in 1923. In Paris, 1925 to 1928, Toyen embraced "poetic artificialism"; first exhibition with Štyrský at the Galerie d'Art Contemporain, Paris, in 1927. Returned to Prague in 1928; the following year began transition to Surrealism. Founder and member of the Surrealist Group in Prague from 1934 until the German occupation of Czechoslovakia forced her underground. Executed three cycles of drawings before and during the war: *The Spectres of the Desert* (1937–38), *The Rifle-Range* (1939–40), and *Hide Yourself War* (1944), published in 1946. Settled in Paris in 1947 where she remained until the end of her life. A retrospective exhibition of the work of Toyen, Štyrský, and Jindrich Heisler was held at the Musée National d'Art Moderne, Centre Georges Pompidou, Paris, in 1982.
Exhibitions: London (1936), Tokyo (1937), Paris (1938), Amsterdam (1938), Paris (1947).

VARO, Remedios

Spanish painter. Born in Anglés, Spain, in 1908, died 1963 Mexico City. Childhood travels in Spain and North Africa with her father, a hydraulic engineer, sparked a lifelong interest in mathematics, mechanical drawing, and fantastic locomotive vehicles. Attended convent schools and the Academia de San Fernando in Madrid; after a brief marriage to a fellow student met the Surrealist poet Benjamin Peret in Barcelona where she had moved to become part of a more avant garde milieu. Settled in Paris with Peret and was active in Surrealist circles there between 1937 and 1939. Forced to leave France for political reasons, the couple settled and married in Mexico in 1942, where Varo remained for the rest of her life. First one-woman exhibition in 1956 at the Galeria Diana in Mexico City; her retrospective at the Museo de Arte Moderno in 1971 drew the largest audiences in Mexican history.
Exhibitions: Tokyo (1937), Paris (1938), Amsterdam (1938), Mexico City (1940), New York (1942), Paris (1947).

Select Bibliography

BOOKS AND CATALOGUES

Ades, Dawn. *Salvador Dali*. London, 1982.

Eileen Agar: Retrospective Exhibition. Exhibition Catalogue. London: Commonwealth Art Gallery, 1971. Introduction by Roland Penrose.

Eileen Agar: A Decade of Discoveries. Exhibition Catalogue. London: New Art Centre, 1976. Introduction by Roland Penrose.

Eileen Agar: Retrospective Exhibition of Paintings and Collages, 1930–1964. Exhibition Catalogue. London: Brook Street Gallery, 1964.

Album Surréaliste: Nippon Salon. Exhibition Catalogue. Tokyo: Ginza Galleries, 1937.

Alexandre, Maxime. *Memoires d'un Surréaliste*. Paris, 1968.

Alexandrian, Sarane. *L'Art Surréaliste*. Paris, 1969.

Arnim, Achim d'. *Contes Bizarres*. Paris, 1933.

Arp on Arp. Ed. M. Jean. Trans. G. Neugroschel. New York, 1969.

Atelier Man Ray: Abbott, Boiffard, Brandt, Miller, 1920–1935. Exhibition Catalogue. Paris: Musée National d'Art Moderne, Centre Georges Pompidou, 1982. Essays by Brigitte Hermann, Pierre Naville, Roméo Martinez.

Balakian, Anna. *Artdré Breton: Magus of Surrealism*. New York, 1971.

Benayoun, Robert. *Erotique du Surréalisme*. Paris, 1965.

Bosquet, Alain. *La Peinture de Dorothea Tanning*. Paris, 1966.

Breton, André. *L'Amour Fou*. Paris, 1937.

——. *Arcane 17*. New York, 1944.

——. *Nadja* (1928). New York, 1960.

——. *Surrealism and Painting*. Trans. S.W. Taylor. New York, 1972.

——. *Les Vases Communicants*. Paris, 1932.

Brion, Marcel. *Léonor Fini et Son Oeuvre*. Paris, 1955.

Britain's Contribution to Surrealism of the 30's and 40's. Exhibition Catalogue. London: Hamet Gallery, 1971.

Cardinal, Roger, and Short, Robert. *Surrealism: Permanent Revolution*. London, 1970.

Leonora Carrington. Exhibition Catalogue. New York: Pierre Matisse Gallery, 1948. Essay by Edward James.

Carrington, Leonora. *La Débutante: Contes et Pièces*. Paris, 1978.

——. *El Mundo magico de los mayas*. Mexico City, 1964.

——. *The Oval Lady*. Santa Barbara, California, 1975.

Leonora Carrington: A Retrospective Exhibition. Exhibition Catalogue. New York: Center for Inter-American Relations, 1976. Introduction by Edward James.

Leonora Carrington. Texts by Juan Garcia Ponce and Leonora Carrington. Mexico City, 1974.

Carter, Angela. *The Sadeian Woman*. London, New York, 1978.

Chadwick, Whitney. *Myth in Surrealist Painting, 1929–1939*. Ann Arbor, Michigan, 1980.

Colquhoun, Ithell. *The Crying of the Wind: Ireland*. London, 1955.

Ithell Colquhoun. Exhibition Catalogue. Cheltenham: Cheltenham Art Gallery, 1936.

Ithell Colquhoun: Paintings. Exhibition Catalogue. London: The Mayor Gallery, 1947.

Ithell Colquhoun: An Exhibition of Surrealist Paintings and Drawings from 1930–1950. Exhibition Catalogue. London: Leva Gallery, 1974.

Colquhoun, Ithell. *Goose of Hermogenes*. London, 1961.

——. *Grimoire of the Entangled Thicket* (Poems). Stevenage, Hertfordshire, 1973.

——. *The Living Stones: Cornwall*. London, 1957.

——. *Osmazone* (Poems). Örkeljunga, Sweden, 1983.

Ithell Colquhoun: Paintings and Drawings, 1930–1940. Exhibition Catalogue. London: Parkin Gallery, 1970.

Ithell Colquhoun: Surrealism. Exhibition Catalogue. Cornwall: Newlyn Orion Galleries, 1976. Essay by Ithell Colquhoun.

Dada and Surrealism Reviewed. Exhibition Catalogue. London: Arts Council of Great Britain, Hayward Gallery, 1978. Edited and with an introduction by Dawn Ades.

Dali, Salvador. *The Secret Life of Salvador Dali*. Trans. H. Chevalier. New York, 1942.

Daumal, René. *Mount Analogue*. Trans. R. Shattuck. Harmondsworth, 1959.

Dedieu, Jean-Claude. *Fêtes Secrètes*. Paris, 1978.

Dictionnaire Abrégé du Surréalisme. Paris, 1938.

Eluard, Nusch. *Collage Dreams*. New York (Nadada Editions), 1978.

Eluard et Ses Amis Peintres. Exhibition Catalogue. Paris: Musée National d'Art Moderne, Centre Georges Pompidou, 1982.

Ernst, Jimmy. *A Not-So-Still Life*. New York, 1984.

Ernst, Max. *Beyond Painting*. New York, 1948.

Exposicion Internacional del Surrealismo. Exhibition Catalogue. Mexico City: Galeria de Arte Mexicano, 1940. Organized by Cesar Moro and Wolfgang Paalen.

Exposition Internationale du Surréalisme. Exhibition Catalogue. Paris: Galerie Beaux-Arts, 1938.

Exposition Internationale du Surréalisme. Exhibition Catalogue. Amsterdam: Galerie Robert, 1938. Organized by André Breton, Paul Eluard, Georges Hugnet, Roland Penrose, E.L.T. Mesens, Kristians Tonny.

Exposition Surréaliste d'Objets. Exhibition Catalogue. Paris: Charles Ratton Gallery, 1936.

Fantastic Art, Dada, Surrealism. Exhibition Catalogue. New York: Museum of Modern Art, 1936–37. Edited by Alfred H. Barr, Jr. Essays by Georges Hugnet.

Fauré, Michel. *Histoire du Surréalisme Sous l'Occupation*. Paris, 1982.

La Femme Surréaliste. Sp. no., *Obliques*. Paris, n.d.

Léonor Fini. Paris, 1981.

Léonor Fini. Exhibition Catalogue. Turin: Galatea-Galleria d'Arte Contemporanea, 1966. Essay by Luigi Carluccio.

Léonor Fini. Exhibition Catalogue. Ferrara: Galleria Civica d'Arte Moderna, 1983. Introduction by Léonor Fini.

Léonor Fini. Exhibition Catalogue. Knokke-le-Zoute: Casino Communale, 1964.

Léonor Fini. Exhibition Catalogue. London: Kaplan Gallery, 1960. Introduction by Max Ernst.

Léonor Fini Graphique. Text by Jean Paul Guibbert. Lausanne, 1971.

Le Livre de Léonor Fini: Peintures, Ecrits, Notes de Léonor Fini. Paris, 1975.

Léonor Fini: Les Merveilles de la Nature. Munich, 1971.

Léonor Fini: Miroir des Chats. New York, 1978.

First Papers of Surrealism. Exhibition Catalogue. New York: Coordinating Council of French Relief Societies, 1942. Foreword by Sidney Janis.

Gauthier, Xavière. *Léonor Fini*. Paris, 1973.

——. *Surréalisme et Sexualité*. Paris, 1971.

Genet, Jean *Lettre à Léonor Fini*. Paris, 1950.

Gilbert, Sandra, and Gubar, Susan. *The Madwoman in the Attic: The Woman Writer and the Nineteenth Century Literary Imagination*. New Haven, 1979.

Graves, Robert. *The White Goddess*. London, New York, 1948.
Guggenheim, Peggy. *Confessions of an Art Addict*. London, 1960.
Haslam, Malcolm. *The Real World of the Surrealists*. New York, 1978.
Herrera, Hayden. *Frida: A Biography of Frida Kahlo*. New York, 1983.
Valentine Hugo: Peintures, Gravures, Dessins. Exhibition Catalogue. Troyes: Centre Culturel Thibaud de Champagne, 1977. Introduction by Bernadette Costes.
International Kunstudstilling: Kubisme-Surréalisme. Exhibition Catalogue. Copenhagen, 1935.
International Surrealist Exhibition. Exhibition Catalogue. London: New Burlington Galleries, 1936.
Jaguer, Edouard. *Les Mystères de la Chambre Noire*. Paris, 1982.
——. *Remedios Varo*. Paris, 1980.
Jaloux, Edmond; Eluard, Paul; Moravia, Alberto; Hugnet, Georges; Ford, Charles Henri; Praz, Mario; and Savinio, Alberto. *Léonor Fini*. Rome, 1945.
Janis, Sidney. *Abstract and Surrealist Art in America*. New York, 1944.
Jean, Marcel. *The History of Surrealist Painting*. Trans. S.W. Taylor. New York, 1960.
Jelenski, Constantin. *Léonor Fini*. Lausanne, 1968 and 1972.
Josephson, Matthew. *Life Among the Surrealists*. New York, 1962.
Frida Kahlo and Tina Modotti. Exhibition Catalogue. London: Whitechapel Art Gallery, 1982. Essays by Laura Mulvey and Peter Wollen.
Künstlerphotographien in XX. Jahrhundert. Exhibition Catalogue. Hanover: Kestner-Gesellschaft, 1977. Essays by Carl-Albrecht Haenlein, Klaus Hornell, Werner Lippert.
Lader, Melvin. "Peggy Guggenheim's Art of This Century: The Surrealist Milieu and the American Avant-Garde, 1942–1947." Unpublished doctoral dissertation, University of Delaware, 1981.
Jacqueline Lamba. Exhibition Catalogue. Paris: Galerie Pierre, 1947.
Jacqueline Lamba. Exhibition Catalogue. New York: Norlyst Gallery, 1944. Introduction by Jacqueline Lamba.
Jacqueline Lamba. Exhibition Catalogue. New York: Passedoit Gallery, 1948.
Levy, Julien. *Memoirs of an Art Gallery*. New York, 1977.
——. *Surrealism*. New York, 1936.
Dora Maar. Exhibition Catalogue. London: The Leicester Galleries, 1958. Preface by John Russell.
Dora Maar: Paysages. Exhibition Catalogue. Paris: Berggruen et Cie., 1957. Introduction by Douglas Cooper.
Mandiargues, André Pieyre de. *Les Masques de Léonor Fini*. Paris, 1951.
Markale, Jean. *Women of the Celts*. Trans. A. Mygind, C. Hauch, and P. Henry. London, 1975.
Masson, André. *Entretiens avec Georges Charbonnier*. Paris, 1958.
Michelet, Jules. *La Sorcière: The Witch of the Middle Ages*. Trans. L.J. Trotter. London, 1863.
Lee Miller in Sussex. Exhibition Catalogue. University of Sussex: Gardner Centre Gallery, 1984. Essay by Anthony Penrose.
Mornand, Pierre. *8 Artistes du Livre*. Paris, 1939.
Nadeau, Maurice. *The History of Surrealism*. Trans. R. Howard. New York, London, 1965.
Nash, Paul. *Outline: An Autobiography and Other Writings*. London, 1949.
Nilsson, Bengt Olaf. *Danska Surrealister 1933–1947*. Lund, 1972.
La Obra Remedios Varo. Exhibition Catalogue. Mexico City: Museo Nacional de Arte Moderno, 1964. Introduction by Horacio Flores-Sanchez.
Meret Oppenheim. Zurich, 1982.
Meret Oppenheim. Exhibition Catalogue. Solothurn: Museum der Stadt, 1974.

Meret Oppenheim. Exhibition Catalogue. Vienna: Galerie nächst St. Stephen, 1981.
Orenstein, Gloria. *The Theater of the Marvellous*. New York, 1975.
Pailthorpe, Grace. *What We Put in Prisons and in Preventive and Rest Homes*. London, 1932.
Palencia, Juan. *Surrealism in Mexican Painting*. Mexico City, 1973.
Paz, Octavio, and Callois, Roger. *Remedios Varo*. Mexico City, 1966.
Peinture Surréaliste en Angleterre 1930–1960. Exhibition Catalogue. Paris: Galerie 1900–2000, 1982. Essay by Michel Rémy.
Penrose, Roland. *Scrapbook 1900–1981*. London, New York, 1981.
Penrose, Valentine. *Herbe à la Lune*. Paris, 1935.
——. *Martha's Opera*. Paris, 1946.
——. *Dons des Feminines*. Paris, 1951.
——. *Poems and Narrations*. Manchester, 1977.
Petersen, Carl. *The Art of the Surrealists in Denmark and Sweden*. Copenhagen, 1936.
——. *Danskekunstenere (Surrealisterne)*. Copenhagen, 1937.
Photographic Surrealism. Exhibition Catalogue. Cleveland: The New Gallery of Contemporary Art, 1979. Essay by Nancy Hall-Duncan.
Photos From the Julien Levy Collection Starting With Atget. Exhibition Catalogue. Chicago: Art Institute of Chicago, 1977.
Plazy, Gilles. *Dorothea Tanning*. Paris, 1969.
Prampolini, Ida Rodriguez. *El Surrealismo y el Arte Fantastico de Mexico*. Mexico City, 1969.
Alice Rahon. Exhibition Catalogue. New York: Willard Gallery, 1951. Introduction by Alice Rahon.
Ray, Man. *Self-Portrait*. Boston, 1963.
Ray, Paul. *The Surrealist Movement in England*. New York, 1971.
Read, Herbert. *Surrealism*. London, 1936.
Sade, Comte Donatien-Alphonse-François de. *Histoire de Juliette*. Vol. 3. Paris, 1954.
Kay Sage: Catalogue for a Retrospective Exhibition. Exhibition Catalogue. New York: Catherine Viviano Gallery, 1960.
Kay Sage, 1889–1963. Exhibition Catalogue. Ithaca, New York: The Herbert F. Johnson Museum of Art, Cornell University, 1977. Essay by Regine Tessier Krieger.
Sage, Kay. "China Eggs." Unpublished memoir on microfilm. Washington, D.C.: Smithsonian Institution, Archives of American Art.
——. *Demain Monsieur Silber* (Poems). Paris, 1957.
——. *Faut Dire C'Qui Est* (Poems). Paris, 1959.
——. *Mordicus* (Poems). Paris, 1962.
——. *The More I Wonder* (Poems). New York, 1957.
——. *Piove*. Milan, 1937.
Ségalat, Roger-Jean. *Album Eluard*. Paris, 1968.
Silberer, Herbert. *Hidden Symbolism of Alchemy and the Occult Arts*. New York, 1971.
Steegmuller, Francis. *Cocteau: A Biography*. Boston, 1970.
Štyrský à Toyen, 1921–1945. Exhibition Catalogue. Brno: Moravska Gallery, 1966.
Štyrský, Toyen, Heisler. Exhibition Catalogue. Paris. Musée National d'Art Moderne, Centre Georges Pompidou, 1982. Essays by František Šmejkal, Radovan Ivsic, Annie le Brun, Vera Linhartová.
Surrealist Intrusion in the Enchanter's Domain. Exhibition Catalogue. New York: D'Arcy Galleries, 1960. Essay by Benjamin Peret.
Surrealist Objects and Poems. Exhibition Catalogue. London: London Gallery, 1937.
Yves Tanguy, Kay Sage. Exhibition Catalogue. Hartford, Connecticut: Wadsworth Atheneum Gallery, 1954.
Tanning, Dorothea. *Abyss*. New York, 1977.
Dorothea Tanning. Exhibition Catalogue. Paris: Centre National d'Art Contemporain, 1974. Interview with Alain Jouffroy.

Dorothea Tanning: Exposition Retrospective. Exhibition Catalogue. Knokke-le-Zoute: Casino Communale, 1977. Essay by Patrick Waldberg.

Dorothea Tanning. Exhibition Catalogue. Paris: Galerie le Point Cardinal, 1966.

Thirion, André. *Révolutionnaires sans Révolution.* Paris, 1972.

Toyen. Paris, 1974.

Toyen. Texts by André Breton, Jindrich Heisler, Benjamin Peret. Paris, 1953.

Tracts Surréalistes et Declarations Collectives. Vol. 1, 1922–39. Paris, 1980.

A Tribute to Kay Sage, 1889–1963. Exhibition Catalogue. New York: Catherine Viviano Gallery, 1960.

Remedios Varo. Exhibition Catalogue. Mexico City: Museo de Arte Moderno, 1983. Introduction by Octavio Paz.

Vergine, Lea. *L'Altra metà dell'Avanguardia, 1910–1940.* Milan, 1980.

Winter, Nina. *Interview with the Muse.* Berkeley, California, 1979.

Wolfe, Bertram. *The Fabulous Life of Diego Rivera.* New York, 1963.

Women Artists: 1550–1950. Exhibition Catalogue. Los Angeles: Los Angeles County Museum, 1977. Essays by Linda Nochlin and Ann Sutherland Harris.

Women in Surrealism. Exhibition Catalogue. Beverly Hills, California: The Image and the Myth, 1977.

Women's Art Show: 1550–1970. Exhibition Catalogue. Nottingham: Nottingham Castle Museum, 1982.

ARTICLES AND PERIODICALS

Ades, Dawn. "Notes on Two Women Surrealist Painters: Eileen Agar and Ithell Colquhoun." *Oxford Art Journal* 3, no. 1 (April 1980): 36–42.

Arson: An Arden Review. January 1942.

Benayoun, Robert. "Entre Chien et Loup, Enigme et Sortilège de Toyen." *Edda* 3 (1961).

Bulletin Internationale du Surréalisme. Nos. 1–4, 1935–36.

Calas, Nicolas, "Freedom, Love and Poetry." *Artforum* 16 (May 1978): 22–27.

Carrington, Leonora. "The Bird Superior, Max Ernst." *View* 2 (April 1942): 13.

Chadwick, Whitney. "*Eros or Thanatos*: The Surrealist Cult of Love Reexamined." *Artforum* 14 (November 1975): 46–56.

Colquhoun, Ithell. "Children of the Mantic Stain." *Athene* (May 1951): 29–34.

———. "The Mantic Stain." *Enquiry* 2 (October–November 1949): 15–21.

Dyn. Nos. 1–6, 1942–44.

Effenburger, V. "L'Evolution du Surréalisme en Tchécoslovaquie." *Change* 25 (December 1975): 27–42.

———. "Le Mouvement Surréaliste en Tchécoslovaquie." *Opus International* (1970): 115–19.

Free Unions Libres. 1946.

Gaggi, Silvio. "Léonor Fini: A Mythology of the Feminine." *Art International* 23 (September 1979): 34–38.

Hall-Duncan, Nancy. "Interview With Julien Levy." *Dialogue,* Akron, Ohio (September–October 1979): 22–26.

Herrera, Hayden. "Frida Kahlo: Her Life, Her Art." *Artforum* 14 (May 1976): 38–44.

Jelenski, Kot. "Dorothea Tanning." *Preuves* (June 1959).

Jouffroy, Alain. "La Révolution est Femme." *XXe Siècle* 36 (June 1974): 108–10.

Kaplan, Janet. "Remedios Varo: Voyages and Visions." *Woman's Art Journal* 1, no. 2 (Fall 1980/Winter 1981): 13–18.

Lauter, Estella. "Léonor Fini: Preparing to Meet the Strangers of the New World." *Woman's Art Journal* 1, no. 1 (Spring/Summer 1980): 44–49.

Levy, Julien. "Tanguy, Connecticut, Sage." *Art News* 53 (September 1954): 24–27.

London Bulletin. Nos. 1–20, 1938–40.

Miller, Lee. "My Man Ray." An Interview with Mario Amaya. *Art in America* 63 (May–June 1975): 54–61.

Miller, Stephen. "The Surrealist Imagery of Kay Sage." *Art International* 26, no. 4 (September–October 1983): 32–56.

Minotaure. Nos. 1–13, 1933–39.

Monegal, Emir. "La Pintura Como Exorcismo." *Mundo Nuevo* 16 (October 1967): 5–21.

New Road. 1943.

Orenstein, Gloria. "Frida Kahlo: Painting for Miracles." *Feminist Art Journal* (Fall 1973): 7–9.

———. "Leonora Carrington's Visionary Art for the New Age." *Chrysalis* 3 (1978): 65–77.

———. "Reclaiming the Great Mother: A Feminist Journey to Madness and Back in Search of a Goddess Heritage." *Symposium* (Spring 1982): 45–70.

———. "Towards a Bifocal Vision in Surrealist Aesthetics." *Trivia* (Fall 1983): 70–87.

———. "La Vision Surréaliste de Kay Sage et la Nouvelle Conscience Féministe." *Mélusine* 3 (1982): 215–21.

———. "Women of Surrealism." *Feminist Art Journal* 2 (Spring 1973): 15–21.

Pailthorpe, Grace. "The Scientific Aspect of Surrealism." *London Bulletin* 7 (December 1938–January 1939): 10–16.

Pierre, José. "Le Surréalisme et le Mexique." *Bulletin de Liaison* 11 (1979): 1–19.

Regler, Gustave. "Four European Painters in Mexico." *Horizon* 16 (August 1947): 96–101.

Renzio, Tony del. "The Uncouth Invasion: The Paintings of Emmy Bridgwater." *Arson* (1942): 24.

La Révolution Surréaliste. Nos. 1–12, 1924–29.

Šmejkal, F. "L'Oeuvre Onirique de Štyrský." *Opus International* 19–20 (1970): 120–24.

———. "Štyrský-Sade." *Světová Literatura* 5–6 (1969): 462.

———. "Surréalisme et Peinture Imaginative en Tchécoslovaquie." *Phases* 10 (September 1965): 47–57.

Soby, James Thrall. "Double Solitaire: Retrospective Exhibition at Wadsworth Atheneum." *Saturday Review,* September 4, 1954, pp. 29–30.

Smith, Terry. "From the Margins: Modernity and the Case of Frida Kahlo." *Block* 8 (1983): 14.

Le Surréalisme au Service de la Révolution. Nos. 1–6, 1930–33.

Tibol, Raquel. "Artes Plasticas: Primera Investigacion de Remedios Varo." *Novedades* (July 28, 1957): 6.

"Dorothea Tanning." Sp. no. *XXe Siècle* (1977).

Tillman, Lynn M. "Don't Cry: Work: Interview with Meret Oppenheim." *Art and Artists* 8 (October 1973): 22–27.

"Extracts of a Conversation with Jacqueline Trutat (Valentine Hugo)." *Cahiers Bleus,* no. 10 (1977).

View. 1940–47.

VVV. Nos. 1–4, 1942–44.

Withers, Josephine. "The Famous Fur-Lined Teacup and the Anonymous Meret Oppenheim." *Arts* 52, no. 3 (November 1977): 88–93.

List of Illustrations

COLOR ILLUSTRATIONS

Index